Political Aesthetics

Also available from Bloomsbury

Working Aesthetics: Labour, Art and Capitalism, Danielle Child
Transitional Aesthetics: Contemporary Art at the Edge of Europe, Uros Cvoro
Ecosophical Aesthetics: Art, Ethics and Ecology with Guattari, edited by Patricia MacCormack and Colin Gardner
Advances in Experimental Philosophy of Aesthetics, Florian Cova and Sébastien Réhault
The Bloomsbury Companion to Political Philosophy, Andrew Fiala

Political Aesthetics

Addison and Shaftesbury on Taste, Morals and Society

Karl Axelsson

BLOOMSBURY ACADEMIC
LONDON • NEW YORK • OXFORD • NEW DELHI • SYDNEY

BLOOMSBURY ACADEMIC
Bloomsbury Publishing Plc
50 Bedford Square, London, WC1B 3DP, UK
1385 Broadway, New York, NY 10018, USA
29 Earlsfort Terrace, Dublin 2, Ireland

BLOOMSBURY, BLOOMSBURY ACADEMIC and the Diana logo
are trademarks of Bloomsbury Publishing Plc

First published in Great Britain 2019
Paperback edition first published 2021

Copyright © Karl Axelsson, 2019

Karl Axelsson has asserted his right under the Copyright,
Designs and Patents Act, 1988, to be identified as Author of this work.

For legal purposes the Acknowledgements on p. viii constitute
an extension of this copyright page.

Cover design by Maria Rajka
Cover image: The Choice of Hercules (oil on canvas), Paolo di Matteis (1662–1728) © Leeds Museums and Art Galleries (Temple Newsam House) UK / Bridgeman Images

All rights reserved. No part of this publication may be reproduced or transmitted in any form or by any means, electronic or mechanical, including photocopying, recording, or any information storage or retrieval system, without prior permission in writing from the publishers.

Bloomsbury Publishing Plc does not have any control over, or responsibility for, any third-party websites referred to or in this book. All internet addresses given in this book were correct at the time of going to press. The author and publisher regret any inconvenience caused if addresses have changed or sites have ceased to exist, but can accept no responsibility for any such changes.

A catalogue record for this book is available from the British Library.

A catalog record for this book is available from the Library of Congress.

ISBN: HB: 978-1-3500-7775-1
PB: 978-1-3502-4368-2
ePDF: 978-1-3500-7776-8
eBook: 978-1-3500-7777-5

Series: Bloomsbury Ethics, 1234567X, volume 6

Typeset by Jones Ltd, London

To find out more about our authors and books visit
www.bloomsbury.com and sign up for our newsletters.

For Camilla

Contents

Acknowledgements	viii
Note to the Reader	x
Introduction	1
Rethinking a provenance	1
Reading the history of aesthetics	5
Addison and the body politic	18
Shaftesbury, affections, and society	26
Part 1 Addison, taste, and the moral body politic	35
1.1 The displacement of political authority	37
1.2 The disposition of taste	59
1.3 Aurelia and Fulvia	71
1.4 Ethico-emotive pleasures	85
1.5 Faith and political enthusiasm	95
1.6 Britain and the new classicism	119
1.7 The perils of the foreign	131
Part 2 Moved by affections: Shaftesbury on beauty and society	143
2.1 Natural affections	147
2.2 Self-knowledge and disinterestedness	157
2.3 A disinterested (aesthetic) perception	177
2.4 The work of art as a *whole*	201
2.5 Taste for society	219
Coda: Reading Addison and Shaftesbury in the future	239
Bibliography	243
Index	267

Acknowledgements

The publication of this book would not have been possible without the support and inspiration from Camilla Flodin and Peter de Bolla. Their writings on the history of aesthetics have always been for me exemplary and without their insightful readings of the manuscript I would not have been able to pull this project through. I also wish to thank Mattias Pirholt, Lawrence E. Klein, Karen Collis, Stephen Ahern, Ewan Jones, John Regan, Paul Nulty, and Tim Stuart-Buttle, for friendship and stimulating discussions.

I owe a lot to my first teachers in aesthetics at Uppsala University, Lars-Olof Åhlberg and the late Göran Sörbom, who opened my eyes to the history of aesthetics. More recently, I have learned either about aesthetics or about myself from talking to Cecilia Sjöholm, Jonas Olson, Michael B. Gill, Simo Säätelä, Anna Cullhed, Sven-Olov Wallenstein, Christine Farhan, Claes Entzenberg, Antonia Hofstätter, Paul Maslov Karlsson, Maria Semi, Rebecka Molin, Oiva Kuisma, Morten Kyndrup, Arto Haapala, Zoltán Somhegyi, and Åsa Arketeg. I wish to express my gratitude to Marie-Christine Skuncke, Annie Mattsson, and Ann Öhrberg for providing an outstanding seminar for eighteenth-century scholars at Uppsala University, and to Ann for also co-hosting seminars with me and for rescuing the project when I was about to lose faith in it.

I am grateful to my dear colleagues and students in Comparative Literature at the School of Culture and Education at Södertörn University in Stockholm. A special thanks to Lawrence E. Klein and the participants of the workshop on *The Moralists* in May 2018, and to Henrik Bohlin, Robert Callergård, Frans Svensson, and Jonas Olson for organizing the Shaftesbury Reading Group at Stockholm University in 2017.

Over the years, I have received economic subventions from the Swedish Research Council and the Swedish Foundation for Humanities and Social Sciences (Riksbankens Jubileumsfond). I have also received financial support from STINT, Anders Karitz stiftelse, Sven & Dagmar Saléns stiftelse, Lars Hiertas Minne, Åke Wibergs stiftelse, Gunvor & Josef Anérs stiftelse, Helge Ax:son Johnsons stiftelse, Birgit & Gad Rausings stiftelse, Magnus Bergvalls stiftelse, and Johan & Jakob Söderbergs stiftelse. I am grateful to all the Swedish foundations for backing a time-consuming project such as this one.

Acknowledgements

I wish to thank my publisher Liza Thompson for moving this project forward with proficiency and enthusiasm. I am grateful to Lisa Hagelin for checking my Latin translations, and to Mikael Johansson, my teacher in Classical Greek, for comments and suggestions.

Some ideas scattered in this book were initially tried out in different contexts. Minor sections of Chapter 1.3 grew from ideas presented in *Estetika: The Central European Journal of Aesthetics* 2 (2009) and parts of Chapters 1.6 and 1.7 contain a modified idea tried out in *Journal of Aesthetics & Culture* 5 (2013). Also, I owe a debt to the Shaftesbury Project, especially to Patrick Müller and Rudolf Freiburg, for the invitation to present a paper at the Tercentenary Conference in Nürnberg in 2012. I am thankful to Friedrich A. Uehlein, for inspiring conversations and for continued correspondence over the years, and to Laurent Jaffro, David Alvarez, Ruben Apressyan, and Isabella Woldt for inspiring discussions during this rare event. Chapter 2.5 includes part of an argument that I made in the last section of my article in the conference proceedings from Nürnberg, *New Ages, New Opinions: Shaftesbury in His World and Today*, edited by Patrick Müller (Frankfurt am Main: Peter Lang, 2014); permission conveyed through Copyright Clearance Center, Inc.

My parents, Ulla and Larsinge Axelsson, my sister Jenny Hjalt and her family, and my dear friend Ulrika Flink have all been loving companions throughout the highs and lows of writing. Lastly, Camilla, my kindred soul and love, I dedicate this third book to you with all my admiration.

Stockholm, February 2019

Note to the Reader

References to Joseph Addison's writings given within the text are to the *Spectator* (abbrev. *S*), 5 vols, ed. Donald F. Bond (Oxford: Oxford University Press, 1965); the *Tatler* (abbrev. *T*), 3 vols, ed. Donald F. Bond (Oxford: Oxford University Press, 1987); and the *Freeholder* (abbrev. *F*), ed. James Leheny (Oxford: Oxford University Press, 1979). Unless otherwise stated, all references are to the volumes (in Roman numerals) of Bond's and Leheny's editions followed by page numbers and original essay numbers (in Arabic numerals).

References to the third Earl of Shaftesbury's writings given within the text are to the *Standard Edition: Complete Works, Correspondence and Posthumous Writings*, ed. Wolfram Benda, Gerd Hemmerich, Christine Jackson-Holzberg, Wolfgang Lottes, Patrick Müller, Ulrich Schödlbauer, Friedrich A. Uehlein, and Erwin Wolff (Stuttgart-Bad Cannstatt: frommann-holzboog, 1981–). Arabic numerals in square brackets refer to page numbers in the 1714/15 edition of *Characteristicks*. For Shaftesbury's references to other authors I have consulted Lawrence E. Klein's edition of Shaftesbury's *Characteristics of Men, Manners, Opinions, Times* (Cambridge: Cambridge University Press, 1999). Manuscript sources are The Shaftesbury Papers in The National Archives (abbrev. TNA), formerly Public Record Office (abbrev. PRO), and the British Library (abbrev. BL, Add. MS).

Introduction

Rethinking a provenance

The eighteenth century is the Grand Siècle in the history of Western aesthetics, and British theories of taste are generally claimed to hold the centre stage as the ancestors of modern aesthetic theory. At the heart of the current narrative is a commitment to the so-called *reconstructive approach* that treats British theories of taste as a crucial foil for a subsequent notion of aesthetic autonomy.[1] However, while claiming a strong sense of continuity in the history of aesthetics from the eighteenth century onwards, the reconstructive approach naturally also suggests a discontinuity. After all, the eighteenth century is famously believed to mark a 'Copernican revolution' in the concept of art, namely the radical transformation from the belief that the aesthetic experience had vital extra-aesthetic functions (*aesthetic instrumentalism*) to the modern belief that it, broadly speaking, holds a distinctive and intrinsic value (*aesthetic autonomy*).[2] Besides minor slants and variations, the reconstructive approach has shown a strong inclination to identify and define itself by embracing historical continuity along with cataclysmic change. The continuity model and the discontinuity model endure, as it often seems, in a productive tension. Completely absorbed in an overall dialogic structure

[1] Preben Mortensen, *Art in the Social Order: The Making of the Modern Conception of Art* (Albany: State University of New York Press, 1997), 50–1.
[2] On the 'Copernican revolution', see M. H. Abrams, 'Art-as-Such: The Sociology of Modern Aesthetics', in *Doing Things with Texts: Essays in Criticism and Critical Theory* (New York: W. W. Norton, 1989), 140. The transformation is characterized in various ways, some of them presented in this introduction. The concept formations *aesthetic instrumentalism* and *aesthetic autonomy* are applied by T. J. Diffey, 'Aesthetic Instrumentalism', *British Journal of Aesthetics* 22, no. 4 (1982). While Diffey's examples of aesthetic instrumentalism are primarily from the nineteenth century, his central point is that 'aesthetic autonomy is something historically located, something manifest in attitudes to art that has been gaining in strength since the eighteenth century to a position of dominance today' (345).

of the history of aesthetics, the reconstructive approach would only fail to extricate the distinctive traits of modern aesthetic autonomy.

While this current coordination of the history of aesthetics might seem appealing, it is greatly problematic. Given that '[r]eputable writers in aesthetics nowadays are autonomists', we should not be surprised to learn that aesthetics usually has favoured the historical relevance of aesthetic autonomy at the sacrifice of 'aberrant' perspectives where especially ethico-political values (i.e. values related to ethics as well as to politics) signify a main purpose of taste.[3] In the established accounts of the transformation from what Larry Shiner describes as a situation where 'taste was usually tied to an "interest" or stake in the purpose of works of art, whether moral, practical, or recreational', to the modern conditions of autonomy, it is as if some of the most historically significant and complex features of the theories of taste have been stifled.[4] The disadvantage of what Nicholas Wolterstorff has recently referred to as *'the grand narrative'* is, I believe, that British eighteenth-century theories of taste have, in a dated fashion, become relevant only in so far as they prove to reveal a clue to aesthetic autonomy and to a putative Kantian paradigm of beauty as causing a 'satisfaction without any interest'.[5]

There is a history awaiting to be written here about the inherent character of theories of taste, rather than primarily regarding them as preliminary works for the paradigm shift between a waning (neo)classicism, and the advent of the modern pledges of aesthetic autonomy and the category of the fine arts (*les beaux arts* or *die schönen Künste*).[6] This book aims to provide a gateway to such a new history by thinking the provenance of British early-eighteenth-century theories of taste anew. I will explore the fertile intermediate ground between historical instrumentalism and modern autonomy, where British philosophers

[3] Diffey, 'Aesthetic Instrumentalism', 337, 345.
[4] Larry Shiner, *The Invention of Art: A Cultural History* (Chicago, IL: University of Chicago Press, 2001), 144.
[5] Nicholas Wolterstorff, *Art Rethought: The Social Practices of Art* (Oxford: Oxford University Press, 2015), 26. For Wolterstorff's account of the grand narrative, see 5–54. For the quotation from Kant, see Immanuel Kant, *Critique of the Power of Judgment*, Cambridge Edition of the Works of Immanuel Kant, ed. Paul Guyer, trans. Paul Guyer and Eric Matthews (Cambridge: Cambridge University Press, 2000), 96 (*Kant's gesammelte Schriften/Akademie-Ausgabe* 5:211). The weakness of the narrative is a supposed *telos* of British theories of taste and a presumed irrelevance of ethico-political meaning in the Third Critique. About this, see Andrew Ashfield and Peter de Bolla's 'Introduction', in *The Sublime: A Reader in British Eighteenth-Century Aesthetic Theory*, ed. Andrew Ashfield and Peter de Bolla (Cambridge: Cambridge University Press, 1996), 3.
[6] For the established account of the emergence of the category of the fine arts, see Paul Oskar Kristeller, 'The Modern System of the Arts: A Study in the History of Aesthetics (I)', *Journal of the History of Ideas* 12, no. 4 (1951); 'The Modern System of the Arts: A Study in the History of Aesthetics (II)', *Journal of the History of Ideas* 13, no. 1 (1952).

and critics made taste, morals, and a politically stable society an integral part of their claims about nature and art. Typically, a historical project such as the one explored throughout the following chapters involves the act of biting off more than one can chew. To moderate that risk, I will proceed by primarily exploring the writings advanced by two of the most prolific men of letters in eighteenth-century Britain, Joseph Addison (1672–1719) and the third Earl of Shaftesbury (1671–1713). By doing so, I intend to challenge a general truth that has been guiding generations of scholars of eighteenth-century thought, namely the conviction that modern aesthetic autonomy was a reorientation in philosophy originally prompted by Addison and Shaftesbury.[7] Such convictions have assumed a variety of shapes over the years. To bring out just one influential voice in the choir, M. H. Abrams's account of the great aesthetic divide remains illustrative of the current. While separating between a historical *construction model* where art was perceived (from the maker's stance) as an instrumental 'means to an external end' and a modern *contemplation model* where art was deemed (from the perceiver's stance) as 'self-sufficient, autonomous, [and] independent',[8] Abrams stresses that

> [t]he perceiver's stance and the contemplation model were products not of late-nineteenth-century aestheticism but of the eighteenth century. More precisely, they appeared at the end of the first decade of the eighteenth century, in the writings of Joseph Addison and of the third Earl of Shaftesbury; only eighty years later, in 1790, they had developed into the full modern formulation of art-as-such in Immanuel Kant's *Critique of Aesthetic Judgment*.[9]

It would be foolish not to acknowledge a slight resemblance between the general ambition of this book and Abrams's aim to alert his readers to the fact that the development of aesthetic autonomy in the eighteenth century now is 'so entirely [taken] for granted that it requires an effort of the historical imagination to realize the radical difference this made' at the time.[10] Although there are relevant reasons to claim that the 'moral effects' of the aesthetic experience slowly but surely came to be, if not 'irrelevant',[11] at least transformed and less dominating, it nevertheless remains problematic to presume that someone like Addison

[7] For an excellent attempt to challenge the idea that Shaftesbury and Addison ought to be regarded in tandem, see Karen Collis, 'Shaftesbury and Literary Criticism: Philosophers and Critics in Early Eighteenth-Century England', *Review of English Studies* 67, no. 279 (2016).
[8] Abrams, 'Art-as-Such: The Sociology of Modern Aesthetics', 136.
[9] Ibid., 138–9.
[10] Ibid., 148. Abrams is concerned with the autonomy of the institutions of art in the eighteenth century.
[11] M. H. Abrams, 'Kant and the Theology of Art', *Notre Dame English Journal* 13, no. 3 (1981), 75.

initiated such a development by favouring conditions where works of fine art could play out their 'role as objects of connoisseurship' precisely by suggesting an 'escape from ordinary utilitarian and moral interests and pursuits'.¹²

The state of the established account has of course varied over the years. To some extent we have moved from extreme accounts on the absolute 'fracturing' where Addison and Shaftesbury simply are regarded as provoking a pure aesthetic attitude that is indifferent to 'religion or learning, history or politics, manners or morals',¹³ towards less radical versions, productively charting new branches of the rise of modern aesthetics, however without questioning the tale where Addison's essays on the *Pleasures of the Imagination* are 'widely regarded to be one of the founding texts of modern aesthetic theory',¹⁴ and Shaftesbury, in a conventional diachronic chain of events, is preoccupied with 'laying the decisive groundwork for Kant's ... aesthetics'.¹⁵ The narrative is thus still coherent and, as Simon Grote remarks, for anyone 'interested primarily in the early eighteenth century, its coherence' is 'disappointingly teleological'.¹⁶

While being sympathetic to a need of coherent narratives, the ambition of this book is to move beyond these well-established beliefs, by re-examining the political relevance of Addison's and Shaftesbury's theories of taste and to show that they were, first and foremost, seeking to fortify a link between the aesthetic experience and the moral preservation of modern society. At the dawn of the

[12] Abrams, 'Art-as-Such: The Sociology of Modern Aesthetics', 152.
[13] Douglas Lane Patey, 'The Eighteenth Century Invents the Canon', *Modern Language Studies* 18, no. 1 (1988), 24–5.
[14] Brian Michael Norton, '*The Spectator*, Aesthetic Experience and the Modern Idea of Happiness', *English Literature* 2, no. 1 (2015), 88.
[15] Dorothea E. von Mücke, *The Practices of the Enlightenment: Aesthetics, Authorship, and the Public* (New York: Columbia University Press, 2015), 28. For similar contributions (but with varying emphases) on the origins of eighteenth-century aesthetics in Addison and/or Shaftesbury, see e.g. Ernst Cassirer, *Die platonische Renaissance in England und die Schule von Cambridge* (Leipzig: B. G. Teubner, 1932), 130; Samuel H. Monk, *The Sublime: A Study of Critical Theories in Eighteenth-Century England* (New York: Modern Language Association of America, 1935); R. L. Brett, *The Third Earl of Shaftesbury: A Study in Eighteenth-Century Literary Theory* (New York: Hutchinson's University Library, 1951), esp. 136–44; Jerome Stolnitz, 'On the Origins of "Aesthetic Disinterestedness"', *Journal of Aesthetics and Art Criticism* 20, no. 2 (1961); Stolnitz, 'On the Significance of Lord Shaftesbury in Modern Aesthetic Theory', *Philosophical Quarterly* 11, no. 43 (1961); Peter Kivy, 'Recent Scholarship and the British Tradition: A Logic of Taste – The First Fifty Years', in *Aesthetics: A Critical Anthology*, ed. George Dickie, Richard Sclafani and Ronald Roblin, 2nd edn (New York: St Martin's Press, 1989); James Shelley, 'Empiricism: Hutcheson and Hume', in *The Routledge Companion to Aesthetics*, ed. Berys Gaut and Dominic McIver Lopes, 2nd edn (London: Routledge, 2005), 42; Allen Carlson, *Nature and Landscape: An Introduction to Environmental Aesthetics* (New York: Columbia University Press, 2009), 2–3; Timothy M. Costelloe, *The British Aesthetic Tradition: From Shaftesbury to Wittgenstein* (Cambridge: Cambridge University Press, 2013), e.g. 38.
[16] Simon Grote, *The Emergence of Modern Aesthetic Theory: Religion and Morality in Enlightenment Germany and Scotland* (Cambridge: Cambridge University Press, 2017), 6. Grote advances a non-teleological account of modern pre-Kantian aesthetic theory, by situating German and Scottish Enlightenment theories in theological contexts.

eighteenth century, aesthetic experience gained a renewed rationale in the British republic of letters by being integrated in the ongoing debate on the displacement of political authority.[17] The way in which Addison's and Shaftesbury's theories of taste, through very different approaches, tried to come to terms with such a political process, by claiming taste to be an integral moral part of the basis of society, will constitute the centre of my investigation.

Reading the history of aesthetics

There are many ways to describe the transformed eighteenth-century perception of nature and art (for Addison and Shaftesbury including especially poetry, but also painting, sculpture, music, and architecture). One productive way is to avoid phrasing the transformation in too hyperbolic a language. The eighteenth century is in many ways a looking glass for modern expectations on aesthetic experience, but to state the parallels between autonomy and instrumentalism, now and then, us and them, in terms of philosophical cataclysms or revolutions is to make an already difficult challenge almost impossible. History rarely offers anything clear-cut. A paradigmatic claim that the 'eighteenth century *was* the century of taste, that is, of the theory of taste',[18] can only be motivated by the modest recognition that a long and gradual succession of artistic, scientific, political, and socio-economic events coincided throughout the century, and interacted with many people's expectations (involuntary or not) about a general life praxis. We tend to define these multilayered interrelations as modern, partly because they are still present in our own lives.

British eighteenth-century theories of taste existed on the threshold of a more modern, and from our perspective perhaps more easily recognizable, self-referential evaluation where natural scenery or art may (or may not) have ethico-political implications, but where such regards were gradually becoming less significant for opinions on the distinct value of the aesthetic experience as such. By the dawn of the century, however, Addison and Shaftesbury showed no inclination of repositioning themselves, and their theories of taste, any closer to such a threshold. Instead, they clung to a familiar trait (rather than a well-defined *unit idea*)[19] in the history of Western aesthetics – often explicitly present

[17] I apply 'aesthetic experience' as a generic term for the affective experience of nature and art.
[18] George Dickie, *The Century of Taste: The Philosophical Odyssey of Taste in the Eighteenth Century* (Oxford: Oxford University Press, 1996), 3.
[19] For a critique of unit ideas, see Quentin Skinner, 'Meaning and Understanding in the History of Ideas', in *Visions of Politics, Volume I: Regarding Method* (Cambridge: Cambridge University Press,

(although constantly shifting its appearance and meaning), and rarely subjected to any detailed questioning, from the classical ideals of Greece and Rome, via the Middle Ages, the Renaissance, right up to the eighteenth century – namely the belief that the experience of nature and art was a determining factor for the configuration of political society, and occasionally even a significant *instrument* to reach distinctive ethico-political ends that secured the continued existence of such a society.[20]

To insist on the presence of such a historical trait does not imply that modern perceptions mark a definite disapproval of such general ethico-political ends. Modern views of the aesthetic experience do not offer any fixed notion of autonomy. Naturally, '[a]ll art and art theory, from any time period', as James I. Porter reminds us, 'bleeds into the social, is contaminated with ideology, [and] carries out moral agenda (however secretively)'.[21] As far as the nature of the aesthetic experience is concerned, there is no positive limit to what natural scenery or art might from time to time prompt an individual or a social community to hold as morally or politically relevant. But while there certainly is no *absolute* autonomy detectable in aesthetics from the eighteenth century onwards, there is a *definitional* autonomy which with gradual intensity aims to outline the distinctive disposition of the modern aesthetic experience.[22] Within the context of such a definitional autonomy, the ethico-political value indeed becomes, slowly but surely, less regarded as a determining factor for the merits of aesthetic experience. However, what is striking about British early-eighteenth-century theories of taste is, as we will see throughout this book, not so much their advancement of such a philosophical transformation by the proclamation of ethico-political values as secondary and accidental ends of the aesthetic experience, as much as their insistence on such values as purposive and primary ends. Addison's and Shaftesbury's theories of taste did not foreshadow or promote the belief that the experience of nature and art ought to transcend concrete moral or political matters, as much as they in fact perceived such an experience to be an integral part of a politically effective society (Shaftesbury),

2002), 83–4. This is a revised version of Skinner's article with the same title published in *History and Theory* 8, no. 1 (1969). See also Mortensen, *Art in the Social Order*, 51.

[20] See also Owen Hulatt, 'Introduction', in *Aesthetic and Artistic Autonomy*, ed. Owen Hulatt (London: Bloomsbury, 2013), esp. 1–2.

[21] James I. Porter, 'Reply to Shiner', *British Journal of Aesthetics* 49, no. 2 (2009), 176.

[22] See Peter Kivy, 'What *Really* Happened in the Eighteenth Century: The "Modern System" Re-examined (Again)', *British Journal of Aesthetics* 52, no. 1 (2012), 65–9. Kivy separates between *absolute* and *definitional* autonomy, claiming the latter as relevant when addressing the autonomy of the fine arts in the eighteenth century.

and to be a decisive instrument to impel a common moral standard for society (Addison).

What was then the aesthetico-political *topos* that Addison and Shaftesbury explored in early-eighteenth-century Britain? Admittedly there is a strong element of instrumentalism in the writings of Addison, as he often appears to value nature and art precisely for possessing a particular ethico-political function. Any worries about the status of the aesthetic experience qua aesthetic experience, in case one should detect a superior non-aesthetic way to generate the same function, would have been alien to Addison. Furthermore, Addison does not always appear to distinguish between what makes the experience of nature and art in *general* a valuable human activity and what makes the experience of a *particular* natural scene or, say, poem or play valuable.[23] Instead, he often tends to run these two properties together. By claiming, for instance, that artistic performances in *general* always must aid the 'Advancement of Morality, and [contribute] to the Reformation of the Age' (*S* IV, 66–7; 446), Addison seems to suggest that the evaluations of a *particular* play can be reduced to the formal confirmation that the best play simply is the one that most successfully produces such a desired moral and political effect. However, it would be a mistake to think that Addison denies the critical value of genuinely experiencing nature and art. Merely to *see* the qualities of beauty is not necessarily significant, neither for modern autonomists nor for a moralist like Addison.[24] Beauty always demands an emotional input and without the aesthetic *experience* questions about intrinsic or instrumental values could not even arise.[25] To claim that the urge to engage in aesthetic experiences was just as significant in the early eighteenth century as it is today, is, however, not inconsistent with the fact that we, over time, learn and unlearn how to respond to nature and art. Affective aesthetic experiences are, so to speak, always contemporary – and in an incessant flux. At the dawn of the eighteenth century, the theories about such affective experiences did not involve a desire to fence off any intrinsic value from morality, politics, or Christian faith, but rather, as Addison argues, a wish to infuse new life into the neoclassical principle that 'Taste is not to conform to the Art, but the Art to the Taste' (*S* I, 123; 29). By doing precisely so, Addison forcefully explored the intermediate value of the aesthetic experience that he thought was active and

[23] This distinction corresponds to Diffey's division between *apologies* for art and *evaluations* of a work of art. See Diffey, 'Aesthetic Instrumentalism', 341.
[24] See also Robert Stecker's reply to Diffey, in 'Aesthetic Instrumentalism and Aesthetic Autonomy', *British Journal of Aesthetics* 24, no. 2 (1984), 161.
[25] Ibid., 160–5.

decisive in leading the individual onwards, towards the Deity and a perfection of moral agency that would enable a politically stable society.

By holding on to the classical idea that beauty and morality always must be *'one and the same'* (*Moralists* 324 [399]), Shaftesbury agreed with Addison on the basic principles of nature and art. But I would hesitate to suggest that Shaftesbury had much confidence in the kind of instrumentalism that Addison pursued.[26] Taste is, to Shaftesbury, always already an integral potential of a natural affective impulse to other human beings and society itself, rather than an instrument for authorizing the individual morality that Addison believed organized the collective principles of a body politic. As Daniel Carey convincingly has demonstrated, Shaftesbury gives, in a Stoic vein, emphasis to a natural a priori anticipation.[27] One of the chief exponents of Stoic philosophy, Epictetus, refers to such innate anticipation as *prolēpseis* (προλήψεις), and Shaftesbury presents Epictetus' notion in *Askêmata* (Ἀσκήματα), the private notebooks that he embarked on during his retreats in Rotterdam, from 1698 to 1699, and again from 1703 to 1704 (*Askêmata* 391).[28] In other parts of his writings he relies on different but related concepts to express 'implanted notions' (ἐμφύτους ἐννοίας), such as '*Preconceptions*', '*Instinct*', and 'natural *Anticipation*'.[29] There are many

[26] One of Shaftesbury's sketchy directives to his unfinished *Plasticks, or the Original, Progress, & Power of Designatory Art* is suggestive of how moral ends nevertheless imbue his philosophical commitment, while the philosophical technique must remain coded and 'indirect' for the reader: 'Remember still: This the Idea of yᵉ Work vizᵗ. *Quasi* The Vehicle of other Problemes, i:e. the Præcepts, Demonstrations &c of real Ethicks. But this hid: not to be said except darkly or pleasantly with Raillery upon Self … ' (*Plasticks* 163).

[27] See Daniel Carey, 'Locke, Shaftesbury, and Innateness', *Locke Studies* 4 (2004), 21–7; also in Carey, *Locke, Shaftesbury, and Hutcheson: Contesting Diversity in the Enlightenment and Beyond* (Cambridge: Cambridge University Press, 2006), 112–16.

[28] See Epictetus, *Discourses*, trans. W. A. Oldfather, Loeb Classical Library 131 (Cambridge, MA: Harvard University Press, 1925), 1.22. Epictetus' *Discourses* were recorded by his disciple Arrian. Shaftesbury notes the entire heading of 1.22: Περὶ τῶν προλήψεων. For further discussion on the notion of *prolēpseis/prolepsis*, see Carey, 'Locke, Shaftesbury, and Innateness', 21–7; *Locke, Shaftesbury, and Hutcheson*, 110–16. For discussion on *Askêmata* and stoicism, see Laurent Jaffro, 'Les *Exercices* de Shaftesbury: un stoïcisme crépusculaire', in *Le stoïcisme au XVIe et au XVIIe siècle: Le retour des philosophies antiques à l'âge classique*, ed. Pierre-François Moreau (Paris: Albin Michel, 1999). For the most detailed reading of *Askêmata*, see Friedrich A. Uehlein, *Kosmos und Subjektivität: Lord Shaftesburys Philosophical Regimen* (Freiburg: Karl Alber, 1976).

[29] About anticipation and ἐμφύτους ἐννοίας, see apparatus criticus to *Miscellaneous Reflections* (see *Printed Notes* 200 [214]). Here, Shaftesbury refers to Jean Le Clerc's *Silvae Philologicae* (1711) when clarifying his position in the debate on innateness. About preconceptions, see *The Moralists* (342 [412]); about instinct, see *The Moralists* (340 [411]); about natural anticipation, see *Miscellaneous Reflections* (258 [214]). A further terminological adjustment is made in a letter to Michael Ainsworth (3 June 1709). There, Shaftesbury speaks of 'innate' as 'a Word [Locke] poorly plays upon', identifying as the 'right word, tho less usd' the term '*connatural*', which he found in Benjamin Whichcote's sermons (*Ainsworth Correspondence* 403). About the impact of Whichcote's argument on Shaftesbury, see Friedrich A. Uehlein, 'Whichcote, Shaftesbury and Locke: Shaftesbury's Critique of Locke's Epistemology and Moral Philosophy', *British Journal for the History of Philosophy* 25, no. 5 (2017). On innateness and Locke, see also Shaftesbury to James Stanhope, 7 November 1709 (TNA,

fascinating aspects of Shaftesbury's participation in the debate on innateness, not least concerning a potential of the human disposition to safeguard the sacrosanct beauty of nature and the natural capacity for taste. What is important for the argument advanced in this book is the way Shaftesbury lets this innate human disposition act together with both aesthetic progression towards experiences of beauty and a natural engagement in society.

The challenge of historical scholarship in aesthetics is thus to determine what kind of ethico-political value in life the affective experience of nature and art had in the past. This opens up a rudimentary difference between the commitment of a *contemporary philosopher* and the endeavors of a *philosopher of the history of aesthetics*.[30] While the latter attempts to clarify various expectations attributed to aesthetic experiences as accurately as possible, in order to understand either the diachronic narrative of aesthetics, or the synchronic relevance of taste at a particular moment in time, the former often seeks to defend an aesthetic theory or aesthetic concept, usually due to an alleged confusion of the general objectives of aesthetics as a discipline.[31] While recognizing that the self-evidence of aesthetic autonomy often has affected our synchronic understanding of the writings of Addison and Shaftesbury, the philosopher of the history of aesthetics can hopefully bring back a sense of balance. One of the assumptions navigating the argument of this book is thus that it is only by acknowledging that the expectations ascribed to aesthetic experiences are historically founded, and by furthermore exploring the unique features of such expectations and experiences, that we can begin to disclose the complexities internal not to only eighteenth-century aesthetics, but to our current naturalized perspective in contemporary philosophical aesthetics as well. The learned kind of writing exercised by Addison and Shaftesbury fits badly with a contemporary professionalized type of academic philosophy. Addison and Shaftesbury were first and foremost *men*

PRO 30/24/22/7, fol. 490ᵛ): 'As for *Innate Principles*, which You mention, 'tis in my Opinion one of the childeshest Disputes that ever was.'

[30] See e.g. Mortensen, *Art in the Social Order*, 43–60. Mortensen distinguishes between a *scientist* position and a *historicist* position. The former position refers to a method trusting that a conceptual apparatus involves a 'transhistorical standard of rationality' (45), while the latter position refers to an approach pointing to the 'historically shifting framework, the contingencies of history, within which philosophical argumentation – in the absence of any universal canon of rationality – always takes place' (43). See also Sarah Hutton, 'Intellectual History and the History of Philosophy', *History of European Ideas* 40, no. 7 (2014). Hutton addresses 'how the history of philosophy has come to be misidentified with the practice of philosophising' (929).

[31] See e.g. Monroe C. Beardsley, *Aesthetics: Problems in the Philosophy of Criticism*, 2nd edn (Indianapolis, IN: Hackett, 1981). Beardsley is a committed autonomist who claims that the *aesthetic experience* is intrinsically valuable. The motive behind his defence is partly his fears of a scientific blurring of the discipline as such. Aesthetics – 'a retarded child' – has been 'contemptuously regarded' (11), and it is high time to 'stak[e] out the boundaries of the field' (6).

of letters, impatiently charting an intellectual topography of *literature* (including philosophy, but also politics, history, and divinity) that separated them from the 'academic specialism of the university and from the narrow and pedantic obsessions of the gentleman *érudit*'.[32] James A. Harris has recently made the point that David Hume perceived philosophy not primarily as a 'body of doctrine', but rather as a 'habit of mind, a style of thinking, and of writing, such as could in principle be applied to any subject whatsoever'.[33] In the following we shall benefit from approaching Addison and Shaftesbury in a similar manner. Addison's periodical essays and Shaftesbury's writings were, at the time, simply integrated in a heterogeneous body of writing and intellectual activity that would only later be compartmentalized into literature, philosophy, politics, and so on.[34]

Ever since Paul Oskar Kristeller's study of the modern system of the arts, where he sought to prove that the nucleus of such a system (consisting of painting, sculpture, architecture, music, and poetry) originates in the eighteenth century, aesthetic autonomy has, in all its various forms, remained positively connoted. Kristeller perceived aesthetic autonomy to be deeply entwined with the emergence of a distinctively *modern* conception of (the) art(s).[35] Essential to such a Kristellerian conception was the idea that art and aesthetic experience no longer were coordinated by ethics or utility values, and, as is noted by one of his most outright opponents, Kristeller 'remains emphatically partial to aesthetic autonomy in its modern form, inasmuch as it stresses that the progress of the arts involved their steady "emancipation" from their background contexts, which is to say, their becoming autonomous from religion, morality, and other strictures, as well as from one another'.[36]

[32] James A. Harris, *Hume: An Intellectual Biography* (Cambridge: Cambridge University Press, 2015), 15. Harris reminds his readers that ' "Literature" in the eighteenth century did not mean, as it often does now, a distinct class of writing, including poetry, novels, and plays, such as might be grouped together by language on library shelves, or examined as an academic subject'.

[33] Ibid., 18.

[34] John Richetti, 'Introduction', in *The Cambridge History of English Literature, 1660–1780*, ed. John Richetti (Cambridge: Cambridge University Press, 2005), 8–9.

[35] Kristeller, 'The Modern System of the Arts: A Study in the History of Aesthetics (I)', 497. Kristeller trusts us to agree that, during the eighteenth century, 'dominating concepts [e.g. taste and sentiment] of modern aesthetics' received their 'definite modern meaning', and that the term ' "Art," with a capital A and in its modern sense' emerged (496–7). A strong association between the *modern* system of the arts and aesthetic autonomy is present (but rarely explicitly stated) throughout Kristeller's essays. See e.g. Kristeller's remarks on *Essai sur le Beau* (1741) by Yves Marie André (1675–1764). While André's work 'moves much closer to the system of the arts' than that of his contemporaries, he was unable to complete the modern system since 'in his treatise the arts are still combined with morality' (II, 20). James I. Porter criticizes Kristeller for 'conflating the "modern system of the arts" with claims to aesthetic autonomy'. See Porter, 'Is Art Modern? Kristeller's "Modern System of the Arts" Reconsidered', *British Journal of Aesthetics* 49, no. 1 (2009), 18; see also, Porter, 'Reply to Shiner', 176–7.

[36] Porter, 'Is Art Modern? Kristeller's "Modern System of the Arts" Reconsidered', 19.

It is no exaggeration to state that Kristeller's so-called discontinuity model (where the eighteenth century signifies a break in valuing nature and art) is well established.[37] Its enormous impact has in recent years taken three different, but related, directions.[38] The first direction pays a somewhat dutiful tribute to Kristeller's discontinuity model, but nevertheless manages to completely ignore its implications. As Martha Woodmansee shows, such readings gain strength from recent anthological constructions 'marked by a systematic "denial" of the historicity of [the] subject matter'.[39] Here, historical variations in claims about nature and art are regarded as primarily 'terminological' differences, and cultural distinctions are smoothed over in favour of a disciplinary dialogue that gives the impression of transcending time and space. As these de-historicizing methods are largely, albeit not solely, strategies exercised by philosophers trying to prove that historical claims are immediately relevant (or irrelevant) for a specific contemporary aesthetic matter, they will only figure indirectly in the following chapters. As we will see, philosophers who only address historical matters as ' "problems" currently deemed philosophical', and only attend to such problems in a manner endorsed by current aesthetics, are more than likely to misinterpret the theories of taste advanced by Addison and Shaftesbury.[40]

Two other directions in which the Kristellerian thesis has evolved are of more relevance for the arguments pushed forward in this book. The first of these stages is a systematic critique of Kristeller. In a recent frontal attack, James I. Porter draws attention to several weak spots of the thesis.[41] Primarily focusing on Kristeller's account of the French cleric Charles Batteux's *Les beaux arts réduit à un même principe* from 1746, Porter claims that there is 'not a whiff of a realignment of art around a new axis of aesthetics, let alone autonomy' in Batteux's work.[42]

[37] Ibid., 2. Porter remarks that 'we are having to do here no longer with an academic thesis, and not even with an orthodoxy, but with a dogma'.

[38] On the protracted debate of the legacy of Kristeller's account, see Allen Speight, 'Hegel on Art and Aesthetics', in *The Palgrave Handbook of German Idealism*, ed. Matthew C. Altman (Basingstoke: Palgrave Macmillan, 2014).

[39] Martha Woodmansee, *The Author, Art, and the Market: Rereading the History of Aesthetics* (New York: Columbia University Press, 1994), 4.

[40] Ibid., 4–5. See also 87–102. Because of this approach, insufficient attempts to understand Addison's *Spectator* essays entitled the *Pleasures of the Imagination* are, according to Woodmansee, present in Peter Kivy's and Jerome Stolnitz's analyses of Addison's role in the history of aesthetics. For a development of Woodmansee's perspective, see Karl Axelsson, 'Joseph Addison and General Education: Moral Didactics in Early Eighteenth-Century Britain', *Estetika: The Central European Journal of Aesthetics* 46, no. 2 (2009).

[41] See Porter, 'Is Art Modern? Kristeller's "Modern System of the Arts" Reconsidered'. See also Porter, *The Origins of Aesthetic Thought in Ancient Greece: Matter, Sensation, and Experience* (Cambridge: Cambridge University Press, 2010), 26–40.

[42] Ibid., 9.

The division between art and morality suggested by Kristeller is, from Porter's perspective, simply nowhere to be found.[43] Here, I shall not dwell on Porter's detailed reading of Batteux,[44] but rather stick to his overall argument, namely that Kristeller's thesis of the modern system of the arts is a 'historical construct that has been put together by Kristeller himself', and that it accordingly must be rejected primarily because it obstructs a proper understanding of aesthetic experience in the classical Greek and Roman period.[45] In this respect, Porter's attack on Kristeller's thesis owes much to a prior, more moderate, critique advanced by Stephen Halliwell. While being less dismissive than Porter, Halliwell nonetheless holds that Kristeller's thesis 'seriously simplifies a far more intricate story in the development of ideas'.[46] Similar to Porter's general proposition, Halliwell believes that Kristeller's thesis systematically obscures the fact that *mimesis* provided antiquity with a concept that is not as far as Kristeller suggests from a 'unified concept of "art" (more specifically, of the mimetic or representational arts as a class)'.[47] Halliwell's point is that the 'representational-cum-expressive character' of mimetic art operating in the fourth century BC had a bearing on the development of the classification of the fine art(s) in the eighteenth century.[48] In this sense, there was, so to speak, an aesthetics *avant la lettre* in the ancient period.[49] The weakness of Kristeller's thesis is that it fails to acknowledge that having relied on the rich tradition of mimesis, the 'eighteenth century then took a sharp (though not complete) turn away from the general understanding of representational art as "imitation"'.[50] What is needed is therefore, according to Halliwell, not a 'radical separation of ancient and modern views of art' but further analysis of a continuing (mimeticist) tradition stemming from antiquity, and a more careful account of a gradual conversion of such a tradition in the eighteenth century.[51]

[43] Ibid., 10.
[44] For further comments on Batteux, and criticism of Kristeller, see James O. Young, 'The Ancient and Modern System of the Arts', *British Journal of Aesthetics* 55, no. 1 (2015). Young argues that the 'ancients had a category essentially indistinguishable from that adopted by Batteux and subsequent thinkers', and that 'Kristeller, and all those who have followed him, are wrong' (1).
[45] Porter, 'Is Art Modern? Kristeller's "Modern System of the Arts" Reconsidered', 13. Cf. Kivy, 'What *Really* Happened in the Eighteenth Century: The "Modern System" Re-examined (Again)', 71–3.
[46] Stephen Halliwell, *The Aesthetics of Mimesis: Ancient Texts and Modern Problems* (Princeton, NJ: Princeton University Press, 2002), 7.
[47] Ibid.
[48] Ibid.
[49] Speight, 'Hegel on Art and Aesthetics', 689.
[50] Halliwell, *The Aesthetics of Mimesis*, 8.
[51] Ibid.

The third direction in which Kristeller's thesis has evolved is paradigmatically represented by the recent writings of Larry Shiner.[52] Whereas the modern concept of the fine arts treats the arts as part of a distinct and normative aesthetic category, the Greek and Roman age referred to technē (τέχνη) and *ars*, both concepts alluding, as Shiner stresses, more to skill or practice rather than to a particular set of objects.[53] Unsurprisingly, the Greek and Roman period also differed substantially from the modern age in experiencing poetic recitals, which people in the past had primarily admired because of the 'union of moral use with felicitous execution'.[54] The list of radical differences between the old system of art and the modern system is, in Shiner's account, extensive (while the modern system of the arts in Kristeller's thesis is a classificatory system, Shiner addresses institutional and socio-economic practices as well).[55] So far there is little new in Shiner's Kristellerian account. However, alongside his acceptance of a discontinuity model, Shiner also fosters a more workable idea of the history of aesthetics, especially in his reply to Porter's attack on Kristeller's thesis, namely that the division was in fact a dialectical process, gradually unfolding from the 1680s (around Charles Perrault's reading of his poem *Le Siècle de Louis le Grand* at Académie Française in 1687) to the 1830s (around Heinrich Heine's observation that the devotees of Goethe [*Goetheaner*] regarded art to be entirely autonomous [*Kunst als eine unabhängige zweite Welt*]).[56] Picking up on this latter point about an abiding continuity in the history of aesthetics makes sense (here Shiner shares relevant points of contact with a classical scholar like Halliwell).[57] If one addresses the eighteenth century as a ground of cataclysmic change, and perceives Addison and Shaftesbury as primarily offering a foretaste of modern aesthetic autonomy, one is likely to exclude aberrant claims that contradict

[52] For further examples, see Woodmansee, *The Author, Art, and the Market*, 1–8; Paul Mattick, *Art in Its Time: Theories and Practices of Modern Aesthetics* (London: Routledge, 2003), 24, 47; Kivy, 'What Really Happened in the Eighteenth Century: The "Modern System" Re-examined (Again)', 61–74.

[53] Shiner, *The Invention of Art*, 19. See also Lars-Olof Åhlberg, 'The Invention of Modern Aesthetics: From Leibniz to Kant', in *Notions of the Aesthetic and of Aesthetics: Essays on Art, Aesthetics, and Culture* (Frankfurt am Main: Peter Lang, 2014), 32. Åhlberg remarks that τέχνη and *ars* are 'usually translated as "art," which is inaccurate and somewhat anachronistic' since they 'included much that is not categorized as art today and excluded much that belongs to the category of art today'.

[54] Shiner, *The Invention of Art*, 25.

[55] Ibid., 309, footnote 1.

[56] Larry Shiner, 'Continuity and Discontinuity in the Concept of Art', *British Journal of Aesthetics* 49, no. 2 (2009), 159–69. See also Shiner, *The Invention of Art*, 14 (on continuity/discontinuity), 79 (on Perrault), and 189 (on Heine). Quote from Heine, see Heinrich Heine, *Die romantische Schule*, in *Historisch-kritische Gesamtausgabe der Werke*, vol. 8.1, ed. Manfred Windfuhr (Hamburg: Hoffmann und Campe, 1979), 152–3.

[57] See Shiner, 'Continuity and Discontinuity in the Concept of Art', 167–9. Shiner recommends Halliwell's approach.

the paradigm – claims that thoroughly challenge our naturalized assumptions about the history of aesthetics. Unfortunately, Shiner does not follow through on his ideas about a dialectical process, and given that he insists on navigating his historical project by the overall conviction that a 'great fracture' separates the 'aesthetic from the instrumental' in the eighteenth century, he remains vulnerable to critique.[58] Characteristically, such a fracture in history also shapes Shiner's readings of Addison and Shaftesbury as primarily philosophical precursors to a modern aesthetic disinterested perception that indeed 'involved an intense "interest", in the sense of focused attention, but a complete absence of *an* interest' of 'moral or religious kind'.[59]

In the wake of the wealth of recent re-examinations of Kristeller's thesis, two points can be retained in order to stake out a productive way between the Scylla of the discontinuity model and the Charybdis of the continuity model.[60] First of all, similar to the classicist critique that the insistence on Kristeller's thesis obstructs a knowledge of a pre-modern notion of art, it can be said that the idea of any radical transformation or fracture (an idea elaborated by recent Kristellerians rather than by Kristeller himself) has too often blinded scholars to the distinctive character of Addison's and Shaftesbury's theories of taste. Addison and Shaftesbury did not take a positive initiative towards a modern split between the aesthetic experience and deliberately ethico-political functions. If anything, they enthusiastically explored a revived care for the interrelation between such experiences and functions. This leads us to a second point worth pursuing. While problematizing any radical Kristellerian discontinuity model, we should still be able to recognize that the eighteenth century in general, and the British eighteenth century in particular, is an outstandingly intense period in the ongoing process of the intellectual history of modernity, and especially so in the development of aesthetic theory – albeit not quite in the way that we have usually maintained.[61] Addison and Shaftesbury work out their theories of taste in the midst of this process, but they are in different ways seeking to advocate and elicit strong interrelations between the experience of nature and art, cultivation of taste, and a politically stable society, rather than challenging established normativity.

[58] Shiner, *The Invention of Art*, 9.
[59] Ibid., 144–5.
[60] See Kivy, 'What *Really* Happened in the Eighteenth Century: The "Modern System" Re-examined (Again)', 64.
[61] See Halliwell, *The Aesthetics of Mimesis*, 12; Kivy, 'What *Really* Happened in the Eighteenth Century: The "Modern System" Re-examined (Again)', 74. Kivy notes that while there is a (healthy) paranoia in Porter's worries that a focus on the origins of the modern concept of art might impede the great impact of classical antiquity, there is also a justified (and healthy) paranoia that the critique of Kristeller(ians) unintentionally might belittle the eighteenth century as an unparalleled period in the history of aesthetics.

The scholarly labour of coming to terms with the continuities and discontinuities of the history of aesthetics is also present in recent studies that are primarily focused on the temporality of taste in British eighteenth-century aesthetics. Indeed, the last decade of the twentieth century has witnessed a promising new direction or minor turn. Paul Mattick captured the fundamental nature of this turn, when noting that while history and the social disciplines gained strength from the 'historical character of cultural objects and of the necessity, if they are to be understood, of viewing them within their complex social contexts', philosophy is 'a major exception, remaining an academic field characterised by very little in the way of historical self-consciousness'.[62] Scholars such as Andrew Ashfield and Peter de Bolla have added force to this historic turn when they have argued that British aesthetic theory in the eighteenth century more than anything showed a 'consistent refusal to relinquish the interconnections between aesthetic judgments and ethical conduct'.[63] On his own, de Bolla has successfully challenged the prevailing propensity in philosophical aesthetics to turn the complex 'polyphony' of eighteenth-century criticism and philosophy into a 'single narrative line'.[64] The scholarly worries were, as Robert W. Jones has claimed, simply that '[t]oo frequently single instances from the highly charged realm of "Taste" have been selected for isolated, if exhaustive, study', and that therefore the temporal ethico-political mobility of the eighteenth-century category of taste might sink into oblivion.[65] It is fair to say that this minor historical turn in aesthetics, at least, has stirred a healthy awareness that something is indeed missing in the established diachronic narrative. It is also fair to say that the works of Addison and Shaftesbury recently have witnessed a renaissance among historiographers, in the case of the latter because of the pioneering works by Lawrence E. Klein, and the ongoing publication of the Shaftesbury Standard Edition by the Friedrich-Alexander University. However, while the 'historical turn in literary studies and the cultural turn in historical studies have worked together to promote interest in Addison',[66] and we have 'witnessed both a long overdue revival of Shaftesbury studies and a concomitant

[62] Paul Mattick, 'Introduction', in *Eighteenth-Century Aesthetics and the Reconstruction of Art*, ed. Paul Mattick, Jr (Cambridge: Cambridge University Press, 1993), 2. See also Robert W. Jones, *Gender and the Formation of Taste in Eighteenth-Century Britain: The Analysis of Beauty* (Cambridge: Cambridge University Press, 1998), 1–36.
[63] Ashfield and de Bolla, 'Introduction', in *The Sublime*, 3.
[64] Peter de Bolla, *The Education of the Eye: Painting, Landscape, and Architecture in Eighteenth-Century Britain* (Stanford, CA: Stanford University Press, 2003), 3.
[65] Jones, *Gender and the Formation of Taste in Eighteenth-Century Britain*, viii.
[66] Lawrence E. Klein, 'Addisonian Afterlives: Joseph Addison in Eighteenth-Century Culture', *Journal for Eighteenth-Century Studies* 35, no. 1 (2012), 101.

re-evaluation of his legacy',[67] aesthetics has largely persisted within its traditional comfort zone. Today, one rarely encounters scholarly works in aesthetics that insist on the relevance of fathoming the temporal qualities of Addison's and Shaftesbury's theories of taste. A not too far-fetched explanation for the current state of affairs is that such a fathoming simply demands an explanation of theories of taste that would have to include questions that are currently regarded as non-aesthetic matters.

An initial effort to step out of the current comfort zone would need to impede what Quentin Skinner, in a somewhat different context, refers to as the *mythology of doctrines*. As philosophers of the history of aesthetics, we cannot merely expect a critic or a philosopher to 'enunciate some doctrine on each of the topics regarded as constitutive of the subject'.[68] Such a mythology encompasses the mistake of 'converting some scattered or incidental remarks by a classic theorist into their "doctrine" on one of the expected themes'.[69] In the light of Skinner's comments, we can observe that although the authority of aesthetic autonomy has been accepted for a long time, men of letters in the early eighteenth century did not share such an acceptance. There is an inevitable risk of forming an *ideal type* of a doctrine. By the establishment of such a type one runs a risk of allowing the analysed doctrine to be, as Skinner observes, 'hypostasised into an entity', and when pursuing one's exegetic undertaking it is 'too easy to speak as if the developed form of the doctrine has always in some sense been immanent in history', even if men of letters did not recognize it, or if the idea underwent some kind of intellectual recession or backlash from time to time, or 'even if an entire era failed to "rise to a consciousness" of it'.[70] We simply tend to hold up any ideal type that appears to anticipate future doctrines and 'to congratulat[e] individual writers for the extent of their clairvoyance', or we rub out the historical relevance completely and agree that philosophers of the past simply should be, as Skinner wittily remarks, 'praised or blamed according to how far they seem to have aspired to the condition of being ourselves'.[71]

The fallacy of reading contemporary values and occurrences into historical texts and provenance of objects (the fallacy of *presentism*) is of course to some extent unavoidable. For instance, throughout this book I apply the anachronistic

[67] Patrick Müller, 'Introduction: Reading Shaftesbury in the Twenty-First Century', in *New Ages, New Opinions: Shaftesbury in His World and Today*, ed. Patrick Müller (Frankfurt am Main: Peter Lang, 2014), 18.
[68] Skinner, 'Meaning and Understanding in the History of Ideas', 59.
[69] Ibid., 60.
[70] Ibid., 62.
[71] Ibid., 63.

prefix *aesthetic* to the term *experience*, self-assured that the benefits (to facilitate an improved understanding of a historical perspective on nature and art) outweigh the disadvantages.[72] Whether we approve or not, we are partly restricted by our present scientific culture when we address historical texts and objects. Hence, we must always strive to spell out the difference between *our* expectations and *historical* expectations, although any expectations when arranging the analyses are, so to speak, inevitably partly *our* expectations.[73] However, the fact that our present knowledge and expectations have bearing on our capacity to apprehend historical sources, does not have to beget a biased perception of history. If, as Skinner remarks, 'our own society places unrecognised constraints upon our imaginations', the 'historical study of the beliefs of other societies should be undertaken as one of the indispensable and the irreplaceable means of placing limits on those constraints'.[74] By divesting our language of value judgements, and allowing for exegetic self-reflections, we can then circumvent a biased understanding of the history of aesthetics. Such circumvention requires a strong sensitivity to the historical imagination, accompanied by conclusions that are drawn from historical evidence. But any understanding of the meaning of a historical utterance also needs, as Skinner stresses, to be supplemented with a second hermeneutical task, where we not only grasp 'the meaning of what is

[72] Alexander Gottlieb Baumgarten charted aesthetics as the science of sensible cognition (*scientia cognitionis sensitivae*) in the Prolegomena to *Aesthetica* (published in two volumes in 1750 and 1758). See Baumgarten, *Ästhetik*, vol. 1, ed. and trans. Dagmar Mirbach (Hamburg: Felix Meiner Verlag, 2007), §1, 10/11. We should be cautious to ascribe too great an impact to the coinage of the philosophical term itself (see Halliwell, *The Aesthetics of Mimesis*, 11). The British eighteenth-century tradition paid no attention to Baumgarten's definition, and aesthetics, as a term of scientific practice, was not common in the English language until the first half of the nineteenth century. About this, see Dabney Townsend, 'Introduction: Aesthetics in the Eighteenth Century', in *Eighteenth-Century British Aesthetics*, ed. Dabney Townsend (Amityville, NY: Baywood, 1999), 1–2. An early and overlooked piece of English writing is George Field, 'Aesthetics, or the Analogy of the Sensible Sciences', *Pamphleteer* 17, no. 23 (1820). Field (1777–1854) introduces a Baumgartian aesthetics as that 'genus of science which comprehends whatever lies between *physical* or *material* and *metaphysical* or intellectual science, which are its two correlative genera; it therefore comprehends whatever belongs to the philosophy of *sense*, as distinguished from *matter* and *intelligence*' (196).

[73] For an illustrative failure to separate between *personal expectations* and *historical expectations*, see Dickie, *The Century of Taste*, 3–5. Dickie intends to give both *explorations* and *evaluations* of the theories of taste. His way of evaluating the theories is simple enough: he merely wishes to explain which theories he likes, and which theories he dislikes. Hence, Dickie's motive for addressing Hume's theory is that it is the most effective theory: 'I have chosen to discuss Hume's theory because I believe it is the most successful of the theories of taste' (4). The standard for effectiveness is a present standard: Hume's theory is 'in many ways like a twentieth-century theory' (4). Confusion arises when Dickie's ahistorical standard is combined with historical expectations. Part of Dickie's premises for the *exploration* of Associationism (e.g. the works by Alexander Gerard and Archibald Alison) is its vital historical value: 'I have chosen to discuss Gerard and Alison's associationism because it was such a popular view in its day' (4). Thus, Dickie applies a double standard and it remains unclear if the theories of taste are addressed because they are historically significant, or because they are successful according to current standards.

[74] Skinner, 'Meaning and Understanding in the History of Ideas', 89.

said, but at the same time the intended force with which the utterance is issued'.[75] We furthermore need to allow enough scope for Addison's and Shaftesbury's claims per se and what they actually meant – within a specific historico-cultural context – by their claims, and we must at all times strive to avoid applying the present as the regulatory temporal referent. Throughout this book I will hopefully be able to hover between unfolding the imagined historical moral agents of taste, so frequently and grippingly portrayed by Addison and Shaftesbury, and developing a new picture of a particular moment of thinking in the history of aesthetics and the culture of early-eighteenth-century Britain, by outlining how Addison's and Shaftesbury's concepts of taste were, to speak with de Bolla, related to 'other concepts in historically defined networks'.[76]

Addison and the body politic

Any sensitivity to the historical disposition of Addison's theory of taste would have to consider that aesthetic experience gained a renewed value in the early eighteenth century, due to the ongoing process of the displacement of political authority.[77] Synoptically speaking, the gradual transposition of political authority remains one of the prime mechanisms of modernity, revolving around an ontological shift in the distribution of power, where references to theological authorities step by step are challenged and transformed. While man in the past had, as Sheldon S. Wolin concisely notes, 'entreat[ed] kings; kings confess[ed] to priests; and priests beseech[ed] the gods', and 'early philosophers ritualized

[75] Ibid., 82. See also Daniel Garber, 'What's Philosophical about the History of Philosophy?', in *Analytic Philosophy and the History of Philosophy*, ed. Tom Sorell and G. A. J. Rogers (Oxford: Oxford University Press, 2005), 135. In his article on Descartes's philosophy and the antiquarian history of philosophy, Garber stresses that to 'understand the views and arguments that Descartes puts forward, we have to understand what they were directed against'.

[76] Peter de Bolla, *The Architecture of Concepts: The Historical Formation of Human Rights* (New York: Fordham University Press, 2013), 25. In this study, de Bolla develops a new method for understanding the 'architecture' of concepts (i.e. the concept's inner construction and network connections), where he seeks 'to go past or see beyond what one might take to be the mental landscape of an agent' with the purpose of re-examining the particular culture within which the agent's sense-making was performed. De Bolla's object of study is the concept of human rights, but the innovative methodology suggested (see e.g. 48–130), and the principal claim that concepts are cultural entities that 'can be understood as inhabiting the common unshareable space of culture' (14), should be of great relevance for future philosophical studies of historical aesthetic concepts (see esp. 11–47). See also de Bolla, 'The Invention of Concepts: Sense as a Way of Knowing According to Francis Hutcheson', *Études Anglaises* 66, no. 2 (2013).

[77] See also Mortensen, *Art in the Social Order*, 83–9. Mortensen makes the radical (and exaggerated) claim that the focus on taste 'must be seen against the background of the *collapse* [my italics] of the old social order' (83). The old social order in Britain did not dissolve as much as it was gradually reformed.

inquiry, inserting themselves in place of the priests and the *logos* of reason for the gods', European philosophy witnessed, in the seventeenth and the eighteenth centuries, a new inquisitiveness for the nature and truth of political power.[78] The creation and re-creation of society would still imply vital theological constituents, for instance, by resembling God's creation of man in his own image, and the critical purpose of the aesthetic experience remained a re-awakened ethico-emotive awareness of the Deity's power. But concurrently, society was now also believed to hinge on the participation, creative invention, and rational consent of, as it seemed, emotionally and morally self-legislative individuals. Even if the critical objective of experiencing beauty was, as Addison claimed, an absolute recognition of the supernal Deity (an objective purposefully implanted by the Deity in the emotional disposition of man), such an experience simultaneously attained a new set of goals and values. All these interrelated changes – commonly captured in the growing obsession with how subjective aesthetic experiences might constitute a basis of interpersonally valid judgements[79] – were indeed manifest in the early eighteenth century and they have rightly prompted a general understanding of a definitional aesthetic autonomy. But while the power of the traditional theological authorities gradually faded away during the century, and ultimately were replaced by modern subjectivity, thus allowing aesthetic autonomy to 'appear as the inevitable end-product of a long chain of development', we should, to a larger extent than is currently the case, be wary of perceiving our 'historical predecessors' as 'immature or incomplete forms of the present'.[80] Indeed, a closer look at Addison's theory of taste will reveal just how sophisticated, vigorous, and unrelenting the bond between taste, morality, and society were at the time.

Arguably no eighteenth-century moulder of public opinion was as proficient and attentive as Addison in diagnosing the displacement of political authority and exploiting a mistrust of the body politic as an enduring and natural entity of truth. In the wake of Thomas Hobbes's political thinking, philosophy displayed a readiness to renegotiate, reframe, and reformulate the truth of political authority and power relations. While the classical Aristotelian belief in the *polis* as a creation of nature ($τῶν\ φύσει\ ἡ\ πόλις\ ἐστί$) and that man by nature is a political animal ($ὁ\ ἄνθρωπος\ φύσει\ πολιτικὸν\ ζῷον$) was discarded by Addison,

[78] Sheldon S. Wolin, *Politics and Vision: Continuity and Innovation in Western Political Thought*, expanded edn (Princeton, NJ: Princeton University Press, 2004), 394.
[79] See Paul Guyer, *A History of Modern Aesthetics, Volume 1: The Eighteenth Century* (Cambridge: Cambridge University Press, 2014), 36.
[80] Mortensen, *Art in the Social Order*, 50.

the modern body politic was, along Hobbesian lines, believed to be valid only as long as its rational citizens agreed to put their faith in its ability to supervise its members and honor its commitments.[81] The great architect of truth and meaning was to a larger extent than previously thought to be rational man himself, and the purposeful act of constructing the reality of society itself was, for Addison, to be compared to a moment of artistic creativity, and the body politic to be likened to an original work of art, now produced circuitously with the rational harmony of God's nature.

In Britain, the displacement of political authority was related to a historical change where ideological representation incorporated the ethico-emotive conduct of the extensive stratum of the middling orders, ranging from near-aristocratic standards of living to the lifestyles of craftsmen and retailers, consisting of shopkeepers, manufacturers, independent artisans, civil servants, professionals, lesser merchants, and so forth.[82] As has been demonstrated elsewhere, the expansion of the middling orders during the first half of the eighteenth century was related to the growth of a free market and a commercial culture.[83] Addison's essayistic technique had to allow for the fact that the social scope of the middling orders was increasingly vast. By the mid-eighteenth century, Hume would confidently posit the members of the 'Middle Station of Life' as 'susceptible of Philosophy; and [that] therefore, all Discourses of Morality ought principally to be address'd to them'.[84] However, in the time of Addison's writings, no efficient moulding of public opinion could emerge from pursuing the common value system of an already politically initiated agency. Instead, Addison subscribed to the Horatian principle of *utile dulci*, where he could address both *Mercurial* moral agents, requiring 'Speculations of Wit and Humour', and the solemn *Saturnine* ones, who desire 'Papers of Morality and

[81] Aristotle, *Politics*, in *The Complete Works of Aristotle*, The Revised Oxford Translation, vol. 2, ed. Jonathan Barnes (Princeton, NJ: Princeton University Press, 1984), 1253a1–3. See also, 1252b31–2.
[82] Frank O'Gorman, *The Long Eighteenth Century: British Political & Social History 1688–1832* (London: Hodder Arnold, 1997), 108. See also Margaret R. Hunt, *The Middling Sort: Commerce, Gender, and the Family in England, 1680–1780* (Berkeley: University of California Press, 1996), 15.
[83] O'Gorman, *The Long Eighteenth Century*, 108–13.
[84] David Hume, 'Of the Middle Station of Life', in *Essays Moral, Political, and Literary*, ed. Eugene F. Miller, rev. edn (Indianapolis, IN: Liberty Fund, 1987), 546. The middle station is happily positioned, argues Hume, between the *Great* who pursue pleasure and the *Poor* who are 'too much occupy'd in providing for the Necessities of Life, to hearken to the calm Voice of Reason'. About this, see Harvey Chisick, 'David Hume and the Common People', in *The 'Science of Man' in the Scottish Enlightenment: Hume, Reid and Their Contemporaries*, ed. Peter Jones (Edinburgh: Edinburgh University Press, 1989). See also Addison (S IV, 138; 464) for similar arguments ('The middle Condition seems to be the most advantageously situated for the gaining of Wisdom. Poverty turns our Thoughts too much upon the supplying of our Wants, and Riches upon enjoying our Superfluities ... ') on the moral benefits of a balanced distribution of wealth ('the middle Condition is most eligible to the Man who would improve himself in Virtue').

sound Sense' (*S* II, 204; 179).⁸⁵ Given that the 'very Title of a Moral Treatise has something in it Austere and Shocking to the Careless and Inconsiderate', Addison set out to diffuse his principles of taste and morals to 'Disciples' that 'would give no attention to Lectures delivered with a Religious Seriousness or a Philosophic Gravity', and make them 'insnared into Sentiments of Wisdom and Virtue when they do not think of it' (*S* II, 204–5; 179).⁸⁶ Whenever the readers felt that the 'middle style' of the essays were, as Addison himself put it, a 'little out of their Reach', he 'would not have them [the readers] discouraged, for they may assure themselves the next shall be much clearer' (*S* I, 245; 58).⁸⁷

The thirst for ethico-emotive principles was bound by close ties to the middling orders. Readily arraying his arguments in poetic allegories – 'Man improves more by reading the Story of a Person eminent for Prudence and Virtue, than by the finest Rules and Precepts of Morality' (*S* III, 67–8; 299)⁸⁸ – Addison engages in the topic in an essay on 29 September 1711 (*S* II, 219–23; 183), where he retells the account of Socrates' last morning from Plato's *Phaedo*. Phaedo's account lets us know that Socrates, after having his fetters removed, embarked upon a philosophical reflection on pleasure and pain, remarking that a fable would have to represent them by illustrating a causal link since pleasure and pain constantly 'succeed one another' (*S* II, 222; 183).⁸⁹ If Plato would have proceeded along Socrates' reflections he might, or so Addison argues, have created a beautiful allegory. But since the account of Socrates' last morning served a very different purpose, it falls to Addison's self-appointed lot to produce

[85] For the motto of *S* II, 204; 179, see Horace, *Ars poetica*, in *Satires, Epistles and Ars poetica*, trans. H. Rushton Fairclough, Loeb Classical Library 194 (Cambridge, MA: Harvard University Press, 1929), 341–4. Addison states that he prefers 'Instructing' to 'Diverting'. But given his aim to be 'useful to the World', he must nevertheless take the world 'as [he] find[s] it', and exploit both sides of the Horatian principle (*S* II, 205; 179).

[86] See *S* II, 204–8; 179. To limit himself to *Mercurial* or *Saturnine* readers would mean, as Addison acknowledges, that 'one half of my Readers would fall off from me' (204). Addison takes advantage of the fact that his readers are unsure of which category he is addressing. For a comment, see Günther Blaicher, '"The Improvement of the Mind": Auffassungen vom Lesen bei John Locke, Richard Steele und Joseph Addison', in *Lesen und Schreiben im 17. und 18. Jahrhundert: Studien zu ihrer Bewertung in Deutschland, England, Frankreich*, ed. Paul Goetsch (Tübingen: Gunter Narr, 1994), 105–6. Blaicher emphasizes the politically reconciling function of the passage, between a civic middle station (*bürgerlichen Mittelstand*) and an upper stratum of the aristocracy.

[87] On the qualities of Addison's 'middle style', see Samuel Johnson, *The Lives of the Most Eminent English Poets; With Critical Observations on Their Works*, vol. 3, ed. Roger Lonsdale (Oxford: Oxford University Press, 2006), 38.

[88] See also *T* II, 106; 98. Richard Steele (1672–1729), the cofounder of the *Spectator*, makes an analogous claim about poetry, when retelling a meeting with an 'ingenious and worthy Gentleman' (possibly Thomas Walker, 1647–1728, Schoolmaster at Charterhouse 1679–1728, see *T* II, 105; 98 (footnote 5)): 'I have always been of Opinion, (says he) that Virtue sinks deepest into the Heart of Man, when it comes recommended by the powerful Charms of Poetry.'

[89] See Plato, *Phaedo*, in *Euthyphro, Apology, Crito, Phaedo, Phaedrus*, trans. Harold North Fowler, Loeb Classical Library 36 (Cambridge, MA: Harvard University Press, 1960), 60A–60C.

one in the 'Spirit of that Divine Author'. In his allegory, Addison identifies the '*Creatures of a middle kind*', as inhabitants of the '*middle Station of Nature*' and as natural human beings in general, prevailing between two emotions or extreme '*Race[s] of Beings*': One of them, '*Pleasure, who was the Daughter of Happiness*', originating from heaven, and the other, '*Pain, who was the Son of Misery*', stemming from hell. In the allegory, Jupiter claims that the middle kind is '*too virtuous to be miserable, and too vicious to be happy*', preventing him to distinguish the good from the bad, and thus he assigns Pleasure and Pain the task of dividing '*Mankind between them*'. But given that they are unable to identify any '*Person so Vicious who had not some Good in him, nor any Person so Virtuous who had not in him some Evil*', the task becomes impossible. As it turns out, the nature of the moral values of the middle kind is defined by its ideal combination of a moderate emotional and ethico-political conduct. To resolve the dilemma in the allegory, a marriage between the emotions Pleasure and Pain is finally proposed. Jupiter, however, remains unsatisfied, since Pleasure and Pain have failed their initial undertaking. The solution is ultimately to grant Pleasure and Pain to '*possess … the Species indifferently*', but to analyse man when passing away, and depending on the '*proportion*' of evil or good uncovered in him, man must either '*dwell with Misery, Vice, and the Furies*', or he must '*dwell with Happiness, Virtue and the Gods*' (*S* II, 223; 183). The allegory enables Addison to put forward the representative affective qualities of a politically ideal middle position in life. As we will see in yet another allegory (on Aurelia and Fulvia) in Part One, the men and women of the middling orders had to rub off their emotional and political extremes, which did not imply that they were emotionally disengaged when experiencing nature and art, but only that they exposed precisely the ideal kind of self-possessed absorption, mandatory for an engagement in political society, when having such an experience.

The traditional rationalization and prerogatives of political power authorized in the Great Chain of Being and by the established regimes of aristocracy were slowly but surely beginning to be challenged by the expansion and impact of the middling orders. Standing amid this ongoing displacement of political authority, it is evident for Addison that any Absolutism proposing to 'make our Governments on Earth like that in Heaven', which is 'altogether Monarchical and Unlimited' (*S* III, 21; 287), involves a risk of exposing oneself and Britain to arbitrary political powers. Instead, individual freedom, science, arts, and the realization of ideal society are secured only 'when there is no part of the People that has not a common Interest with at least one part of the Legislators' (*S* III, 19; 287). The modern body politic must be in the 'Hands of Persons so happily

distinguished, that by providing for the particular Interest of their several Ranks, they are providing for the whole Body of the People' (S III, 19; 287). The individuated moral body of taste (*part*) simply had to foster a new perceptiveness of its decisive function for the greater health of the body politic (*whole*).

Thus, to recognize the philosophical fundamentals of Addison's theory of taste we need to distinguish the extensiveness of the ongoing displacement of political authority; a development first indicated in British seventeenth-century philosophical principles and becoming gradually more visible in the eighteenth-century moral values that Addison intends to represent and improve by a normativity of taste. Both Addison and Shaftesbury were, as it turned out, destined to grapple with the fact that the monarch naturally reigned but – after the Revolution in 1688–9 and the deposing of King James II – evidently not solely by *Dei gratia*. The 'civic enfranchisement',[90] the ongoing relocation of political rights to a self-imposed authority (the Westminster Parliament), and the increasing warrants of the respect for gradually more self-legislative agents claimed a reformed stance towards the ethico-emotive disposition of agency. Moral agency naturally had to be reconcilable with the new conception of the political *whole*. Subjective emotions and taste could not within such a context be allowed any absolute self-determinacy. Such autonomy stored, from Addison's perspective, a germ of political volatility. While claiming a new kind of intermediate instrumental value, sentiments had to be self-disciplined. It is, as we will see in Part One, precisely within the context of this interdependence that Addison's theory of taste pursues its magnetic normativity.

The exploration of the interdependence of subjective taste and the political stability of the body politic calls for a certain cautiousness on behalf of philosophers of the history of aesthetics. We should be on guard against reducing beauty (of nature and art) and aesthetic experience to a Habermasian emancipatory force of critical public reason or political society, but also against beliefs that Addison ascertained values of beauty and aesthetic experience by their straightforward sensuous *representation* of ethico-political values.[91] The interdependence is, in

[90] See Terence Bowers, 'Universalizing Sociability: *The Spectator*, Civic Enfranchisement, and the Rule(s) of the Public Sphere', in *The Spectator: Emerging Discourses*, ed. Donald J. Newman (Newark, NJ: University of Delaware Press, 2005), 152–3.

[91] See Jürgen Habermas, *The Structural Transformation of the Public Sphere: An Inquiry into a Category of Bourgeois Society*, trans. Thomas Burger (with the assistance of Frederick Lawrence) (Cambridge: Polity, 1992), e.g. 29, 31–7. Habermas perceives early reflections on autonomous art (i.e. the commodification of art, 'the loss of their [i.e. the artworks'] aura of extraordinariness and … the profaning of their once sacramental character') as the foundation of the public sphere and the rationalization of politics in the late eighteenth century (36). For a different perspective, see Jonathan M. Hess, *Reconstituting the Body Politic: Enlightenment, Public Culture and the Invention of*

Addison's theory of taste, complex, precisely because it is reciprocal. It is generally maintained that the non-political realm of aesthetic autonomy attains its political function on account of the *political* becoming an autonomous sphere that allows it to be refashioned by aesthetics from an external position.[92] As Jonathan M. Hess argues (with particular focus on the German tradition, especially Kant's Third Critique and Karl Philipp Moritz's essays in *Berlinische Monatsschrift*), there is a *dynamic of displacement* at work in the relation between aesthetic autonomy and the body politic, and it is by being unattached from the political that aesthetics is eventually given its modern political significance.[93] The expectations of the ethico-political impact on aesthetic experience were of course different in the early-eighteenth-century British republic of letters. Still, the reciprocal disposition did not end due to the invention of the normative concept of aesthetic autonomy. Rather, expectations of an effective reciprocity between the aesthetic experience and ethico-political values altered their shape and substance, while the pattern of the interdependence itself undoubtedly was to remain one of the most scrutinized and vital properties of modern aesthetic theory and art.

Thus, Part One of this book intends to provide a new perspective on a defining period in the history of aesthetics, by re-evaluating Addison's theory of taste. A biased focus on Addison's *Spectator* essays entitled the *Pleasures of the Imagination* (S III, 535–82; 411–21), published between 21 June and 3 July in 1712, has led to a philosophical deadlock in the current accounts of his theory of taste.[94] In order to get out of a one-sided attention that locks up Addison as the originator of modern aesthetic autonomy by routinely claiming that '*On the Pleasures of the Imagination* marks the beginning of modern aesthetic theory',[95] we need to stop singling out this particular series of essays and instead

Aesthetic Autonomy (Detroit, MI: Wayne State University Press, 1999), 25–6, 111–18. Autonomous art did not 'help prod along the development of the political public sphere' as much as it 'marks a normative category, one that is invented in response to a crisis in precisely that institution Habermas idealizes as the modern public sphere' (26).

[92] Hess, *Reconstituting the Body Politic*, 15–33.
[93] Ibid., e.g. 81–2.
[94] See also Axelsson, 'Joseph Addison and General Education'. On a general lack of interest in Addison in literary theory, see Brian McCrea, *Addison and Steele Are Dead: The English Department, Its Canon, and the Professionalization of Literary Criticism* (Newark, NJ: University of Delaware Press, 1990), esp. 139–216.
[95] Kivy, 'Recent Scholarship and the British Tradition: A Logic of Taste – The First Fifty Years', 259. Without further rationale Kivy also states the following: 'But why begin with Addison, and why in Britain? Most philosophers who worry about such things seem to agree that the discipline of aesthetics, as practiced by professional philosophers today, came into being in Britain early in the eighteenth century and that Addison's *Spectator* papers *On the Pleasures of the Imagination* is the inaugural work, if any single work is' (255). William H. Youngren, 'Addison and the Birth of Eighteenth-Century Aesthetics', *Modern Philology* 79, no. 3 (1982), 268, encapsulates the established view of Addison, when observing that 'Addison has been called the founder of British (and even of

treat Addison's writings in the *Spectator* between 1711 and 1712, and in 1714, as a corpus.[96] In order to work out *how* Addison perceives the judgement of taste to validate a private morality which, in turn, makes up the moral stability of political society, I will, at times, also consider his essays from the *Tatler*, published between 1709 and 1711, and his political and propagandistic essays from the *Freeholder*, published between 1715 and 1716. Originally a classical scholar, educated at Charterhouse School, matriculated at Queen's College in Oxford (1687-9), and a Demy of Magdalen College, 1689-97 (Fellow 1697-1711), Addison's political commitments – comprising governmental positions as Commissioner of Appeal in Excise, 1704-8 (a position left vacant by the death of John Locke), undersecretary of State, Member of Parliament (for Lostwithiel 1708-9, and Malmesbury 1710-19), Chief Secretary to the Earl of Wharton (Lord Lieutenant of Ireland) in 1708-10, crowning his political career as Secretary of State for the Southern Department (1717-18) – are nevertheless ubiquitous in his moral principles of taste.[97] As Part One demonstrates, a central task of Addison's perception of taste consists precisely in shouldering the responsibility of clarifying the reciprocity between individual *part* and political *whole*, and to establish the normativity of taste in such a correlation. At the same time, Addison is of course a cautious *modern*. In his theory of taste, God remains the absolute First as well as the Final Cause of the aesthetic experience. While Addison shifts the 'moral authority from traditional institutions (the Monarchy and the Church) to a new model of civil society with its own authorities', it is, as Klein pinpoints, wrong to conclude that he counters traditional political authorities such as the monarchy or the Church.[98] Rather, Addison suggests a 'moralism and an image of the moralist that subtly *displaced* the very inherited institutions

modern) aesthetics so often that we should expect him to have had a hand in most of the important critical developments that took place during his lifetime'.

[96] For a similar perspective to mine on the *Pleasures of the Imagination*, see Michael G. Ketcham, *Transparent Designs: Reading, Performance, and Form in the Spectator Papers* (Athens: University of Georgia Press, 1985), 69.

[97] For Addison's political commitments, see *The History of Parliament: The House of Commons 1715-1754*, vol. 1, ed. Romney Sedgwick (London: HMSO, 1970), 407-8. Reservations about Addison's capacity as a politician were voiced by e.g. Walpole (1676-1745), and John Perceval (1683-1748), Earl of Egmont. Walpole refers to Addison as a 'miserable secretary of state' (408 [quote from William Coxe (1748-1828), *Memoirs of the Life and Administration of Sir Robert Walpole, Earl of Orford*, vol. 1 (London, 1798), 761]), and the Earl of Egmont remarks that Addison 'knew nothing of business; but this was no reflection on him, his fine parts and genius lying another way, viz., to polite studies' (408 [quote from *Manuscripts of the Earl of Egmont: Diary of Viscount Percival, Afterwards First Earl of Egmont*, vol. 1, 1730-1733 (London: HMSO, 1920), 105]). See also Peter Smithers, *The Life of Joseph Addison* (Oxford: Clarendon Press, 1954), 89-191, 364-415.

[98] Lawrence E. Klein, 'Joseph Addison's Whiggism', in *'Cultures of Whiggism': New Essays on English Literature and Culture in the Long Eighteenth Century*, ed. David Womersley (Newark, NJ: University of Delaware Press, 2005), 110.

that he also defended'.⁹⁹ Furthermore, similar to his defence of the experience of nature and art as having an intermediate value, rather than an autonomous one, Addison holds a larger mediating role between the *Ecclesia Anglicana* and modern secularity, with the intention of inviting the political nonconformists to share a general religious evaluation of nature and art, and accordingly reproduce a desired moral agency of the British nation.¹⁰⁰ The doubleness spotted by Klein and the reconciling position between rational Anglicanism and modern secularity are vital features to keep in mind when embarking upon Addison's theory of taste. Although he ultimately gives precedence to morality over Christian faith, the ethico-emotive conduct relies, for Addison, on natural piety, and vice versa: 'Faith and Morality naturally produce each other' (*S* IV, 143; 465). Hence, while God is succeeded by the ideal Man of Taste as the reliable architect of modern society, the piety and recognition of the beauty of God's providence, induced by the aesthetic experience, still succours man by consolidating an ideal ethico-emotive conduct within such a political society.

Shaftesbury, affections, and society

Shaftesbury was born into a wealthy and politically powerful generation of landed gentry. Shaftesbury's grandfather was named Earl of Shaftesbury in 1672, and he was a member of Charles II's (*r.* 1660–85) Privy Council (the Cabal) and the founder of the Whig party. Locke was a loyal friend and secretary to the first Earl, and an integral part of his political affairs and day-to-day matters. After overseeing a successful medical operation of the first Earl, Locke was the target of his benefactor's debt of gratitude, and the amity between the two men appears to have lasted throughout their lives.¹⁰¹ The third Earl was raised in the

⁹⁹ Ibid. My italics.
¹⁰⁰ See Edward A. Bloom and Lillian D. Bloom, *Joseph Addison's Sociable Animal: In the Market Place, on the Hustings, in the Pulpit* (Providence, RI: Brown University Press, 1971), 175.
¹⁰¹ See Shaftesbury's letter to Le Clerc, 8 February 1705, where he gives an account of his grandfather's close relation to Locke (TNA, PRO 30/24/22/5, fols 375ʳ–378ᵛ). See also Shaftesbury's letter to Lord Chancellor (1725-33) Peter King (c.1669–1734), son of Anne King, first cousin of Locke (TNA, PRO 30/24/22/5, fol. 370ʳ). Here Shaftesbury refers to remarks left by Locke concerning the latter's friendship with the first Earl: 'The few Sheets or Lines however imperfect w:ᶜʰ our deceas'd Friend Mʳ Lock has left on the subject of my Grandfather are (to me at least) very precious Remains and if nothing more, are however the kindest pledges of his Love to the Memory and Family of his great Friend.' See also Locke's French translator Pierre Coste (1668–1747), 'The Character of Mr. Locke', in John Locke, *The Works of John Locke*, vol. 9, 12th edn (London, 1824), 167: 'I wish I could, on the other hand, give you a full notion of the idea, which Mr. Locke had of that nobleman's [i.e. the first Earl's] merit. He lost no opportunity of speaking of it; and that in a manner, which sufficiently showed he spoke from the heart.' See also e.g. K. H. D. Haley, *The First Earl of Shaftesbury* (Oxford: Oxford University Press, 1968), 202–26, and Peter Laslett, 'Introduction', in

household of his grandfather, and Locke became his educational supervisor. Having served Parliament in the closing of the seventeenth century, Shaftesbury came out of his shell as an original thinker, engaged in the bearings of taste and civil society, during the first decade of the eighteenth century. Even if Addison and Shaftesbury shared, as Klein stresses, an ambition to 'switch the locus of philosophy' to a worldliness that 'implied a remapping of the sites of discourse, learning and culture and a redistributing of authority among them', they nevertheless tackled these matters from very different angles, not least so when addressing the topic of taste and society.[102]

While Addison's attempt to reconcile the experience of nature and art with an ideal society is canalized in a theory of taste rooted in a set of political principles ready to pursue national interest, Shaftesbury's approach to the challenge is different. Through a metaphysics that heightens the organic and universal bond between the moral 'Citizen of the Univers' or the '*Citizen of the World*' (*Askêmata* 81, 83) and society as a cosmological whole, society itself becomes, for Shaftesbury, the natural result of our innate affective dispositions as human beings.[103] He idealizes a philosophy that originates from Socrates and is ramified into the Peripatetic and Stoic school.[104] However, such a classical tradition does not belong to the past, but is 'Civil, Social, Theistic' and active in the modern world, and relevant to Shaftesbury because it recognizes that society is 'founded in Nature'.[105] Just like Addison, Shaftesbury is destined to tackle questions raised by the ongoing process of the displacement of political authority, but unlike Addison he perceives no outside positions from which society can be (re)created in a Hobbesian fashion. As Theocles remarks in Shaftesbury's

John Locke, *Two Treatises of Government*, Cambridge Texts in the History of Political Thought, ed. Peter Laslett (Cambridge: Cambridge University Press, 1988), 25–37.

[102] Lawrence E. Klein, 'Making Philosophy Worldly in the London Periodical about 1700', in *Perspectives on Early Modern and Modern Intellectual History: Essays in Honor of Nancy S. Struever*, ed. Joseph Marino and Melinda W. Schlitt (Rochester, NY: University of Rochester Press, 2001), 404.

[103] See Epictetus, *Discourses*, 1.9.1–2. See also Shaftesbury's comment (in *Chartae Socraticae* 143) that Socrates identifies three kinds of laws, referring to '[1] City, & [2] then wth respect to that greater City of ye Univers of wch Socrates considers men as Citizens & thus he afterwards extends this Notion of *Law* to [3] ye Divine Laws & *Good of the Whole*'. For the term 'Citizen of the world', see the Cynic Diogenes of Sinope (c.404–323 BC), in Diogenes Laertius, *Lives of Eminent Philosophers*, vol. 2, trans. R. D. Hicks, Loeb Classical Library 185 (Cambridge, MA: Harvard University Press, 1925), 6.2.63.

[104] In a letter to Coste, dated 1 October 1706, Shaftesbury relies on Horace to outline a structure of philosophy divided into two schools: on the one hand, a philosophy originating from Socrates (regarded by Shaftesbury as 'the very Founder of Philosophy it-self', see *Miscellaneous Reflections* 292 [244]), leading up to the Peripatetic and Stoic school; on the other hand, a philosophy originating from Democritus, leading up to the Cyrenaic school and Epicureanism (see TNA, PRO 30/24/22/7, fol. 524r). The context of the outline is Shaftesbury's belief that Horace was torn between these two schools. Cf. Horace, *Epistles*, in *Satires, Epistles and Ars poetica*, trans. H. Rushton Fairclough, Loeb Classical Library 194 (Cambridge, MA: Harvard University Press, 1929), 1.1.10–19.

[105] TNA, PRO 30/24/22/7, fol. 524r.

dialogue *The Moralists*, 'out of Society and Community [we] never *did*, or ever *can* subsist' (*Moralists* 210 [319]). To perceive society and government as inflicted artificial creations is simply absurd to Shaftesbury. As he notes concisely in *Sensus Communis*: 'HOW the Wit of Man shou'd so puzzle this Cause, as to make Civil Government and Society appear a kind of Invention, and Creature of Art, I know not' (*Sensus Communis* 78 [111]). Addison would indeed have concurred with Shaftesbury's belief that '*Late* ENGLAND, since *the Revolution*', was 'better still than *Old* ENGLAND, by many a degree' (*Miscellaneous* 184/186 [151]), which implies that both of them thought that post-revolutionary Britain maintained appropriate civil liberties to meet the needs of man's natural disposition to experience beauty. However, as we will see in Part Two, Shaftesbury approached the nature of such an experience, and reached his conclusions about the ongoing displacement of political authority, in a very different way from Addison.

Although Shaftesbury's persona in *Miscellaneous Reflections* mentions that of 'all human Affections, the noblest and most becoming human Nature, is that of LOVE *to one's Country*' (*Miscellaneous* 174 [143]), it would be wrong to assume that Shaftesbury evolves his ideas of taste and aesthetic experience with reference to any strong sense of nationalistic realism. Shaftesbury and Addison are both defending a *cosmopolitanism* that concords with nationalism, but the perspective of Addison is bound by closer ties to the concrete political conditions of commercial society.[106] After attending the Royal Exchange in May 1711, Addison states that he is moved to tears by the transnational commerce that makes London a 'kind of *Emporium* for the whole Earth' (*S* I, 293; 69). In the throng of the commercial exchange in the modern metropolis, he discovers that he can adopt different personae and 'fancy [himself] like the old Philosopher [Diogenes of Sinope], who upon being asked what Country-man he was, replied, That he was a Citizen of the World' (*S* I, 294; 69).[107] However, Addison's vision of cosmopolitan citizens 'united together by their common Interest' is not primarily, as Shaftesbury's, conditioned by natural affections and a wish to 'be truly φιλάνθρωπος [lover of mankind]' (*Askêmata* 71).[108] Addison's ideal citizen is first and foremost a native British trader from the

[106] Angela Taraborrelli, 'The Cosmopolitanism of Lord Shaftesbury', in *New Ages, New Opinions: Shaftesbury in His World and Today*, ed. Patrick Müller (Frankfurt am Main: Peter Lang, 2014), 191. Taraborrelli observes that Shaftesbury 'requires a just political system rather than a cultural or ethnic community, or even a "people" in the nationalistic sense of the word'.

[107] See Diogenes Laertius, *Lives of Eminent Philosophers*, vol. 2, 6.2.63. On Shaftesbury's much more complex ideas about philosophical personae, see Laurent Jaffro, 'Shaftesbury on the "Natural Secretion" and Philosophical *Personae*', *Intellectual History Review* 18, no. 3 (2008).

[108] See also Xenophon, *Memorabilia*, in *Memorabilia, Oeconomicus, Symposium, Apology*, trans. E. C. Marchant and O. J. Todd, Loeb Classical Library 168 (Cambridge, MA: Harvard University Press, 2013), 1.2.60.

middling orders, whose acts are of course governed by specific morals, but also attributable to a lack of commercial commodities, rather than a virtuous Shaftesburian agent (expectedly belonging to the upper part of such a social stratum) who 'love[s] whatsoever happens according to those Laws by wch the Univers is upheld' (*Askêmata* 81).

Also, the personalities of Addison and Shaftesbury were anything but like-minded. While Addison relentlessly tried to position himself in the hub of British politics, and anchor his everyday experience in aesthetic matters, Shaftesbury's relationship to Westminster (he served in the House of Commons 1695–8, and after the death of his father in 1699 as a peer in the House of Lords) was, or so he believed, ultimately threatening to his philosophical exertions, and he frequently conveyed how the balance between his own health and his writings required long retreats from the politics of everyday life in order not to deteriorate.[109] Shaftesbury's philosophical focus can be précised in Theocles' melancholic observation that the 'Ballance of EUROPE, of Trade, of Power, is strictly sought after; while few have heard of *the Ballance of their Passions*, or thought of holding these Scales even' (*Moralists* 176 [294]). This was of course deeply unfortunate. From Shaftesbury's perspective, morality and social prosperity were always conditioned by balanced affections.

However, this does not prevent Shaftesbury from also being, at times, very specific about the beneficial political conditions that finally made an ideal society within reach. According to Shaftesbury, post-revolutionary Britain maintained the appropriate civil liberties and toleration to allow society to enter an era of common sensibility, naturalness, and taste. But such circumstances transpired against a depressingly bleak image of the state of modern philosophy.[110] In the opening of *The Moralists*, the sceptic Philocles laments that while it has

[109] See 'Introduction', in *Askêmata*, esp. 22–33. One of Shaftesbury's letters to Locke (in part cited by the eds [22]), dated 9 April 1698, is revealing (for quotation, see *Correspondence* 255): The letter begins with Shaftesbury longing to be 'more Conversant with the Antients, & less with the People of the Age. I am sure it had been better for my self: And, for any thing that I, or any meer Honest Man is able to do in publick affairs in such a generation as this, I think it would have been altogather as well for my Country & Mankind, if I had don nothing'. Due to his ill health (chronic asthma), Shaftesbury resided in Chiaia, near Naples (his 'resting Place', see letter from Rome, 6 November 1711 [TNA, PRO 30/24/21, fol. 146r]) during the final months of his life. In his *Letter Concerning Design* (42 [398]), written during his residence in Italy, and addressed to Lord Somers, Shaftesbury describes his political fate in the following words: 'There was a Time, and that a very early one of my Life, when I was not wanting to my Country ... But after some Years of hearty Labour and Pains in this kind of Workmanship, an unhappy Breach in my Health drove me not only from the Seat of Business, but forc'd me to seek these foreign Climates.'

[110] At an early stage, in a letter to Locke (29 September 1694), Shaftesbury suggests that philosophy lost a general relevance after Socrates. When the 'Socratick Spiritt' faded away it was taken for granted that 'to Profess Philosophy, was not to Profess a Life: and yt it might bee said of one, yt *Hee was a great Man in Philosophy*; whilst nobody thought it to the purpose to ask *how did Hee Live? what Instances of his Fortitude, Contempt of Interest, Patience, &c*:? What is Philosophy, then,

'become fashionable in our Nation to talk Politicks in every Company', there is nevertheless a complete failure to perceive '*Politicks* to be of [philosophy's] Province' (*Moralists* 22/24 [183/184]). In the wake of the separation of philosophy and the political, 'we Moderns' have, argues Philocles, 'degraded her [i.e. philosophy], and strip'd her of her chief Rights' (*Moralists* 24 [184]). The prospect of a necessary reunification is, for Philocles, given by the fact that if morals still constitute an essential part of philosophy (which Shaftesbury claims), then '*Politicks* must undeniably be hers [i.e. philosophy's]'. Shaftesbury's thinking revolves around the organic interdependence between private small-scale systems of animals and human beings, and larger (universal) systems. Given such an interdependence we must, from Shaftesbury's perspective, set off by 'study[ing] *Man* in particular', before we can examine his correlation to any political community or nation (*Moralists* 24 [185]). To perceive, in an Addisonian manner, moral agency to be 'ingag'd to this or that Society, by Birth or Naturalization' is, from Shaftesbury's perspective, a too simplistic way of addressing man's natural belongingness within society. Instead we must, in the words of Philocles, begin by 'search[ing] his Pedegree in Nature, and view his End and Constitution in it' (*Moralists* 24 [185]).

Thus, while Addison's theory of taste is governed by a set of political principles, Shaftesbury's theory gradually unveils a political bearing via the philosophical tenet that human beings share a natural disposition to experience beauty and participate in society.[111] Based on his censure of Locke's objection to innate principles, Shaftesbury wants to draw attention to the natural human disposition to abide by 'that which *Nature* teaches' (*Moralists* 340 [411]). However, that does not imply that we can experience beauty without a demanding cognitive practice in which we gain proper knowledge of self. A perfected self-knowledge, displayed in what Shaftesbury refers to as 'natural affections', is ultimately what concretizes nature and beauty to us. Although it is seldom recognized by contemporary philosophers of art, one reason for the relevance of Shaftesbury as a model man of letters in European Enlightenment is precisely that he relates the moment when nature and beauty is made concrete to us – the very moment of the realization of the aesthetic experience – with a social and civic-minded receptivity. The complex cultivation of our instincts for beauty where we, so

if nothing of this is in ye case?' (*Correspondence* 203). See also Shaftesbury's letter to a friend (TNA, PRO 30/24/47/25, fol. 2r): 'the Philosophers of Our days are Hugely given to Wealth and Bugbears: And Philosophy seems at present to be the Study of making Virtue a Burden and Death uneasy.'

[111] See Richard Glauser, 'Aesthetic Experience in Shaftesbury', *Proceedings of the Aristotelian Society, Supplementary Volumes* 76, no. 1 (2002), 34.

to speak, evoke a memory of nature always coincides, to Shaftesbury, with an emotional sensitivity towards other human beings and natural society itself.

Part Two intends to demonstrate just how a neglect of the engrained civic-minded disposition of Shaftesbury's notion of taste and beauty has resulted in reductionist readings in aesthetics. I wish to remedy such analyses as far as possible by showing that Shaftesbury's theory of taste rests on primarily two claims. First, Shaftesbury adheres to the traditional tripartite of truth, goodness, and beauty. The modus operandi throughout his works is classical: he does not seek to liberate a specific disinterested aesthetic perception or attitude from matters of morality, politics, and religion. Rather than paving the way for a modern aesthetic disinterestedness where the agent's perception terminates upon the aesthetic object, he is preoccupied with our natural moral and emotional engagement and immersion in the *Whole* (both in the form of natural society and nature designed by the Deity, and in the form of individual works of art). Thus, to make sense of his concept of beauty and taste, we must allow for the fact that it discloses a strong ethico-theological dimension. Second, at the heart of Shaftesbury's thinking is the notion of natural affections connecting individual agents with fellow citizens, human sociability, and ultimately society itself. Shaftesbury's classification of the affections as pivotal for morality has great bearings for his notion of taste, beauty, and his vision of an enlightened British society after the Revolution.[112]

Shaftesbury's *An Inquiry Concerning Virtue, or Merit* is perhaps the most frequently cited of his works in present-day philosophy (which is ironic, as this piece deviates greatly in style and tone from his corpus of writings). The *Inquiry* was published for the first time by the Irish freethinker John Toland, on his own initiative, in 1699, with the title *An Inquiry Concerning Virtue, in Two Discourses*. Whether Shaftesbury wholeheartedly objected to Toland's publication remains somewhat uncertain.[113] In a letter dated 3 June 1709, to his Oxford protégé Michael Ainsworth, Shaftesbury comments that the *Inquiry* was 'an imperfect

[112] Given Shaftesbury's view of philosophy this is not surprising. See Friedrich A. Uehlein, 'Anthony Ashley Cooper, Third Earl of Shaftesbury: Bibliographie der Schriften – Doxographie – Wirkung', in *Grundriß der Geschichte der Philosophie: die Philosophie des 18. Jahrhunderts*, vol. 1, ed. Helmut Holzhey and Vilem Mudroch (Basel: Schwabe, 2004), 51–6, 62–89, and 164–8.

[113] See e.g. Isabel Rivers, *Reason, Grace, and Sentiment: A Study of the Language of Religion and Ethics in England, 1660–1780. Volume II: Shaftesbury to Hume* (Cambridge: Cambridge University Press, 2000), 14–15. For good reasons, Rivers claims that Shaftesbury probably approved of Toland's publication. Shaftesbury himself suggests differently (at least in public). See also the fourth Earl of Shaftesbury's sketch of the life of his father, in TNA, PRO 30/24/21, fols 253(A)r–263r. Regardless of the fourth Earl's personal interest of dissociating his father's posthumous reputation from Toland, it remains noteworthy that he claims that the third Earl 'was greatly chagrined ... and immediately bought up the whole Impression before many of the Books were sold' (TNA, PRO 30/24/21, fol. 258r).

Thing, & brought into y^e world many years since contrary to y^e Author's design, in his absence beyond-sea, & in a disguisd disorderd Style' (*Ainsworth Correspondence* 407). Shaftesbury entertained a hope that the publication 'may one day, perhaps, be set righter', and he urged Ainsworth to '[h]ave patience in y^e mean while' (*Ainsworth Correspondence* 407). Shaftesbury then included a revised version called *An Inquiry Concerning Virtue, or Merit* in his three-volume collection entitled *Characteristicks of Men, Manners, Opinions, Times* (1711). In addition to the *Inquiry*, the collection contained four previously published treatises – *A Letter Concerning Enthusiasm* (1708), *Sensus Communis, An Essay on the Freedom of Wit and Humour* (1709), *Soliloquy, or Advice to an Author* (1710), and *The Moralists, a Philosophical Rhapsody* (1709) – supplemented by an extensive five-chapter commentary on the previous two volumes, entitled *Miscellaneous Reflections on the Preceding Treatises and Other Critical Subjects*. The success of *Characteristicks* was instant. Next to Locke's *Second Treatise of Government* and the immense impact of the *Spectator* (memorably deemed by Addison's biographer Peter Smithers as 'second only to the Bible in its influence upon British manners and morals'),[114] it was the most reprinted work in English in the eighteenth century,[115] and its impact on the continent was substantial, especially in the German *Bildungstradition*. All at once, *Characteristicks*, issued the same year as the *Spectator*, succeeded in being an accessible, witty, and substantial philosophical work.

However, at the time there was no agreement on this in Britain. Shaftesbury was reproached for being, as George Berkeley maintained in one of his distorted portrayals, 'a loose and incoherent writer'.[116] While Berkeley had his own motives to caricature Shaftesbury's writings as the chaotic product of a radical, anti-Christian freethinker,[117] the Earl himself did his share by declaring that the 'most ingenious way of becoming foolish, is *by a System*' (*Soliloquy* 210 [290]). Reading *Characteristicks* today, however, is nothing but invigorating.

[114] Peter Smithers, 'Introduction', in *The Spectator*, vol. 1, ed. Gregory Smith (London: Dent, 1967), viii.
[115] Costelloe, *The British Aesthetic Tradition*, 11–12.
[116] George Berkeley, *The Theory of Vision or Visual Language Shewing the Immediate Presence and Providence of a Deity Vindicated and Explained*, in *The Works of George Berkeley, Bishop of Cloyne*, vol. 1, ed. Arthur Aston Luce and Thomas Edmund Jessop (London: Thomas Nelson, 1948), 251–76 (3:252). Berkeley misrepresented and ridiculed Shaftesbury's philosophy most memorably in the Christian apologetics *Alciphron: Or the Minute Philosopher*, in *The Works of George Berkeley*, vol. 3, e.g. the third dialogue, 112–40.
[117] Alfred Owen Aldridge observes in 'Shaftesbury and the Deist Manifesto', *Transactions of the American Philosophical Society* 41, no. 2 (1951), 298, that 'Shaftesbury was variously regarded [throughout the eighteenth century] as an orthodox Christian, a deist, and an infidel. Much of this confusion is caused by inadequate knowledge of the background of Shaftesbury's work. Many of the so-called anti-Christian passages in the *Characteristics* are not anti-Christian at all, but merely vigorous protests against the efforts of organized religion to assume political powers.'

One is almost overwhelmed by the extraordinary spangle of philosophical and literary techniques displayed throughout the work. While the *Inquiry* is a systematically arranged treatise to such an extent that Shaftesbury's persona in *Miscellaneous Reflections* bemoans that the author 'discovers himself openly, as a plain *Dogmatist*, a *Formalist*, and *Man of Method*' (*Miscellaneous* 166 [135]), the epistolary *A Letter Concerning Enthusiasm* is characterized as neither a 'formal TREATISE' nor 'design'd for *publick* View' (*Miscellaneous* 44 [20]). Furthermore, while *Soliloquy* is claimed to be accompanied by a '*Miscellaneous* Air' (*Miscellaneous* 166 [135]), *The Moralists*, acknowledged by Shaftesbury's persona as the central piece of *Characteristicks*, 'aspires to *Dialogue*, and carrys with it not only those Poetick Features of the Pieces antiently call'd MIMES', but also 'attempts to unite the several Personages and Characters in ONE *Action*, or *Story*' (*Miscellaneous* 332 [285]).[118]

The Moralists is indeed an exceptional piece of Enlightenment writing.[119] It was initially included in a letter dated 20 October 1705 to Shaftesbury's friend, the influential statesman Lord Somers. Published privately and anonymously, it carried the title *The Sociable Enthusiast; a Philosophical Adventure, Written to Palemon* and was, in the words of Shaftesbury, an 'odd Book without Date, Preface or Dedication'.[120] Somers was straightforwardly requested to 'burn it' if he did not fancy reading it.[121] Three years later, in a letter dated 10 December, Somers received a new and altered copy, entitled *The Moralists, a Philosophical Rhapsody. Being a Recital of Certain Conversations on Natural and Moral Subjects*, which was published in London in 1709.[122] In *The Moralists*, the sceptic Philocles, in a letter to the melancholic Palemon, narrates a revolutionary conversation with Theocles, the midwife of Philocles' knowledge of true beauty. Throughout the dialogue, Shaftesbury excels in a variety of narrating techniques and, as he himself remarks, manages to include the '*Simple, Comick, Rhetorical*, and even the *Poetick* or *Sublime*' styles (*Miscellaneous* 334 [285]).[123] The portraits

[118] Comparing *The Moralists* with the *Inquiry*, Shaftesbury remarks that the former must be 'reckon'd as an Undertaking of greater weight' (*Miscellaneous* 332 [285]).

[119] For eighteenth-century appraisals of *The Moralists*, see e.g. Leibniz's comments on *Characteristicks* (TNA, PRO 30/24/26/8, fol. 60ᵛ): 'Le tour du Discours, la Lettre, le Dialogue, le Platonisme nouveau, la maniére d'argumenter par interrogations, mais sur tout la grandeur et la beauté des Idées, l'Enthousiasme lumineux, la Divinité apostrophée me ravissoient et me mettoient en extase.'

[120] TNA, PRO 30/24/22/4, fol. 284ʳ.

[121] Ibid.

[122] See ibid., fols 326ʳ–327ᵛ. For comparison of the different editions of the work, see Horst Meyer, *Limae labor: Untersuchungen zur Textgenese und Druckgeschichte von Shaftesburys 'The Moralists'* (Frankfurt am Main: Peter Lang, 1978).

[123] On the complex dialogic structure of *The Moralists*, see Michael Prince, *Philosophical Dialogue in the British Enlightenment: Theology, Aesthetics, and the Novel* (Cambridge: Cambridge University Press, 1996), esp. 47–73.

of Palemon ('the Man of Quality'), Philocles ('an airy Gentleman of the World, and a thorow Raillyer'), and Theocles (the '*Gentleman*-Philosopher') carry such a psychological depth that they form a version of Shaftesbury's thinking in miniature and encourage the reader to pursue further connections to his other works (*Miscellaneous* 334/336 [287/288]).

At the same time, given the great mixture of techniques and the idiosyncratic miscellaneousness of topics that come from engaging in the interface between different treatises, and ultimately from addressing *Characteristicks* as a whole, it is understandable that the systematic structure of the *Inquiry* might seem to offer sweet relief by meeting a current methodical inclination of philosophy.[124] Such relief is of course illusory. While the *Inquiry* is an analytically arranged work, and Shaftesbury's persona holds some of the other treatises in *Characteristicks* as preparatory to the *Inquiry*,[125] it gains greatly in clarity if read along with the other works in *Characteristicks*, as well as with sections from the *Askêmata* notebooks and the first two treatises (*A Letter Concerning the Art, or Science of Design* and *A Notion of the Historical Draught or Tablature of the Judgment of Hercules*) which were to be included in *Second Characters*, had Shaftesbury only lived to complete it.[126] Shaftesbury himself advanced a complex system of cross-references between his works, and although I will begin Part Two by revisiting some of the main arguments made in the *Inquiry*, I intend to move ahead in a related manner.[127]

[124] See also Stanley Green, *Shaftesbury's Philosophy of Religion and Ethics: A Study in Enthusiasm* (New York: Ohio University Press, 1967), 14.
[125] See *Miscellaneous Reflections* (228 [189]): 'We are now, in our Commentator-Capacity, arriv'd at length to this *second* Volume [i.e. *Inquiry* and *The Moralists*], to which the three Pieces of his *first* [i.e. *A Letter Concerning Enthusiasm*, *Sensus Communis* and *Soliloquy*] appear preparatory.'
[126] Shaftesbury completed *A Letter Concerning the Art, or Science of Design* and *A Notion of the Historical Draught or Tablature of the Judgment of Hercules* in the last months of his life in Chiaia (from 20 November 1711 to 15 February 1713). In these two works, Shaftesbury devotes himself primarily to aesthetics and art. See letter to Coste (29 March 1712): 'Vous savez l'état miserable où je suis à l'égard de ma Santé, qui m'a fait chercher ce Climat, où le seul Divertissement que j'ay, et toute la Conversation ne roule que sur la Peinture et ces autres Arts' (*Letters & Billets on Hercules* 372).
[127] See Theocles' defence of the author of the *Inquiry* (*Moralists* 134 [263]).

Part One

Addison, taste, and the moral body politic

Part One sets itself the ambitious task of providing a new account of Addison's theory of taste. The ongoing philosophical concern for the displacement of political authority had strong bearings on how Addison perceived the value of experiencing nature and art, and to begin with I will consider how a modern political *whole* (the body politic), defined by its moral singular *parts* (autonomous agents), is reflected in Addison's political essays and in the outlines of his model of taste (Chapters 1.1 and 1.2). To concretize his theory of taste, as well as to separate a politically valued moral agent of taste from a vulgar and politically destabilizing one, Addison relies on moral *exempla*. I will explore one such *exemplum* in detail, the enlightening fable of the life of Aurelia and Fulvia, two exact opposites (Chapter 1.3). This will abet an improved understanding of the ethico-political significance of Addison's series of *Spectator* essays referred to as the *Pleasures of the Imagination* (S III, 535–82; 411–21), published in the summer of 1712 (Chapter 1.4). As a close reading of key passages in the series reveals, God has, according to Addison, purposely intended man to emotionally engage in an experience of the powers of the Deity, by assigning an innate predestined pleasure to such an aesthetic experience. A revealed knowledge about God is not achieved *sola scriptura* as the Protestant Reformation had declared. Instead, it is the aesthetic experience that, according to Addison, pushes the agent onwards in his religious and moral engagements. Addison's strong commitment to the ethico-political value of aesthetic experience leads him, furthermore, to engage in the validity of the affective experience of nature and art by involving himself in the historical discourse on the ontology of religious enthusiasm (Chapter 1.5). However, Addison addresses the question of religious enthusiasm by mapping out the political importance of fighting radical enthusiasm on moral values

rather than on religious principles. From Addison's perspective, we, as human beings, engage in nature and art because we are predetermined to participate in pleasures with the purpose of engaging in God's providence and the fate of our private morals. A perfected morality is then believed to ramify itself into the benefit of the body politic. As we will see, the rhetorical strategy advanced by Addison to make art and ethico-political values form a convincing entity depends on accentuating a strong nexus between a distinctive British taste and classical ideals, separated from continental taste and arts (Chapters 1.6 and 1.7).

1.1

The displacement of political authority

At the heart of eighteenth-century aesthetic theory lingers the question of how a subjective experience of, say, reading *Paradise Lost* or mesmerizingly viewing the 'verdure of the Grass, the Embroidery of the Flowrs, and the Glistring of the Dew'[1] might constitute a valid foundation of interpersonal judgements of taste.[2] For British men of letters in general, and for Addison in particular, the philosophical exploration of this question also covered possibilities of a reciprocity between subjective taste and a set of interpersonal ethico-political matters, commonly captured in the image of how a *natural moral body* related to a *political body*. It was frequently suggested that the sanctified religious and political conditions of Britain – 'enjoy[ing] a purer Religion, and a more excellent Form of Government, than any other Nation under Heaven' (*F* 59; 5) – involved a particular moral commitment of its citizens.[3] '[O]ne must', argues Addison in an essay in the *Freeholder* on 6 January 1716, 'look upon [oneself] as indispensably obliged to the Practice of a Duty' (*F* 59; 5). This implies that a virtuous citizen ought to 'turn ... his Thoughts towards the Publick, rather to consider what Opportunities he has of doing Good to his Native Country, than to throw away his Time in deciding the Rights of Princes, or the like Speculations, which are so far beyond his Reach' (*F* 59; 5). The self-imposed government and the exercised Protestantism are, according to Addison, 'determined by Reason and Conviction' (*S* III, 18; 287). In case one relies on prejudice, it is, as far as government and religion are concerned, also acceptable since it would, from

[1] See *S* III, 563–64, Bond (footnote 2); 417.
[2] See Guyer, *A History of Modern Aesthetics, Volume 1: The Eighteenth Century*, 36. See also James Engell, *Forming the Critical Mind: Dryden to Coleridge* (Cambridge, MA: Harvard University Press, 1989), 103–25.
[3] See Linda Colley, *Britons: Forging the Nation 1707–1837*, 2nd edn (New Haven, CT: Yale University Press, 2005), 33. Colley discusses the idea of British Protestantism and the belief that Britain was sanctioned by a divine premise (and stood in for Israel). See also Colley, *Acts of Union and Disunion: What Has Held the UK Together – and What Is Dividing It?* (London: Profile Books, 2014), e.g. 48.

Addison's perspective, involve an 'honest Prejudice' that 'arises from the Love of [one's] Country' (*S* III, 18; 287). The repute and status of a mixed government rely on its ability to prevent arbitrary political power and to guarantee egalitarian freedom. The most commonsensical 'form of Government' is, argues Addison, that 'which is most conformable to the Equality that we find in Human Nature, provided it be consistent with Publick Peace and Tranquillity' (*S* III, 19; 287). In a *Spectator* essay from 29 January 1712, Addison voices a surprisingly spirited egalitarianism on the current government's protection of liberty:

> Liberty should reach every Individual of a People, as they all share one common Nature; if it only spreads among particular Branches, there had better be none at all, since such a Liberty only aggravates the Misfortune of those who are deprived of it, by setting before them a disagreeable subject of Comparison. (*S* III, 19; 287)

There is, or so Addison argues in his opening essay in the *Freeholder*, 23 December 1715, 'an unspeakable Pleasure in calling any thing one's own' (*F* 41; 1), and the civil liberty protected by a mixed government consists, Addison emphasizes in a Lockean vein, primarily in the protection of the right to property.[4] A successful safeguard of individual property creates loyal and free agents with further confidence in the political authority. Addison deprecates any argument 'for Argument's sake' since it has 'no real Concern in the Cause which [it] espouses' (*F* 39; 1). The 'Passion for Liberty which appears in a Grub-street Patriot, arises only from his Apprehensions of a Gaol' and such passions are merely false and self-interested (*F* 39; 1). Instead, true liberty must, argues Addison, grow from a political process and interaction where a *real* matter, such as the natural right to property, is at stake. Any liberty in political society needs to be as wide-ranging as possible, or else its moral value (especially the prospect of maintaining political stability) will be neutralized by excluded citizens. Addison frequently presses on this kind of synoptic view of an effective political society and its interpersonal relations, only to abruptly switch his focus to the sense of duty ascribed to the individual moral agent. This successful hovering between the completion of the political *whole* and the distinctive conduct and rational responsibility of the individual citizen is, as we will see further ahead, particularly evident in Addison's examination of taste.

[4] *F* 41; 1: 'How can we sufficiently extol the Goodness of His present Majesty [George I], who is not willing to have a single Slave in His Dominions! Or enough rejoyce in the Exercise of that Loyalty, which, instead of betraying a Man into the most ignominious Servitude, (as it does in some of our neighbouring Kingdoms) entitles him to the highest Privileges of Freedom and Property!'

The emotive disposition of such a citizen is, in a Gracián fashion, a characteristic of the virtuous countenance of the 'accomplished Man' of taste (*S* III, 527; 409). The kind of Whig political stability sought by Addison could only be preserved by such moral bodies of taste, reinforcing the body politic by allocating a part of their singular power (the absolute right to self-preservation) to a political authority in exchange of safety and liberty. Addison's point – so characteristic of the turn of the century – was that the natural body and its subjective emotions were synergetic to the configuration of the political body and its interpersonal relations. The Scottish pamphleteer Andrew Brown captured this common early-eighteenth-century conviction, when commenting on the subject in *The Character of the True Publick Spirit* (1702):

> The dangers and difficulties of a Nation, or the *Body politick*, are often like the diseases of the *Body natural*, well known they may be said to be half cured, But then it must be by the sagacious and perspicatious, who looking beyond the superficies of things into their innermost recesses, perceave *dangers* in the *Spring* and *Bud* and then they are easily Cureable, but when they appear evident and conspicous to all, then like some Diseases of the *Body natural*, frequently they are desperat and incurable.[5]

The sagacious moral agents, referred to by Brown, were expected to actively participate in a rational discourse where '*Fellow-feeling* and *Sympathising Publick Genius*' naturally tended to spill over from the subjective '*Sphere of Self*' and 'like the *Anima Mundi* of the *Philosophers*' was 'disposed to communicat due *Vigor, Spirit* and *Growth* to all the parts of the *Body Politick*'.[6] The common state of the body politic was, from Brown's federalist perspective, proportional to the physical and emotional condition of the self-legislative Christian natural body. The insistence on a greater authority of the Vox Populi entailed a moral imperative on every citizen to act for the benefit of the political *whole*.[7] The sovereign '*Government* of a Nation' was, according to Brown, after all but 'an *Embleme* of the Genius of the People; so the state and condition of the People, seems to be the *Transcript* of the *force* of the *Government*, and of its *Sufficiency*'.[8]

[5] Andrew Brown, *The Character of the True Publick Spirit* ... (Edinburgh, 1702), 6. See also George Mackenzie (Earl of Cromarty in 1703), *Parainesis Pacifica; or, a Perswasive to the Union of Britain* (Edinburgh, 1702), e.g. v. The Scottish statesman Mackenzie (1630–1714) argued for the union between Scotland and England, and he underscored the beneficiary interrelation between political *parts* (here Scotland and England) and the body politic (Britain). Mackenzie illustrated his arguments by reflecting on the arduous state of affairs between Denmark and Sweden, which could, from Mackenzie's perspective, be amended only by an operative body politic.
[6] Ibid., 25.
[7] Ibid., 38.
[8] Ibid., 9.

The question of the proper distribution of political influence was ultimately a matter of justice. If the body politic was an artificial creation, it implied a plasticity that was effective whenever political authorities were unsuccessful in realizing their moral obligations. When confronting parliamentarian Sir Humphrey Mackworth's claim that political authority strictly relied on monarchy, Lords, and Commons, Daniel Defoe characteristically stresses that the '*Vox Dei* has been found ... not in the *Representatives*, but in their Original the *Represented*'.[9] The advantages of such a (re)distribution of power was that when Britain faced the political crisis accompanying the events of 1688–9, the 'Original of Power, *the People*' could, from Defoe's perspective, redistribute 'New Powers for their future Government, and accordingly [make] a New Settlement of the Crown, a New Declaration of Right, and a new Representative of *the* People'.[10]

While the Whig moralists' own portrayals of the Revolution and its succeeding years often were stated in clichéd terms of a Manichean shift from absolute monarchy to regulated monarchy, parliamentary power, and an imprecise but extensive feeling of liberty, there was, however, also in the early eighteenth century a real fear that the 'absolute power of kings had merely been replaced by the absolute power of parliaments'.[11] What status did the individuals, in fact, have in relation to the new conception of the political body? Was the governing body, as Brown stressed, an emblem of the *body natural*, or did parliament have an autonomous and plenary authority in relation to its constituents?[12]

The metaphor capturing the subjective natural body's emotional relation to the political body was originally encapsulated in the 'most famous visual image in the history of political philosophy', Hobbes's *Leviathan* (1651), where half of the upper part of the frontispiece of the printed version shows the torso and arms of a colossus crowned sovereign, composed of coupled small figures (both men and women) looking towards him (I refer to the engraving, not the vellum manuscript presented to Charles II).[13] Already in the introduction of *Leviathan*, Hobbes outlines the anatomy of this artificial body politic and effectively captures the complex interface between moral agency and political *whole*. While

[9] Daniel Defoe, *The Original Power of the Collective Body of the People of England, Examined and Asserted* (London, 1702), 8.
[10] Ibid., 10.
[11] Mark Goldie, 'The English System of Liberty', in *The Cambridge History of Eighteenth-Century Political Thought*, ed. Mark Goldie and Robert Wokler (Cambridge: Cambridge University Press, 2006), 41.
[12] Ibid., 60.
[13] See Noel Malcolm, 'Editorial Introduction', in Thomas Hobbes, *Leviathan*, vol. 1, ed. Noel Malcolm, The Clarendon Edition of the Works of Thomas Hobbes (Oxford: Oxford University Press, 2012), 128.

God controls the world through nature ('the Art whereby God hath made and governes the World'), the art of human beings consists in creating an artificial man, namely that 'great LEVIATHAN called a COMMON-WEALTH, or STATE, (in latine CIVITAS)'.[14] The physical anatomy of this creation consists of vital organs such as the 'Artificiall *Soul*' (the sovereignty) that brings the body to life, physical strength consisting of the prosperity of the inhabitants, memory consisting of counsellors, an artificial reason and will made of equity and laws, and so forth. The task of the colossal (gender neutral) figure is the *salus populi*,[15] and although it is an artificial creation by the art of human beings, Hobbes was forthright, and groundbreaking in the modern discourse on the body politic, when he accentuated the resemblance of such a making and God's own creation described in Gen. 1.26: 'the *Pacts* and *Covenants*, by which the parts of this Body Politique were at first made, set together, and united, resemble that *Fiat*, or the *Let us make man*, pronounced by God in the Creation.'[16] Thus the physique of the sovereign body was an artifice, on the one hand, made by the art of individuated bodies and, on the other hand, consisting of human bodies.

Nature is famously characterized by Hobbes as an apolitical condition, and when humans 'live without a common Power to keep them all in awe, they are in that condition which is called Warre', which does not mean there is constant warfare, but that they permanently reproduce their disposition to conflict.[17] Nature is thus an antagonistic and emotionally chaotic community dominated by special interests, where there can be no 'Arts; no Letters; no Society; and

[14] Thomas Hobbes, *Leviathan, or the Matter, Forme, & Power of a Common-Wealth Ecclesiasticall and Civill*, vol. 2, ed. Noel Malcolm, The Clarendon Edition of the Works of Thomas Hobbes (Oxford: Oxford University Press, 2012), 16.

[15] See e.g. 'Hobbes, History, Politics, and Gender: A Conversation with Carole Pateman and Quentin Skinner', in *Feminist Interpretations of Thomas Hobbes*, ed. Nancy J. Hirschmann and Joanne H. Wright (Pennsylvania: Pennsylvania State University Press, 2012). Skinner stresses that the person (Leviathan) created out of the covenant holds no gender. While, for Hobbes, the 'sovereign can be a man or a woman, what matters most is the state, which has no gender at all' (27).

[16] Hobbes, *Leviathan*, 16. On Hobbes's groundbreaking metaphor, see Barbara Stollberg-Rilinger, *Der Staat als Maschine: Zur politischen Metaphorik des absoluten Fürstenstaats* (Berlin: Duncker & Humblot, 1986), 49.

[17] Ibid., 192. Addison did not have any deliberate interest in the details of Hobbes's particular perception of human nature. Addison simply claims that 'MR HOBBS, in his Discourse of Human Nature [in *Elements of Law, Natural and Politic*]', presents 'much the best of all his Works' (S I, 200; 47). Addison did not follow up this remark. However, other *Spectator* writers did: see e.g. the Presbyterian theologian Henry Grove (1684–1738) in S V, 10–14; 588. Grove claims that human beings hold a 'double Capacity' making them reasonable and social (10). While the first capacity refers to self-love and personal interest, the second capacity refers to benevolence and sociability. The double capacity is 'so agreeable to Reason, so much for the Honour of our Maker, and the Credit of our Species', that a negative perception of nature is absurd. Following Epicurus' perception of nature, Grove stresses that Hobbes unfortunately carries on the thought that beneficence must be 'founded in Weakness' (10). Grove doubts that a society with 'no other Bottom but Self-Love on which to maintain a Commerce, [could] ever flourish' (12).

which is worst of all, continuall feare, and danger of violent death; And the life of man, solitary, poore, nasty, brutish, and short'.[18] Hobbes's rational egoism wishes to capture a state of logical, albeit mercenary and calculated, selfishness.[19] What is needed in order to regulate this natural state is an authoritative sovereign, a representative of the joint will and emotions of the individual members of the multitude that is now, more accurately, acting as a single will of *one* person, *one* body. By acting as one person and consenting to a sovereign (one ruler or an assembly), the members relinquish a vital part of their *jus naturale*, namely essentially their right to decide for themselves what they need for self-preservation, as well as their claim to determine the required means to maintain their self-preservation.[20] The advantage is of course that by entrusting the political authority of the sovereign with absolute power, the members replace disturbed emotions of insecurity and fear that characterize the state of nature with the civil laws of protection characteristic of modern civil society (or commonwealth, which is the term applied by Hobbes). Thus, the emotions of the singular body become part of the artificial body and the 'Generation of that great LEVIATHAN, or rather (to speake more reverently) of that *Mortall God*, to which wee owe under the *Immortall God*, our peace and defence'.[21]

Hobbes is certainly no ideal guardian of a modern democratic organization of politics. The power of the sovereign is absolute, and the 'freedom a subject enjoys under a government is restricted to those matters about which the sovereign chooses not to legislate'.[22] But despite the autocratic nature of the political authority suggested in *Leviathan* (much in agreement with King James I's own conviction that he was a God on earth who could 'make and unmake [his] subjects'), it is vital to recognize what is at stake in mid-seventeenth-century thought.[23] The unrestricted power of the sovereign (Hobbes does not distinguish between state and government) does not accurately originate in a traditional divine right-theory of kingship. The political power does not in reality answer

[18] Ibid.
[19] Elisabeth Ellis, 'The Received Hobbes', in *Leviathan: Or the Matter, Forme, & Power of a Common-Wealth Ecclesiasticall and Civill*, ed. Ian Shapiro (New Haven, CT: Yale University Press, 2010), 493.
[20] The extent of rights relinquished remains ambiguous, see A. P. Martinich, *Hobbes: A Biography* (Cambridge: Cambridge University Press, 1999), 232–3.
[21] Hobbes, *Leviathan*, 260.
[22] A. P. Martinich, 'Thomas Hobbes in Stuart England', in *A Hobbes Dictionary* (Oxford: Blackwell, 1995), 5.
[23] Ibid., 6. For the quotation from James I, see *A Speech to the Lords and Commons of the Parliament at White-Hall* from 1610, republished in *Divine Right and Democracy: An Anthology of Political Writing in Stuart England*, ed. David Wootton (London: Penguin, 1986), 107: 'Kings are justly called gods for that they exercise a manner or resemblance of divine power upon earth. For if you will consider the attributes to God, you shall see how they agree in the person of a king.'

to God but rather to the citizens that bestow the moral authority upon the sovereign. The image of autonomous agents seemingly divided in their emotions and interests, but expected to recognize the communal benefits arising from entrusting the state with power and, metaphorically speaking, allowing their bodies and emotions to enter into a greater and more powerful (yet artificial) body at the same time as each particular body maintains its individuality, is a vigorous image of a future modern society and state. As such it frames, on the one hand, a growing concern for the organizing principles of the state as a cohesive entity of interpersonal judgements and, on the other hand, the ongoing modern process of displacement of political authority. After all, it is as if the sovereign in the image is not wholly master of his own anatomy, and as if the bodily composition is able to operate successfully only by the mercy of the tiny singular bodies, rather than by a *jure divino*.[24] The Hobbesian agent engendering artificial society is, in the words of Mark Roelofs, somewhat '[u]ninhibited by any sense of natural station, or of preordained essence seeking fulfillment, and at the same time, clothed, indeed, suited and armored by its newly recovered universalized personhood'.[25] In order for the state to carry out its promise of security, its singular parts and subjective emotional experiences have to merge, without sacrificing their individual autonomy, into one artificially created body, one political *whole*. Thus, the state is for Hobbes not something naturally present, as Aristotle's teleological view in the *Politics* maintained, but an artifice that the populace now is expected to purposely construct and reconstruct from a position external to politics itself.[26] On the one hand, the state is thus a fragile creation of humans acting out of emotions of anxiety and fear, and, on the other hand, humans are, in this particular creation, godly. As Hess argues, the 'body politic metaphor becomes in Hobbes a creative act that marks the process by which art displaces nature', and by 'granting primary status to the secondary creation act, the *Leviathan* does not simply represent the product of a displaced theology', but rather 'Hobbes's construction of the state as body politic enacts the very process of this displacement'.[27] As we will see further ahead, everything

[24] See Wolin, *Politics and Vision*, 238: 'The sovereign's powerful body is, so to speak, not his own; its outline is completely filled in by the miniature figures of his subjects. He exists, in other words, only through them. Equally important, each subject is clearly discernible in the body of the sovereign. The citizens are not swallowed up in an anonymous mass, nor sacramentally merged into a mystical body. Each remains a discrete individual and each retains his identity in an absolute way.'

[25] H. Mark Roelofs, 'Democratic Dialectics', *The Review of Politics* 60, no. 1 (1998), 9.

[26] See Alan Ryan, 'Hobbes's Political Philosophy', in *The Cambridge Companion to Hobbes*, ed. Tom Sorell (Cambridge: Cambridge University Press, 1996), 216: 'States exist [according to Hobbes] by convention, and conventions are manifestly man-made, so states are self-evidently artificial and thus nonnatural.' Cf. Aristotle, *Politics*, e.g. 1252b30–1253a6.

[27] Hess, *Reconstituting the Body Politic*, 91.

Addison and Shaftesbury argued for in their theories of taste bear the stamp of the ongoing process of displacement of political authority. And although Shaftesbury would go on and become one of the most fervent critics of Hobbes's conception of human nature and society, the political shift was a reality that the Earl thoroughly recognized, even though his justification for society – because of natural social affections – was completely different from Hobbes's anti-Aristotelian belief that it has 'to be made, and, once made, kept going, by suppressing what is anti-social in human beings'.[28]

While the end of the Interregnum and the beginning of the Restoration in 1660 marks the reappearance of the Stuart monarchy, the displacement of political power is, at the same time, visible in an intensified concern for ethico-political and religious-ecclesiastical topics on toleration and the realm. By the time of Charles II passing away in 1685, this concern was about to reach a crisis point. While the Restoration does not mark a clear-cut turning point where the development of constitutional monarchy becomes inescapable as a result of growing religious toleration (or religious unconcern), it is equally true that the second half of the seventeenth century witnessed a growing philosophical ambition to problematize political authority in general, and the bond between monarchy and Parliament in particular, ultimately climaxing, as Jonathan Israel suggests, in 'arguably the most intensely ideological and philosophical of all major episodes in English history', namely the events of 1688–9.[29] Hence, while Britain remained a personal monarchy and the monarchy sustained its vital impact in politics throughout the second half of the century, a general anxiety about its course was inevitably on the cards.[30]

Although Charles II had been sympathetic to Catholicism, his religious faith, and his all but uncomplicated relations with Parliament, did not bear a comparison with what lied ahead during the reign of his brother and heir to the throne, James II. James had converted to Catholicism in 1669, and his second

[28] Tom Sorell, 'Hobbes, Locke and the State of Nature', in *Studies on Locke: Sources, Contemporaries, and Legacy*, ed. Sarah Hutton and Paul Schuurman (Dordrecht: Springer, 2008), 29.

[29] Jonathan I. Israel, 'General Introduction', in *The Anglo-Dutch Moment: Essays on the Glorious Revolution and Its World Impact*, ed. Jonathan I. Israel (Cambridge: Cambridge University Press, 1991), 6. See also Barry Coward, *The Stuart Age: England, 1603–1714*, 4th edn (London: Routledge, 2014), 287–90.

[30] Coward, *The Stuart Age*, 287–90. See also Peter Jupp, *The Governing of Britain, 1688–1848: The Executive, Parliament and the People* (London: Routledge, 2006), e.g. 7–8: 'The vast majority of the elite that was responsible for these laws [i.e. Bill of Rights, Act of Settlement, Triennial Act] had no wish to reduce the monarchy to a cipher. Rather, their intention was to take practical steps to curb the arbitrary, and from their point of view, revolutionary, actions of James II, and, as events unfolded, to guard against similar actions by his successors. Thus, although these measures undoubtedly placed severe limitations on the unfettered exercise of kingship, British monarchs still possessed considerable power and influence.'

wife Princess Mary of Modena was a devout Roman Catholic. In 1688, the Archbishop of Canterbury, along with six other bishops, openly opposed the now King James II's attempt to suspend laws against Protestant Dissenters and Catholics (*Declaration of Indulgence*), a declaration also issued during the reign of Charles II. In the public eye, Catholicism reverberated of fearful reminiscences of the Civil War. The atmosphere of anti-Catholicism among the masses was enduring throughout the second half of the seventeenth century, and Addison himself would later on foment such an atmosphere by associating popery, vulgar taste, oppressive and capricious Absolutism, France, and a corrupted political *whole*.[31] It did not matter that the members of the public who were Catholics were few, Catholic priests heavily divided, and Catholic political activism a myth rather than a real threat to be reckoned with.[32] The religious-political campaign was intact, and had been so long enough to produce the desired effect of anxiety and fear among the general public.

If one should remember just one 'political Maxim', it has to be, argues Addison later on in 1716, that it is 'impossible for a Nation to be happy, where a People of the Reform'd Religion are govern'd by a King that is a Papist' (*F* 230; 43). A 'nominal *Roman* Catholick' might under certain circumstances be tolerable, but a 'Scheme of Government' is, according to Addison's Whig principles, simply 'impracticable in which the *Head* [the monarch] does not agree with the *Body* [the people]' (*F* 230–1; 43).[33] The events of 1688–9 instigated, as Shaftesbury also understood it, a 'happy Ballance of Power' between the monarch and the people that 'secur'd our hitherto precarious Libertys, and remov'd from us the Fear of Civil Commotions, Wars and Violence, either on account of Religion and Worship, the Property of the Subject, or the contending Titles of the Crown' (*Soliloquy* 122 [216]). In the midst of the momentous series of political events surrounding 1688–9, Shaftesbury writes in a letter from Hamburg, dated 3 May 1689, to his father, the second Earl, of the great sense of relief attending 'our late Purge from those promoters of yt Interest', namely the Tories, that would 'have Enslavd us to ye Horridest of all Religions', namely Catholicism, and simply would have forced Britain to the 'Service of the Usurpations & treacheryes of that Neibouring Crown', namely France, that 'has Aimd so long att ye Subjection of all Europe' (*Correspondence* 71).[34] Still, this was, as both Shaftesbury and Addison

[31] See also Bloom, *Joseph Addison's Sociable Animal*, 147.
[32] Coward, *The Stuart Age*, 321–42.
[33] My italics.
[34] See also Lawrence E. Klein, 'Introduction', in Shaftesbury, *Characteristics of Men, Manners, Opinions, Times*, ed. Lawrence E. Klein (Cambridge: Cambridge University Press, 1999), xvii.

eagerly alerted, a *precarious* freedom. The '*Free Government* and *National Constitution*' could, according to Shaftesbury, easily be politically and morally destabilized by the radical terror of Catholic France that he claimed ultimately 'threaten'd the World with a Universal Monarchy, and a new Abyss of Ignorance and Superstition' (*Soliloquy* 122 [216/217]).

As far as national identities go, any successful society or nation relies to a significant part on what it believes it is not. Given that popery frequently was 'coupled with corrupt governance' in the minds of the people, it was, as Clare Haynes underlines, a political matter that 'held the nation together'.[35] As a means to self-identification, ' "No Popery" became the British shibboleth' although it had 'long served the Protestants of the four nations'.[36] Thus, while Britain certainly did not display any domestic political or religious unanimity, it is accurate to argue, as Linda Colley does, that the 'sense of a common [British] identity here did not come into being, then, because of an integration and homogenisation of disparate cultures', as much as it was 'superimposed over an array of internal differences in response to contact with the Other, and above all in response to conflict with the Other'.[37] Since 'Thee *Goddess*, Thee *Britannia*'s Isle adores', and since ''Tis *Liberty* that Crowns *Britannia*'s Isle', it is, Addison writes in his verse epistle *A Letter from Italy* (1701) to his Whig patron Charles Montagu, Lord Halifax, a moral obligation to keep a close eye on the volatile continent:[38]

> 'Tis *Britain*'s Care to watch o'er *Europe*'s Fate,
> And hold in Balance each contending State,
> To threaten bold presumptious Kings with War,
> And answer her afflicted Neighbour's Pray'r.[39]

However, the capricious Other that Addison paid most attention to awaited just across the Channel. Addison's protracted Grand Tour (1699–1704) only enhanced his Whig principles and fortified his adverse position to France, Catholicism, and what he recognized as arbitrary political powers challenging a modern body politic.[40] In a letter to John Hough, Bishop of Lichfield and Coventry, written from Marseille, 29 November 1700, Addison pens that he is 'pleas'd to Quit the French Conversation; which since the promotion of their

[35] Clare Haynes, *Pictures and Popery: Art and Religion in England, 1660–1760* (Aldershot: Ashgate, 2006), 11.
[36] Ibid.
[37] Colley, *Britons: Forging the Nation 1707–1837*, 6.
[38] Addison, *A Letter from Italy, to the Right Honourable Charles, Lord Halifax* (London, 1709), 7. See also Donald R. Johnson, 'Addison in Italy', *Modern Language Studies* 6, no. 1 (1976).
[39] Addison, *A Letter from Italy*, 8.
[40] See also Smithers, *The Life of Joseph Addison*, 90.

young prince [Philip, Duke of Anjou, grandson of Louis XIV of France] begins to grow Insupportable'.[41] Apart from a few 'Men of Letters' (especially Malebranche and Boileau), Addison writes that '[t]hat which was before the Vainest Nation in the World is now worse than ever' and that '[t]here is scarce a Man in it that dos not give himself greater Airs and look as well pleas'd as if he had receivd some considerable Advancement in his own fortunes'.[42] The general French public was, from Addison's Francophobe Grand Tour perspective, loquacious, lighthearted, and in blithe ignorance of the complexities of modern politics.[43] In his essays, Addison's Whig position towards especially French politics came to assume a variety of shapes, where moral principles, mercantile economy, property rights, and the Protestant version of Christianity coalesced (Addison is, however, not consistently disturbed by French culture; see e.g. S I, 66; 15).[44] On account of the War of the Spanish Succession, Addison addressed the mercantile challenges posed by a French-Spanish coalition in his Whig pamphlet *The Present State of the War, and the Necessity of an Augmentation Consider'd* (1708). Addison's mercantile position towards such a coalition was a classic fusion of complacent self-sufficiency and belief in the moral superiority of the British nation, and anxious admonitions of foreign threats (in the case of the War of the Spanish

[41] Addison, *The Letters of Joseph Addison*, ed. Walter Graham (Oxford: Oxford University Press, 1941), no. 21, 25.

[42] Ibid. There was an upsurge of attention in the writings of Nicolas Malebranche (1638–1715) among English scholars and men of letters in the late seventeenth century. See Stuart Brown, 'The Critical Reception of Malebranche, from His Own Time to the End of the Eighteenth Century', in *The Cambridge Companion to Malebranche*, ed. Steven Nadler (Cambridge: Cambridge University Press, 2000), 262. During his Grand Tour, Addison visited Malebranche in Paris in 1700. In this letter (no. 21) he praises Malebranche for his 'particular Esteem for the English nation' and expresses his disapproval (with some claimed support by Malebranche himself) of the 'French [who] dont care for following him [Malebranche] through such deep Reserches, and look upon the New Philosophy in General as Visionary or Irreligious' (25). Addison also remarks that he has 'had the good fortune to be introduc'd to Mons' Boileau', who is 'Old and Deaf, but talks incomparably well in his own Calling', and 'heartily hates an Ill poet, and puts himself in a passion when he talks of any one that has not a high respect for the Ancients' (25–6).

[43] See Addison, *The Letters of Joseph Addison*, no. 8, 8. Addison's letter from Paris, October 1699, to Hough encapsulates his position during the Grand Tour, where his remarks on the general 'National Fault' of Frenchmen are interspersed with more sympathetic, yet condescending, remarks: 'tho I believe the English are a much wiser Nation the French are undoubtedly much more Happy ... An Antediluvian coud not have more life and briskness in him at Three-Score and ten.' French art made a slightly more positive impression on Addison. See e.g. ibid., no. 10, 11, where Addison compares the Palace of Fontainebleau (the 'King has Humourd the Genius of the place and only made use of so much Art as is necessary to Help and regulate Nature without reforming her too much') with the garden and the Grand Gallery at Versailles, in a letter to Congreve.

[44] See also Robert Voitle's comment on Shaftesbury's Grand Tour in *The Third Earl of Shaftesbury 1671–1713* (Baton Rouge: Louisiana State University Press, 1984), 20. Voitle highlights that while 'Ashley was from childhood until death an inveterate and relentless enemy of Louis XIV and his policies', he did simultaneously try to 'separate French politics from French culture'. The Grand Tour accounts were generally double-edged. While '[m]ost of those on tour found much to object to in France', Paris was, after all, the 'most splendid city in the world, and most of the serious travellers, tacitly or not, admitted this and profited from it'.

Succession, Addison was no enemy of trade war).⁴⁵ While claiming that '*Great Britain* [not] only [is] rich as she stands in comparison with other States, but is really so in her own intrinsick Wealth', such visions could, after all, only succeed in an unholy alliance with the alarming reminders of the perturbing political dangers across the Channel, ultimately threatening, according to Addison, the entire mercantile and moral status of Britain.⁴⁶

> THE *French* are certainly the most implacable, and the most dangerous Enemys of the *British* Nation. Their Form of Government, their Religion, their Jealousy of the *British* Power, as well as their Prosecutions of Commerce, and Pursuits of Universal Monarchy, will fix them for ever in their Animosities and Aversions towards us, and make them catch at all Opportunities of subverting our Constitution, destroying our Religion, ruining our Trade, and sinking the Figure which we make among the Nations of *Europe*.⁴⁷

If, as Addison assumed, the tyranny of the capricious catholic absolute monarchy of the *Ancien Régime* endangered the political stability of Europe, it was – along with the persisting threat of the *Pretender* and a Stuart Restoration – also a domestic British concern that one had started to address in the course of the removal of James II from the throne.⁴⁸ Whether James II genuinely aimed to advance religious toleration or rather intended, as traditional Whig history would suggest, to use it as an apology to set up an absolutist state and impose Catholicism, I must leave to others to consider.⁴⁹ What is significant here is, however, that when William of Orange finally was invited in 1688 to intervene in order to remove James II from power, and himself be crowned William III, it was within the context of an ongoing philosophical discourse on the displacement of political authority. One of Locke's intellectual acquaintances, Toland, captured

⁴⁵ Addison, *The Present State of the War, and the Necessity of an Augmentation Consider'd* (London, 1708), 8: 'Let it not therefore enter into the Heart of any one that hath the least Zeal for his Religion, or Love of Liberty, that hath any regard either to the Honour or Safety of his Country, or a well Wish for his Friends or Posterity, to think of a Peace with *France*, till the *Spanish* Monarchy be entirely torn from it, and the House of *Bourbon* disabled from ever giving the Law to *Europe*.'
⁴⁶ Ibid., 42. See also Bloom, *Joseph Addison's Sociable Animal*, 67–83.
⁴⁷ Ibid., 1–2. See also Smithers, *The Life of Joseph Addison*, 55.
⁴⁸ See also Addison, *F* 75–82; 9. The Pretender, James Francis Edward Stuart (1688–1766) was the son of James II.
⁴⁹ For the original Whig historiography, see Herbert Butterfield's *The Whig Interpretation of History* (London: G. Bell, 1931). Steve Pincus offers, in *1688: The First Modern Revolution* (New Haven, CT: Yale University Press, 2009), an interesting interpretation of the events of 1688–9, where the 'ideological agenda' of James II is perceived in 'European terms' rather than within a traditional 'British context' (122). Instead of recognizing the Revolution as un-revolutionary, sensible, and conservative, Pincus regards it as radical, violent, and modern. And while James II 'understood that he could gain a strategic advantage by professing support for religious toleration', he was not a 'defender of religious pluralism', but 'wanted to establish a Catholic church reminiscent of the Gallician church of Louis XIV' (138).

the quintessence of this paradigmatic shift when stressing, in *Anglia Libera* (1701), that citizens accepting the moral intervention of the Dutch king and the crowning of William III could 'safely conclude, that no King can ever be so good as one of their own making; as there is no Title equal to their Approbation, which is the only divine Right of all Magistracy, for *the Voice of the People is the Voice of God*'.[50] James II forfeited, or so Toland argues, his moral right to reign when he breached the 'natural Relation or original Compact between all Kings and their Subjects', especially by 'endeavoring to extirpat the *Protestant Religion*'.[51] The reaction to James II's 'arbitrary and tyrannical Proceedings' was, from Toland's radical perspective, simply commonsensical. While 'most Contrys of *Europe* are overwhelm'd with a Deluge of Tyranny', Britain has 'arriv'd at a Height which wants very little of Perfection'.[52] This realization of liberty was ultimately depending on the agent's ability to support its first principles and rationally decide on a sovereign that was best adapted ('the fittest Person') to '*protect them hereafter from any Violation of the Rights they had so lately asserted, and from all other Attempts on their Religion and Liberties*'.[53]

It is indeed an essential condition of modern political logic that any authority failing to fulfil its duties to the public is, sooner or later, likely to be questioned. Locke himself touched upon this matter, in what was to become the most reprinted philosophical work in eighteenth-century Britain, *Two Treatises of Government*, when he accentuated that in the golden age, before the cursed love of gain (*amor sceleratus habendi*) depraved human beings, there was 'no contest betwixt Rulers and People about Governours or Government'.[54] However, when the balance between political authority and its commitment to the public became disturbed, and it was argued that the former had 'distinct and separate Interests from their People', it caused a new concern for the moral nature of political authority itself, where 'Men found it necessary to examine more carefully *the Original* and Rights of *Government*; and to find out ways to

[50] John Toland, *Anglia Libera: Or the Limitation and Succession of the Crown of England Explain'd and Asserted; as Grounded on His Majesty's Speech; The Proceedings in Parliament; The Desires of the People, The Safety of Our Religion; The Nature of Our Constitution; The Balance of Europe; And The Rights of All Mankind* (London, 1701), 26. See also Jonathan I. Israel, *Radical Enlightenment: Philosophy and the Making of Modernity 1650–1750* (Oxford: Oxford University Press, 2001), 73. On the relation between Toland and Locke, see Justin Champion, *Republican Learning: John Toland and the Crisis of Christian Culture, 1696–1722* (Manchester: Manchester University Press, 2003), esp. 73–80.
[51] Ibid., 23.
[52] Ibid., 18.
[53] Ibid., 24.
[54] John Locke, *Two Treatises of Government*, Cambridge Texts in the History of Political Thought, ed. Peter Laslett (Cambridge: Cambridge University Press, 1988), §111, 342–3. See also Ovid, *Metamorphoses*, vol. 1, trans. Frank Justus Miller, Loeb Classical Library 42, 2nd edn (Cambridge, MA: Harvard University Press, 1971), 1.131.

restrain the Exorbitances, and *prevent the Abuses* of that Power which they having intrusted in another's hands only for their own good, they found was made use of to hurt them.'[55] The challenges posed by the presence of absolute monarchs to purely reign by godly rights are throughout the seventeenth and the eighteenth centuries tackled with increasing urgency in British philosophy and replaced by a greater concern for the potential benefits of a more dynamic relation between public and political authority, and the creation of an expediently modern moral body politic.[56] While Hobbes indeed played a part in this ongoing process of displacement of political power, Locke and his *Second Treatise* – in various ways immersed in the political set of circumstances succeeding the end of the Protectorate and Charles II's return from his exile and reclaim of the throne in May 1660 – did so to an even greater extent.[57]

Initially, Locke's view of the state of nature appears to differ significantly from the one evolved by Hobbes. The state of nature is according to Locke a moral state of perfect freedom and equality, and not, as Hobbes thought, anti-political. The threatening immoral disorder that Hobbes detects in such a natural state is, as it seems, simply not present. A law of nature, depending on reason, reigns, according to Locke, and the presence of reason implies a set of moral obligations that ensures a minimum of order and harmony: 'The *State of Nature* has a Law of Nature to govern it, which obliges every one: And Reason, which is that Law, teaches all Mankind, who will but consult it, that being all equal and independent, no one ought to harm another in his Life, Health, Liberty, or Possessions.'[58] However, a dilemma is inherent in the moral state of nature. Although such a natural state contains the conclusive law of reason that should be coherent to all

[55] Locke, *Two Treatises of Government*, §111, 343.
[56] See e.g. Mark Kishlansky, *A Monarchy Transformed: Britain 1603–1714* (London: Penguin, 1996), 35–6. Kishlansky characterizes the status of divine rights in the early seventeenth century in the following way: 'These patriarchal explanations, particularly of the origins and nature of kingship, were rarely questioned in Britain at the beginning of the seventeenth century. Royal authority was too commonly on display, royal power too firmly embedded in the ordinary activities of government to require much speculation about origins and first principles.'
[57] Whether the *Second Treatise* was a retrospective apology for the Revolution or not, or whether it preceded the *First Treatise* or not, is a matter of scholarly controversy that lies beyond my concern here. About the controversy, see Laslett, 'Introduction', in Locke, *Two Treatises of Government*, esp. 45–66. In his groundbreaking research, Laslett claims that Locke had composed the *Second Treatise* already during the Exclusion Crisis (that is, the attempt to prevent the Duke of York, later on James II, from succeeding the throne) in 1679–81, and that the treatise was accordingly a 'demand for a revolution to be brought about, not the rationalization of a revolution in need of defense' (47). For a critique of Laslett's account, see Richard Ashcraft, *Locke's Two Treatises of Government*, Routledge Library Editions: Political Science, vol. 17 (London: Routledge, 2010), esp. 286–97 (appendix). A recent contribution to the debate on the dating of Locke's writing is David Armitage, 'John Locke, Carolina, and the *Two Treatises of Government*', *Political Theory* 32, no. 5 (2004).
[58] Locke, *Two Treatises of Government*, §6, 271.

rational agents, it appears to lack a 'common measure to decide all Controversies'.[59] While the law of reason is coherent on a general level, it fails in individual cases, because of the partial interests of the involved agents. Furthermore, the state of nature lacks, according to Locke, a *'known and indifferent Judg'* to resolve possible conflicts, and a coordinated force to implement the law of nature.[60] Thus Locke's concern is essentially that the executive power, in all its various forms, is not firmly anchored in an operative governing body, but simply belongs to the arbitrary judgement of the agent (although such arbitrariness should, due to the law of reason, not be viable, there are evidently no assurances that one can agree on the right application of the moral obligations in a personal conflict of interest). Thus, somewhat more in tune with Hobbes's comprehension of nature, Locke points out that the subjective executive power exposes the state of nature to a severe biased principle where 'Self-love will make Men partial to themselves and their Friends' and 'Ill Nature, Passion and Revenge will carry them too far in punishing others'.[61] Locke clearly retreats from Hobbes when stressing the 'plain *difference between the State of Nature, and the State of War*, which however some Men have confounded', and Locke rejects any postulation that equates the state of nature with 'Enmity, Malice, Violence, and Mutual Destruction'.[62] The state of nature might indeed be a state of war; however, it is, for Locke, not so by definition.[63] Instead, the state of nature is characterized by the absence of a common authority.[64] Ultimately it is precisely the dangers of partial subjectivity in relation to each individual's self-preservation that must drive people out of the arbitrary state of nature towards the political society or civil society (which is the same thing to Locke).[65]

However, for Locke one further important circumstance adds to the need to depart from the state of nature. Although God bestowed the world to mankind as a whole – according to *'Revelation*, which gives us an account of those Grants God made of the World to *Adam*, and to *Noah*, and his Sons, 'tis very clear, that God, as King *David* says ... *has given the Earth to the Children of Men*, given it to

[59] Ibid., §124, 351.
[60] Ibid., §125.
[61] Ibid., §13, 275.
[62] Ibid., §19, 280.
[63] See also Sorell, 'Hobbes, Locke and the State of Nature', 38.
[64] Locke, *Two Treatises of Government*, §19, 280: 'Men living together according to reason, without a common Superior on Earth, with Authority to judge between them, is *properly the State of Nature.*' See also Paul Kelly, *Locke's 'Second Treatise of Government': A Reader's Guide* (London: Continuum, 2007), 54–6.
[65] Ibid., e.g. §123, 350. Here, Locke asks why man is ready to relinquish nature's 'Empire, and subject himself to the Dominion and Controul of any other Power'. The answer is that while nature promises absolute autonomy, such autonomy remains 'unsafe' and 'very unsecure'.

Mankind in common' – it would, according to Locke, be a mistake to believe that it will remain a shared property.[66] While no one has 'originally a private Dominion, exclusive of the rest of Mankind', man will nevertheless have to appropriate whatever is given by nature to the benefit of the whole, in order to make it useful to himself and secure his self-preservation.[67] Locke famously argues that 'every Man has a *Property* in his own *Person*', which means that when the agent by the labour of his body takes something away from the state of nature, he also invalidates the common right to such a property.[68] By this relocation, objects (e.g. fruits and venison) thus become the agent's own private property. The problem with the state of nature is simply that it does not provide any organization allowing the private property to be secured. Consequently the agent benefits from voluntarily enrolling in political society (Locke distinguishes the political society from other kinds of societies, such as the *conjugal society*)[69] and conveying his subjective preservation to a governing authority, and to a common law and judicature that cares for his needs and the necessities of his fellow citizens.[70] This self-imposed authority is for Locke neither a sovereign assigned absolute political power, as Hobbes had argued, nor is it an absolute monarchy governed by divine rights, as Sir Robert Filmer notably had maintained – Filmer's vindication of the divine right of kings, *Patriarcha*, was published posthumously in 1680 as a justification of Stuart Absolutism – but *one* body politic where the '*act of the Majority* passes for the act of the whole, and of course determines, as having by the Law of Nature and Reason, the power of the whole'.[71]

Attached to seventeenth-century patriarchal naturalism, where the government was instituted by God, was the abiding idea that the royal authority of the Stuart monarchs utterly reflected a natural patriarchal order intended by God.[72] Filmer, who was the target of Locke's *First Treatise*, characteristically

[66] Ibid., §25, 285–6.
[67] Ibid., §26, 286.
[68] Ibid., §27, 287–8.
[69] Ibid., §77–84, 318–22.
[70] See ibid., esp. §87–94, 323–30: 'Where-ever therefore any number of Men are so united into one Society, as to quit every one his Executive Power of the Law of Nature, and to resign it to the publick, there and there only is a *Political, or Civil Society*' (§89, 325).
[71] Ibid., §96, 332. For Locke's critique of Filmer see the *First Treatise*, §1–169, 141–263. Locke perceives Filmer as the 'great Champion of absolute Power' and criticizes him (via an analysis of his biblical references) for claiming '*That all Government is absolute Monarchy*', and '*That no Man is Born free*' (§2, 141–2).
[72] See A. John Simmons, 'John Locke's *Two Treatises of Government*', in *The Oxford Handbook of British Philosophy in the Seventeenth Century*, ed. Peter R. Anstey (Oxford: Oxford University Press, 2013), 545. See also Kishlansky, *A Monarchy Transformed*, 35: 'As the head of the body politic, the king directed all of the other parts to provide nourishment and safety. These homologies reinforced hierarchy and interdependence while demonstrating how monarchy emulated the natural order.'

justified the political authority of absolute monarchy and the natural subjection of citizens, by a scriptural exegesis of Genesis, where Adam's authority over his children and the world originally was bestowed by God.[73] In a long chain of patriarchal power ('If we compare the natural duties of a father with those of a king, we find them to be all one'), the 'natural right of regal power' ultimately then derived from Adam.[74] Instead of perceiving the arbitrary political power as a result of tyrannical Absolutism, Filmer's patriarchal naturalism tried to expound the necessity of liberating the natural constitution of regal rights 'from subjection to an arbitrary election of the people'.[75] While reassuring observations that '[t]here is, and always shall be continued to the end of the world, a natural right of a supreme father over every multitude' arguably fitted the Tory propaganda of the 1680s, the patriarchalism issuing out of *Patriarcha* was of course a suitable target for Locke's Whig attack.[76] Locke's declared anticipation in the *Two Treatises* was in fact that his account of government would be '*sufficient to establish the Throne of our Great Restorer, Our present King William*', and '*to make good his Title, in the Consent of the People, which being the only one of all lawful Governments, he has more fully and clearly than any Prince in Christendom*'.[77] While children are naturally and legitimately under the parental guidance and control up to the age when they become rational and free agents (any such guidance and control existing precisely for the pursuit of such rationality and freedom), they are as morally mature agents able to exercise their judgement, rationality, and liberty.[78] Thus they were also emotionally capable of actively coming together in interpersonal relations with other rational and free agents and, in the words of Locke, 'make one People, one Body Politick under one Supreme Government'.[79] And by agreeing a transfer of rights and executive powers to a self-imposed authority the agent could thus begin, according to Locke, to shape a legitimate political *whole* that was

[73] Sir Robert Filmer, *Patriarcha*, in *Patriarcha and Other Writings*, Cambridge Texts in the History of Political Thought, ed. Johann P. Sommerville (Cambridge: Cambridge University Press, 1991), 7: 'This lordship which Adam by creation had over the whole world, and by right descending from him the patriarchs did enjoy, was as large and ample as the absolutest dominion of any monarch which hath been since the creation.'

[74] Ibid., 11–12.

[75] Ibid., 35.

[76] Ibid., 11.

[77] Locke, *Two Treatises of Government*, 137 (preface).

[78] Ibid., §118, 347: 'He [the child] is under his Fathers Tuition and Authority, till he come to Age of Discretion; and then he is a Free-man, at liberty what Government he will put himself under; what Body Politick he will unite himself to.'

[79] Ibid., §89, 325.

expected to remedy the lack experienced in the state of nature, preserve the agent's property, and ensure that his rights were met.[80]

> MEN being, as has been said, by Nature, all free, equal and independent, no one can be put out of this Estate, and subjected to the Political Power of another, without his own *Consent*. The only way whereby any one devests himself of his Natural Liberty, and *puts on the bonds of Civil Society* is by agreeing with other Men to joyn and unite into a Community, for their comfortable, safe, and peaceable living one amongst another, in a secure Enjoyment of their Properties, and a greater Security against any that are not of it. This any number of Men may do, because it injures not the Freedom of the rest; they are left as they were in the Liberty of the State of Nature. When any number of Men have so *consented to make one Community* or Government, they are thereby presently incorporated, and make *one Body Politick*, wherein the *Majority* have a Right to act and conclude the rest.[81]

The image of the political *whole* (the body politic) is defined by its *parts* (autonomous agents), and by the shifting principles of the latter, the former is fated to adjust or perish. The modern political *whole*, outlined by Hobbes, and more distinctly portrayed, and passed on to the eighteenth century, by Locke, does not only rely on the traditional principles of the aristocracy, but on the morals of a larger social stratum of rational human beings. In the awaiting decades, the rise of the urban middling orders matured into an influential factor, and rather than giving emphasis to the hereditary relation between the aristocracy and the sovereign king, the subjective *part* began, so to speak, gradually to pertain to the *whole* much as a rational singular part pertains to its jointly accepted construction, created in consent with fellow citizens. Locke displayed that the preservation of the state depended on an 'individuated and self-regulating body whose labor made the land productive'.[82] Such a concern for the morally self-legislative agent, and the focus on the implications of its physical and emotional appropriateness for the formation and sustainability of the political *whole*, undeniably held in store a different set of potentials for a discourse on morality and taste.

[80] Ibid. The body politic does not necessarily have to be created. Man can also 'joyn ... himself to, and incorporate ... with any Government already made'.
[81] Ibid., §95, 330–1.
[82] Jim Egan, *Authorizing Experience: Refigurations of the Body Politic in Seventeenth-Century New England Writing* (Princeton, NJ: Princeton University Press, 1999), 21.

Recent scholarship has tried to counterbalance the great impact often assigned to Locke's *Two Treatises* in early modern political theory.[83] Naturally Locke's Whig account was not unchallenged. What I wish to sketch here, however, is not the finer political points provided by Locke, but the fact that the implications of Locke's analysis went far beyond answering a general question about the nature of political authority, and that such effects drove Addison's theory of taste to its form of normativity. If the agent could not confide in the laws of reason when he himself was part in a conflict of interest but had to transfer the power to a collectively preferred authority, and form the political *whole*, to guarantee that moral obligations were respected, such a *whole* would inevitably need to attend to the complete ethico-emotive disposition of the agent. Political society was, after all, a deeply moral community intended to dissociate itself from the 'corruption, and vitiousness of degenerate Men' in nature.[84] The price paid by a politically radical agent for absolute emotional and moral self-determination, and for the unlimited freedom to do, as Locke states, 'what he thinks fit', was simply a brutal exclusion as a '*Member of that Civil Society*' and a protracted existence in an emotional chaos and arbitrary state of nature (only a 'Patron of Anarchy' could, according to Locke, dispute the definite differences between nature and society).[85] As Victoria Kahn has shown, the post-Civil War era witnessed a remarkable concern for political obligation, where a 'crisis of allegiance' turned out to be 'inseparable' from a 'crisis of the affections'.[86] A similar point can be made here: a more complex relation between, on the one hand, the affective capacities and moral conduct of a self-legislative agent and, on the other hand, a modern political *whole* relying on precisely the merits of its integral singular *parts* was destined to become of renewed interest from the early eighteenth century onwards. The emergence of a morally and emotionally self-legislative agent simply demanded a new kind of responsiveness from Addison and other

[83] See e.g. J. G. A. Pocock, *The Machiavellian Moment: Florentine Political Thought and the Atlantic Republican Tradition* (Princeton, NJ: Princeton University Press, 1975), 424: 'Among the revolutionary effects of the réévaluation of his [Locke's] historical role initiated by [Peter] Laslett and continued by [John] Dunn has been a shattering demolition of his myth: not that he was other than a great and authoritative thinker, but that his greatness and authority have been wildly distorted by a habit of taking them unhistorically for granted.' See also Pocock, *The Ancient Constitution and the Feudal Law: A Study of English Historical Thought in the Seventeenth Century* (Cambridge: Cambridge University Press, 1987), 353–65; John Dunn, *The Political Thought of John Locke: An Historical Account of the Argument of the 'Two Treatises of Government'* (Cambridge: Cambridge University Press, 1969), 8: 'But if the prominence of the role [of *Two Treatises*], and more especially its causal efficacy, has been exaggerated, its ambiguity has, if anything, been understated.'

[84] Locke, *Two Treatises of Government*, §128, 352.

[85] Ibid., §94, 330.

[86] Victoria Kahn, *Wayward Contracts: The Crisis of Political Obligation in England, 1640–1674* (Princeton, NJ: Princeton University Press, 2004), 4.

arbiters of taste, and the interpersonal relations of society itself, to avoid political and social disorder. Thus, a growing stress on the ethico-emotive self-legislation was on no account prompting any radical divorce between the agent and the body politic.

Instead, any such self-autonomy had to learn to combine its resource – the subjective judgement of taste – with the political *whole*. To 'act or continue [as] one Body, *one Community*' it was, as Locke states, essential to consensually 'move one way'.[87] Due to the Civil War, matters of political and social disorder carried a particularly disturbing meaning for British men of letters writing from the mid-seventeenth century onwards. Addison was repeatedly voicing his personal fears that especially political party divisions and a lacking moral conformity among the citizens could be the occasion for a new Civil War.[88] In the opening essay of the *Spectator*, Addison staked out his own political 'Neutrality between the Whigs and the Tories' (*S* I, 5; 1). Although Addison's political position ('a Spectator of Mankind' rather than 'one of the Species', *S* I, 4; 1) is best characterized as putatively impartial, it is true that he largely avoided hostile party factionalism in his writings in the *Spectator*.[89] But there is no need to cherish any illusions about the non-discriminatory principles of his political project. If the last decades of rereading the Habermasian account of the communicative rationality of the tolerant coffeehouse culture has taught us anything, it is that such rationality did not occur without friction on *one* homogenous level of the modern public sphere.[90] Addison's need to state his own political autonomy as a paradigmatic

[87] Locke, *Two Treatises of Government*, §96, 332. For a detailed discussion of Locke's ambitions to establish moral consensus among contrasting political and social factions, see Greg Forster, *John Locke's Politics of Moral Consensus* (Cambridge: Cambridge University Press, 2005).

[88] See also Donald J. Newman, 'Introduction', in *The Spectator: Emerging Discourses*, ed. Donald J. Newman (Newark, NJ: University of Delaware Press, 2005), esp. 24–9. Newman suggests a similar reason for Addison's avoidance of explicit party factionalism, namely that he did not 'want to participate in creating the very situation [he was] trying to remedy' (26). Addison associated factionalism with a political volatility that destabilized the body politic.

[89] Political party factionalism was a matter of great concern. See e.g. Johnson, *The Lives of the Most Eminent English Poets*, vol. 3, 8. Johnson referred to the appeasing role played by Addison's essays: 'It has been suggested that the Royal Society was instituted soon after the Restoration, to divert the attention of the people from public discontent. The Tatler and Spectator had the same tendency: they were published at a time when two parties, loud, restless, and violent, each with plausible declarations, and each perhaps without any distinct termination of its views, were agitating the nation; to minds heated with political contest, they supplied cooler and more inoffensive reflections.'

[90] For criticism of Habermas's account of the public sphere and the role of the *Spectator* from a gender perspective, see Anthony Pollock, *Gender and the Fictions of the Public Sphere, 1690–1755* (New York: Routledge, 2007), esp. 1–16, 55–74; Erin Mackie, *Market à la Mode: Fashion, Commodity, and Gender in The Tatler and The Spectator* (Baltimore, MD: Johns Hopkins University Press, 1997). As Markman Ellis concisely concludes in 'Coffee-Women, "*The Spectator*" and the Public Sphere in the Early Eighteenth Century', in *Woman, Writing and the Public Sphere, 1700–1830*, ed. Elizabeth Eger, Charlotte Grant, Clíona Ó Gallchoir and Penny Warburton (Cambridge: Cambridge University Press, 2001), 32: 'It is clear ... that women were not unknown in the coffee-house of

moral case in the squabbles of party factionalism was indeed emanating from a profound fear of Civil War, but the wish to no longer 'regard our Fellow-Subjects as Whigs or Tories, but [to] make the Man of Merit our Friend, and the Villain our Enemy' (S I, 512; 125) was at the same time a simple technique to extend the impression of the uncontroversial and judicious nature of Whig politics. Addison's political egalitarianism was chamaeleonic. While he, as we will see further ahead, occasionally argued for participatory equality in the republic of taste, he was unsurprisingly also solidifying traditional gender hierarchies.[91] Due to flat political concerns – 'there are none to whom this Paper [the *Spectator*] will be more useful, than to the female World' (S I, 46; 10) – rather than sound egalitarian principles, Addison came to include traditionally omitted groups and social strata in the same breath as he excluded others. It is rarely recognized that one of the main reasons for the arbitrary impression arising here originates in Addison's overriding Whig concern to ensure political stability. The political end, as it were, justified his arbitrary means.[92]

The 'Spirit of Division as rends a Government into two distinct People' (S I, 509–10; 125) divided, according to Addison, the nation as an operative political *whole*, and reduced its security and undermined its ability to defend itself from foreign threats. The breeding ground for any such destabilized protection of the public was that the 'inhuman Spirit' of political division was, in Addison's words, firmly related to individuals 'alienated from one another in such a manner, as seems ... altogether inconsistent with the Dictates either of Reason or Religion'

eighteenth-century London, but their presence requires a more complex model of social interaction than that proposed by Habermas.' See also Brian Cowan, 'What Was Masculine about the Public Sphere? Gender and the Coffeehouse Milieu in Post-Restoration England', *History Workshop Journal* 51 (2001). Cowan addresses the ambiguous position of women in regard to English coffeehouse culture and to Habermasian notions of the public sphere.

[91] See Newman, 'Introduction', in *The Spectator: Emerging Discourses*, 19. Newman observes that the essays in the *Spectator* frequently deal with gender-related topics, although 'one has to wonder how serious this commitment to women as reasonable creatures is when it is noticed that the greatest share of critical gender-related topics in one way or another criticize women for foibles and follies, usually stereotypical, associated with their particular sex'. See also Kathryn Shevelow, *Women and Print Culture: The Construction of Femininity in the Early Periodical* (London: Routledge, 1989), 1. Shevelow draws attention to a similar equivocality in the *Spectator*'s approach to gender-related topics, where 'at the same historical moment that women were, to a degree unprecedented in western Europe, becoming visible as readers and writers, the literary representation of women ... was producing an increasingly narrow and restrictive model of femininity'. However, as Shevelow suggests, this paradox is to some degree 'only contradictory if we insist upon equating access to the mechanisms of print exclusively with metaphors of enfranchisement and inclusion rather than those of restriction and containment'.

[92] See Brian Cowan, 'Mr. Spectator and the Coffeehouse Public Sphere', *Eighteenth-Century Studies* 37, no. 3 (2004), 346. Cowan offers a convincing critique of Habermas's reliance on periodical essays, like the *Spectator*, to back his conclusions about the modern public sphere. Instead of aiming to 'encourage or even condone Habermas's "political public-ness" (*politische Öffentlichkeit*)' the 'Spectatorial public sphere ... sought to tame it and make it anodyne'.

(*S* I, 510; 125). Party factionalism, and lack of political conformity, striking at the foundation of individual morality, also caused a further lack of taste. Given that political differences could have an effect on judgements, one quickly exposed the 'Incapacity of discerning either real Blemishes or Beauties', a weakness that was schizophrenically anchored in a 'Man of Merit', and as such, according to Addison, 'prevails amongst all Ranks and Degrees in the *British* Nation' (*S* I, 511; 125). The 'influence [of political party division] is very fatal both to Mens Morals and their Understandings' and 'sinks the Virtue of a Nation', and, if it comes to the worst, it could, or so Addison argued, result in a new Civil War:

> A furious Party Spirit, when it rages in its full Violence, exerts it self in Civil War and Blood-shed; and when it is under its greatest Restraints naturally breaks out in Falshood, Detraction, Calumny, and a partial Administration of Justice. In a word, It fills a Nation with Spleen and Rancour, and extinguishes all the Seeds of Good-nature, Compassion and Humanity. (*S* I, 510; 125)

Thus, to avoid alienation among citizens and a destabilized nation, singular agents (male or female) had to be emotionally and morally adapted to their political purpose. Immoral and alienated agents would only set a corrupt common value system in motion. Consequently, moral matters, where the normativity of taste persistently plays out its key role, become, on the one hand, a more individuated and self-legislative concern and, on the other hand, a more public political matter of the middling orders. The famous progressive eighteenth-century solution to potential tension arising from the fact that the subjective *part* does not only act within the *whole*, but the interpersonal judgements of the *whole* also act within the *part*, revolves around the converging nature of a good self-interest and a good public interest.[93] But the concern for this matter also cuts through one of the main aesthetico-political questions at the time regarding the need for cultivating individuated sensuousness and the affective capacity of the agent in order to make it politically purposeful. As we will see next, Addison stresses virtue and taste as human dispositions. However, his main concern is, throughout his writings, how to effectively instruct the agent and thus navigate any assumed self-legislation into a meaning for Britain as a political *whole*.[94]

[93] See also Ashfield and de Bolla, 'Introduction', in *The Sublime*, 3.
[94] The difficulty of positioning Addison in this matter springs from the fact that he often gives priority to real political consequences rather than to cogency of the arguments. Edward A. Bloom and Lillian D. Bloom perceive Addison's view of virtue as a conative disposition and as a 'result of God's indwelling spirit', and they make the following reasonable comment in 'Addison on "Moral Habits of the Mind"', *Journal of the History of Ideas* 21, no. 3 (1960), 419: 'Addison respected pragmatic values as did his middle-class society, which admired material progress as a *raison d'être* for man's intellectual accomplishments. To put the best face on the matter, he insisted that learning brings utilitarian rewards to the nation as a whole as well as to the individual.'

1.2

The disposition of taste

National unity relies, argues Addison on 6 January 1716, on the 'secret Suggestions of Nature', namely a human instinct (*F* 55; 5). The ramification of such a human disposition is to an equal extent a private and a public virtue. On an individuated level, it is related to a sensible self-love vital for the 'Good and Safety of each particular Person' (*F* 56; 5). But its value consists also in a distribution and transformation into the 'most sublime and extensive of all social Vertues' (*F* 57; 5), expedient precisely to the kind of rational care for the nation and patriotism that Addison wishes to revive among his fellow citizens.

Addison praises Locke's complete 'System of Being' (*S* IV, 349; 519), trusts in 'Mr. *Lock*'s Authority' when discussing the 'complex *Idea of God*' (*S* IV, 392–3; 531), and remains Lockean in his Whig conception of political society and in his analysis of the displacement of political authority. As the Blooms observe, Addison defends, in a Lockean vein, a 'rational liberalism', where the contract that creates the state 'liberates individual benevolence, works for the public good, and secures for its constituents peace, safety, and happiness'.[1] Due to the fact that a majority agrees to a conferral principle where political power is granted in exchange of protection and cessation of emotional anarchy, man is in political society ultimately able to move 'among his fellows openly and unarmed because he assumes that others will not, unprovoked, harm, or attack him'.[2] Indeed, Addison is just as impatient as Locke to remove traditional moral arbitrariness of political authority and to prevent, as Locke states, 'too great a temptation to humane frailty apt to grasp at Power'.[3] Jointly agreed laws check the political sovereign, not necessarily because he is immoral, but, according to Addison,

[1] Bloom, *Joseph Addison's Sociable Animal*, 113. On Locke's general importance for Addison's conception of criticism, see also Collis, 'Shaftesbury and Literary Criticism: Philosophers and Critics in Early Eighteenth-Century England'.
[2] Bloom, *Joseph Addison's Sociable Animal*, 117.
[3] Locke, *Two Treatises of Government*, §143, 364. Locke is addressing the need to have a legislative power that is itself 'subject to the Laws'.

because 'arbitrary Power naturally tends to make a Man a bad Soveraign' (*F* 83; 10). A 'fickle and unsteady Politicks' prompts the 'Dissentions and Animosities' that makes the 'Nation unhappy', while a 'constant and unshaken Temper' of the sovereign causes 'Peace of His Government, and the Unanimity of His People' (*F* 44; 2). Here, the image of a modern British society assumes the shape of a created body whose somatic impulses and taste must either devotedly care for the jointly constructed physique of the political body, and acknowledge, as Addison states, that the 'Safety of the *Whole* requires our joint Endeavours', or else such corporeal parts must simply be dismissed as 'dead Limbs, which are an Incumbrance to the Body [politic], instead of being of Use to it' (*F* 97; 13).

The body politic consists, in Addison's account, of a reigning upper part (*government*) that needs to initiate and preserve a special relationship to the morality and faith of the citizens. The legislature of a self-imposed and ideally balanced government ought, as Addison suggests in the *Spectator* (III, 18–22; 287), the *Freeholder* (256–60; 51), and later on also in *The Old Whig: On the State of the Peerage; with Remarks upon the Plebeian* (1719), to be 'distributed into three Branches': the regal, the noble, and the plebeian.[4] The reason is simply that the 'whole Community is cast under these several Heads, and has not in it a single Member who is without his Representative in the Legislature of such a Constitution'.[5] The sine qua non of a mixed government is that it 'encourage[s] and propagate[s] Religion and Morality among all its particular Members' (*F* 157; 29). Within the political *whole* its individuated moral bodies of taste (*members*) operate, which furthermore consist of singular anatomical parts. The individuated anatomy of the agent is wittily described by Addison as a singular 'System of Tubes and Glands', and he recommends either labour or exercise to cultivate the 'Spirits that are necessary for the proper Exertion of our intellectual Faculties, during the present Laws of Union between Soul and Body' (*S* I, 471; 115). Following Addison, a rational man cannot remain emotionally indifferent to the intricate anatomical system of the human body, nor to that

[4] Addison, *The Old Whig: On the State of the Peerage; with Remarks upon the Plebeian* (London, 1719), 2. See also, e.g. *S* III, 19; 287: 'If there be but one Body of Legislators, it is no better than a Tyranny; if there are only two, there will want a casting Voice, and one of them must at length be swallowed up by Disputes and Contentions that will necessarily arise between them. Four would have the same Inconvenience as two, and a greater number would cause too much Confusion. I could never read a Passage in *Polybius* [*c*.200–*c*.118 BC], and another in *Cicero*, to this purpose, without a secret Pleasure in applying it to the *English* Constitution, which it suits much better than the *Roman*. Both these great Authors give the Pre-eminence to a mixt Government, consisting of three Branches, the Regal, the Noble, and the Popular.' See also Edward A. Bloom and Lillian D. Bloom, 'Joseph Addison and Eighteenth-Century "Liberalism"', *Journal of the History of Ideas* 12, no. 4 (1951), esp. 566–8.

[5] Addison, *The Old Whig*, 2.

of the animal body, since they bear a constant witness of a moral beauty and rationality that exceeds his own body, namely the 'transcendent Wisdom' of the 'Supreme Being' (*S* IV, 444; 543). Although the fate of modern individuality is in the hands of an emotionally and morally self-legislative agent, sensitivity to our personal physical ability must ultimately become, for Addison, a reminder of God's rational providence. It is by 'reflecting upon Myriads of Animals that swim in those little Seas of Juices that are contained in the several Vessels of an human Body', that Addison senses that his own mind is 'filled with that secret Wonder and Delight', that, furthermore, yields him a moral sentience of himself 'as an Act of Devotion' (*T* II, 206; 119). In the spirit of Galen, 'Description of the Parts of [the] human Body' must ultimately, argues Addison, become a '*Hymn to the Supreme Being*' (*T* II, 206; 119).⁶ The principle that 'God created man in his *own* image' (Gen. 1.27) conceded to an introspection of the self and nature as a technique to acquire further devotion and moral sentience. The aesthetic experience serves, as we will see further ahead, a very similar purpose. Man is not only emotionally designed to become attentive to the power of the Deity by reflecting on his own physical anatomy, but indeed emotionally prearranged to achieve his awareness by means of the aesthetic experience of nature and art.

Given that the anatomy and somatic impulses belong to the complete ethico-emotive conduct of the agent that ultimately determines the creation and movement of the political *whole*, we should not be surprised to find that Addison gives flesh and bone to the anatomy of such an ideal body by referring to the Spanish seventeenth-century Jesuit Baltasar Gracián. In *The Courtiers Manual Oracle, or, the Art of Prudence* (*Oráculo manual y arte de prudencia*), Gracián remarked on the natural moral progression towards a 'point of Consummation', where the 'Accomplished Man' holds a 'quaint perception, readiness in discerning, solidity of judgment, tractableness of will, and circumspection in words and actions'.⁷ Addison refers to Gracián by reminding his readers that '*GRATIAN* very often recommends *the fine Taste*, as the utmost Perfection of an accomplished Man' (*S* III, 527; 409). Evidently, the ethico-emotive sensitivity of

⁶ See also *T* II, 205–9; 119. See footnote 4 on John Tillotson (1630–1694), Archbishop of Canterbury (1691–4), *The Works of the Most Reverend Dr. John Tillotson, Late Lord Archbishop of Canterbury*, vol. 2, 5th edn (London, 1735), 553: 'The frame of our bodies is so curiously wrought, and every part of it so full of miracle, that *Galen* [Galen of Pergamum, 129–c.216 AD] (who was otherwise backward enough to the belief of a God) when he had anatomised man's body, and carefully surveyed the frame of it, viewed the fitness and usefulness of every part of it, and the many several intentions of every little vein, and bone, and muscle, and the beauty of the whole; he fell into a pang of devotion, and wrote a hymn to his Creator.'
⁷ Baltasar Gracián y Morales, *The Courtiers Manual Oracle, or, the Art of Prudence* (London, 1685), 5 (maxim 6).

such an *accomplished* human being requires persistent care and must, according to Addison, be brought under some feasible regime of taste in order to be interpersonally valid and truly purposeful.[8]

That the realization of such a normative regime as one of Addison's primary objectives was certainly not a secret for early-eighteenth-century readers. Much in tune with Shaftesbury's anti-scholasticism, most vividly expressed in Philocles' bemoaning, in *The Moralists*, that 'we have immur'd her [i.e. philosophy] (poor Lady!) in Colleges and Cells' (*Moralists* 24 [184])[9] – further on also lamented by Hume, when stating that 'Learning has been as great a Loser by being shut up in Colleges and Cells, and secluded from the World and good Company'[10] – Addison observes, with a great sense of content, the close points of similarity between his own approach to the worldliness of philosophy and the paradigmatic position of Socrates in ancient Greece.[11] While it was said of the latter (originally by Cicero) that he 'brought Philosophy down from Heaven, to inhabit among Men', Addison wishes that it be said of himself that he 'brought Philosophy out of Closets and Libraries, Schools and Colleges, to dwell in Clubs and Assemblies, at Tea-Tables, and in Coffee-Houses' (*S* I, 44; 10).[12] The plain objective of the essays in the *Spectator* is, as Addison states in his premier essay, to be of 'Benefit of

[8] See also Walter Göricke, *Das Bildungsideal bei Addison und Steele* (Bonn: Peter Hanstein, 1921). The strength of Göricke's classic study remains its exploration of the correlations between Addison's moral ideals of the Gentleman and Baldassare Castiglione's (1478–1529) *Il Cortegiano* (1528). Castiglione captured an intellectual ideal, summed up by Göricke in the Socratic phrase *Tugend ist Wissen* (9), which was then appended with a sixteenth-century *Nützlichkeitsideal* (15). Addison effectively strikes, according to Göricke, the golden mean between the Gentleman ideals of Renaissance Humanism and the Puritan ideals of utility (e.g. 44).

[9] See also a letter to Ainsworth (10 May 1707). Here, Shaftesbury reminds Ainsworth (commencing his university studies) that the 'highest Principle wch is ye Love of God is best attain'd not by dark speculations & Monkish Philosophy but by moral practice a Love of Mankind & a studdy of their Interest, the cheif of wch & that wch only raises them above the Degree of Brutes is Freedome of Reason in the learn'd world, & Good Government & Liberty in the civil world' (*Ainsworth Correspondence* 353/355). See also apparatus criticus to *Soliloquy* (*Printed Notes* 58 [333]). Here Shaftesbury bemoans that 'Academys for Exercises, so useful to the Publick, and essential in the Formation of a genteel and liberal Character, are unfortunately neglected', and 'Letters are indeed banish'd, I know not where, in distant Cloisters and *unpractis'd Cells*, as our Poet has it, confin'd to the Commerce and mean *Fellowship of bearded Boys*'.

[10] Hume, 'Of Essay-Writing', in *Essays Moral, Political, and Literary*, ed. Eugene F. Miller, rev. edn (Indianapolis, IN: Liberty Fund, 1987), 534. Resembling Shaftesbury and Addison, Hume 'consider[s] [himself] as a Kind of Resident or Ambassador from the Dominions of Learning to those of Conversation; and shall think it my constant Duty to promote a good Correspondence betwixt these two States, which have so great a Dependence on each other' (535). See also Marc Hanvelt, *The Politics of Eloquence: David Hume's Polite Rhetoric* (Toronto: University of Toronto Press, 2012), 59.

[11] See also *F* 235; 45: '*Socrates*, who was the greatest Propagator of Morality in the heathen World, and a Martyr for the Unity of the Godhead, was so famous for the Exercise of this Talent among the politest People of Antiquity, that he gained the Name of (ὁ Εἴρων) the *Drole*.'

[12] See also Cicero, *Tusculan Disputations*, trans. J. E. King, Loeb Classical Library 141 (Cambridge, MA: Harvard University Press, 1927), 5.4.10–11.

my Contemporaries', and to 'contribute to the Diversion or Improvement of the Country' (S I, 5; 1), and the immense public response is well documented.[13] There is, as he argues further ahead, 'nothing ... which we ought more to encourage in our selves and others, than that Disposition of Mind which in our Language goes under the Title of Good-nature' (S II, 165; 169). This mental disposition is, for Addison, essentially inborn. It is, as he argues, a 'Constitution, which Education may improve but not produce' (S II, 166; 169). Apart from being the consequence of a natural human constitution, and provided that it survives a systematic test, such a good nature is, in a later essay, also characterized as a moral virtue. In order to earn the 'Title of a Moral Virtue' it should, according to Addison, demonstrate 'Steadiness and Uniformity in Sickness and in Health', follow the 'Rules of Reason and Duty', which implies that one does not exert a good nature 'promiscuously towards the Deserving and the Undeserving', and, finally, stand a test where it works to our own disadvantage and where we are ready to risk 'our Reputation, our Health or Ease, for the Benefit of Mankind' (S II, 197–8; 177). The reason why moral conduct is of such pivotal concern and, to Addison, requires both this methodical three-step examination and additional encouragement is simply because there is 'no Society ... to be kept up in the World without Good-nature, or something which must bear its Appearance, and supply its Place' (S II, 165; 169).

The objective of Addison's *Spectator* essays is furthermore related to a general cultural decline, and he intends to 'enliven Morality with Wit, and to temper Wit with Morality' and render his readers 'recovered ... out of that desperate State of Vice and Folly into which the Age is fallen' (S I, 44; 10). A couple of months later we understand that such a moral shaping of the agent is intimately amalgamated with an accurate judgement of writing, when Addison, due to his overall aim, namely to 'banish Vice and Ignorance out of the Territories of *Great Britain*', sets out to 'establish among us a Taste of polite Writing' (S I, 245; 58). Thus, the remedy for an immoral, or even collapsed, political *whole* is firmly attached to the fate and prosperity of each agent's individuated taste. To recognize personal moral responsibilities and prospects, one has to set off in a genuine 'Knowledge

[13] About the success of the *Spectator*, see F 235; 45. See also S I, 44; 10: 'IT is with much Satisfaction that I hear this great City inquiring Day by Day after these my Papers, and receiving my Morning Lectures with a becoming Seriousness and Attention. My publisher tells me, that there are already Three Thousand of them distributed every Day: So that if I allow Twenty Readers to every Paper, which I look upon as a modest Computation, I may reckon about Three-score thousand Disciples in *London* and *Westminster*, who I hope will take care to distinguish themselves from the thoughtless Herd of their ignorant and unattentive Brethren.'

of ones-self' (*S* I, 45; 10) and affective 'Enjoyment of ones self' (*S* I, 67; 15), without which there can be no proper commitment to the political *whole*.

These primary objectives are anything but subtly conveyed by Addison. Setting him slightly apart from the rest of the influential republic of letters at the time (especially Tory Scriblerians like Swift in his apology for *A Tale of a Tub* and Pope in the *Dunciad*), the moral manifesto of especially the *Spectator* is perfectly clear about whom to address: men and women of 'ordinary Capacities' (*S* I, 245; 58).[14] Such a category was significant not only because of its conceivable magnitude, but also for the reason that the largest part of such a category had not previously been greatly involved in the culture of the arts. All that was about to change.

In the late seventeenth century, 'high culture' moved, as John Brewer has shown, 'out of palaces and into coffee houses, reading societies, debating clubs, assembly rooms, galleries and concert halls; ceasing to be the handmaiden of royal politics, it became the partner of commerce'.[15] In this new distribution of political authority, the desired qualities of taste came to involve the ethico-emotive conduct of a new urban middling social stratum. A stratum that men of letters, writing from within the ongoing process of the displacement of political authority, now needed to set in motion in order for the political *whole* to remain morally vigorous.

Addison quickly acknowledges the vital consequences of the ongoing shift of political power and stresses his qualifications to generate a sense of social and affective inclusion of the middling orders.[16] If the ethico-emotive conduct of the self-legislative agent is to be elevated to a participating body in the creation of a political *whole*, its aesthetic and moral values need to be represented in everyday life, which is precisely a need that Addison intends to cover. The individual is like a concealed work of art, waiting to reveal its beauty and moral worth to society. Although a process of education certainly cannot produce a mental disposition, it can, as we observed earlier, cultivate the disposition into an unplumbed level of emotional sensitivity. The 'Human Soul without Education' is, in the words of

[14] See McCrea, *Addison and Steele Are Dead*, esp. 23–78. McCrea brings out the fundamental nature of the popular essayistic technique advanced by a Kit-Kat like Addison, by positioning him (and Steele) against the discriminatory irony, 'carefully crafted, tonally complicated appeals to the tasteful few', pursued by Tory Scriblerians like Swift and Pope (30).

[15] John Brewer, *The Pleasures of the Imagination: English Culture in the Eighteenth Century* (London: HarperCollins, 1997), 3.

[16] See e.g. *S* I, 142; 34: 'My Readers too have the Satisfaction to find, that there is no Rank or Degree among them who have not their Representative in this Club, and that there is always some Body present who will take Care of their respective Interests, that nothing may be written or publish'd to the Prejudice or Infringement of their just Rights and Privileges.'

Addison, 'like Marble in the Quarry, which shews none of its inherent Beauties, till the Skill of the Polisher fetches out the Colours, makes the Surface shine, and discovers every ornamental Cloud, Spot and Vein that runs through the Body of it' (*S* II, 338; 215). The natural ethico-emotive disposition must be realized in order for the beauty of man, or the beauty of art, to be effective. Because the 'Figure is in the Stone, the Sculptor only finds it' (*S* II, 338; 215), Addison claims a similar role as the accomplished sculptor, when he, next to his passage on man as a hidden statue in a block of marble, maintains that he by means of 'Discourses of Morality, and Reflections upon human Nature', intends to 'recover our Souls out of the Vice, Ignorance and Prejudice which naturally cleave to them' (*S* II, 341; 215).

The self-legislative ethico-emotive project of the individual, which Addison articulates by a gentle 'polishing of Mens Minds', brings out new emphasis and concern in relation to a politically stable society. If the ideal set out to expose a 'complete correspondence between the public and private self in a society where public and personal benefit were identical, where the single man was a microcosm of the body politic', the claims were likely to bring home a new kind of gravity vis-à-vis the normativity of taste and the civic virtues internal to the agent himself.[17] Because the ethico-emotive fate of the agent overlapped with the fate of the political *whole*, the destiny of the subjective judgement of taste was, so to speak, also the destiny of a public and interpersonally effective judgement of taste. Thus, a new kind of significance was infused in the moral merits of the arts. Artworks lacking such qualities were correspondingly believed to compromise the civic virtues and public spirit that eventually regulated the political *whole* itself.

Thus, while the privileges of taste were a largely internal affair of seventeenth-century court culture and aristocracy, the ongoing displacement of political authority set taste in motion in a partly new context in the early eighteenth century. Given that the agent's taste was suggestive of his morals, as well as instrumental for realizing morality as such, and that the habitus of such an agent was a largely new social middling order, whose taste had previously been of little or no consequence for political authority, but now made claims of political impact, such a taste could no longer be permitted to slip under the radar. Changes present in the point of intersection between seventeenth- and eighteenth-century culture were wide-ranging. Artistic creations during the last few decades of the seventeenth century were largely restricted to the courts,

[17] James William Johnson, 'What *Was* Neo-Classicism', *Journal of British Studies* 9, no. 1 (1969), 62.

which had limited economic possibilities to provide for the arts. Culture in general was, as Brewer underlines, 'starved for lack of funds', and the Protestant church was often hostile to the making of music and the display of art.[18] There was furthermore an import ban on foreign art. Theatrical performances were limited to two patent companies in England, and there were no such things as professional (i.e. self-supporting) writers, concert series, or public exhibitions of art. In short, there was, as Brewer argues, 'no market for culture'.[19] However, processual changes occurred during the eighteenth century; changes that gradually transformed the traditional scenario for the arts. Indeed, during the 'first decades of the eighteenth century the interest in the arts practically exploded',[20] and by the late eighteenth century London hosted concert and opera performances every night of the week.[21] Moreover, while public pleasure gardens (like Vauxhall and Ranelagh in London) previously had, in part, been places of drinking and prostitution, they now began to host performances of small-scale operas and concertos, and composers from the European continent queued up to perform in the city.[22] And because of the lapse of the Licensing Act in 1695, prior censorship ended and the old press monopoly, held by the Stationers Company, ceased.[23] Printers, publishers, writers, and artists all began to see their chance.

The middling social stratum equipped to study Addison's regime of taste and have its conception of political society confirmed was indeed educated, though, as Robert DeMaria, Jr, observes, 'not as learned as the audience for periodical writing in many of the "Reviews," "Works of the Learned," journals of societies … and even book catalogues'.[24] Apart from the labouring poor, Addison's writings were accessible to surprisingly large sections of the public. The readers held art, learning, taste, and culture in the highest regard, but the 'world [was] too much

[18] John Brewer, 'Cultural Production, Consumption, and the Place of the Artist in Eighteenth-Century England', in *Towards a Modern Art World*, ed. Brian Allen (New Haven, CT: Yale University Press, 1995), 8.
[19] Ibid.
[20] Mortensen, *Art in the Social Order*, 83.
[21] Brewer, 'Cultural Production, Consumption, and the Place of the Artist in Eighteenth-Century England', 8–9. See also Brewer, '"The Most Polite Age and the Most Vicious": Attitudes towards Culture as a Commodity, 1660–1800', in *The Consumption of Culture 1600–1800: Image, Object, Text*, ed. Ann Bermingham and John Brewer (London: Routledge, 1995), esp. 345–50.
[22] Addison reports a visit to the Spring Gardens at Vauxhall with his fictional character Sir Roger de Coverley (see S III, 436–9; 383). Here, the garden is not yet an altogether proper eighteenth-century scene of politeness: on the one hand, nature stirs Sir Roger's aesthetic sensuousness and invites him to a '*Mahometan* Paradise', on the other hand, he is, before he falls 'into a fit of musing', abruptly awaken by an indecent Masque (438).
[23] Brewer, 'Cultural Production, Consumption, and the Place of the Artist in Eighteenth-Century England', 8–9.
[24] Robert DeMaria, Jr, 'The Eighteenth-Century Periodical Essay', in *The Cambridge History of English Literature, 1660–1780*, ed. John Richetti (Cambridge: Cambridge University Press, 2005), 528.

with them to permit settled habits of study'.²⁵ The endeavour set out by Addison was to remedy such a growing demand. Rather than covering actual political news, Addison 'tutors his readers, refines and disambiguates critical terms and instils principles of good taste as well as fine judgement'.²⁶ By absorbing Addison's introduction to these principles, the readers interacted with the Whig position of the political arguments, and by doing so they also evolved into emotionally and morally accomplished subjects of taste, ready to engage themselves in political society. As a printed letter addressed to Mr Spectator, published on 19 August in 1712, confirms in all its plainness:

> YOU [Mr. Spectator] very much promote the Interests of Virtue, while you reform the Taste of a prophane Age, and perswade us to be entertain'd with Divine Poems. While we are distinguish'd by so many thousand Humours, and split into so many different Sects and Parties, yet Persons of every Party, Sect, and Humour are fond of conforming their Taste to yours. You can transfuse your own Relish of a Poem into all your Readers, according to their Capacity to receive; and when you recommend the pious Passion that reigns in the Verse, we seem to feel the Devotion, and grow proud and pleas'd inwardly, that we have Souls capable of relishing what the SPECTATOR approves. (*S* IV, 126; 461)

Ideally, the extension and corroboration of Addison's normative principles of taste were, as the writer of the letter suggests, a communal completion, where conflicting political directions might be united, and consensus could prevail. In reality, however, the moral and aesthetic values proposed by Addison had to work as a watershed between morality and immorality, between accomplishment and deficiency, and between the emotions of a healthy agent accepted and invited to reinforce the balance of the body politic, and the emotions of a vulgar and destabilizing agent.²⁷ In an essay in the *Tatler*, 17 December 1709, Addison displays this in a full light, by almost conveying a critique of Hobbes's dark view of nature for counteracting the vital artistic separations of virtue and vice. If not prevented by his nationalistic ethos, Addison could easily have included Hobbes in his moral attack on 'modish *French* Authors' that 'depreciate human Nature, and consider it under its worst Appearances' (*T* II, 156; 108). In the opening of the essay, Addison sneaks into a theatre to 'enlarge [his] Thoughts', only to witness a 'Monster' taking the shape of 'different Animals' before turning into a

²⁵ Ibid.
²⁶ Ibid., 538.
²⁷ See also de Bolla, *The Education of the Eye*, 40: 'The aesthetic is, from its earliest formulations, engaged in the process of social discrimination: one argument has it that art is only art insofar as it is out of the reach of the vulgar.'

human being. While the London audience exults at 'this strange Entertainment', Addison fears he is among foreigners where 'human Nature can rejoice in its Disgrace'. Surely, taste and the moral decorum of art cannot consist in demeaning nature. Thus, Addison goes on by arguing that it is an absolute necessity that art can 'widen the Partition between the Virtuous and the Vicious, by making the Difference betwixt them as great as between Gods and Brutes' (*T* II, 156; 108). To 'represent Human Nature in its proper Dignity' (*T* II, 156; 108) is inevitably to create art (especially poems) that can, from Addison's perspective, single out a moral agency from a vulgar one in the cosmological hierarchy.[28] Social mobility was certainly accepted, even politically encouraged, within the extensive margins of the middling orders, and the 'World of Life' (i.e. 'all those Animals with which every Part of the Universe is furnished') involved, according to Addison, such a subtle order that the 'little Transitions and Deviations from one Species to another, are almost insensible' (*S* IV, 345–8; 519).[29] Still, the exclusive position of man – 'who fills up the middle Space between the Animal and Intellectual Nature, the visible and invisible World, and is that Link in the Chain of Beings which has been often termed the *nexus utriusque mundi*' (*S* IV, 349; 519)[30] – naturally covered an effective aesthetic shibboleth to regulate the moral distinction between a politically functional taste and an undesirable and vulgar one.[31] Social mobility was certainly not expected to be untrammelled. Accordingly, one of the major pitfalls of the artist was a mistreatment of the rational order of nature, where the breeding authority of art was debilitated.[32] Once again, France ('that trifling Nation'), and one of its considered artistic and

[28] See *T* II, 154–9; 108.

[29] Addison (*S* IV, 345–6; 519) distinguishes between the 'System of Bodies into which Nature has so curiously wrought the Mass of dead Matter, with the several Relations which those Bodies bear to one another' (Material World), and the animals inhabiting the universe (World of Life). This essay was appended in the posthumously published apologetic piece *Evidences of the Christian Religion* (London, 1730), 117–25.

[30] See also Arthur O. Lovejoy, *The Great Chain of Being: A Study of the History of an Idea* (Cambridge, MA: Harvard University Press, 1936), 195.

[31] See *S* III, 523–6; 408. In a letter addressed to Mr Spectator, the initials 'T. B.' provides the representative understanding of the rational Great Chain of Being: 'As Nature has framed the several Species of Beings as it were in a Chain, so Man seems to be placed as the middle Link between Angels and Brutes: Hence he participates both of Flesh and Spirit by an admirable Tie, which in him occasions perpetual War of Passions; and as a Man inclines to the angelick or brute Part of his Constitution, he is then denominated good or bad, virtuous or wicked; if Love, Mercy, and good Nature prevail, they speak him of the Angel; if Hatred, Cruelty, and Envy predominate, they declare his Kindred to the Brute' (524).

[32] See *T* II, 154–9; 108. Addison compares the rationale of 'Good-Breeding', namely to 'lift up human Nature, and set it off to an Advantage', and the underlying principle of poetry, architecture, painting, and statuary, and concludes that they are all 'invented with the same Design' (157). However, among the arts that are intended to 'wear … off or throw … into Shades the mean and low Parts of our Nature', poetry 'carries on this great End more than all the rest' (157–8).

philosophical representatives, François VI, Duc de La Rochefoucauld and his popular aphorisms in *Maximes* (1664/5), was the target of Addison's attack, since he, and the likes of him, 'endeavour[ed] to make no Distinction between Man and Man, or between the Species of Men and that of Brutes' (*T* II, 156; 108).[33] Art neglecting such primary distinctions, and thus 'resolv[ing] Virtue and Vice into Constitution', was diagnosed by Addison as a major ethico-political impediment. Such art had to be debarred, and its vulgar agents excluded from any (re)creation of political society.

[33] Ibid., 156: 'As an Instance of this kind of Authors, among many others, let any one examine the celebrated *Rochefaucault*, who is the great Philosopher for administring of Consolation to the Idle, the Envious, and worthless Part of Mankind.'

1.3

Aurelia and Fulvia

At the mercy of man, modern society is to Addison a delicate artifice: it can be strong and resilient, or weak and vulnerable. Furthermore, economic prosperity, morality, and peace, or exposure to political disorder, immorality, and conflicts, share a common denominator in their dependence on the ethico-emotive responsiveness of an agent of taste, an agent attesting his eligibility as a rational participant in ideal common value systems and political society. A national political unity was sought in shared taste, and moral distinctions abetting the conflict between a right judgement of taste and a wrong one were destined to become of increasing value in such a context.

One of the typical features of Addison's writings is that he frequently determines the nature of such distinctions by allowing the abstract agent of taste to come alive in moral *exempla*. In an early *Spectator* essay from 17 March 1711, he relates such a distinction in a short and fascinating fable on the life of Aurelia and Fulvia, two exact opposites. The opening motto of the essay is *Parva leves capiunt animos*, found in Ovid's *Ars Amatoria*, and it refers here to a female discourse where women appear to reproduce a certain ostentation focusing merely on superficial exteriors.[1] This leads Addison to moralize on the daily lives of Aurelia and Fulvia. While Aurelia ('a Woman of Great Quality') 'delights in the Privacy of a Country Life, and passes away a great part of her Time in her own Walks and Gardens', Fulvia 'lives in a perpetual Motion of Body, and Restlessness of Thought, and is never easie in any one Place when she thinks there is more Company in another' (*S* I, 68; 15). The morals introduced throughout this essay relate to the whole complexity of eighteenth-century living conditions and ideal objects in life. Aurelia and her family 'abound with good Sense, consummate Virtue, and a mutual Esteem' (*S* I, 68; 15). She is distinctly established in the upper stratum of the British middling orders.

[1] Ovid, *The Art of Love, and Other Poems*, trans. J. H. Mozley, Loeb Classical Library 232, 2nd edn (Cambridge, MA: Harvard University Press, 1979), 1.159.

A precondition for leisure and moral pleasure is of course sound finances: easy access to capital and property (the family divides its time between the town and the country, depending on their frame of mind). But to problematize the family's private wealth suits neither Addison's intention nor his polite manners. Rather, he alludes to private wealth by colourful sketches of a moral life that transcends material conditions. The only piece of financial information given to the reader is that the private economy is of such a disposition that Aurelia and her 'Bosom Friend, and Companion in her Solitudes', form part of a privileged 'Common-Wealth within it self' (*S* I, 68; 15), thus indicating that Aurelia has already created a private and effective political entity ready to involve itself in the greater body politic.

Jeremy Black underlines that '[e]ighteenth-century political rhetoric posited the idea of the sturdy, rational "middling sort" (the soul of the nation), against various foes, real or imagined', and such rhetoric, dynamically exercised, is, I believe, vital to Addison.[2] Thus, after sketching the caricaturistic life of Aurelia, Addison exclaims, 'How different to this is the Life of *Fulvia*!' (*S* I, 68; 15). In sharp contrast, Fulvia regards her 'Life lost in her own Family, and fancies her self out of the World when she is not in the Ring, the Play-House, or the Drawing-Room' and 'pities all the valuable Part of her own Sex, and calls every Woman of a prudent modest retired Life, a poor-spirited, unpolished Creature' (*S* I, 68–9; 15). As Brewer remarks, in the commercialized society of early-eighteenth-century Britain, 'cultural sites were places of self-presentation'.[3] To decipher the polite and moral codes incorporated in such social performances was delicate work and Fulvia was unsuccessful in the task. By 'setting her-self to View' Fulvia is 'exposing her self', and Addison concludes with ill-concealed disdain that she 'grows Contemptible by being Conspicuous' (*S* I, 69; 15).

It has been suggested that the moral *exemplum* of Aurelia and Fulvia is intended to assist the male reader in choosing a female spouse.[4] More recently it has also been argued that 'Fulvia represents all of the upper-class stereotypes that Aurelia repudiates', and that Fulvia's 'public life is explicitly equated with unnatural failure as a wife and mother, negating the value of family-centered domesticity'.[5] There is a good deal of truth in such observations. But at the same time, this fable does so much more than that. What is presented in the

[2] Jeremy Black, 'The Middling Sort of People in the Eighteenth-Century English-Speaking World', *XVII–XVIII* 72 (2015), DOI: 10.4000/1718.286.
[3] Brewer, '"The Most Polite Age and the Most Vicious": Attitudes towards Culture as a Commodity, 1660–1800', 348.
[4] Bloom, *Joseph Addison's Sociable Animal*, 32.
[5] Shevelow, *Women and Print Culture*, 139.

fable of Aurelia and Fulvia is a required hiatus in the reader's codification of the imaginative powers, implying, rather than exhausting, antinomies between a polite imagination and a vulgar imagination, as well as between an emotionally and morally accomplished agent of taste (Aurelia) and an insensitive and morally unaccomplished one (Fulvia). While Aurelia will teach herself by means of nature and the arts, and as a result nurture a proper judgement of taste which, as Addison emphasizes elsewhere, provides 'another Sense' (*S* I, 397; 93)[6] and allows her to interpersonally engage in the political *whole* and play her part in the body politic, Fulvia will end up a 'Distracted Person', where the 'Imagination is troubled, and [the] whole Soul disordered and confused' (*S* III, 579; 421). This moralizing intimation is a trademark of Addison's writings. Square dichotomies are rarely employed to bring home the argument. Both Aurelia and Fulvia hold a potential to put the decorums of a polite imagination on view; rather, what separates them is the emotional state that ultimately shines through in their self-presentations. As Klein observes, *politeness* did not 'serve principally as a wall to segregate a small polite elite from the vulgar', but rather 'to help articulate a complex and evolving set of social and cultural relations involving the traditional landed elite, along with the non-landed pseudo-gentry, and a spectrum of elements within the "useful" part of the population, the variety of middling sorts'.[7] Thus, what is important to Addison is to tactfully draw out a set of advantages accompanying the social ambitions displayed by Aurelia and a set of disadvantages related to the conduct of Fulvia.

Because of her moral conduct, Aurelia will naturally enlarge the province of ethico-emotive values by acting in accordance with Anglican convictions. Elevated and serene emotions originate from a moral meditation filled with awe for the Deity that, according to Addison, has designed the human mind to permanently search out the true beauty of providence itself, and by such a process strengthen individual morality. Human beings are then by nature charmed by 'Great' or 'Unlimited' creations, by which they experience 'Admiration, which is a very pleasing Motion of the Mind' (*S* III, 545; 413). At this point the admiration 'immediately rises at the Consideration of any Object that takes up a great deal of room in the Fancy, and, by consequence, will improve into the highest pitch of Astonishment and Devotion when we contemplate *his* Nature' (*S* III, 545; 413,

[6] *S* I, 397; 93: 'A Man that has a Taste of Musick, Painting, or Architecture, is like one that has another Sense, when compared with such as have no Relish of those Arts.'
[7] Lawrence E. Klein, 'Politeness for Plebes: Consumption and Social Identity in Early Eighteenth-Century England', in *The Consumption of Culture 1600–1800: Image, Object, Text*, ed. Ann Bermingham and John Brewer (London: Routledge, 1995), 366.

my italics), which is also what Addison suggests when he portrays Aurelia as a woman of serene contemplation who loves sauntering in the privacy of nature. In view of the fact that God has 'given almost every thing about us the Power of raising an agreeable Idea in the Imagination', it is, according to Addison, 'impossible ... to behold his Works with Coldness or Indifference' (S III, 546; 413). Hence, Aurelia's emotional sagacity is authenticated in her sensibility for nature (external as well as internal), and by trusting in her imaginative powers, she behaves in accordance with her original supernal design and displays her Anglican principles as well. And in view of the fact that 'Faith and Morality naturally produce each other' (S IV, 143; 465), or as Shaftesbury remarks in the *Inquiry*, the 'End of Religion is to render us more perfect, and accomplish'd in all moral Dutys and Performances' (*Inquiry* 160 [88]), Aurelia will strengthen her moral manners even further.

In two later essays Addison pinpoints that this kind of conduct is allied with the agent's *cheerfulness* (S III, 429–32; 381, and S III, 451–4; 387). Such a mental disposition is a '*Moral* Habit of the Mind' (S III, 451; 387) and has nothing to do with a merry mood accompanied by mirth. Instead, the cheerful agent is a 'perfect Master of all the Powers and Faculties of his Soul', which implies that the 'Imagination is always clear', and the 'Judgment undisturbed' (S III, 430; 381). A strong and poised imaginative power and taste are thus united in an 'inward Chearfulness' that is 'an implicit Praise and Thanksgiving to Providence under all its Dispensations' (S III, 430; 381). Human beings are simply emotionally designed by the Deity to engage in this moral conduct. Not even the sublime and 'grotesque Parts of Nature' can, from Addison's perspective, be omitted as aesthetic objects capable of reinforcing the devotion for the Deity and strengthening morality:

> We may further observe how Providence has taken care to keep up this Chearfulness in the Mind of Man, by having formed it after such a manner, as to make it capable of conceiving Delight from several Objects, which seem to have very little use in them, as from the Wildness of Rocks and Desarts, and the like grotesque Parts of Nature. (S III, 453; 387)

The aesthetic experience of nature and art distributes an indispensable sensitivity for the surroundings and discloses the opportunity for engaging and recognizing God's infinite presence in life. If we relate this experience with Addison's general perspective on religion, it becomes clear that it is indeed an experience of profound human consolation. While 'he who considers himself abstractedly from this Relation to the Supreme Being' will have 'dark and melancholly Views

of Human Nature', a man that recognizes that he is determined by 'so infinitely Wise and Good a Being' is able to 'comfort ... himself with the Contemplation of those Divine Attributes, which are employed for his Safety and his Welfare' (*S* IV, 49; 441). By 'reap[ing] the Benefit of every Divine Attribute', the agent is ultimately able to 'lose ... his own Insufficiency in the Fullness of infinite Perfection' (*S* IV, 49; 441). Moral cheerfulness is an integral and natural part of this interaction between the agent and the *divine attributes*, and within such a context it is fair to say that the short account of Aurelia becomes a paradigmatic moral *exemplum*. Aurelia exercises her natural disposition and mental design; she engages in the introspective practice of the imagination and displays its cultivation in an emotionally self-assured contemplation.

Aurelia is positioned amid a prolific project, characteristic to early-eighteenth-century Britain, where she and her serene and flawless family can reduce any likely ideological tension. From Addion's perspective, they are naturally 'adored by their Servants, and are become the Envy, or rather the Delight, of all that know them' (*S* I, 68; 15). Aurelia is evidently an emotionally and morally accomplished subject ready to press her proved proficiencies forward and involve herself in political society. As Berkeley argued in a piece with the informative title *An Essay towards Preventing the Ruin of Great Britain* (1721), '[f]rugality of manners is the nourishment and strength of bodies politic'.[8] Aurelia presents precisely such a favoured conduct. Fulvia, on the other hand, with her anxious domestic position, and her narcissistic and extrovert character, is never able to genuinely engage neither with the arts nor with society. While she is at all times active, she lacks good sense and 'looks upon Discretion, and good House-Wifery, as little domestick Virtues, unbecoming a Woman of Quality' (*S* I, 68; 15). She remains unresponsive to her inner imaginative faculty and affections, and she acts contrary to the expected morality demonstrated by Aurelia, that would allow her to engage in the creation and re-creation of the political *whole*. While Aurelia looks inwards, discovering her imaginative and emotional power, detecting a heterocosm of nature and art, and is able to separate herself from any vulgar behaviour, Fulvia turns outwards, exposing her insecurity and lack of taste. As Addison continues his examination of the imagination by arguing that we are 'flung into a pleasing Astonishment at ... unbounded Views, and feel a delightful Stillness and Amazement in the Soul at the Apprehension of them'

[8] George Berkeley, 'An Essay towards Preventing the Ruin of Great Britain', in *The Works of George Berkeley, Bishop of Cloyne*, vol. 6, ed. Arthur Aston Luce and Thomas Edmund Jessop (London: Thomas Nelson, 1953), 74. The political context of Berkeley's arguments was the burst of the South Sea bubble in 1720.

(*S* III, 540; 412), the reader cannot help remembering the daily life of Aurelia, who embodied all such qualities.

The allegorical arguments evolved here should be further considered in the light of Addison's notion of happiness and unobtrusive nature. For Addison, happiness is an essential philosophical goal, conditioned by true virtue. As a moral façade, happiness is related to disparate pleasures, luck, or fortune. 'True Happiness', on the other hand, argues Addison, 'is of a retired Nature, and an Enemy to Pomp and Noise' (*S* I, 67; 15).[9] Such a retired nature is the product of moral self-knowledge – 'it arises, in the first place, from the Enjoyment of ones self' – where the emotions and the manners are well-balanced and the subject appears to be indifferent to any opinion that the context might have of its conduct: 'In short, it [true happiness] feels every thing it wants within it self, and receives no Addition from Multitudes of Witnesses and Spectators' (*S* I, 68; 15). Here, the ideal moral existence becomes, as Michael G. Ketcham argues in his reading of the *Spectator*, a 'type of retirement, a harmony and completeness in one's self, isolated from and indifferent to the demands of the public world'.[10] However, since this particular 'form of retirement returns to society, becoming apparent in an easy and natural grace', it does not exclude a successful participation in political society.[11] The ideal moral existence simply exceeds monotonous quotidian matters and obeys profounder ethico-political motives. By not being exposed to the unpredictability and impulsiveness that Addison associates with Fulvia, such a purpose encompasses self-knowledge and a desired political stability. In fact, there is, argues Addison, 'nothing more glorious than to keep up an Uniformity in … Actions, and preserve the Beauty of … Character to the last' (*S* III, 299; 349). The ethico-emotive compass of someone like Aurelia is so deep-seated and confident that nothing can disrupt her actions. What is cultivated in the case of polite imagination, then, is an emotional sensitivity distinguishing the morally accomplished subject of taste from the vulgar. While the latter is emotionally impulsive and, due to a lack of taste, incapable of observing anything but disorder in nature (external as well as internal), a subject with a polite imagination has enough social self-confidence to carefully contemplate and take pleasure in nature and art.

[9] For a comment on the fable of Aurelia and Fulvia in relation to retired life and family, see Ketcham, *Transparent Designs*, 112–13. Ketcham argues that '[s]ocial life and retired life begin to merge in the cohesion of the family'.

[10] Ibid., 61.

[11] Ibid. See also ibid., 51, where Ketcham observes that '[f]or *The Spectator*, the ground of society exists in the private movements of consciousness' and '[s]ocial life includes complex processes of self-reflection and perceptual sensitivity, both of them indispensable parts of social life'.

Within this context, it should be recognized that taste is, in a way, self-creative and self-legislative. Apart from the typical *je ne sais quoi* (disseminated in early modern European thought by Boileau in his preface to the French translation of Longinus' ancient treatise *Peri hupsous* [Περὶ ὕψους] in 1674)[12] where neoclassical formalism is challenged by traces of a new insistence on the Longinian literariness of a poem, Addison is, as Shaun Irlam recognizes, pursuing 'no less than the moral and epistemic claims made for the faculty of taste'.[13] Taste is for Addison thus 'not only an aptitude that creates aesthetic distinctions and cultural commodities, it also creates *itself* as the cultural and aesthetic law to which it then submits'.[14] In this sense, taste is *sui generis*. Needless to say, as a faculty of judgement, taste – '*that Faculty of the Soul, which discerns the Beauties of an Author with Pleasure, and the Imperfections with Dislike*' (*S* III, 528; 409) – will execute an important classifying function vis-à-vis the objects of an aesthetic experience. Addison recognizes two interrelated kinds of taste: the *sensitive* (gustatory) taste that 'gives us a Relish of every different Flavour that affects the Palate' and the *mental* (aesthetic) taste that 'distinguishes all the most concealed Faults and nicest Perfections in Writing' (*S* III, 527; 409).[15] Although, regarded as judgements, they interact and share the ability of making proper distinctions, it is, of course, the *mental* taste that is the concern of Addison. It is with such a *faculty of the soul* that Aurelia is proficient enough to outline and

[12] Nicolas Boileau-Despréaux, 'Préface', *Traité du sublime ou du merveilleux dans le discours, traduit du grec de Longin*, in *Œuvres Complètes* (Paris: Gallimard, 1966), 336. Boileau sought to establish the reputation of Longinus not only as an able rhetorician (*habile Rheteur*) but as an admirable philosopher (*Philosophe digne*). When proving his point (about Longinus as well as *Peri hupsous*), Boileau refers to the quality of *je ne sais quoi*: 'Le caractere d'honneste homme y paroist par tout [in *Peri hupsous*]; et ses sentimens ont *je ne sçais quoy* [my italics] qui marque non-seulement un esprit sublime, mais une ame fort élevée au-dessus du commun.' See also 'Préface', *Œuvres Complètes* (Paris: Gallimard, 1966), 1. Here, Boileau asserts his gratitude to his readership and states that a likely reason for their loyalty must be his lengthy labour to catch their taste. Great and witty art, argues Boileau, involves qualities of agreeableness (*agrément*) and salt (*sel*). In his attempt to substantiate his remark, Boileau clarifies the popular credo of *je ne sais quoi*: 'Que si on me demande ce que c'est que cet agrément et ce sel, Je répondray que c'est un *je ne scay quoy* [my italics] qu'on peut beaucoup mieux sentir, que dire. A mon avis neanmoins, il consiste principalement à ne jamais presenter au Lecteur que des pensées vraies et des expressions justes.' For a discussion on the history of *je ne sais quoi* in early modern European philosophy and poetry, see Richard Scholar, *The Je-Ne-Sais-Quoi in Early Modern Europe: Encounters with a Certain Something* (Oxford: Oxford University Press, 2005).
[13] Shaun Irlam, *Elations: The Poetics of Enthusiasm in Eighteenth-Century Britain* (Stanford, CA: Stanford University Press, 1999), 84.
[14] Ibid. Irlam stresses that '[t]aste not only produces aesthetic discriminations that systematically become the basis of class discriminations and the basis of the aestheticization of social distinction in general, but in the same process taste, as a faculty of judgment, determines itself'.
[15] See also David Hume, 'Of the Standard of Taste', in *Essays Moral, Political, and Literary*, ed. Eugene F. Miller, rev. edn (Indianapolis, IN: Liberty Fund, 1987), 235. After recounting the famous episode from *Don Quixote* about wine tasting, Hume refers – in an Addisonian manner – to the 'great resemblance between mental and bodily taste'. For an account of the gustatory aspects of taste, see Denise Gigante, *Taste: A Literary History* (New Haven, CT: Yale University Press, 2005).

defend her experience of nature and art. But the very exercise of such a faculty will inevitably also categorize her as a moral agent. Hence, while she, on the one hand, *discerns* the qualities and values of her aesthetic experience, she is, on the other hand, herself destined to be *discerned* as a morally sufficient partaker in a common value system and society. To speak with Irlam, '[t]aste, by virtue of its acquisition, turns its possessors, discriminators of beauty, *into* objects of beauty, admiration, and emulation themselves', by converting subjects into 'aesthetic objects through the display of taste'.[16]

Let us pause here to recognize that the self-creative and self-legislative qualities of taste were indeed an integral part of British eighteenth-century aesthetics. As such they were most notably attended to by Hume in 'Of the Standard of Taste' (1757), frequently considered by current Anglophone philosophers as a standard burdened by a vexing circularity that needs to be resolved. Let us look briefly at Hume's 'mannered Addisonian' position, to better bring out the significance of the self-creative and self-legislative qualities of taste.[17]

In his famous essay, Hume singles out five general principles – neither of them alien to Addison – that one should obey in order to become a critic with a proper taste: the critic needs to (1) possess a delicacy of the imagination; (2) engage himself in the '*practice* in a particular art, and the frequent survey or contemplation of a particular species of beauty'; (3) repeatedly peruse the aesthetic objects and 'form *comparisons* between the several species and degrees of excellence'; (4) free himself from prejudices; and (5) apply good sense.[18] Given that these principles are observed, one should be able to identify a normative disposition of taste. However, the nature of the true critic and his judgement of taste appear to be somewhat entangled: the question concerning good taste refers to the critic, and the question concerning what distinguishes the critic refers to good taste. Accordingly, Hume's standard seems to be caught in a vicious circle, where we, in order to determine whether, for instance, *Paradise Lost* is a better poem than the *Aeneid*, seek the advice from a critic that claims to match the principles. When analysing whether or not the critic meets the principles, we are, needless to say, required to evaluate the judgement of the critic: has the critic recognized the actual merits and weaknesses of the poems? Given that our evaluation of the judgement made by the critic clearly presupposes taste, we are now caught in a circle.

[16] Irlam, *Elations*, 86.
[17] Mary Mothersill, 'Hume and the Paradox of Taste', in *Aesthetics: A Critical Anthology*, ed. George Dickie, Richard Sclafani and Ronald Roblin, 2nd edn (New York: St Martin's Press, 1989), 270.
[18] Hume, 'Of the Standard of Taste', 234–40.

Many contemporary philosophers have attempted to solve Hume's vicious circle. Peter Kivy commenced the modern debate on the circularity in the 1970s. He sought to break the circle by drawing attention to the fact that three of Hume's criteria (delicacy of the imagination, lack of prejudice, and good sense) did not simply refer to the critic and the judgement of taste, but to non-aesthetic pursuits as well, allowing the critic to not merely be defined by reference to good art.[19] However, having solved the dilemma of circularity, Kivy nevertheless exposed an *infinite regress* in Hume's arguments. An attempt to solve a disagreement of the evaluation of individual works of art might, according to Hume, be abetted by the conversion of judgements based on sentiments into judgements based on facts. However, by such a move, one is, according to Kivy, still burdened by a focus on evaluative judgements, since judgements referring to facts partly are, precisely, evaluative.[20] Thus Kivy claimed to have detected an infinite regress. Kivy's analysis was naturally followed by an impressive plethora of replies and new considerations of Hume's theory of taste, aspiring to rescue Hume from Kivy's charges of regress and inconsistencies, but naturally detecting new problems in their place.[21]

I shall have nothing to say about those replies here; what I rather wish to point out by very briefly recalling Hume's so-called vicious circle and Kivy's famous attempt to break it is the kind of cul-de-sac methodology that sometimes is exercised by *contemporary philosophers* when addressing specific historical arguments as perennial and timeless propositions.[22] While it is symptomatic that Kivy is generally disturbed by Hume's lack of 'plausible aesthetic logic', such

[19] Peter Kivy, 'Hume's Standard of Taste: Breaking the Circle', *British Journal of Aesthetics* 7, no. 1 (1967), esp. 61–3.
[20] Ibid., 63–5.
[21] See e.g. Noel Carroll, 'Hume's Standard of Taste', *Journal of Aesthetics and Art Criticism* 43, no. 2 (1984); Jeffrey Wieand, 'Hume's Two Standards of Taste', *Philosophical Quarterly* 34, no. 135 (1984); for a reply to Wieand, see James Shelley, 'Hume's Double Standard of Taste', *Journal of Aesthetics and Art Criticism* 52, no. 4 (1994); Jerrold Levinson, 'Hume's Standard of Taste: The Real Problem', *Journal of Aesthetics and Art Criticism* 60, no. 3 (2002); for a reply to Levinson, see Wieand, 'Hume's Real Problem', *Journal of Aesthetics and Art Criticism* 61, no. 4 (2003); for a reply to Wieand, see Levinson, 'The Real Problem Sustained: Reply to Wieand', *Journal of Aesthetics and Art Criticism* 61, no. 4 (2003).
[22] Similar problems arise elsewhere when contemporary philosophers address historical matters without paying attention to the temporality of the matter. For a comment, see e.g. Eric A. Havelock, *Preface to Plato* (Oxford: Blackwell, 1963), 7. In the interpretative context of Plato, Havelock refers to a 'method of reduction' in the readings of Plato's *Republic*: 'modern prejudice ... finds it necessary from time to time to save Plato from the consequences of what he may be saying in order to fit his philosophy into a world agreeable to modern taste. This may be called the method of reduction – a type of interpretation that can be applied also to certain facets of his politics, psychology and ethics – and it consists in pruning his tall trees till they are fit to be transplanted into a grim garden of our own making.' For further discussion, see Hutton, 'Intellectual History and the History of Philosophy'.

a critique remains nonsensical for anyone with a historical approach to Hume and British eighteenth-century theories of taste.[23] That does not imply that Kivy and others are mistaken in their claims on circularity, or that they are to be criticized for their struggle to solve any of the problems arising from Hume's principles. But if arguments advanced in a historical source ultimately are valid or not, remains, for the philosopher of the history of aesthetics, a matter of evaluation secondary to whether or not the source was important at the time. As it happens, Hume is in fact pursuing a similar focus himself, when dealing with the principle about prejudices (principle 4). Works of art, argues Hume, 'must be surveyed in a certain point of view', and, in order to be evaluated and fully appreciated, they cannot be assessed by someone who is 'not conformable to that which is required by the performance'.[24] Thus, individual works call for a specific kind of attention, and, accordingly, any critic 'of a different age or nation', expecting to engage himself in a historical work or discourse, must take the complex premises of the past into serious account.[25] Ultimately, what Hume pleads for is a radical removal of a too strong self-interest, or presentism, whenever we address historical artefacts.[26] A putative 'natural position' from which one claims to engage in history is, as it turns out, treacherously unnatural, since if a 'work be addressed to persons of a different age or nation, he [who 'maintains his natural position'] makes no allowance for their peculiar views and prejudices; but full of the manners of his own age and country, rashly condemns what seemed admirable in the eyes of those for whom alone the discourse was calculated'.[27] The primary objective of the historical approach that I pursue here is, in the same way, first and foremost to *understand* as far as possible why historical arguments were fashioned in a particular way (or to speak with Hume, to pursue the point of view that the 'performance supposes'). Such a position, and eventually comprehension, does not simply result from claims present in the primary sources but, more importantly, from absent or (occasionally

[23] Peter Kivy, *The Seventh Sense: Francis Hutcheson and Eighteenth-Century British Aesthetics*, 2nd. rev. edn (Oxford: Clarendon, 2003), 315. See also Wieand, 'Hume's Real Problem', 396, and Levinson, 'The Real Problem Sustained: Reply to Wieand', 398. Wieand claims to be confused whether a prior reading by Levinson is 'one he believes Hume argued and intended' or rather one that Hume 'should have said and did inspire'. Levinson replies that he only tackles the part of Hume's theory that 'seems most pressing for *us*', claiming that his 'solution is Humean in spirit'.

[24] Hume, 'Of the Standard of Taste', 239.

[25] Ibid.

[26] Ibid., 239–40: 'If the work be executed for the public, he [who 'maintains his natural position'] never sufficiently enlarges his comprehension, or forgets his interest as a friend or enemy, as a rival or commentator. By this means, his sentiments are perverted; nor have the same beauties and blemishes the same influence upon him, as if he had imposed a proper violence on his imagination, and had forgotten himself for a moment.'

[27] Ibid.

intentionally) omitted claims. While Kivy exercises his creative imagination to disentangle Hume from a circular line of reasoning and thus (hopefully) improve the clarity of Hume's arguments, the philosopher of the history of aesthetics uses her imagination in order to achieve a more elementary object, namely to uncover traces of the original cause or intention motivating Hume to his somewhat paradoxical claims. In a Windelbandian sense, the difference between Kivy's ahistorical *nomothetic* ideals (focused on general regularities) and the *idiographic* aims of the historian (focused on unique temporalities) is for obvious reasons not as unambiguous as I have drafted here.[28] Still, the nomothetic ambitions of Kivy to a complex (and inconsistent) historical matter are destined to leave anyone with an interest in the temporality of historical thinking unsatisfied. As Raymond Geuss remarks, '[t]he pursuit of clarity is in general a good thing, but the indiscriminate pursuit of clarity is a vice and a serious obstacle to the proper understanding of large parts of human life. This is particularly the case when considering the philosophical past.'[29]

The fact that the theory of taste frequently referred to a particular kind of British moral agent, who was defined with reference to subjective aesthetic experiences and judgements of taste, was indeed a common feature in the eighteenth-century debate. As Mortensen argues, British early-eighteenth-century theories of taste were 'part of the search for new social standards and new forms of regulating behaviour', due to the fact that 'social positions had become less transparent'.[30] The reason why the self-creative and self-legislative quality of taste is so frequently present is indeed that the relevance of a definite external reference (the church, the court, the aristocracy) is, as we have already seen, slowly but surely beginning to vanish in favour of a broader intersubjective standard. Someone like Addison is moving such a standard forward with the explicit intention to involve a new social stratum. Neither Addison nor Hume is, in reality, troubled by the fact that their analysis of taste might appear logically implausible. Although we might want to limit the historical investigation to

[28] On the famous distinction between nomothetic and idiographic objectives and knowledge, see Wilhelm Windelband's speech (delivered when elected rector at the Kaiser-Wilhelms-Universität in Strasbourg in 1894), *Geschichte und Naturwissenschaft* (Strasbourg: Heitz, 1904), e.g. 12. Windelband did not claim that nomothetic knowledge excluded *particulars*, but he posed the inevitable question, 'was ist für den Gesamtzweck unserer Erkenntnis wertvoller, das Wissen um die Gesetze oder das um die Ereignisse? das Verständnis des allgemeinen zeitlosen Wesens oder der einzelnen zeitlichen Erscheinungen?' (18).

[29] Raymond Geuss, *A World without Why* (Princeton, NJ: Princeton University Press, 2014), 10. Geuss also refers (see esp. 1–21) to Windelband's *Geschichte und Naturwissenschaft*.

[30] Mortensen, *Art in the Social Order*, 83. However, as previously mentioned, Mortensen occasionally exaggerates the political changes in Britain that partly impelled the moral concern for taste.

exploring *mental* taste as a pure judgement of aesthetic objects, we must thus remain sensitive to the fact that British eighteenth-century aesthetics in general, and Addison in particular, regard the dual-purpose of taste – a judgement that, on the one hand, discerns the qualities and values of nature and art and, on the other hand, discerns the pronouncer herself – as absolutely pivotal for their moral criticism and philosophy.

It is fair to say that contemporary philosophical aesthetics prefers to focus on taste as a pronounced judgement of a set of aesthetic objects, while remaining largely indifferent to the fact that such a concentration would have been utterly irrational for its eighteenth-century originators.[31] However, even when we attempt to take the shortcut and deal with taste simply as a judgement we are likely to encounter some critical challenges. To be sure, the intermediate function of taste present in Addison's theory is certainly not a straightforward recognition of the non-autonomous value of experiencing nature and art. As we observed in the introduction, there are indeed some understandable reasons why we frequently have come to identify Addison's and Shaftesbury's writings as the beginning of aesthetic autonomy. Still, any justification of such claims would have to dispense with a complex of arguments that are inconsistent with beliefs about a self-sufficient experience of nature and art. One could try to bring some order to the matter by pursuing a separation between, on the one hand, conditions that must be fulfilled in order to have an aesthetic experience, in which case the advantages of someone like Aurelia are evident enough, and, on the other hand, the outcome of having an aesthetic experience, in which case one might argue that the genuine introspection demonstrated by Aurelia ultimately must allow her to exercise a disinterested aesthetic perception, while Fulvia appears to be too easily impressionable and distracted by other concerns to genuinely appreciate the exercise of perception alone.[32] But such a conclusion would be too hasty. For Addison, the experience of nature and art is always expected to bring about a further awareness of the Deity and an expanding private moral expedient to a political *whole*. That could indeed be the unintentional outcome of a disinterested experience of nature and art as well, but it is of fundamental

[31] See Engell, *Forming the Critical Mind*, 104: 'The concern over principles echoed a preoccupation with the larger question of "rules of art" and the social function of literature. These issues could not, ultimately, be taken up separately – and any debate about critical principles or evaluation becomes suspect unless it is founded on assumptions about the role and reception of literature in society.'

[32] See Diffey, 'Aesthetic Instrumentalism', 339: 'The autonomist will accept that certain conditions must be satisfied if aesthetic contemplation is to be engaged in or successfully undertaken. What these conditions are will be a matter for aesthetic theory to settle. But the autonomist will deny that there is any outcome or end result that is to be attained through aesthetic appreciation. On the contrary aesthetic appreciation is a self-rewarding activity.'

importance to recognize that such further awareness is, in the case of Addison, not accidental and secondary, but purposive and primary. The success of the aesthetic experience of nature and art is simply evaluated by whether it results in such awareness or not. As we have already observed, the absolute cause and purpose of experiencing beauty is ultimately the awareness of the supernal design of man and nature, which allows for ethico-emotive realizations: we are as it seems emotionally premeditated to find pleasure in perceiving a beautiful landscape, which is furthermore intentionally shaped to motivate an increasing awareness of God's great providence and accordingly to reinforce individual morality.

1.4

Ethico-emotive pleasures

The *exemplum* about Aurelia and Fulvia abets an understanding of Addison's pivotal opening essay of the series referred to as the *Pleasures of the Imagination*, published in the summer of 1712, including what is frequently acknowledged to constitute the '*locus classicus* of modern aesthetic theory'.[1] When launching the topic of the series on 19 June 1712, Addison banters, while addressing the intermediate position of taste as partly congenital, partly cultured, over 'One of the most eminent Mathematicians [plausibly Newton] of the Age', who is apparently without any taste whatsoever ('it very often happens, that those who have other Qualities in Perfection are wholly void of this [i.e. taste]'), though he obviously is an excellent mathematician (S III, 529; 409).[2] When reading the *Aeneid* the mathematician confuses Addison by assuring that the 'greatest Pleasure he took in reading *Virgil*, was in examining *Æneas* ... Voyage by the Map'. Here, knowledge in mathematics restricts the reader's access to 'bare matters of Fact' (S III, 529; 409). The inability to formulate a proper judgement of taste prevents the mathematician from having any further emotional experience of the *Aeneid*, and vice versa. Clearly, one of the most famous voyages in the Western literary canon must, as Addison indicates, have qualities beyond a matter-of-fact value. While the mathematician claims to have gained an intense pleasure from following the voyage of Aeneas, Addison would have defined such a pleasure as a gain of hard facts attached to our understanding, rather than as a genuine pleasure of the imagination.

Further ahead in an essay from 21 June, Addison begins, as it seems, to tentatively substantiate his argument regarding the possibility of a distinctively self-sufficient experience of nature and art. The affective pleasure we obtain from

[1] Brian Michael Norton, '*The Spectator* and Everyday Aesthetics', *Lumen: Selected Proceedings from the Canadian Society for Eighteenth-Century Studies* 34 (2015), 128.
[2] See Bond (footnote 1), S III, 529; 409. The mathematician is unidentified, but, for obvious reasons, the name Newton immediately suggests itself. Bond remains unconvinced.

the creative exercise of the imagination is, according to Addison, neither as 'gross as those of Sense', nor as 'refined as those of the Understanding' (*S* III, 537; 411). Although we might find it appropriate to recommend, as the mathematician would suggest, the pleasure of understanding, since it is 'founded on some new Knowledge or Improvement in the Mind', the pleasure of the imagination is actually just as gratifying: 'A beautiful Prospect delights the Soul, as much as a Demonstration; and a Description in *Homer* has charmed more Readers than a Chapter in *Aristotle*' (*S* III, 537–8; 411). The advantage of the emotional experience we have of nature and art, over the experience we might have of engaging in Aristotelian logic, arises, argues Addison at this point, from the immediate access of the 'Beauty of an Object'. The instant sensuous experience of beauty – 'It is but opening the Eye, and the Scene enters' – requires, as it appears, no 'enquiring into the particular Causes and Occasions of it' (*S* III, 538; 411). What then follows is one of the most quoted passages in modern philosophical aesthetics (only comparable to a passage in Shaftesbury's *The Moralists*, which we will consider in Part Two, Chapter 2.3), claiming Addison as the originator of a modern disinterested aesthetic perception of nature and art:[3]

> A Man of Polite Imagination, is let into a great many Pleasures that the Vulgar are not capable of receiving. He can converse with a Picture, and find an agreeable Companion in a Statue. He meets with a secret Refreshment in a Description, and often feels a greater Satisfaction in the Prospect of Fields and Meadows, than another does in the Possession. It gives him, indeed, a kind of Property in every thing he sees, and makes the most rude uncultivated Parts of Nature administer to his Pleasures: So that he looks upon the World, as it were, in another Light, and discovers in it a Multitude of Charms, that conceal themselves from the generality of Mankind. (*S* III, 538; 411)

Though the mathematician's personal experience of the matter-of-fact value of the *Aeneid* is unlikely to be held as vulgar, Addison makes the same separation here as in the fable of Aurelia and Fulvia, between pleasures arising from a polite imagination and pleasures arising from a vulgar imagination.[4] While the former

[3] See e.g. Norton, '*The Spectator* and Everyday Aesthetics', 128. Occasionally, the two paradigmatic passages from Addison and Shaftesbury (*Moralists* 320 [396/397]) are also brought together to illustrate that the 'principle of disinterestedness' is an 'aesthetic vision' that is 'devoid of any practical or instrumental interest in the object', see Norton, '*The Spectator*, Aesthetic Experience and the Modern Idea of Happiness', 90.

[4] The notion of the imagination has a long history in British philosophy and science, where observations on the creative role of the imagination frequently are combined with scepticism regarding its undisciplined power and its relevance for science. For a general overview, see Karl Axelsson, *The Sublime: Precursors and British Eighteenth-Century Conceptions* (Oxford: Peter Lang, 2007), 153–97. Francis Bacon – who shaped much of the conditions of the scientific and

pleasures appear to belong to a self-sufficient agent capable of experiencing nature and art disinterestedly, the latter pleasures seem to refer to a rather disoriented generality, for which the affective pleasures of beauty remain largely inaccessible. The antonym of a tangible or intangible possession of property is, as we can see, not necessarily a disadvantageous lack, but, as it appears, rather a preamble to the unveiling of a hidden secret: an aesthetic perception that is not a target for undesirable political conditions, but which rather seems to control the object and thus allows the agent to obtain a self-sufficient pleasure from perception itself, an emotional pleasure otherwise veiled from man. We might thus wish to conclude that Addison argues for a disinterested perception that simply terminates upon the object, or, as one scholar claims, that 'Mr. Spectator is vitally interested in everything he surveys, but his interest, to use a later terminology, is intrinsic to the experience ("for its own sake") rather than extrinsic to it ("instrumental")'.[5] By exercising taste – by *discerning* the aesthetic object and making a judgement – the agent might thus simply be content. Indeed, such a conclusion contains a grain of truth since Addison undoubtedly sketches a distinction between *possessions* and *pleasures*, with the former holding strong connotations of utility, and the latter appearing to be self-sufficient and without any purpose besides itself. But, such a conclusion would also require that we ignore Addison's argument on nature and art as a whole. The immediate sensuous experience of beauty is certainly not accepted by Addison as an aesthetic principle for experiencing nature and art. As Thomas Rymer had already stressed in his *A Short View of Tragedy* (1693), the seductiveness of the perception of nature and art occasionally distorts the judgement of taste, because the '*Eye* is a quick sense,

philosophical debate during the seventeenth century – assigned a certain status to the category of the imagination in his scheme of human learning. See Francis Bacon, *The Advancement of Learning*, in *The Works of Francis Bacon*, vol. 3, ed. James Spedding, Robert Leslie Ellis, and Douglas Denon Heath (London: Longman, 1870), 329. Hobbes made crucial remarks about the creative power of the imagination in *Leviathan*, 26–46; see also, Thomas Hobbes, *The Answer of Mr. Hobbes to Sir William Davenant's Preface before Gondibert*, in *The Collected Works of Thomas Hobbes*, vol. 4, ed. William Molesworth (London: Routledge/Thoemmes, 1992), 441–58; Thomas Hobbes, *The Iliads and Odysses of Homer. Translated out of the Greek into English, by Thomas Hobbes of Malmesbury*, in *The Collected Works of Thomas Hobbes*, vol. 10, ed. William Molesworth (London: Routledge/Thoemmes, 1992), 3–10. Locke did not concern himself specifically with the notion of fancy or imagination, but, through his claims on the creative power of forming complex ideas, he nevertheless had a vital impact on the debate on the inventive structure of the imagination. See John Locke, *An Essay Concerning Human Understanding*, The Clarendon Edition of the Works of John Locke, ed. Peter H. Nidditch (Oxford: Oxford University Press, 1975), 2.12, 163–6.

[5] Norton, '*The Spectator* and Everyday Aesthetics', 128. Norton's position is puzzling since, besides claiming Addison as the champion of modern aesthetic disinterestedness (133), he also stresses that 'Addison proceeds from the empirical observation of Nature to advance teleological arguments about its design, purposes, and creator' (128).

[and it] will be in with our Fancy, and prepossess the Head strangely'.[6] For Rymer (famously attacking Shakespeare's *Othello* for its improbable narrative, lack of poetic justice, and Shakespeare himself for being a derisory vulgar writer of tragedy), it is, for instance, a non-reflective need for performing *actions* (they are 'speaking to the Eyes') in tragedies that sometimes impede the pertinent rational comprehension of the morals of actions themselves.[7] Rymer also condemned French opera for its 'Cup of Enchantment, [where] there is Musick and Machine; *Circe* and *Calipso* in conspiracy against Nature and good Sense', and in a very similar fashion, Addison goes on to stress, more often than not, the immediacy of sensuousness as a source of moral problems, as will be explored later when he addresses the artistic disposition of Italian opera.[8] We should note that even though Addison writes within the tradition of Locke and stresses the *primary pleasures* of the imagination as determined by 'such Objects as are before our Eyes', and the *secondary pleasures* of the imagination, which even though the objects are 'form'd into agreeable Visions of Things that are either Absent or Fictitious' nevertheless 'flow from the Ideas of visible Objects' (S III, 537; 411), there is, as we will see, a lot more to sensuousness than exercising vision and taking an instant, disinterested pleasure in discerning the aesthetic object.[9]

In what sense, then, is it problematic to rely on Addison as an early defender of the intrinsic value of aesthetic experience? A further argument, developed on 24 June, appears to in fact add to this common belief. Although we clearly experience an intense emotional pleasure from certain objects, Addison acknowledges that since we 'know neither the Nature of an Idea, nor the Substance of a Human Soul, which might help us to discover the Conformity or Disagreeableness of the one to the other', it remains 'impossible for us to assign the necessary Cause of this Pleasure' (S III, 544–5; 413). Thus, as regards the *efficient causes* of the secondary pleasures of the imagination, Addison merely recognizes that it is a pleasure caused by the free and intense activity of the mind

[6] Thomas Rymer, *A Short View of Tragedy; It's Original, Excellency, and Corruption, with Some Reflections on Shakespear, and Other Practitioners for the Stage* (London, 1693), 3.
[7] Ibid.: 'We go to see a Play *Acted*; in Tragedy is represented a Memorable *Action*; so the Spectators are always pleas'd to see *Action*, and are not often so ill-natur'd to pry into, and examine whether it be Proper, Just, Natural, in season, or out of season.'
[8] Ibid., 9.
[9] Addison's analysis of primary and secondary pleasures of the imagination rests to some extent on Locke's explanation of simple and complex ideas. See Locke, *An Essay*, 2.5–8, 127–43 (on simple ideas), and 2.12, 163–6 (on complex ideas). James Engell stresses in *The Creative Imagination: Enlightenment to Romanticism* (Cambridge, MA: Harvard University Press, 1981), 36, that Addison set up his categories of pleasures on 'Locke's division of simple and complex ideas', and that '"primary" and "secondary" pleasures are roughly equivalent to "primary" and "secondary" activities of the imagination itself'.

when comparing 'Ideas arising from the Original Objects, with the Ideas we receive from the Statue, Picture, Description, or Sound that represents them' (*S* III, 560; 416). However, there is more to the argument. While we cannot always provide a detailed explanation of the *efficient causes* of the pleasure we experience when comparing original objects and individual works of art, we are, more importantly, purposely and divinely designed, according to Addison, to fully recognize the *final causes* of our pleasure. While God is a First Cause a priori 'on whose transcendence and immanence everything else depend[s]',[10] the 'Final Causes of our Delight' (*S* III, 545; 413) originate, or so Addison argues emphatically, from the fact that human beings are emotionally premeditated to recognize the value of the Deity through the aesthetic object. Addison deduces, with reference to Ovid's *Metamorphoses*, that *causa latet, vis est notissima fontis* ('[t]he cause is hidden; but the enfeebling power of the fountain is well known').[11] I will come back to the critical implication of Addison's stress on especially the final cause, but I will first make a brief comment about his understanding of aesthetic objects.

In the same essay as Addison addresses *efficient* and *final* causes, he sets out to distinguish between objects that are *great, uncommon,* or *beautiful* (although he also recognizes that the aesthetic experience is greatly improved when the different categories coincide). Greatness refers here to singular objects as well as to the immensity of a prospect grasped by perception itself ('the Largeness of a whole View, considered as one entire Piece'), for instance when we view extremely large mountains or high precipices (*S* III, 540; 412). These 'stupendous Works of Nature' are characterized by a profusion of objects that can challenge and eventually emancipate our creative imaginative powers as well as our perception. While the imagination relishes 'any thing that is too big for its Capacity', and the 'Mind of Man naturally hates every thing that looks like a Restraint upon it … when the Sight is pent up in a narrow Compass', the perception of the limitless vista of nature becomes, for Addison, an elevated 'Image of Liberty' (*S* III, 540–1; 412). By referring to the image of liberty, Addison joins the re-awakened Longinian tradition where 'influences of the sublime bring power and irresistible might to bear, and reign supreme over every hearer'.[12] Needless to say, a general Longinian impact was felt throughout the eighteenth century. Beginning with Thomas Burnet's claim that vast mountains (*great ruins*) simply overpower the

[10] Bloom, *Joseph Addison's Sociable Animal*, 182.
[11] Ovid, *Metamorphoses*, vol. 1, 4.287.
[12] Longinus, *On the Sublime*, ed. and trans. W. Rhys Roberts (Cambridge: Cambridge University Press, 1907), 43.

human mind,[13] and sustained in the mid-century debate by men of letters like Edmund Burke, John Baillie, and Robert Lowth – who in his *Lectures on the Sacred Poetry of the Hebrews* (*De sacra poesi Hebraeorum*) argued that it was the very labours of the human imagination to 'comprehend what is beyond its powers', that ultimately 'demonstrate[s] the immensity and sublimity of the object' – the proposal that an authentic experience of the sublime involved an extraordinary intense exercise and expansion of the imaginative powers became one of the most reiterated *topoi* in British eighteenth-century aesthetics.[14] Standing in the midst of the re-awakened attraction for the Longinian sublime, such a claim implicates, for Addison, a physical and emotional autonomy, where the 'Eye has Room to range abroad ... and to lose it self amidst the Variety of Objects', and the imagination, whilst it engages in prospects and objects that challenge its creative sinews, allows the agent to be 'flung into a pleasing Astonishment at such unbounded Views, and feel a delightful Stillness and Amazement in the Soul' (*S* III, 540–1; 412).

However, it is not only the imaginative powers that are tried. The human mind is expected to be motivated in its entirety. The very magnitude of an object is, for Addison, proportional to both the mental ability of reason and comprehensions of the Deity: 'The more extended our Reason is, and the more able to grapple with immense Objects, the greater still are those Discoveries which it makes of Wisdom and Providence in the Work of the Creation' (*S* IV, 442; 543). The *uncommon* objects have a very similar appeal that 'serves us for a kind of Refreshment, and takes off from that Satiety we are apt to complain of in our usual and ordinary Entertainments' (*S* III, 541; 412). Both the *great* and the *uncommon* are furthermore completed by *beauty*, which, for Addison, refers to, on the one hand, the immediate pleasure we experience when discerning beauty in our own species and, on the other hand, a 'second kind of *Beauty* that we find in the several Products of Art and Nature' (*S* III, 543; 412). When all three

[13] See Thomas Burnet, *The Sacred Theory of the Earth: Containing an Account of the Original of the Earth, and of All the General Changes Which It Hath Already Undergone, or Is to Undergo, till the Consummation of All Things*, vol. 1, 4th edn (London, 1719), 191–3. The cosmography advanced in *The Sacred Theory of the Earth* (originally in *Telluris Theoria Sacra*, published 1681) was popular among early-eighteenth-century literati. About this, see Al Coppola, 'Imagination and Pleasure in the Cosmography of Thomas Burnet's *Sacred Theory of the Earth*', in *World-Building and the Early Modern Imagination*, ed. Allison B. Kavey (Basingstoke: Palgrave Macmillan, 2010); Marjorie Hope Nicolson, *Mountain Gloom and Mountain Glory: The Development of the Aesthetics of the Infinite* (Seattle: University of Washington Press, 1997; orig. 1959), esp. 184–270. Addison wrote an ode to Burnet (see *The Sacred Theory of the Earth*, vi–x), prefaced to all eighteenth-century editions from 1719 onwards. Steele admired Burnet's text (see *S* II, 67–8; 143) and associated it (along with a passage from Cicero, *Tusculan Disputations*, 1.41) with sublimity (see *S* II, 75–7; 146).

[14] Robert Lowth, *Lectures on the Sacred Poetry of the Hebrews*, vol. 1, trans. G. Gregory (London, 1787), 353.

categories – the *great, uncommon,* and *beautiful* – are interrelated in the same aesthetic object, and sight is supplemented with other senses (such as hearing and smell), the momentum of the human mind attains its cognitive apogee:

> Thus any continued Sound, as the Musick of Birds, or a Fall of Water, awakens every moment the Mind of the Beholder, and makes him more attentive to the several Beauties of the Place that lie before him. Thus if there arises a Fragrancy of Smells or Perfumes, they heighten the Pleasures of the Imagination, and make even the Colours and Verdure of the Landskip appear more agreeable. (S III, 544; 412)

What is then the *final cause* of all this pleasure and enhanced attention? Is the emotional responsiveness acquired from appreciating a little cataract while listening to a beautiful birdsong, or the sensitivity gained from experiencing the 'different Colours of a Picture, when they are well disposed, [and] set off one another' (S III, 544; 412), self-sufficient? Rather than being ends in themselves, the pleasures, and more importantly the enhanced attention gained from the experience of such pleasures, appear here to be intermediate ends. Although he primarily sees in Addison a modern defender of the intrinsic pleasures arising from the free play of the imagination, Paul Guyer makes the valuable point that 'no more than Shaftesbury does [Addison] infer ... that aesthetic pleasure must be described independently of the language of interest altogether'.[15] In fact, as Guyer remarks, when discussing the locus classicus from the *Spectator*, Addison's view of the 'capacity for the pleasures of the imagination actually extends our interest in the world' and is 'not so much disinterested as it heightens our interest in the world'.[16] But what then is the actual purpose of such an interest? The moral responsiveness acquired from the aesthetic experience leads Addison onwards, towards an enlightening claim, on 24 June 1712, of the engaging outcome of experiencing *greatness*, where the 'Supreme Author' has conceived and designed the agent's interest in gaining aesthetic pleasure, and thus is able to lead his or her actions towards the greatest attainable pleasure possible for a human being, namely the awareness of the original divine principle of that pleasure:

[15] Guyer, *A History of Modern Aesthetics, Volume 1: The Eighteenth Century*, 71. In his comments on Addison's *Spectator* essays (the *Pleasures of the Imagination*), Guyer refuses to perceive Addison as a straightforward contributor to aesthetic autonomy: 'Addison by no means completely disconnects the enjoyment of the free play of the mind with nature and art from all conceptions of utility as well as from all thoughts of divinity, but he makes the connection indirect' (70).

[16] Ibid. See also Guyer, *Values of Beauty: Historical Essays in Aesthetics* (Cambridge: Cambridge University Press, 2005), 22. In his chapter on Addison (21–8), Guyer stresses that the 'kind of disinterestedness he [Addison] has in mind is not supposed to entail the independence of the pleasures of the imagination from all other sources of pleasures in our lives'.

> One of the Final Causes of our Delight, in any thing that is *great*, may be this. The Supreme Author of our Being has so formed the Soul of Man, that nothing but himself can be its last, adequate, and proper Happiness. Because, therefore, a great Part of our Happiness must arise from the Contemplation of his Being, that he might give our Souls a just Relish of such a Contemplation, he has made them naturally delight in the Apprehension of what is Great or Unlimited. (*S* III, 545; 413)

To experience beauty is thus to be truly subjected to an amplifying sense of God's providence. Speaking from beyond the grave, it is almost as if Addison wishes to caution against any modern claims that one ought to perceive nature and art disinterestedly, and to alert us not to overlook the conclusive primary end of every aesthetic experience, when he underlines that God has in fact 'annexed a secret Pleasure to the Idea of any thing that is *new* or *uncommon*' (*S* III, 545; 413). It is a secret pleasure simply because the enjoyment acquired from experiencing nature and art might initially seem gratifying enough to make us entirely content. Along those lines we should face no problems in making Addison the prime advocate of a modern aesthetic autonomy. What the secret pleasure achieves, however, is a private attentiveness that, according to Addison, inevitably 'engage[s] us to search into the Wonders of his [God's] Creation' (*S* III, 545; 413). God has thus purposely intended man to emotionally pursue an experience of the moral powers of the Deity, by assigning an innate predestined (secret) pleasure to such an experience.

Neither for Addison nor, as we shall see in Part Two, for Shaftesbury is a revealed knowledge about God obtained, as Protestant Reformation primarily had maintained, *sola scriptura*. Instead of Scripture being the absolute source of Christian truth, and as such the only applicable moral principle to obey, the aesthetic experience of nature or art reveals an opening where man is permanently, in the words of Addison, 'encourage[d]' in a pleasurable 'Pursuit after Knowledge' of the Deity (*S* III, 545; 413). Characteristically, when reflecting on the main art form to engender a primary pleasure of the imagination, namely architecture, Addison accentuates that man is always 'obliged to Devotion for the noblest Buildings' (*S* III, 555; 415). The greatest architectural works are, on the one hand, exemplarily constructed in order to 'invite the Deity to reside within it', and, on the other hand, naturally intended to 'open the Mind to vast Conceptions, and fit it to converse with the Divinity of the Place' (*S* III, 555; 415). The architectural work (the structural design of the building) is thus a divine site and as such a superior human channel of communication for the

agent. Hence in their capacity of being objects where the agent is subjected to the presence of the Deity – and thus in their capacity of being objects that enable a further recognition of the value of God's providence – nature and art are here distinctly integrated in religious-ecclesiastical matters.

Along those lines, Addison's prime example of a work of art that achieves all this is most effectively expressed in his apotheosis of Milton's *Paradise Lost* (canonized by Addison in the *Spectator* in 1711–12).[17] While the general biblical theme of the Fall of Man, and Adam and Eve's banishment from Paradise, is much to Addison's approval, he acknowledges that the mimic virtuosity of Milton not only draws on, and occasionally exceeds, paradigmatic poets like Homer and Virgil, but also imitates the composers of biblical psalms.[18] In his analysis of book 5 of the poem, Addison remarks on 15 March 1712 that in his account of Adam and Eve, Milton typically imitates a psalm where the 'Psalmist calls not only upon the Angels, but upon the most conspicuous parts of the inanimate Creation, to join with him in extolling their Common Maker' (*S* III, 200; 327). By doing so, the psalm, as well as Milton's account, constitutes precisely the kind of ideal object apt to the aesthetic experience, that manages to 'fill the Mind with glorious Ideas of God's Works, and awaken that Divine Enthusiasm, which is so natural to Devotion' (*S* III, 200; 327). And in a very similar fashion Addison also honours Sir Richard Blackmore's *Creation: A Philosophical Poem* (1712) as 'the most useful and noble Productions in our *English* Verse' (*S* III, 261; 339). By combining the 'Depths of Philosophy' with the 'Charms of Poetry', Blackmore specifically demonstrates 'that Design in all the Works of Nature, which necessarily leads us to the Knowledge of its first Cause' (*S* III, 261; 339).

Clearly, the experience of nature and art has a potential to lead us onwards towards true Christian devotion and morality. Although art does not need to have explicit biblical themes, as in the paradigmatic poems by Milton and Blackmore, to serve such a purpose, the basis of Addison's theory of taste is, as we can see, the moral potential of nature and art to allow the agent to recognize and engage in the supernal power. Especially poetry has, as one of Isaac Bickerstaff's

[17] Addison's first reading of Milton's *Paradise Lost* was published in the *Spectator*, 31 December 1711 (*S* II, 516–20; 262). The following series of essays were published on Saturdays and the analysis of the poem was completed 3 May 1712 (*S* III, 385–92; 369). Addison probably did more than any other British eighteenth-century man of letters to canonize *Paradise Lost*. His essays were translated into Italian and German. See also Smithers, *The Life of Joseph Addison*, 216.

[18] See e.g. *S* III, 564–6; 417. While Homer 'strikes the Imagination wonderfully with what is Great', Virgil strikes the imagination 'with what is Beautiful', and Ovid 'with what is Strange' (564), Milton is a 'perfect Master in all these Arts of working on the Imagination' (566). Milton also 'copied or improved *Homer* or *Virgil*, and raised his own Imaginations by the use which he has made of several Poetical Passages in Scripture' (*S* III, 392; 369).

(Richard Steele's *eidolon*) many interlocutors claims, the moral potential to carry the agent's mental positions. By first controlling the imagination ('the most active Principle in our Mind') and then overwhelming the passions, the poet will ultimately assure that 'Reason surrenders it self with Pleasure', and that the agent is 'insensibly betrayed into Morality, by bribing the Fancy with beautiful and agreeable Images of those very Things, that in the Books of the Philosophers appear austere, and have at the best but a kind of forbidden Aspect' (*T* II, 106; 98).[19] The theological aura encompassing Addison's own judgement of ideal art, and the purposefulness of experiencing such art, does not, however, imply that moral values outdo aesthetic values. The general value of art depends of course on its artistic execution (*Greatness of the Manner*). For the mind to unfold, and man to be emotionally disposed to experience a work of art, its execution has to be achieved with great artistic skills. Accordingly, Addison is also able to argue that it is indeed possible to engage in the beauty of God's providence by experiencing an Ancient Roman building like the Pantheon, turned into a church by Pope Boniface IV in the early seventh century, and be only 'little, in proportion ... affected with the Inside of a *Gothick* Cathedral, tho' it be five times larger than the other' (*S* III, 556; 415). '[P]hiloromanism' was indeed, as Philip Ayres argues, frequently displayed as an 'intentional contrast to Roman Catholicism',[20] but what Addison is after here is the 'immediate Tendency' of great architecture (and art in general), be it in the hands of the Church of Rome or other Christian faiths, to serve a moral purpose as a source of engagement in God's infinite presence and beauty, by letting our imaginations be 'filled with something Great and Amazing' (*S* III, 556; 415).

[19] Bickerstaff's interlocutor was of course not the first to argue that philosophy must assume the shape of (or even become) poetry to convey any valuable moral knowledge. See e.g. Sir Philip Sidney's Renaissance poetics, *A Defence of Poetry*, in *Miscellaneous Prose of Sir Philip Sidney*, ed. Katherine Duncan-Jones and Jan Van Dorsten (Oxford: Oxford University Press, 1973), 75. Almost like a policy statement, Sidney maintains right from the outset of his highly influential poetics that 'Thales, Empedocles, and Parmenides sang their natural philosophy in verses; so did Pythagoras and Phocylides their moral counsels'. Also, if one examines Plato's dialogues carefully, one will, argues Sidney, observe that 'though the inside and strength were philosophy, the skin, as it were, and beauty depended most of poetry'. Ultimately, 'neither philosophers nor historiographers could at the first have entered into the gates of popular judgements, if they had not taken a great passport of poetry'.

[20] Philip Ayres, *Classical Culture and the Idea of Rome in Eighteenth-Century England* (Cambridge: Cambridge University Press, 1997), 153.

1.5

Faith and political enthusiasm

Addison's theory of taste offers no absconding from theological matters. But apart from the posthumously published apologetic piece *Evidences of the Christian Religion* (1730), his concern often relates to the subjective and societal ethical value of religion in relation to the aesthetic experience of nature and art, rather than to Christian faith as such.[1] Religion is defined by Addison in terms of *belief* and *practice* (see esp. S IV, 118–20; 459). While the former refers to Christian faith and 'whatever is revealed to us in the Holy Writings' rather than a gained knowledge from the 'Light of Nature', the latter refers to morality and what we ought to practice (*moral duties*), and to which we are 'directed by Reason or Natural Religion' (S IV, 118; 459). In two essays published in the *Spectator* in August 1712, Addison gives his most detailed account of how Christian faith and subjective morality are naturally related and determined by their reciprocal actions. While an accomplished man of taste certainly cannot overlook either faith or morality, Addison appears to ascribe a more significant functional value to the latter. In relation to faith, morality has, in the words of Addison, the 'Pre-eminence in several Respects' (S IV, 118; 459). Addison registers six conclusive reasons for such an ascendancy, all of them referring to the 'fixt Eternal Nature' of morality, the pre-eminence of perfecting human nature in its 'private Capacity', and the probability that such an individual realization expands into a benefit of society (S IV, 118–19; 459).[2]

[1] About the reception of *Evidences of the Christian Religion*, see Gordon D. Fulton, '*Evidences of the Christian Religion*: Using Pascal to Revise Addison in Eighteenth-Century Scotland', *Lumen: Selected Proceedings from the Canadian Society for Eighteenth-Century Studies* 26 (2007).

[2] For the list of reasons given, see S IV, 118–19; 459: (1) 'Because the greatest part of Morality ... is of a fixt Eternal Nature, and will endure when Faith shall fail, and be lost in Conviction'; (2) 'Because a Person may be qualified to do greater Good to Mankind, and become more beneficial to the World, by Morality, without Faith, than by Faith without Morality'; (3) 'Because Morality gives a greater Perfection to human Nature, by quieting the Mind, moderating the Passions, and advancing the Happiness of every Man in his private Capacity'; (4) 'Because the Rule of Morality is much more certain than that of Faith, all the Civilized Nations of the World agreeing in the great Points of Morality, as much as they differ in those of Faith'; (5) 'Because Infidelity is not so malignant a Nature

However, to claim faith as inferior to morality is undeniably to run a risk of heresy, and Addison cannot afford to expose himself as a doubting moralist. Hence, by stressing the ascendancy of morality, Addison does not explicitly intend to reduce the impact of faith, but rather to call attention to the fact that if forced to choose between them, the individual, as well as society as a whole, is likely to benefit somewhat from choosing morality (although such a morality naturally always entails a religious faith).[3] Addison's rationale for discreetly maintaining the ascendancy of morality must, as we will see, be related to his vision of the political *whole* in order to make sense.

Following Addison's argument, faith and the belief in revealed religion strengthen the 'Practice of Morality' in everyday life by, for instance, providing 'more amiable Ideas of the Supreme Being, more endearing Notions of one another, and a truer State of our selves' (*S* IV, 119; 459). Although if we are forced to fix upon one of them, we are likely to learn that morality is pre-eminent to faith, Addison stresses that private and public morality claims the Christian faith to be realized. Since a 'Man cannot be perfect in his Scheme of Morality, who does not strengthen and support it with that of the Christian Faith' (*S* IV, 119; 459), Addison goes on to clarify the techniques to reinforce faith. It is essential to Addison that faith eludes a superficial relation to *beliefs*. Faith must be fixed to something more enduring than merely an acceptance with no need for further rational proof or evidence. Much in line with what we have observed regarding Addison's claims on ethico-emotive conduct, the inevitable firmness and value of a Christian faith must accordingly arise from the corroboration of the emotions: 'The Devout Man does not only believe, but *feels* there is a Deity' (*S* IV, 143; 465).[4] This moral agent undergoes, argues Addison, an 'Experience [that] concurs with his Reason' (*S* IV, 143; 465). This leads us back to the value and applicability of the emotive experience of beauty and sublimity in nature and art. The emotional response and validation require a genuine aesthetic experience for the agent to free himself from being subjected to distracting objects. For instance, the 'variety of Objects which press upon [us] in a great City' obstructs the true experience of the objects 'which are of the utmost Concern' to us (*S* IV, 143; 465). In our analysis of Aurelia and Fulvia, we observed that authentic happiness was of a withdrawn kind, opposed to the extroverted and vulgar pageantry demonstrated by Fulvia. That argument reappears here, when

as Immorality'; and (6) 'Because Faith seems to draw its Principal, if not all its Excellency, from the Influence it has upon Morality'.
[3] See also Bloom, 'Addison on "Moral Habits of the Mind"', 410.
[4] My italics.

Addison claims that in 'Retirements every thing disposes us to be serious' (*S* IV, 143; 465). In such a mental state man will inevitably go on to prefer the objects that serve the purpose of strengthening faith and, accordingly, reinforce morality even further. As it seems, the Deity is thus ultimately immanent *in* the preferred aesthetic object.

> Faith and Devotion naturally grow in the Mind of every reasonable Man, who sees the Impressions of Divine Power and Wisdom *in every Object* on which he casts his Eye. The Supream Being has made the best Arguments for his own Existence, in the Formation of the Heavens and the Earth, and these are Arguments which a Man of Sense cannot forbear attending to, who is out of the Noise and Hurry of Human Affairs.[5] (*S* IV, 144; 465)

It must be stressed right away that the understanding of nature and art as *objects* raises significant questions about their ontological status (see also Part Two, Chapter 2.3). Indeed, a beautiful scene of nature, a poem, or a painting are of course objects by being physical phenomena that we can perceive by our senses, or recall by a creative act of our imagination, and that might cause a particular kind of strong emotion. But for Addison they are not objects in the sense that they are reactive entities awaiting a specific (aesthetically disinterested) perception to become sources of aesthetic pleasures. They are rather objects immanent with the greatest moral subject and rational presence in the universe: the 'Supreme Author of our Being' (*S* III, 545; 413). As Addison claims in one of his attacks on the 'Disbelief of a Supreme Being' (atheism), the absolute *truth* present in human life is the 'Being of a God', while there is something deeply 'offensive to Human Nature in the Prospect of Non-Existence' (*S* III, 431; 381). The verification of the absolute *truth* is furthermore revealed in the aesthetic object: 'For my own part, I think the Being of a God is so little to be doubted, that it is almost the only Truth we are sure of, and such a Truth as we meet with *in* every *Object*, in every Occurrence, and in every Thought' (*S* III, 431; 381; see also *S* IV, 529–33; 565).[6] Thus, to claim that we can be profoundly pleased by merely perceiving a beautiful meadow or simply reading *Paradise Lost* is somewhat to curtail Addison's conception of the object of our experience, as well as to abridge the purposiveness of such an experience (I am not claiming that an aesthetic experience without further purposiveness is a second-rate experience, but only that such an experience was implausible from Addison's perspective).

[5] My italics.
[6] My italics.

The object is not the end of perception, but rather the intermediate goal or the real commencement of a true awareness of the rationality of the providential mind itself, and of achieving perfect morality.

That one must be subject to the omniscience/omnipresence/omnipotence of the aesthetic object can, however, be a source of existential vexation. On 9 July 1714, Addison recollects a sublime 'Sun-set [while] walking in the open Fields, till the Night insensibly fell upon me' (*S* IV, 529; 565; see also *Evidences of the Christian Religion*, 84). While beholding the 'Blewness of the Æther' and the 'Galaxy ... in its most beautiful White', being perfected by the full moon (naturally reminding Addison of a section in *Paradise Lost* and Hesperus, the 'Ev'ning star | Love's Harbinger'), an irresistible 'new Picture of Nature' appears (*S* IV, 529; 565).[7] However, the 'surveying of the Moon' leaves Addison with perturbed sentiments about the revelation of the Deity in nature. Recalling David's contemplation of 'thy heavens, the work of thy fingers, the moon and the stars, which thou hast ordained' (Ps. 8.3), Addison goes on to reflect on himself, and his fellow citizens, being at risk of remaining unseen and lost in the 'Immensity of Nature' (*S* IV, 530; 565).[8] In order to rid himself of the unbearable thought of the insignificance of modern human existence within the cosmography, Addison reiterates that 'Beings of finite and limited Natures' simply 'cannot attend to many different Objects at the same time' and that while we 'inspect some Things, we must of Course neglect others' (*S* IV, 530–1; 565). Unfortunately, human beings have, argues Addison, a tendency to anthropomorphize God and the beauty of rational providence by transmitting their own limited perceptual circumference – 'stinted to a certain number of Objects' – to 'him in whom there is no shadow of Imperfection' (*S* IV, 531; 565). While reason, according to Addison, can ensure that God's 'Attributes are Infinite', the very 'Poorness of our Conceptions is such, that it cannot forbear setting Bounds to every thing it contemplates' (*S* IV, 531; 565). The solution can only follow from the stronger act of reason that challenges our unpremeditated mental biases as human beings, thus clearing the way for the recognition of the omnipresence and omniscience of God. The omnipresence pledges that the

[7] See John Milton, *Paradise Lost*, in *John Milton: Complete Poems and Major Prose*, ed. Merritt Y. Hughes (Indianapolis, IN: Hackett, 2003), bk 4, lines 605–9: 'With living Sapphires: *Hesperus* that led | The starry Host, rode brightest, till the Moon | Rising in clouded Majesty, at length | Apparent Queen unveil'd her peerless light, | And o'er the dark her Silver Mantle threw.' On the mythological Hesperus, see also *Paradise Lost*, bk 9, lines 48–50: 'The Sun was sunk, and after him the Star | Of *Hesperus*, whose Office is to bring | Twilight upon the Earth...' For 'Ev'ning Star | Love's Harbinger', see *Paradise Lost*, bk 11, lines 588–9.

[8] *S* IV, 530; 565: 'I could not but look upon my self with secret Horror as a Being, that was not worth the smallest Regard of one who had so great a Work under his Care and Superintendency.'

Deity's 'Substance is within the Substance of every Being, whether material or immaterial, and as intimately present to it as that Being is to it self' (*S* IV, 531; 565; see Ps. 139.15-16). Divine omniscience, argues Addison, naturally follows from omnipresence, and it guarantees that God is naturally mindful of every (e)motion in the material world. The Deity's 'Being' reinforces the 'whole Frame of Nature' and inhabits every object: '[H]e is a Being whose Centre is every where, and his Circumference no where' (*S* IV, 531; 565).[9] By reference to Newton's *Opticks*, and the distinction between the *Sensorium* (of the Godhead) and the *Sensoriola* of man, Addison remarks the following:[10]

> Brutes and Men have their *Sensoriola*, or little *Sensoriums*, by which they apprehend the Presence, and perceive the Actions of a few Objects that lie contiguous to them. Their Knowledge and Observation turns within a very narrow Circle. But as God Almighty cannot but perceive and know every thing

[9] Here Addison claims to quote 'the old Philosopher', without further reference. The passage quoted can be ascribed to numerous philosophers and treatises. See e.g. the world view of Empedocles (*c*.495-35 BC), expressed in his fragments, *Die Fragmente der Vorsokratiker*, vol. 1, ed. Hermann Diels and Walther Kranz, 5th edn (Berlin: Wiedmann, 1934-7), 324. See also the obscure twelfth-century pseudo-Hermetic *Liber XXIV philosophorum*, published by Clemens Baeumker, 'Das pseudo-hermetische "Buch der vierundzwanzig Meister" (Liber XXIV philosophorum): Ein Beitrag zur Geschichte des Neupythagoreismus und Neuplatonismus im Mittetalter', in *Studien und Charakteristiken zur Geschichte der Philosophie insbesondere des Mittelalters: Gesammelte Vorträge und Aufsätze von Clemens Baeumker*, ed. Martin Grabmann (Münster: Aschendorff, 1927), 194-214, for trans., 207-14, for quote (proposition 2), 208: *Deus est sphaera infinita, cuius centrum est ubique, circumferentia nusquam* (God is an infinite sphere, whose centre is everywhere, whose circumference nowhere). The metaphor on divine omnipresence presented in proposition 2 of *Liber XXIV philosophorum* was known and referred to by both Meister Eckhart (*c*.1260-*c*.1328) and Nicholas of Cusa (1401-1464). About this, see Karsten Harries, 'The Infinite Sphere: Comments on the History of a Metaphor', *Journal of the History of Philosophy* 13, no. 1 (1975), esp. 7-8. Hence it is not surprising that Addison picked up the metaphor. Although he was not particularly 'old' to Addison, it has also been suggested that the 'old Philosopher' might be Blaise Pascal (1623-1662). About this, see e.g. *S* IV, 531; 565, Bond (footnote 2); Michael J. Crowe, *The Extraterrestrial Life Debate, 1750-1900: The Idea of a Plurality of Worlds from Kant to Lowell* (Cambridge: Cambridge University Press, 1986), 32. Addison's essay (*S* IV, 529-33; 565) is, as noted by Crowe, Pascalian in its attempt to 'deal with the place of the individual in this vast cosmos'. See Pascal, *Pensées*, in *Œuvres Complètes*, vol. 2 (Paris: Gallimard, 2000), 609: 'C'est une sphère infinie dont le centre est partout, la circonférence nulle part.' See also *Pensées*, 1392-3 (footnote 1), for similar formulations.

[10] See Isaac Newton, *Optice: Sive De Reflexionibus, Refractionibus, Inflexionibus & Coloribus Lucis. Libri Tres* (London, 1706), *Qu*. 20, 307-15 (esp. 315), and *Qu*. 23, 322-48 (esp. 346-7). This is the enlarged Latin edition, made by Samuel Clarke (1675-1729), of the first edition of Newton's *Opticks* published already in 1704 (the Latin edition contains the added Queries [*Qu*.] that Addison appears to have in mind). A second edition in English was published in 1717/18, where *Qu*. 20 and *Qu*. 23 (from the Latin edition) correspond to *Qu*. 28, 345, and *Qu*. 31, 379. See Isaac Newton, *Opticks: Or, a Treatise of the Reflections, Refractions, Inflections and Colours of Light*, 2nd edn (London, 1718), *Qu*. 28, 345: '[D]oes it not appear from Phænomena that there is a Being incorporeal, living, intelligent, omnipresent, who in infinite Space, as it were in his Sensory, sees the things themselves intimately, and throughly perceives them, and comprehends them wholly by their immediate presence to himself: Of which things the Images only carried through the Organs of Sense into our little Sensoriums, are there seen and beheld by that which in us perceives and thinks. And tho' every true Step made in this Philosophy brings us not immediately to the Knowledge of the first Cause, yet it brings us nearer to it, and on that account is to be highly valued.'

in which he resides, Infinite Space gives room to Infinite Knowledge, and is, as it were, an Organ to Omniscience. (*S* IV, 532; 565)

Hence, natural objects (but also individual works of art) encompass the infinite presence of the Deity. While Shaftesbury lets Theocles in *The Moralists* state that he has a private obligation to 'tread the Labyrinth of wide Nature' to be able to 'trace thee in thy Works' (*Moralists* 248 [346]), Addison pursues a similar kind of natural human responsibility, where the agent is emotionally premeditated to experience (though *not* wholly comprehend), via his *little Sensoriums*, the objects of God's coherent providence, and to venerate the absolute presence of the Deity through the focus on particular natural objects and works of art. In fact, when providing material for the pleasures of the imagination, nature and art are, according to Addison, involved in an interplay, which ultimately seeks to unlock the agent's emotional reverence of the Deity, and to reinforce his morals. In an essay published on 25 June 1712, Addison begins by comparing the 'Works of *Nature* and *Art*, as they are qualified to entertain the Imagination', and he concludes that there is 'something more bold and masterly in the rough careless Strokes of Nature, than in the nice Touches and Embellishments of Art' (*S* III, 548–9; 414). Nature also impregnates works of art, which allow nature to gain a new artistic shape. Addison associates, as we have observed, God's nature with qualities of 'Vastness and Immensity' (*S* III, 548–9; 414), which furthermore stimulate the human mind and bestow pleasures on the creative faculty of the imagination. In the experience of the beauty of nature, perception encounters the self-determination of its own sensuous power: '[I]n the wide Fields of Nature, the Sight wanders up and down without Confinement, and is fed with an infinite variety of Images, without any certain Stint or Number' (*S* III, 549; 414).[11] However, soon it becomes apparent that Addison is not trying to set up a hierarchy of different sources of pleasures, because this interplay and fulfilment of art by nature and vice versa provides the most valid source of the pleasures of the imagination. Nature as a cause of pleasure is relative to its resemblance to art, due to a 'double Principle', where the eye recognizes the 'Agreeableness of the Objects', as well as identifies the objects 'Similitude to other Objects' (*S* III, 550; 414). However, if the 'Products of Nature rise in Value', due to their resemblance to art, the latter also has, or so Addison argues, a similar effect on the former,

[11] This is, according to Addison, also the reason why 'we always find the Poet in love with a Country-Life, where Nature appears in the greatest Perfection, and furnishes out all those Scenes that are most apt to delight the Imagination' (*S* III, 549; 414).

'because here the Similitude is not only pleasant, but the Pattern [i.e. pattern of nature] more perfect' (S III, 550; 414).

The concrete interplay of nature and art, and the qualities attached to art by its resemblance to nature, is particularly revealing in Addison's remarks on the *camera obscura* at Greenwich Park (S III, 550–1; 414).[12] Here, Addison refers to a beautiful landscape occurring 'on the Walls of a dark Room, which stood opposite on one side to a navigable River, and on the other to a Park' (S III, 551; 414). In the camera obscura a moving picture appears with 'Green Shadows of Trees, waving to and fro with the Wind, and Herds of Deer among them in Miniature, leaping about upon the Wall' (S III, 551; 414). The laws of optics allow us to experience the image ('drawn' on the wall) deriving from external nature, and though the 'Novelty of such a sight' is likely to astound the imagination, the 'chief Reason' of the pleasures received from the camera obscura ensues from the image's 'Resemblance to Nature, as it does not only, like other Pictures, give the Colour and Figure, but the Motion of the Things it represents' (S III, 551; 414). Thus, what the camera obscura offers is ideal nature materialized in the picture – a perceptible substantiation of the Deity's nature, visible in the moving proto-cinematic object itself. Through this interplay of nature and art, the critical purpose and true moral value of works of art are unlocked. As we have already observed, Addison mentions how great architectural works can be sites of the presence of the Deity, which offer the agent a possibility of further religious engagement. The optical effect of the dark chamber creates a similar opportunity. When experiencing natural beauty or canonical works of architecture, like the Egyptian pyramids or the Great Wall of China, Addison believes that the human mind can emancipate itself into more complex religious emotions, where the work 'imprints an Awfullness and Reverence on the Mind' and 'strikes in with the Natural Greatness of the Soul' (S III, 555; 415). The final cause of the experience of the Egyptian pyramids is thus elicited by the emotional reverence we encounter when confronted with such works of art.

Now, with the reservation that the technical term *object* clearly is more complex than it might appear at first (especially since the experience of beauty transcends a division of *subject* and *object*, and the physical objects discussed by Addison and Shaftesbury contain the Supreme Being), we should go on to recognize that a Christian faith is expected to circumvent a set of superficial beliefs by allowing the predestined emotions of the agent to corroborate the divine power *in* the aesthetic object. It is the fact that the agent responds

[12] See Bond (footnote 2), S III, 550–1; 414.

emotionally when interacting with the aesthetic object (he *feels* that there is a Deity) that ultimately turns out to be the rational proof of the existence of God. Nevertheless, regarded as evidence of God, as well as evidence of a true aesthetic experience, a powerful emotional reaction always leaves a great deal to be desired. Should, for instance, all strong feelings simply be trusted as proofs of the existence of God? The problem with refuting or proving the validity of a subjective emotion is, as Hume would famously acknowledge, that '[a]ll sentiment is right; because sentiment has a reference to nothing beyond itself'.[13]

In his attempt to formulate an answer about the validity of the affective reaction to the experience of nature and art, Addison crosses the threshold into an extensive historical discourse in Western philosophy and theology, namely the discourse on the ontology of religious enthusiasm. Addison has, along with Shaftesbury, been claimed to be responsible for the ongoing 'aestheticization' of enthusiasm in the early eighteenth century, and Addison, in particular, has been regarded as a 'palaeo-poetic' enthusiast.[14] Although I do not raise any objection to such readings, I think we must be more open to the possibility that Addison is, in fact, struggling to outline the menaces of a radical *political enthusiasm*, by exploiting the traditional attributes of the Protestant critique of extremist religious enthusiasm, rather than identifying him as a typical mediator between an ecclesiastical discourse (*religious enthusiasm*) and aesthetics (*poetic enthusiasm*).[15] Here we need to briefly enter the historic discourse on enthusiasm, in order to fully appreciate Addison's understanding of the ethico-emotive pleasures of experiencing nature and art, and its relation to the functionality of the political *whole*. Given the complex and contradictory history of the concept of religious enthusiasm, Addison's take is, as we will see, not by any standard original. However, due to the great interest he pays to the prodigious experience of nature and art, his remarks on enthusiasm not only bring him close to the crux of the concept itself but also allow him to map out the political merits of opposing radical enthusiasm on moral principles rather than on religious ones.

Addison stages, in an essay dated 20 October 1711, an Anglican routine-like policing of radical religious enthusiasm. The motto of the essay, *Religentem esse oportet, religiosus ne fuas*, is a verse found in Aulus Gellius' second-century

[13] Hume, 'Of the Standard of Taste', 230.
[14] Irlam, *Elations*, 37. For a critique of Irlam and an attempt to stress the persistence of anxieties about enthusiasm throughout the century, see Jon Mee, *Romanticism, Enthusiasm, and Regulation: Poetics and the Policing of Culture in the Romantic Period* (Oxford: Oxford University Press, 2005).
[15] See Irlam, *Elations*, e.g. 53–6, 83–110. Irlam claims that Addison (along with Dennis, Shaftesbury, and others) remodelled the seventeenth-century perception of religious enthusiasm as a respectable category of poetic enthusiasm.

discussion of religiosity in *Noctes Atticae* and refers to the reminder that one should be religious, not superstitious.¹⁶ While he naturally recognizes that it is challenging to decide if the 'Propensity of the Mind to Religious Worship' is the 'effect of a Tradition from some first Founder of Mankind', and thus 'conformable to the Natural Light of Reason', or if it 'proceeds from an Instinct implanted in the Soul it self', Addison begins by regarding them as 'concurrent Causes', since they ultimately and 'manifestly point ... to a Supreme Being as the first Author' (*S* II, 288; 201). Here, the critical question, addressed by Addison, is not the 'Methods of Devotion', but rather 'into what Errors even this Divine Principle [i.e. the Supreme Being as the first Author] may sometimes lead us' (*S* II, 288; 201). Because human beings can too easily be emotionally deceived into extreme religious devotion, which 'does not lie under the check of Reason' (*S* II, 289; 201). Devotion unrestrained by reason is, to Addison, equivalent to religious enthusiasm. When becoming too inflamed with devotion, one can confuse false enthusiasm and inspiration with true divine enthusiasm, which might furthermore cause 'imaginary Raptures and Extasies' (*S* II, 289; 201). When the agent mistakenly 'fancies her self under the Influence of a Divine Impulse' she is destined to become politically dangerous by slighting 'Human Ordinances' and refusing to 'comply with any established Form of Religion' (*S* II, 289; 201).

The discourse on divine inspiration and enthusiasm, originating in the Greek term *entheos* (ἐν [in/on/at/among], θεός [God]), and its cognitive relevance can be dated back to Plato. In *Ion*, Socrates exemplifies the rhapsode's remoteness to knowledge and truth, by a reference to the Heraclean stone, a magnet that attracts iron rings but likewise instils an energy that allows them to appeal to new rings.¹⁷ In a similar way, the poet (the first ring), the rhapsode (the middle ring), and the audience (the last ring) rely on the Muse.¹⁸ Neither the poet nor the rhapsode depends on art (τέχνη) or knowledge (ἐπιστήμη).¹⁹ Instead, argues Socrates, they live off a problematic divine dispensation (θείᾳ μοίρᾳ).²⁰ The poet and the rhapsode might be divinely inspired, but because of this, they are also at the mercy of the Deity and accordingly not to be trusted. A different perspective is presented in *Phaedrus*, where Socrates himself is caught by divine inspiration

¹⁶ Gellius, *Attic Nights*, vol. 1, trans. John C. Rolfe, Loeb Classical Library 195 (Cambridge, MA: Harvard University Press, 1927), 4.9.1. Gellius cites from the Roman savant Nigidius Figulus' work *Commentarii grammatici* of the mid-first century BC, where Nigidius quotes a poet who states that '[b]est it is to be religious, lest one superstitious be'. The poet remains unknown.
¹⁷ Plato, *Ion*, in *The Statesman, Philebus, Ion*, trans. Harold N. Fowler and W. R. M. Lamb, Loeb Classical Library 164 (Cambridge, MA: Harvard University Press, 1925), 533D.
¹⁸ Ibid., 535E–536A.
¹⁹ Ibid., 536C.
²⁰ Ibid.

and practically performs dithyrambs.²¹ While associations between divine inspirations and madness (μανία) are explicitly spelled out in this dialogue, they are not rendered undesirable or deceitful. Instead, poetry created with crafts and skills becomes inferior to that which is created with divine inspiration and madness.²² When referring to madness and frenzy, Plato now implies a positive divine enthusiasm. As Josef Pieper stresses in his classic interpretation of *Phaedrus*,

> If the word enthusiasm were not so debased in English, it would in fact most fittingly describe what Plato intended, and indeed he himself uses it in the sense of 'being filled with the god.' In the middle of the *Phaedrus*, Socrates speaks of a man thus possessed by *mania*. 'The multitude', he says, 'regard him as being out of his wits, for they know not that he is full of a god (*enthousiazon*).'²³

An explanation to 'enthusiasm' which, as a concept, is vitiated by troubles needs to consider the impact of the Protestant discourse in the seventeenth and the early eighteenth centuries, where the affirmative meaning of divine enthusiasm is generally avoided. Within such a context enthusiasm is typically employed, as Addison displays, in a polemical and politically disparaging sense with the purpose of confronting and condemning excessive irrational emotions, undisciplined imaginations, and ecstatic religious revivalism. To that extent Addison is subscribing to a long Protestant tradition. The Protestant attacks on enthusiasm date from the early stages of the Lutheran Reformation and its insistence to seek God in his Word and sacraments.²⁴ In his attack on the so-called Zwickau Prophets (a group of radical reformers prophesizing in Zwickau, Saxony, from 1521 and onwards) and their spiritualizing of Christian pneumatology and stress on the direct inspiration and knowledge of God without relying on the Scripture, Luther maintained, in his lectures on Genesis, that the Holy Spirit did not teach any new revelations apart from the instructions given by God's Word. Individuals called by the noun *Schwärmer* (along with those accused of *Schwärmerei*, which is generally applied by Luther in his Lectures) were, together with Anabaptists, according to Luther, enthusiasts and fanatical

[21] Plato, *Phaedrus*, in *Euthyphro, Apology, Crito, Phaedo, Phaedrus*, trans. Harold N. Fowler, Loeb Classical Library 36 (Cambridge, MA: Harvard University Press, 1914), 238D.
[22] Ibid., 245A.
[23] Josef Pieper, *Enthusiasm and Divine Madness: On the Platonic Dialogue Phaedrus*, trans. Richard Winston and Clara Winston (South Bend, IN: St Augustine's Press, 2000), 50. See orig. *Begeisterung und Göttlicher Wahnsinn: Über den platonischen Dialog Phaidros* (Munich: Kösel-Verlag, 1962), 85.
[24] For a survey of the concept of religious enthusiasm, see Michael Heyd, *'Be Sober and Reasonable:' The Critique of Enthusiasm in the Seventeenth and Early Eighteenth Centuries* (Leiden: Brill, 1995), esp. 11–43 (about the Reformation).

instructors (*fanatici Doctores*),[25] and, in his lectures on Isaiah, he accused the papists and the *Schwärmer* for blasphemy.[26] Rather than teaching Christ's Word, the deceptive *Schwärmer* lectured their own zealous doctrine, exclaiming, according to Luther, 'Spirit, Spirit', but never reaching or instructing a genuine knowledge of God.[27] *Schwärmerei* captured, for Luther, a self-delusional state of mind where one was confident to be enthused by a godly inspiration, although one was merely a deceived victim of the unreliable powers of the imagination. However, in the Lutheran lexis, *Schwärmerei* also made possible a more concrete association to a state of enthusiasm characterized by an ecstatic mass-psychosis, where one could easily imagine a blind and naïve crowd that temporarily swarm (*schwärmen*), like an excited group of bees in a tree, around some self-proclaimed inspired priest.[28] In the spiritual ecstasy of a deluded prophet, the impulsive mob (*Pöbel*) was the obvious prey.

While the notion of religious enthusiasm naturally entered new and different contexts before being addressed by Addison, its connotations of somatic ecstasy, spiritual disease, and undisciplined imaginative powers proved to be enduring. The Cambridge Platonist Henry More draws, in a representative manner, all the characteristics of the discourse together in his *Enthusiasmus Triumphatus* (1656). More brings enthusiasm back to its original complex relation to the term *inspiration*. While to be '*inspired, is to be moved in an extraordinary manner by the power or Spirit of God to act, speak, or think what is holy, just, and true*', enthusiasm is, according to More, an aberrant and deceptive conduct where there is '*full, but false persuasion in a man that he is inspired*'.[29] It is essential for More's comprehension of religious enthusiasm that the higher mental faculty of reason is outmanoeuvred by the '*inward figuration of our brain or spirits into this or that representation*', that is to say that reason is firmly subjugated by a potent act of the imagination.[30] The imagination can, according to More, be further

[25] Martin Luther, 'Lectures on Genesis', in *Luther's Works*, vol. 2, ed. Jaroslav Pelikan (Saint Louis, MO: Concordia, 1960), 162: 'For the Holy Spirit does not – as the enthusiasts and the Anabaptists, truly fanatical teachers, dream – give His instruction through new revelations outside the ministry of the Word.' See also 'Text der Genesisvorlesung', in *Martin Luthers Werke: Kritische Gesamtausgabe*, vol. 42 (Weimar: Hermann Böhlaus Nachfolger, 1911), 376.

[26] Luther, 'Lectures on Isaiah', in *Luther's Works*, vol. 16, 324. See also 'Vorlesung über Jesaja', in *Martin Luthers Werke*, vol. 31.2, 240.

[27] Ibid., vol. 17, 80. See also 'Vorlesung über Jesaja', in *Martin Luthers Werke*, vol. 31.2, 324.

[28] Anthony J. La Vopa, 'The Philosopher and the *Schwärmer*: On the Career of a German Epithet from Luther to Kant', *Huntington Library Quarterly* 60, nos 1/2 (1997), 88. See also Peter Fenves, 'The Scale of Enthusiasm', in *Enthusiasm and Enlightenment in Europe, 1650–1850*, ed. Lawrence E. Klein and Anthony J. La Vopa (San Marina, CA: Huntington Library, 1998), 120.

[29] Henry More, *Enthusiasmus Triumphatus, or, a Discourse of the Nature, Causes, Kinds, and Cure, of Enthusiasme* (London, 1656), 2.

[30] Ibid., 4.

affected by a sudden paroxysm of melancholy, a mental disease that implants the imagination forcefully enough to make reason completely incapable of refuting the irrational representations, causing '*Epilepsies, Apoplexies, or Extasies*'.[31] While generally trusted representations of the imagination include utterly perverse and unrealistic images, the intensity of the delusion is, in the case of religious enthusiasm, proportionate to the enthusiast's uncompromising conviction: the stronger the representations appear, the stronger the mistaken belief that they are in fact natural and divine.

More's account of religious enthusiasm is certainly not without nuances. Indeed, he mentions briefly that there also exists a 'true and warrantable Enthusiasme of devout and holy souls', in men acting rationally (characteristically, Shaftesbury refers, in a letter to Ainsworth in 1709, to More as 'perhaps as great an Enthusiast as any of those whom he wrote against' [*Ainsworth Correspondence* 409]).[32] Such rational men neither 'pretend to equallize themselves to Christ', nor advance from 'some Hypochondriacall distemper'.[33] For More, the path away from a pathologically enthusiastic distemper, towards good health and the true experience of the spirit of God, consists of temperance, humility, and, most importantly, the perseverance of reason.[34] Arranging radical enthusiasm as the exact opposite of moral rationality, and as an emotional immoderation in acute need of the adjusting power of reason, naturally turns out to be a highly effective rhetorical technique in confronting the enthusiasts.

Similar to More, Locke, in *An Essay Concerning Human Understanding* (1690), goes on to arrange religious enthusiasm as a conceptual adversative to the faculty of reason and claims the latter to grant a corrective against the former.[35] Locke's simple truth principle hinges on that the agent does not 'entertain ... any Proposition with greater assurance than the Proofs it is built upon will warrant', and he is eager to point out that the love of truth, and assent to propositions, must rely on rational evidence.[36] The problem is of course that a politically and religiously subversive enthusiast is a fideist and thus not obedient to the principles of reason. While the religious enthusiast claims, as Addison remarks, to be 'under the Influence of a Divine Impulse' when he in fact 'flings'

[31] Ibid., 28.
[32] Ibid., 59. At the end of *Enthusiasmus Triumphatus*, More even claims to have made no actual critique of *true* religious enthusiasm. See also Green, *Shaftesbury's Philosophy of Religion and Ethics*, esp. 19–36.
[33] Ibid.
[34] Ibid., 51.
[35] For definition and further discussion of reason, see Locke, *An Essay*, 4.17, 668–88, and 4.18, 688–96.
[36] Ibid., 4.19, §1, 697.

himself into completely irrational 'imaginary Raptures and Extasies', he is also displaying a 'Madness' (S II, 289; 201). The enthusiast claims, as Locke argues, a compelling internal light that only obeys its own emotional evidence: since the enthusiast *feels* the divine spirit within himself, he does not seem to require rational deduction.[37] The enthusiasts 'feel the Hand of GOD moving them within, and the impulses of the Spirit, and cannot be mistaken in what they feel'.[38] Emotions are, as we have already observed, neither easy to dispute nor amendable to rational counterevidence, since they merely refer to themselves. Rhetorically, Locke then goes on to ask the enthusiast who claims to have an 'awaken'd Sense' if his perception is a 'perception of the Truth of the Proposition', or if it is a 'Revelation from GOD', before Locke reminds his reader that from the observation of the truth of a proposition it does not necessarily follow that the agent perceives an immediate revelation.[39]

By stressing the need of rational evidence for the experience of divine revelation, Locke is neither attempting to voice critical scepticism of God nor doubting any prospects of prophesy.[40] That would simply be a politically too dicey suggestion to make in *An Essay*. Rather, Locke wishes to focus on the given evidence that is frequently claimed to give rational support to the internal light of the radical enthusiast. One might set out to confirm the truth of the internal light by referring to its 'own self-evidence to natural Reason', or to the 'rational Proofs that make it out to be so'.[41] But if these proofs turn out to be satisfying, there is, argues Locke, no need to claim any immediate revelation from God, since we are able to prove the truth without any reference to a revelation. The fanatical enthusiast is thus left with only emotional ignis fatuus, and a set of invalid beliefs incompatible with reason:

> If they believe it to be true, because it is a *Revelation*, and have no other reason for its being a *Revelation*, but because they are fully perswaded without any other

[37] See e.g. ibid., §7, 699: 'This I take to be properly Enthusiasm, which though founded neither on Reason, nor Divine Revelation, but rising from the Conceits of a warmed or over-weening Brain, works yet, where it once gets footing, more powerfully on the Perswasions and Actions of Men, than either of those two, or both together.'

[38] Ibid., §8, 700. Enthusiasm is essentially circular. See Forster, *John Locke's Politics of Moral Consensus*, 124: '[T]he more strongly an enthusiast believes, the more sure he is (on the evidence of the strength of his belief) that his beliefs are true; the more sure he is that his beliefs are true, the more strongly he believes.'

[39] Ibid., §10, 700–1.

[40] See Jordana Rosenberg, *Critical Enthusiasm: Capital Accumulation and the Transformation of Religious Passion* (Oxford: Oxford University Press, 2011), 38: 'The peril of enthusiasm, as Locke sees it, is not that the enthusiastic subject has an overly passionate relationship to divinity, but rather, that this subject has an insufficiently empirical relation to himself.'

[41] Locke, *An Essay*, 4.19, §11, 702.

reason that it is true, they believe it to be a Revelation only because they strongly believe it to be a Revelation, which is a very unsafe ground to proceed on, either in our Tenets, or Actions.[42]

The cognitive scope of man is limited, and without the act of reason he is simply expected to make mistakes in his acceptance or rejection of a revelation. Central for Locke is rather the assessment that man is able to execute because God has originally provided him with reason. When God 'illuminates the Mind with supernatural Light, he does not extinguish that which is natural'.[43] When creating the prophet, God did not 'unmake the Man' but left, Locke reminds us, 'all his Faculties in their natural State, to enable him to judge of his Inspirations'.[44] Locke is certainly not denying that God can cause the internal light by an immediate influence, but points out that any religious inspiration must be rationally assessed in an expository philosophical mode.[45] The ecstatic mind and arcane imagination of the radical religious enthusiast must simply be debarred as potential sources of truth and knowledge.

The epistemic objections to the claims of religious enthusiasm, such as the lack of rationally conclusive evidence, also thrives in the organized scientific movement encircling the Royal Society and among the propagandists of natural philosophy in the late seventeenth century, although they are more openly partisan in their political purposes. Within such a context, a new philosophical prose paradigm is often claimed to have been advanced, idealizing a referential and demonstrative standard, and exploiting the priority of content over style in science, famously captured by Thomas Sprat, one of the founding members of the Royal Society in 1660, in his vision of 'positive expressions' and 'Mathematical plainness'.[46] While Addison, unlike Shaftesbury,[47] praises the 'Authors of the

[42] Ibid., 702–3.
[43] Ibid., §14, 704.
[44] Ibid.
[45] See ibid., §16, 705: 'In what I have said I am far from denying, that GOD can, or doth sometimes enlighten Mens Minds in the apprehending of certain Truths, or excite them to Good Actions by the immediate influence and assistance of the Holy Spirit, without any extraordinary Signs accompanying it.'
[46] Thomas Sprat, *The History of the Royal Society: For the Improving of Natural Knowledge* (London, 1667), 113. The Royal Society demonstrates in the words of Sprat a 'constant Resolution, to reject all the amplifications, digressions, and swellings of style: to return back to the primitive purity, and shortness, when men deliver'd so many *things*, almost in an equal number of *words*'. About the impact of the classical rhetorical tradition of *res* and *verba* (e.g. Cicero and Quintilian) on some of the members of the Royal Society, and on seventeenth-century philosophers (Bacon, Hobbes, et al.), see A. C. Howell, '*Res et Verba*: Words and Things', *ELH* 13, no. 2 (1946). See also Cicero, *De Oratore*, vol. 2, trans. H. Rackham, Loeb Classical Library 349 (Cambridge, MA: Harvard University Press, 1942), 3.37.149; Quintilian, *Institutio Oratoria*, vol. 3, trans. H. E. Butler, Loeb Classical Library 126 (Cambridge, MA: Harvard University Press, 1921), e.g. 8.20–1.
[47] Shaftesbury expressed strong doubts about the new (natural) philosophy. See e.g. Shaftesbury's letter to Locke (29 September 1694): 'Itt is not in my case as with one of ye men of new Systems, who are to

new Philosophy' and their 'Contemplations on Nature' (S III, 574–5; 420), the relation between what has been characterized as the 'most ambitious manifestations of protological positivism in the history of English prose style', and art and aesthetics is of course extremely complex.[48] I will come back to this shortly, but let us first recognize that when Sprat referred to *plainness*, he did not of course suggest that a non-figurative prose style was altogether achievable for experimental philosophers. Hobbes's prior declaration that 'Metaphors, and senslesse and ambiguous words, are like *ignes fatui*; and reasoning upon them, is wandering amongst innumerable absurdities; and their end, contention, and sedition, or contempt', pledged a scientific prose standard that needless to say no philosopher could reach.[49] What was intended was rather a systematization of an ideal scientific prose paradigm that reinforced the principle that a prerequisite in modern scientific accounts should be a definite avoidance of mysticism and extreme spiritualism. A raison d'être for the philosophical ideals of the scientific movement in Britain consisted precisely in an aversion to irrational enthusiasm, and someone like Sprat positioned the *positiveness* and *plainness* within the ongoing conflict between the philosophical paradigm of the scientific movement and the alleged irrational and immoral otherworldliness of radical enthusiasts.[50] The true national character was, in Sprat's account, intimately allied with a scientific prerogative that allowed England to 'justly lay claim, to be the Head of a *Philosophical league*, above all other Countries in *Europe*' and grow to be a 'Land of *Experimental knowledge*'.[51] The establishment of the

build ye credit of their own invented ones upon ye ruine of ye Ancienter & ye discredit of those Learned Men yt went before' (*Correspondence* 201). See also a letter to Ainsworth (28 January 1708/1709): '… & all that Dinn & Noise of Metaphysicks, all that pretended studdy & Science of Nature calld natural Philosophy, Aristotelean Cartesian or wtever else it be, all those high Contemplations of Starrs & Spheres & Planets & all the other inquisitive Curiouse parts of Learning, are so far from being necessary Improvements of the Mind, that without ye utmost Care they serve only to blow it up in Conceit & Folly, & render Men more stiff in their Ignorance & Vices' (*Ainsworth Correspondence* 377). See also Brian Cowan, 'The Curious Mr Spectator: Virtuoso Culture and the Man of Taste in the Works of Addison and Steele', *Media History* 14, no. 3 (2008). While approving of the progress of natural philosophy and particular virtuosi (e.g. Robert Boyle and Newton), Addison (and Steele) questioned the function of the Royal Society. Cowan stresses that the appeal of the discourse on taste assisted Addison's and Steele's reshaping (rather than rejection) of the old baroque seventeenth-century virtuoso culture, by enabling them to 'prioritize the *aesthetic* interests of the virtuosi and to "de-prioritize" as it were the place of natural philosophy and erudite antiquarianism' (276).

[48] Ryan J. Stark, 'From Mysticism to Scepticism: Stylistic Reform in Seventeenth-Century British Philosophy and Rhetoric', *Philosophy and Rhetoric* 34, no. 4 (2001), 328.

[49] Hobbes, *Leviathan*, 74.

[50] See Ryan J. Stark, *Rhetoric, Science, and Magic in Seventeenth-Century England* (Baltimore, MD: Catholic University of America Press, 2011), 49–50. Sprat positioned the 'plain style movement within a larger theological struggle between good and evil, between the experiments of scientists and the experiments of preternatural charmers'.

[51] Sprat, *The History of the Royal Society*, 113–14.

Academy in London had a different purpose for Sprat than Cardinal Richelieu's institution of the Académie Française in 1635, whose purpose was primarily intended to create a 'smoothing' of the 'Style'.[52] The '*English Genius*' was, in the words of Sprat, after all 'not so airy, and discoursive, as that of some of our neighbors', since the nation's philosophers 'generally love[ed] to have Reason set out in plain, undeceiving expressions', while France and other countries on the continent wished to 'have it deliver'd with colour, and beauty'.[53] However, Sprat was first and foremost addressing a domestic debate, and accordingly he made a special effort to assure his own sensible Anglican readers that the experimental philosopher was the exact opposite of the zealous religious enthusiast who 'pollutes ... *Religion*, with his own passions'.[54] While he acknowledged that the new experimental philosophy might arouse suspicion of an insufficient conformity to the '*Doctrine* of *Prophecies*' and 'all *remarkable Providences*',[55] he accentuated that such qualms must be resolutely dismissed, since to 'slight all pretenders, that come without the help of *Miracles*, is not a contempt of the Spirit, but a just circumspection, that the *Reason* of men be not over-reach'd'.[56]

Sprat returned to the subject in a sermon preached before Charles II, at Whitehall on Christmas Eve in 1676, where he commented on radical religious zeal. A '*Zealous Affection*' could indeed be vented in order to prevent sacrilege and impiety, but on the whole it must be delegated to the 'Lawful, Publick Authority in Church and State', in order to be morally disciplined, because it is only within such an authority 'that Zeal becomes a Sovereign Virtue'.[57] A sensible religious zeal and enthusiasm is by Sprat accepted as a rational result, while affective extremeness, without epistemic justification, is dismissed as a downright mental disease that does not only intrude upon 'Spiritual Graces', but also destabilizes 'Moral Virtues and Dictates of Nature'.[58] The extremist 'Antichristian Raptures of Zeal' have for too long undermined political society,[59] and it is, according to Sprat, high time that 'We, of all Nations under Heaven', who have 'just Reason to abhor all falsly-inspired Principles of Godliness',[60] prove to be 'truly zealous towards God' in order to not only become 'united within ourselves', but, more importantly, because a true and rational zeal

[52] Ibid., 39.
[53] Ibid., 40.
[54] Ibid., 361.
[55] Ibid., 357.
[56] Ibid., 359.
[57] Thomas Sprat, *Sermons Preached on Several Occasions* (London, 1710), 181.
[58] Ibid., 183.
[59] Ibid., 188.
[60] Ibid., 185.

underpins the moral bond of society as a whole: 'True Zeal, in Religion, is of all Things the best Means of Union.'[61]

A connecting thought in the historical discourse on enthusiasm is thus the quandary of accurately discriminating the prophets maintaining a divine inspiration on *false* grounds from the prophets maintaining an inspiration on *true* grounds. As Locke and others point out, reason is here expected to provide a corrective and to either verify or refute the claimed internal light of the enthusiast. But adjacent to stipulating the rational assessment of religious enthusiasm, there subsists, of course, a persistent conceptualization in the arts and in aesthetics, where the faculty of reason is not so much recommended for monitoring a claimed inspiration, as it is expectantly awaited to succumb to the emotional power of the unique experience of nature and art. In contrast to a rationalist theologian such as More, who relates the enthusiastic condition of imagination, causing a diseased state of ecstasy, to a destabilized faculty of reason and the paroxysm of melancholia, eighteenth-century men of letters often relate enthusiasm to artistic elevation, like John Dennis, who claims that it is utterly 'impossible to succeed in Poetry without Enthusiasm'.[62] From the stance of poetics, enthusiasm was the instrumental premise of any moral work of art. As such, the aroused enthusiasm was entirely rational (although it was rational in a different way than More and Locke had claimed).[63] Hence the Phaedrian emotional and ecstatic transport often came to represent prime evidence for a true aesthetic experience, in which one valued precisely the ecstatic moment where reason dissolved in its assessment of a claimed divine inspiration. While such a collapsed rational deduction was, within an established Protestant theology, evidence enough that the divine inspiration and the enthusiasm were *false*, early-eighteenth-century aesthetics deemed, to an ever increasing extent, such a (rational) collapse as possible evidence for the inspiration and the enthusiasm in fact being *true*.

The Sidneyian rehabilitation of the poet as a *vates* (prophet), granting 'that high flying liberty of conceit proper to the poet' which 'did seem to have some divine force in it', remained a natural and inherent feature of British

[61] Ibid., 186–7.
[62] John Dennis, *An Essay on the Opera's after the Italian Manner, Which Are about to Be Establish'd on the English Stage: With Some Reflections on the Damage Which They May Bring to the Publick*, in *The Critical Works of John Dennis*, vol. 1, ed. Edward Niles Hooker (Baltimore, MD: Johns Hopkins Press, 1939), 386.
[63] See Phillip J. Donnelly, 'Enthusiastic Poetry and Rationalized Christianity: The Poetic Theory of John Dennis', *Christianity and Literature* 54, no. 2 (2005). Donnelly characterizes Dennis's notion of enthusiasm as 'rational enthusiasm', upholding a 'strong passion directed toward a moral end by means of an intelligible art' (241).

eighteenth-century poetics and criticism. The prophetic poet performed an act of balance, where he was expected to fully obey his enthusiasm, but only as long as it was genuinely true. Shaftesbury's Theocles is, in a characteristic fashion, extremely anxious about coming across as a mad poetic enthusiast stretching his inspired flight too much. After a raptured speech, Theocles begs Philocles to review if he appeared to be caught in a 'sensible kind of Madness, like those Transports which are permitted to our *Poets*? or was it downright Raving?' (*Moralists* 248 [346/7]). A little further ahead, Theocles worries yet again, and he criticizes Philocles for not interrupting him when he 'grow[s] extravagant', stating disappointedly that he never trusted himself with Philocles 'in this *Vein of Enthusiasm*' (*Moralists* 288 [374/5]). Hence, after Theocles fearing, in yet another pause of his speech, that he 'in these high Flights ... might possibly have gone near to burn [his] Wings' (*Moralists* 296 [381]), Philocles and Theocles finally find a way to resolve the matter. In order to make his 'Map of *Nature*' more intelligible, Philocles allows Theocles the 'PEGASUS of the Poets, or that wing'd *Griffin* which an *Italian* Poet [i.e. Ludovico Ariosto] of the Moderns gave to one of his Heroes [in *Orlando Furioso*, 1516]', on condition that he will make no Icarian 'extravagant Flight' but rather 'keep closely to this Orb of *Earth*' (*Moralists* 298 [382]).[64]

This image of a controlled aerial artistic autonomy, where, as William Smith recognized in his popular reading of Longinus in 1739, '[t]*he Space between Heaven and Earth* marks out the Extent of the Poet's Genius', might seem incompatible with more emphatic negative claims.[65] It might indeed be tempting to subscribe to a traditional polarity between, on the one hand, the negative disposition of religious enthusiasm and, on the other hand, the positive disposition of poetic enthusiasm. However, such a distinction would risk omitting that there is a persistent liminal value in the very concept of enthusiasm, where negative claims unintentionally intersect with the idealized Longinian principles of the ecstatic and concentrated emotional transport of the agent's consciousness, and passion finally is perfected when it 'bursts out in a

[64] See Ludovico Ariosto, *Orlando Furioso*, trans. David R. Slavitt (Cambridge, MA: Harvard University Press, 2009), where the mythological Hippogryph is a winged steed (with the body of a horse and the head of a griffin) that holds a 'will of its own' (6.23). The Hippogryph 'chase through the air like an eagle' (4.33). On the Hippogryph, Astolfo (cousin of the hero Orlando) flies 'to that highest mountain peak that is thought to be close to the moon's orbit' (34.48). For further comments, see Marianne Shapiro, *The Poetics of Ariosto* (Detroit, MI: Wayne State University Press, 1988), esp. 111–22.

[65] William Smith, 'Some Account of the Life, Writings *and* Character of *Longinus*', in *Dionysius Longinus on the Sublime* (London, 1739), xix.

wild gust of mad enthusiasm [ἐνθουσιαστικῶς] and as it were fills the speaker's words with frenzy'.[66]

Here, it is useful to make a rough distinction between a *thin* and a *thick* meaning of the British late-seventeenth- and early-eighteenth-century notions of enthusiasm. In a *thin* meaning there is of course a difference between someone arguing that enthusiasm and religious zeal should be verified by the perseverance of reason, and someone arguing that a genuine aesthetic experience is supported by an ecstatic moment of transport, rampant enthusiasm, and a slight disintegration of reason. Here we appear to encounter an all-too-familiar scientific abyss between, on the one hand, a mode of emotional *subjectivity* referring to an aesthetic experience characterized by ecstasy and its internal sentimental effects on the recipient and, on the other hand, a mode of rational *objectivity*, referring to truth as an 'external (even cosmic) scheme of things apprehended as undeniably "out there"'.[67] Within the confines of the *thin* meaning of enthusiasm, Addison is destined to appear inconsistent, since he, on the one hand, claims that in order to police the zealous religious enthusiasm we must 'keep our Reason as cool as possible, and to guard our selves in all Parts of Life against the Influence of Passion, Imagination, and Constitution' (*S* II, 289; 201) and, on the other hand, persistently idealizes the sublime power of an ecstatic *je ne sais quoi*, where the apotheosis of the creative imagination consists precisely in enabling the recipient to be 'struck, we know not how, with the Symmetry of any thing we see' (*S* III, 538; 411).

One way to avoid getting caught up in this *thin* meaning of enthusiasm involves refraining from simply taking historical claims at face value. The persistently resurfacing categories (us–them; sanity–madness; truth–falsehood; reason–imagination) in the critique of radical religious enthusiasm are simply applied in a too politically tendentious and polemical manner to be straightforwardly accepted without further reflection.[68] Brian Vickers has shown just how the

[66] Longinus, *On the Sublime*, 59. On the notion of *ekstasis* and the famous thunderbolt simile, see ibid., 43. See also Stephen Halliwell, *Between Ecstasy and Truth: Interpretations of Greek Poetics from Homer to Longinus* (Oxford: Oxford University Press, 2011), 327–66.
[67] Halliwell, *Between Ecstasy and Truth*, 331. Halliwell makes this relevant claim with reference to ecstasy and truth in Longinus' treatise. Longinus does not adopt a 'non- or anti-cognitivist construal of the mind's responsiveness to sublimity', but applies, as Halliwell remarks, a 'cognitivist model of the sublime, a model in which thought and emotion – both focusing themselves on what Longinus takes to be permanent features of reality ... – work in close harness' (336–7). Hence a distinction between emotional subjectivity and external objectivity is problematic. Truth seems to be valid in both modes.
[68] A crucial point made by Brian Vickers, 'The Royal Society and English Prose Style: A Reassessment', in Brian Vickers and Nancy S. Struever, *Rhetoric and the Pursuit of Truth: Language Change in the Seventeenth and Eighteenth Centuries* (Los Angeles: William Andrews Clark Memorial Library, University of California, 1985), esp. 41–2.

propagandists of the scientific movement merged with the Church of England in the critique of the religious enthusiasts, by structuring a 'self-validating myth of their plain style and rational proceeding'.[69] The verbal attacks on the enthusiasts cannot be accurately identified as honest attempts to restructure the scientific prose style but must be recognized within a political context, where established institutions try to confront a potentially morally subversive constituent that one fears might endanger society. Addison's self-contradictory claims seem to require a very similar exegetical sensitivity to the conditions of the claims themselves, for their implications to be intelligible.

A *thick* meaning of enthusiasm, then, acknowledges the relevance of such conditions by accepting that a general distinction between religious enthusiasm and poetic enthusiasm is not a clear-cut separation ready to be explored by the historian, and that the condemnation of radical religious enthusiasm is frequently occurring within a polemical and partisan context where political and religious authorities are systematically attempting to attribute a politically subversive feature to their opponents.[70] By arguing for a restrained creative imagination when addressing extreme religious devotion, Addison is certainly not saying that reason should detract from the imagination in general. He is, as we can see, rather ascribing to a historically forceful political strategy within the established Church to proclaim *itself* as the arbiter of reason and truth by belittling moral alternatives.

On a general political level, it is accurate to bring out the fact that altered political conditions gradually affected the approaches to enthusiasm after the Revolution.[71] Addison's Whig position towards radical enthusiasm was no exception, and his view was arguably influenced by him now being part of the governing political power. The critique against religious enthusiasts thus became a crucial part of a larger semi-secular discourse on polite sociability, where the aim was, as Klein argues, 'the depiction of a sociable religion, a religion that could be imagined as decorous in its rituals and affable in the behavior of its adherents'.[72] In the early eighteenth century, religious enthusiasm thus had less to do with the propriety of Christian faith as such, and more to do with the

[69] Ibid., 42.
[70] See Irlam, *Elations*, 23. After the 1650s and the end of the English Civil War, enthusiasm 'became a labile political term liberally applied to almost all perceived enemies of Church and State, every variety of theological and political discontent (Puritan, Papist, Quaker, Antinomian, Leveller, Digger, Ranter, Illuminist, etc.) and a legion of social "pathologies"'.
[71] See Lawrence E. Klein, 'Sociability, Solitude, and Enthusiasm', in *Enthusiasm and Enlightenment in Europe, 1650–1850*, ed. Lawrence E. Klein and Anthony J. La Vopa (San Marino, CA: Huntington Library, 1998).
[72] Ibid., 164.

overall conduct of moral agency. While '[e]nthusiasm remained an enemy of true religion', it became, as Klein observes, for Addison 'an enemy of gentility as well'.⁷³ Indeed, as we observed earlier, Addison's brief notes on the ascendancy of morality above Christian faith plant an interesting and revealing seed of doubt about his theological interests in the rhetorical attacks on radical religious zeal and enthusiasm overall. What Addison does is that he exploits the historical *topoi* in the critique on religious enthusiasm, where philosophy and theology engage and express their anxieties of the potential threats of extremism in relation to established political and moral authorities. Having been written in the early eighteenth century, his critique is, however, fated to be less disturbed by the details of the destabilization of religious faith, than by the subversion of private and public ethics.

It is suggestive of the value Addison ascribes to a normative regime of taste that extreme religious devotion somewhat dutifully and routinely refers to religious concerns, while it is eagerly linked to a concrete ethico-political context. An uncontrolled religious enthusiasm is, according to Addison, the property of a radical spiritual zealot. Common to the 'most Zealous for Orthodoxy' is their 'Intimacies with vitious immoral Men' (*S* II, 228; 185). Religious zeal is, to Addison, problematic, since it is intersected with self-centred interests. When radical zealots appear in the shape of religious infidels, Addison is offended by their irrational 'Creed' declaring the 'Mortality of the Soul, the fortuitous Organization of the Body, [and] the Motions and Gravitation of Matter', which oddly enough make the infidels insist on an 'infinitely greater measure of Faith than any Sett of Articles which they so violently oppose' (*S* II, 230; 185).

Similar to what we have observed regarding the ecstatic transport of religious and poetic enthusiasm, religious zeal is, however, certainly not rejected overall, but only when it is part of a threat that endangers the political *whole*. Christian faith is of course incontestable as an intrinsic property. But what is interesting is that the beating heart of Addison's remarks on faith and enthusiasm is the critical moral value we can redeem of true faith for the agent and for Britain as a political *whole*. Faith is expected to improve personal as well as societal morality, and if it fails in its proper task (as in the case of the 'false Zealots in Religion'), 'Faith is vain', and 'Religion unprofitable' (*S* II, 229; 185). However, when the true zeal – that 'generous and publick-Spirited Passion' (*F* 55; 5) – achieves its moral end and reinforces private and national principles, it is a cogent and embraced force: 'I love to see a Man zealous in a good matter, and especially when his

⁷³ Ibid., 167.

Zeal shows it self for advancing Morality' (*S* II, 229; 185). A true zeal is, from Addison's Whig perspective, furthermore cohesive to the moral fortification of Britain as a whole, where we are commended to the 'Practice of that Vertue', that is 'call'd *The Love of one's Country*', which is a 'fix'd Disposition of Mind to promote the Safety, Welfare, and Reputation of the Community in which we are born, and of the Constitution under which we are protected' (*F* 55; 5). Accordingly, Addison stresses that King George I, in his speech to Parliament in January 1716, exhorted the citizens to be '*zealous Assertors of the Liberties of our Country*', with the aim of preventing political turmoil distinguished by 'arbitrary, tyrannick or despotick Power' (*F* 82; 10). As expected, a lack of politically motivated emotional zeal is also a threat to the national body politic in its entirety: 'THERE is no greater Sign of a general Decay of Vertue in a Nation, than a Want of Zeal in its Inhabitants for the Good of their Country' (*F* 55; 5).

The traditional discourse on extremist religious enthusiasm is, as we can observe, in the hands of Addison explicitly converted into a discourse on radical political enthusiasm. While Addison claims, in the *Spectator*, 20 October 1711, that an 'Enthusiast in Religion is like an obstinate Clown' (*S* II, 289; 201), he argues, in the *Freeholder*, 6 February 1716, that the confused '*Political Faith* of a Tory' is an emotional property of someone who acts like an 'obstinate Knight in *Rabelais*, that every Morning swallowed a Chimera for his Breakfast' (*F* 99; 14). Apart from confounding Cervantes' knight Don Quixote with Rabelais's noble giant Bringuenarilles (the windmill-swallower), the meaning of Addison's remarks should be clear enough. The political faith of a political enthusiast (an obstinate Tory), exercised by a 'Man in a Dream' that persists in a mental and immoral delusion where he experiences 'Objects that have no Reality or Existence' (*F* 99; 14), is similar to a religious enthusiast (an obstinate clown) who flings himself into a figment of the imagination and reveals an irrational emotional zeal and ecstasy.

The corrupt political enthusiast does not 'give Credit to any thing because it is probable, but because it is pleasing', and rather than following the moral law of reason, he turns his back on 'Matter of fact' to such an extent that he totally misplaces his 'Taste of Truth in political Matters' (*F* 99–100; 14). While this Tory enthusiast is politically malcontent he is already cut off from genuinely experiencing nature and art. A proper Christian faith and true religious zeal will, from Addison's perspective, ideally generate private morality and prevent immorality, which furthermore assists the preferred reproduction of ideal society. Aesthetic experience holds the capacity to position religious faith in an auspicious state where it can augment precisely such a generation. However,

the extremist emotional zeal of the Tory enthusiast revolves around a particular kind of corrupted self-interested gratification, where he praises an immoral political ecstasy and sacrifices rationality and truth. By doing so he exposes himself as politically subversive and as someone who acts in conflict with the moral Anglican who displays a true emotional and rational zeal coherent with the human instinct for new and uncommon aesthetic objects. While the zeal of the political Tory enthusiast is contrary to the natural predisposition of man, the moral Anglican preserves his *appetites* (curiosity) and *passions* (admiration), which enables him to emotionally experience the true pleasures of beauty, and by such an experience confirm the true reverence for the Deity:

> IT is very reasonable to believe, that part of the Pleasure which happy Minds shall enjoy in a future State, will arise from an enlarged Contemplation of the Divine Wisdom in the Government of the World, and a Discovery of the secret and amazing Steps of Providence, from the Beginning to the End of Time. Nothing seems to be an Entertainment more adapted to the Nature of Man, if we consider that Curiosity is one of the strongest and most lasting Appetites implanted in us, and that Admiration is one of our most pleasing Passions; and what a perpetual Succession of Enjoyments will be afforded to both these, in a Scene so large and various as shall then be laid open to our View in the Society of superior Spirits, who perhaps will joyn with us in so delightful a Prospect. (S II, 420; 237)

To conclude, the completion of the aesthetic experience of nature and art cannot accurately be characterized as a disinterested moment where perception terminates upon the object, because such a moment is for Addison always intentionally functioning to allow for the emotional epiphany of the Deity's power and an additional moral perceptiveness of the agent as well as of society. Given this *intentionality*, we approximate Addison's theory of taste with a stronger sense of consistency if we maintain that aesthetic experience holds an intermediate value. In earlier pages I have highlighted that Addison distinguishes between, on the one hand, knowledge and understanding and, on the other hand, the pleasures of the imagination. We might indeed wonder just how one can claim to enter a proper understanding or sensitivity of the Deity's power, while lacking a complete knowledge, or, indeed, in what manner one is able to take pleasure in experiencing God's beautiful providence without fully understanding its glorious composition. For Addison, these are, however, extraneous questions. While the knowledge of the mathematician who surveys Aeneas's voyage by the map permits him to reach matters of fact, the true aesthetic experience of nature

or art would have allowed him to enter an experience of a momentous ethico-emotive awareness of the Deity, as well as a personal failure to gain any proper knowledge of matters of fact about God's providence. While God, according to Addison, indeed has, as we have observed, provided a secret pleasure to the experience of nature and art that encourages us in our pursuit after a knowledge of God's providence, it is nevertheless a search that, as far as knowledge of matters of fact are concerned, must remain patently absurd and otiose.

However, the *pursuit* of knowledge remains imperative, since it perpetually leads us towards the desired emotional awareness of God's providence, including the awareness of our own insufficiency as human beings to achieve an absolute knowledge of such an omniscient power. After all, human beings can perceive only a part of true beauty. While, as Addison argues, the 'Providence in its OEconomy regards the whole System of Time and Things together', man simply remains unable to wholly 'discover the beautiful Connexions between Incidents which lye widely separated in Time, and by losing so many Links of the Chain, our Reasonings become broken and imperfect' (S II, 422; 237). However, neither our sensuous pleasures nor our awareness of the Deity is circumscribed by the fact that we lack the capacity to survey the complete beauty that transcends time and is perceived by the omniscient Deity. Ultimately, our pleasures and awareness must simply incorporate the primary recognition that 'little arrives at our Knowledge', and that 'those Parts in the Moral World which have not an absolute, may yet have a relative Beauty, in respect of some other Parts concealed from us, but open to his Eye before whom *Past, Present* and *To come*, are set together in one point of View' (S II, 422; 237). Our ability to take pleasure in experiencing nature and art does not rely on our mental disposition to experience a transcendent beauty or achieving an absolute knowledge of the Deity. According to Addison, we engage in nature and art because as human beings we are predetermined to pursue such pleasures in order to engage in God's providence and to act morally. By perfecting our morality, we can realize our natural disposition as human beings engaged in political society. A rhetorical strategy to distinguish between a morally accomplished man of taste and a vulgar one, and to allow for the prospects of art and the ethico-political values to move in a similar edifying direction and thus to constitute a convincing entity, consists, as we will see next, in exploiting a moral ethos about the national political *whole*, especially by claiming a strong nexus between British arts and classical ideals.

1.6

Britain and the new classicism

Men of letters showed a remarkable creativity in their eagerness to enquire into possible ties between Britain and the classical world of Rome and Greece. Such a creativity was often caught up in rediscovering political and artistic parallels, and by doing so bringing out patriotism and a sense of national superiority. A 'growing British nationalism liked', as Ayres remarks, 'to stress the superiority of the present political order to that of classical precedents', while of course maintaining any possible resemblance to the political principles of the classical world.[1] In this chapter, I will consider some of the ways classical ideals were established in order to accomplish an *othering* of continental cultures and to claim political and artistic superiority.

While we are today perhaps more familiar with Graecophilia as integral to German neohumanism,[2] it was also vital to the British discourse on taste and important for the vitality of the poetic philhellenism that reached a Byronic climax in the nineteenth century.[3] Reminiscent of German philhellenism, political liberty and the body politic, in general, were among British men of letters assumed to be fixed in a network of national artistic merits. No political liberty or historical body politic was regarded as more praiseworthy than the Greek polis ($\pi \acute{o} \lambda \iota \varsigma$).[4] Political absolutism may perhaps, as Addison stresses, work satisfactorily as long as the virtues and judgements of the sovereign remain elevated. But the moral arbitrariness of such political circumstances is of course anything but satisfactory. Besides, any natural virtue contains the potential of being disintegrated into

[1] Ayres, *Classical Culture and the Idea of Rome in Eighteenth-Century England*, xiv. Ayres addresses the idealized image of republican Rome in post-revolutionary Britain.
[2] See Suzanne L. Marchand, *Down from Olympus: Archaeology and Philhellenism in Germany, 1750–1970* (Princeton, NJ: Princeton University Press, 1996). Marchand's overall claim is that German philhellenism was 'an institutionally generated and preserved cultural trope' and that '[a]rt was the one realm in which ... the "ancients" had not been definitively defeated by the "moderns", and hence provided an ideal source for neohumanist pedagogical philosophy' (xix).
[3] See Terence Spencer, *Fair Greece, Sad Relic: Literary Philhellenism from Shakespeare to Byron* (London: Weidenfeld & Nicolson, 1954).
[4] Marchand, *Down from Olympus*, 9.

harmful vice, whenever exercised by an absolute sovereign: the 'Honest private Man often grows cruel and abandoned, when converted into an Absolute Prince' (*S* III, 20; 287). Immorality will ensue from tyranny, and when idealizing a classical past, Addison challenges the reader to 'Look upon *Greece* under its free States, and you would think its Inhabitants lived in different Climates, and under different Heavens, from those at present; so different are the Genius's which are formed under *Turkish* Slavery, and *Grecian* Liberty' (*S* III, 22; 287). In a culture with a thriving liberty such as Greece, 'Learning and all the Liberal Arts will immediately lift up their Heads and flourish' (*S* III, 21; 287). As Addison's own versifier Mark Akenside declared, in his ode to the tenth Earl of Huntingdon in 1748, when seeking out a position between his Whig patriotism and the classical patriotism of Pindar, '*great Poetical Talents, and high Sentiments of Liberty, do reciprocally produce and assist each other*'.[5]

It is with great confidence that many early-eighteenth-century philosophers and critics explore and mythologize historical continuity along with provinciality, when distinguishing the potential of the aesthetic experience to strengthen political society and reinforce national unity. Of course, Addison's essays remain a moral hub for any writer wishing to expand the political relevance of experiencing nature and art. Thus, for one of the most influential writers on painting at the time, Jonathan Richardson the Elder, it is 'worthy of a Gentleman to read *Horace, Terence, Shakespear*, the *Tatlers*, and *Spectators*'.[6] However, reading is not enough. A taste relying on verbal art must be supplemented by visual art which is, to Richardson, 'another sort of Writing'.[7] We shall pause briefly here to see just how someone like Richardson fashions his arguments about the art of painting to add force to a sense of national superiority.

In *A Discourse on the Dignity, Certainty, Pleasure and Advantage, of the Science of a Connoisseur* (1719), Richardson wishes to frame the Horatian call for integrating profit with pleasure, by means of delighting and instructing (*omne tulit punctum qui miscuit utile dulci,* | *lectorem delectando pariterque monendo*) within a new scientific setting.[8] Richardson is troubled by the fact

[5] Mark Akenside, *An Ode to the Right Honourable the Earl of Huntingdon* (London, 1748), 25. For a comment on Akenside's political and patriotic strains, see Dustin Griffin, 'Akenside's Political Muse', in *Mark Akenside: A Reassessment*, ed. Robin Dix (Cranbury, NJ: Associated University Presses, 2000).

[6] Jonathan Richardson, *A Discourse on the Dignity, Certainty, Pleasure and Advantage, of the Science of a Connoisseur* (London, 1719), 38.

[7] Ibid., 17.

[8] Horace, *Ars poetica*, 343–4. See also Carol Gibson-Wood, *Jonathan Richardson: Art Theorist of the English Enlightenment* (New Haven, CT: Yale University Press, 2000), 145–6. Gibson-Wood stresses the relevance of the Horatian dictum in relation to Richardson's *An Essay on the Theory of Painting* from 1715. For a general overview of *A Discourse on the Dignity, Certainty, Pleasure and Advantage,*

that a 'Countrey as Ours, Rich and abounding with Gentlemen of a Just, and Delicate Taste' lacks '*Connoisseurs* in Painting'.[9] In 'particulars' such as poetry, music, and statesmanship, these gentlemen are unrivalled – 'there is no Nation under Heaven which we do not excel' – but when it comes to painting there is a lack of education.[10] Hence, Richardson suggests a new science, a new branch of knowledge: *The Science of a Connoisseur* (or what he refers to by the French term *connoissance*). Naturally, this science vouches for a 'New Scene of Pleasure', but, along the Horation decorum, it also promises to increase 'Reputation, Riches, Virtue, and Power'.[11] By effective trickle-down effects, the *connoissance* of gentlemen – 'our Nobility, and Gentry' – is expected to influence 'the Common People' and to 'be of great Advantage to the Publick' by not only reforming manners, but by 'Increas[ing] ... our Wealth'.[12] Thus, Richardson's confident narrative of art takes as a fact that 'Our Common People have been exceedingly Improv'd within an Age' and that the 'whole Nation would by' *connoissance* 'be removed some Degrees higher into the Rational State, and make a more considerable Figure amongst the Polite Nations of the World'.[13] Here, Richardson's arguments become fascinatingly instrumental. A *connoissance* that increases British wealth and adds imperial 'Power to this Brave Nation' is simply 'Means to attain this End'.[14]

The conditions to achieve such an end are furthermore very promising. The historical structure of art and politeness are, according to Richardson, in 'constant Rotation' and at this specific moment in history (early eighteenth century) we are witnessing a 'certain Revolution of Time'.[15] Trickle-down effects are clearly expected also in history itself: ancient Greek culture cultivated art because of improvements in Egypt and Persia; Italian culture received its impetus from the Greeks; and 'These parts of *Europe* have twice received them from *Italy*'.[16] The good news is that the exceptional liberty stemming from the 'Glory of Reformation' and the 'Glory of the Protestant Church', and especially

of the *Science of a Connoisseur* (which constituted part 2 of Richardson's *Two Discourses*), see Gibson-Wood, *Studies in the Theory of Connoisseurship from Vasari to Morelli* (New York: Garland, 1988), 95–137.

[9] Richardson, *A Discourse on the Dignity, Certainty, Pleasure and Advantage, of the Science of a Connoisseur*, 3–4.
[10] Ibid., 4.
[11] Ibid., 7 (pleasure) and 41 (reputation).
[12] Ibid., 8 (nobility and gentry), 44 (common people), 41 (wealth). On trickle-down effects, see also Gibson-Wood, *Jonathan Richardson*, 202.
[13] Ibid., 46–7.
[14] Ibid., 62.
[15] Ibid., 52.
[16] Ibid.

of the Church of *England*', which Richardson argues is the 'Best National Church in the World', has prepared pious citizens for becoming connoisseurs who freely form their judgements of taste ('Here we are all *Connoisseurs* as we are Protestants').[17] And since art is 'now a third time much declin'd in *Italy*; Some Other Countrey may succeed Her in This particular, as she succeeded *Greece*'.[18] There is no ambiguity concerning which country Richardson has in view: If the 'Great Taste in Painting' ever will 'revive in the World 'tis Probable 'twill be in *England*'.[19]

A very similar claim is made in *An Essay on the Theory of Painting*, published four years earlier, and not merely addressed to future connoisseurs, but to painters themselves or anyone already accustomed to the power of visual art. Here, Richardson states firmly that apart from being 'useful to Improve and Instruct us', painting is 'greatly *instrumental* to excite proper Sentiments and Reflections', and a good painting is much like 'a History, a Poem, a Book of Ethics, or Divinity is: The truth is, they mutually assist one another'.[20] The aesthetic value of experiencing such a painting goes well beyond art itself. Anyone engaged here is namely expected to add to the vigorousness of the body politic by instinctively advancing 'more Love to his Country, more moral Virtue, more Faith, more Piety and Devotion'.[21] Although Richardson claims that paintings speak in a language that is universal, there is clearly a variety of artistic accents that appeal to different cultural temperaments, since the painter is always 'speaking' to the spectators 'in their own Mother Tongue'.[22] Ultimately, a painting, and the aesthetic experience of it, has an exceptional power to strengthen national identities by reinforcing the virtuousness of each citizen, thus allowing the public to rise as one man and facilitate the true values of art.

Here, Richardson stretches out the historical continuum by relating a story about a performance of an ancient tragedy by Aeschylus. In the performance a short approval of impiety occurs, producing a moral reaction from the audience, which consists of individuals who have proved their virtuousness in the past when defending their country in the Graeco-Persian wars and preserving Greek liberty. When, according to Richardson, '*Amynias* [Aeschylus' brother] immediately leap'd upon the Stage, and produced his Shoulder from whence

[17] Ibid., 230–1. See also Carol Gibson-Wood, 'Jonathan Richardson and the Rationalization of Connoisseurship', *Art History* 7, no. 1 (1984), 50.
[18] Ibid., 52.
[19] Ibid., 53.
[20] Jonathan Richardson, *An Essay on the Theory of Painting*, 2nd edn (London, 1725), 11. My italics.
[21] Ibid., 13.
[22] Ibid., 4.

he had lost his Arm at the Battle of *Salamis*' the audience naturally 'condemn'd *Æschylus*, but gave his Life to his Brother *Amynias*'.²³ Here, Richardson cannot restrain from crying out, 'These were *Greeks*! These were the People who shortly after carry'd Painting, and Sculpture to so great a Height'.²⁴ Hence, while Aeschylus' performance is sent off track, it is immediately put right by a united, virtuous, and patriotic audience. Since Aeschylus himself had participated in the infantry ranks in the battle of Marathon and in the battle of Salamis, the audience's response is, to Richardson, sound.

The parallel between the story and the reality of early-eighteenth-century Britain is not long in coming: British art is at last prepared to fulfil its purpose since, according to Richardson, 'No Nation under Heaven so nearly resembles the Ancient *Greeks*, and *Romans* as We'.²⁵ This resemblance is supposed to emerge from a free association with the anecdote retold earlier, since '[t]here is a Haughty Courage, an Elevation of Thought, a Greatness of Taste, a Love of Liberty, a Simplicity, and Honesty among us, which we inherit from our Ancestors, and which belong to us as *Englishmen*; and 'tis in These this Resemblance consists'.²⁶ Here, then, Richardson is not merely referring to artists or art anymore, but to a general group of patriotic citizens ('I could exhibit a long Catalogue of Soldiers, Statesmen, Orators, Mathematicians, Philosophers') who 'do Honour to Our Country'.²⁷ This blurring of identities is unproblematic for Richardson. A synthesis of the identities of artists and loyal citizens is exactly what he is trying to accomplish, since they all interrelate in a patriotic moral purpose.

Richardson avoids proposing a national painter of dignity (even though he notes that the Flemish painter Anthony van Dyck, when knighted and included in the court-circles of Charles I, 'brought *Face-Painting* to Us', and that since then '*England* has excell'd all the World in that great Branch of the Art')²⁸ because 'National Virtues sprout up first in Lesser Excellencies, and proceed by an Easy Gradation'.²⁹ But he observes that '*Greece*, and *Rome* had not Painting and Sculpture in their Perfection till after they had exerted their Natural Vigour in Lesser Instances', before concluding that when the 'Ancient Great, and Beautiful Taste in Painting revives it will be in *England*'.³⁰

[23] Ibid., 220.
[24] Ibid.
[25] Ibid., 222–3. See also Gibson-Wood, *Jonathan Richardson*, 172.
[26] Ibid., 223. See also Anthony D. Smith, *National Identity* (London: Penguin Books, 1991), 85.
[27] Ibid.
[28] Ibid., 39.
[29] Ibid., 224.
[30] Ibid.

Unlike German philhellenic beliefs that modern political society neglected the taste, beauty, and wisdom of the classical world,[31] British men of letters did not, then, generally wish to reconcile possible differences between political society, art, and the classical age. Instead, they often resorted to ancient standards in attempts to prove the *fons et origo* of British arts and politics. As Dennis claimed, in *An Essay on the Opera's after the Italian Manner*, because Italian opera was 'soothing the Senses' and made man excessively self-interested – 'too much in love with himself' – it was 'emasculating and dissolving the Mind' and undermining the British 'publick Spirit'.[32] In an effort to save the '*British* Muse' by 'timely Prevention' of the deeply immoral and effeminate sensual pleasures attacking from the European continent,[33] Dennis argued that he was looking after the 'real Interests' (namely public virtue, rationality, and national liberty) of his *natale solum*.[34] In the end, Britain was not thought to be different from classical antiquity. Thus, when warning his compatriots against the immoral political effects of acquiescing to the shape of Italian opera, it was natural for Dennis to stress that 'Declension of Poetry in *Greece* and antient *Rome*, was soon follow'd by that of Liberty and Empire'.[35]

While Dennis famously questioned Rymer in *The Impartial Critick* (1693) (especially on the artistic potential of the ancient chorus in modern English theatrical performances), they were actually not that far off from each other when nostalgically addressing especially the ethico-political principles of theatrical representations.[36] In his position as Historiographer Royal (taking office in 1692) for William III, Rymer was not slow to suggest a model of the superiority of the artists of classical Greece (the Romans were 'wonderful jealous' of '*Grecian Arts*'), due to their alleged submissiveness to political principles and objectives.[37] In a moment of sentimental retrospective, Rymer addressed the

[31] See Marchand, *Down from Olympus*, 9.
[32] Dennis, *An Essay on the Opera's after the Italian Manner*, 389.
[33] Ibid., 386.
[34] Ibid., 385.
[35] Ibid., 390.
[36] See John Dennis, *The Impartial Critick: Or, Some Observations upon a Late Book, Entituled, a Short View of Tragedy, Written by Mr. Rymer*, in *The Critical Works of John Dennis*, vol. 1, ed. Edward Niles Hooker (Baltimore, MD: Johns Hopkins Press, 1939), esp. 11–14. Dennis did not have reservations about the relevance of the chorus in the historical Greek tragedy, but claimed that the chorus would 'ruine the *English Drama*' if it was applied in the modern age: 'For to set up the *Grecian* Method amongst us with success, it is absolutely necessary to restore not only their Religion and their Polity, but to transport us to the same Climate in which *Sophocles* and *Euripides* writ' (11).
[37] Rymer, *A Short View of Tragedy*, 25. Roman poets were, according to Rymer, too occupied with 'Show', meaning that their 'Genius dwelt in their eye; there they fed it, there indulg'd and pamper'd it immoderately' (28). Indeed, Rymer acknowledged that the Romans' '*Theatres* and their *Amphitheatres* will always be remembered, tho their *Tragedy* and *Comedy* be only shadow; or *Magni Nominis umbra*' (28).

'days of *Aristophanes* ... when it was on all hands agreed, that the best *Poet* was he who had done the most to make men vertuous and serviceable to the Publick'.³⁸ Along those lines, Aeschylus' great tragedies incited and secured, from Rymer's perspective, political loyalty among the citizens, '[s]o when his *Princes at Thebes*, and when his *Persians* were acted, not a Spectator, but bit his Thumbs with impatience for the Field, to give the Enemy Battel'.³⁹ These classical tragedies did nothing less than drive the 'Countrey-men to Vertue, and provoke them to a generous Emulation'.⁴⁰ The relation between the poet – who like Aeschylus ideally '*ran a Muck* at all manner of Vice' – and the audience was, or so Rymer believed, the same as a moral bond between a teacher and a child.⁴¹ The political authority exercised by governments in order to regulate the moral principles of the poets was not thought to conflict with personal liberty or emancipation. In fact, it was precisely the intimate bond between political impact and poetry that, according to Rymer, fortified personal and artistic liberty. While the agent's eye was occasionally too *quick* a sense, there was nevertheless a 'special eye' belonging to a 'Virtuous Government' that might, according to Rymer, hinder theatrical performances from converting into the '*Pest of Common-wealths*'.⁴² A systematic political participation ensured, according to Rymer, artistic taste, as well as public moral progression.⁴³ By, on the one hand, learning from a glorious ancient past and, on the other hand, deepening and cultivating a classical model of the intersection between political power and theatrical performances, a national moral agency and taste could ultimately be reformed.

The productive alliance between aesthetic experience and national public interests would persist, with shifting intensity, well into the second half of the eighteenth century. If one thought, as Henry Home (Lord Kames) did in

[38] Ibid., 21. See also, 41: 'When King *Archelaus* [of Macedon, 413–399 BC] asked *Plato* what book he might read to learn the state of Affairs and Government in *Athens*, *Plato* bid him only to read *Aristophanes*'. See also Paul D. Cannan, '*A Short View of Tragedy* and Rymer's Proposals for Regulating the English Stage', *The Review of English Studies* 52, no. 206 (2001), esp. 211. Cannan claims that the most distinguishing quality of Rymer's *A Short View of Tragedy* is precisely a 'sense of national individuality' where Rymer demonstrates an 'almost unprecedented appreciation for the interrelation between literature and social environment' (210).

[39] Ibid., 21.

[40] Ibid., 22.

[41] Ibid.

[42] Ibid., 50.

[43] See also Cannan, '*A Short View of Tragedy* and Rymer's Proposals for Regulating the English Stage', 211. It is also, as Cannan concludes, the fact that Shakespeare's *Othello* was produced without governmental direction that set off Rymer's famous attack on Shakespeare's tragedy: 'That Rymer's aim is not merely to malign Shakespeare is also evident in the fact that he offers a solution to the problems *Othello* makes manifest: to increase government involvement in the English stage, and to reintroduce the ancient chorus into modern tragedy as a means of regulating dramatic expression and interpretation' (221).

Elements of Criticism (1765), that a 'taste in the fine arts' was 'nearly allied' to a moral sense, and that the fine arts,⁴⁴ similar to morals, might turn into a 'rational science',⁴⁵ one easily proceeded into issues about national identity. Unsurprisingly, Kames holds that to 'promote the fine arts in Britain, has become of greater importance than is generally imagined', the reason being that the corrupted end result (selfishness) of a thriving commerce and opulence 'extinguishes the *amor patriæ*, and every spark of public spirit'.⁴⁶ The most effective manner to prevent private vices from infecting public virtues, and to avoid corrupting the British body politic, was, according to Kames, to strengthen the status of the arts. Along these lines, Kames asks rhetorically, since 'ancient Greece furnishes one shining instance' of such reinforcement, 'why should we despair of another in Britain?'⁴⁷

Homi K. Bhabha's observation that '[n]ations, like narratives, lose their origins in the myths of time and only fully realize their horizons in the mind's eye' holds true also for early-eighteenth-century Britain.⁴⁸ Myths about a glorious past, and confidence in a moral common purpose, were (and still are) essential for ideas about national identities. To add force to a shared self-image of continuity and progress, one also had to let the tie between Britain and classical antiquity coalesce with a particular provincial nature of arts and society. An effective common history could not simply be composed of transnational, artistic, or static political duplication. Identities are elusive and fluid, and a shared past – engaging idealized ideas about historical continuity and inclusion, as well as interruption and exclusion – had to be dynamically and originally (re)created to maintain any relevance whatsoever.

True originality surfaced from a spirited reproduction of, and self-identification with, a classical paradigm. To become inimitable (*unnachahmlich*), one had to advance, as Richardson's 'diligent student' Winckelmann observed, from the imitation (*die Nachahmung*) of the ancients.⁴⁹ Authentic inimitability originated from the artistic imitation of originality. But at the same time, if, as Dabney Townsend stresses, 'native Britain was to compete with classical Greece

⁴⁴ Henry Home (Lord Kames), *Elements of Criticism*, vol. 1, 3rd edn (Edinburgh, 1765), 5.
⁴⁵ Ibid., 6.
⁴⁶ Ibid., vii.
⁴⁷ Ibid.
⁴⁸ Homi K. Bhabha, 'Introduction: Narrating the Nation', in *Nation and Narration*, ed. Homi K. Bhabha (London: Routledge, 1990), 1.
⁴⁹ Johann Joachim Winckelmann, *Gedanken über die Nachahmung der griechischen Werke in der Malerei und Bildhauerkunst*, in *Kunsttheoretische Schriften* 1, Studien zur deutschen Kunstgeschichte, vol. 330 (Baden-Baden: Heitz, 1962), 3. On the impact of Richardson on Winckelmann's writings, see e.g. Katherine Harloe, *Winckelmann and the Invention of Antiquity: History and Aesthetics in the Age of Altertumswissenschaft* (Oxford: Oxford University Press, 2013), 70–94.

and Rome, it was felt that it must have its own classical age'.⁵⁰ How could one then be self-determining and independent without compromising the historical sustainability of one's views over a wider time frame? To answer such a question, we need to understand the *relational* properties of national identity and nationalism, and that national evaluations and experiences of art did not simply refer to the European continent with the intention of developing new artistic ideas, but rather to 'assert the superiority'.⁵¹

We have already observed Addison's adverse position to France and Catholicism, and the strategies for distancing British arts and politics from circumstances on the continent advanced on various societal levels. While the Counter-Reformation continued on the continent, the Protestant Reformation was, as Colley argues, still progressing in Britain, and even if the legal system reduced the autonomy and power of Catholics in civil society, Protestantism was often assumed to be in danger of aggressive Catholicism.⁵² A common antagonist was essential to a sense of a shared moral standard. The 'emerging sense of Britishness' did not merely evolve from 'consensus or homogeneity or centralisation at home', rather 'the essential cement' turned out to be a 'strong sense of dissimilarity from those without'.⁵³ A developing sense of national identity was thus depending on inclusion as well as exclusion (although any successful exclusion had to be, as it were, integrated in a preferred identity). In the words of Colley,

> men and women came to define themselves as Britons – in addition to defining themselves in many other ways – because circumstances impressed them with the belief that they were different from those beyond their shores, and in particular different from their prime enemy, the French.⁵⁴

One should neither take the presence of internal discrepancies in religion and culture, during the time of the Act of Union, too lightly, nor underestimate that a sense of nationhood was at the time, as Frank O'Gorman argues, 'not a theoretical construct but an active and practical catalyst for the creation and definition of people's identities'.⁵⁵ Early-eighteenth-century Britain can be

⁵⁰ Townsend, 'Introduction: Aesthetics in the Eighteenth Century', 6. Townsend makes his remark with reference to the Ossian imposture.
⁵¹ Mark A. Cheetham, *Artwriting, Nation, and Cosmopolitanism in Britain: The 'Englishness' of English Art Theory since the Eighteenth Century* (Farnham: Ashgate, 2012), 15–16.
⁵² Colley, *Britons*, 19–23.
⁵³ Ibid., 17.
⁵⁴ Ibid.
⁵⁵ O'Gorman, *The Long Eighteenth Century*, 62. O'Gorman is not suggesting that the developing nation did not contain a great deal of political and religious frictions. See also Colin Kidd, 'Protestantism, Constitutionalism and British Identity under the Later Stuarts', in *British Consciousness*

characterized as 'an increasingly centralized body politic but one with powerful local variations in its political, religious and economic life'.[56] While we know that such differences were real, and that distinctly fixed or unchallenged identities are myths themselves, we can even so recognize that a new sense of national distinctiveness was approaching (or, if you prefer, a new narrative; in the words of Geoffrey Bennington, '[a]t the origin of the nation, we find a story of the nation's origin').[57] As O'Gorman argues, '[i]n the quarter of a century after the Glorious Revolution, indeed, a British national identity, born of tradition, Protestantism, war against France and, increasingly, commercial and colonial achievement, was emerging'.[58] As we have already seen, a vital component for the disposition of such an identity consisted in identifying the threatening *Other*, such as France, the catholic haven for the forced abdication of James II, representing, from the horizon of Addison and Shaftesbury, an absolute body politic in poor health.[59] However, while Addison remained largely unconcerned with any of man's deeper moral motive forces behind, and possible beneficial outcomes of, constantly identifying a fearsome *Other*, Shaftesbury actually showed an inclination to problematize the latter. In *Sensus Communis* he admits that it is paradoxically 'in War that the Knot of *Fellowship* is closest drawn' and 'mutual Succour is most given, mutual Danger run, and *common Affection* most exerted and employ'd' (*Sensus Communis* 82 [113]). However, conflicts and war remain, of course, precarious routes to tread, according to Shaftesbury, especially since the emotional span between struggles for the *right* ethico-political ends, and the risk to reach the *wrong* ends, is infinitesimal.[60]

The wavering between provinciality (*othering* cultures and stressing cultural difference) and a transcultural quality (pursuing a cultural and historical continuum) have the same end for Addison: a disconnection of assumed national features from an unwanted and threatening cultural characteristic, thus offering a promise of moral and artistic supremacy. I agree with Alok Yadav's claim that British neoclassicism promoted imperial interests and a nationalistic ethos.[61]

and Identity: The Making of Britain, 1533–1707, ed. Brendan Bradshaw and Peter Roberts (Cambridge: Cambridge University Press, 1998).
[56] Ibid.
[57] Geoffrey Bennington, 'Postal Politics and the Institution of the Nation', in *Nation and Narration*, ed. Homi K. Bhabha (London: Routledge, 1990), 121.
[58] O'Gorman, *The Long Eighteenth Century*, 62.
[59] Colley, *Britons*, 17.
[60] Shaftesbury stresses (*Sensus Communis* 82 [113]) that 'by a small misguidance of the Affection, a Lover of Mankind becomes a Ravager: A Hero and Deliverer becomes an Oppressor and Destroyer'.
[61] Alok Yadav, *Before the Empire of English: Literature, Provinciality, and Nationalism in Eighteenth-Century Britain* (New York: Palgrave MacMillan, 2004), 159. Yadav is referring to Addison.

But Yadav does not want to render metropolitan centrality to neoclassicism and instead acknowledges it in terms of provincial anxiety. Thus, he pushes the sense of historical continuum into the background.[62] Yadav addresses classicism primarily in terms of (Aristotelian) poetic rules, which then causes him to claim, in the main, that national particularities arose from the rejection of such poetics.[63] In my opinion, the theories of taste did not simply problematize and discard the classical rules of poetry in order to claim cultural autonomy: in fact, they drew on an idealized image ascribed to classical antiquity (even if this was done in an associative manner), in order to enable the amplification of their own national ethos.[64] Consequently, the British body politic obtained strength from being provincial in othering continental cultures and from mounting a discriminatory transcultural bond to classical antiquity.

In a similar way in which the presence of Troyan or Teutonic myths in philosophy and the arts aided the creation of a self-image which asserted parallels between Britain and a godly past, the link between Britain and the classical world presented an opportunity to position oneself and others in time and space, and to give worth to one's moral being and the political *whole* itself.[65] Whether such a disposition matched reality was not the issue. What mattered was, as Krishan Kumar has shown, that the 'joint parents of European civilization, Greece and Rome, could be treated heuristically' and as such separated from 'their actual, messy, reality'.[66] Every kind of 'historical comparison … involve[s] selectivity, but classical parallels were especially in need of trimming and filtering'.[67] Thus, classical Greece and Rome were, as we have seen, frequently applied as 'tropes, figurative or metaphorical symbols'.[68] By the time the architect of the King's Works, Robert Adam, published his *Ruins of the Palace of the Emperor*

[62] Ibid., 2–3.
[63] Ibid., e.g. 136–53. Yadav demonstrates how George Farquhar (1678–1707) rejects the employment of Aristotle's rules of poetry to English drama and emphatically accentuates the cultural difference between Britain and classical Greece, to reinforce a national particularity.
[64] Cf. ibid., e.g. 139–42.
[65] On the dominating myths in English history (Troyan/Arthurian myths, and Teutonic/Anglo-Saxon myths), see Hugh A. MacDougall, *Racial Myth in English History: Trojans, Teutons, and Anglo-Saxons* (Montreal: Harvest House, 1982). On the analogies exploited between Britain and a godly past, see Colley, *Britons*, 30–43. On the bearing of the myths in the arts, see Ken McLeod, 'Ideology and Racial Myth in Purcell's *King Arthur* and Arne's *Alfred*', *Restoration: Studies in English Literary Culture, 1660–1700* 34, nos 1–2 (2010). On the Teutonic origin of Britain, see MacDougall, *Racial Myth in English History*, 81–2. For illustrative mid-eighteenth-century accounts, see Montesquieu, *De L'Esprit des Lois*, in *Oeuvres complètes de Montesquieu*, vol. 3, ed. Catherine Volpilhac-Auger (Oxford: Voltaire Foundation, 2008), 238; and David Hume, *The History of England: From the Invasion of Julius Caesar to the Revolution in 1688*, vol. 1 (Indianapolis, IN: Liberty Fund, 1983), 160–1.
[66] Krishan Kumar, 'Greece and Rome in the British Empire: Contrasting Role Models', *Journal of British Studies* 51, no. 1 (2012), 82.
[67] Ibid., 81.
[68] Ibid., 82.

Diocletian at Spalatro in Dalmatia (1764), he plainly presupposed the legitimacy of the general view that this was indeed the 'time when the admiration of the Grecian and Roman Architecture [had] risen to such a height in Britain, as to banish in a great measure all fantastic and frivolous tastes'.[69] As is also observed by historian David Spadafora, eighteenth-century Britons were, according to Adam, simply witnessing the signs of an 'Æra no less remarkable than that of PERICLES, AUGUSTUS, or the MEDICIS'.[70]

[69] Robert Adam, *Ruins of the Palace of the Emperor Diocletian at Spalatro in Dalmatia* (London, 1764), 4.
[70] Ibid., iv. See also David Spadafora, *The Idea of Progress in Eighteenth-Century Britain* (New Haven, CT: Yale University Press, 1990), 72.

1.7

The perils of the foreign

Bickerstaff reports, on 18 April 1709, from Will's coffeehouse in Covent Garden, on received letters, about a celebrated performance of the opera *Pyrrhus and Demetrius* at the Queen's Theatre in the Haymarket (*T* I, 39–40; 4). Originally created by the Italian composer Alessandro Scarlatti and including a performance by the Neapolitan contralto Nicola Grimaldi (Nicolini), but arranged by the Irish-born manager Owen Swiny, *Pyrrhus and Demetrius* is in Bickerstaff's satirical account disturbing. The audience's enthusiastic response to this bilingual performance and artistic transculturation is politically scandalous and immoral. While the stage must involve an artistic performance intended for our rational mental faculties, *Pyrrhus and Demetrius* only manages to briefly hold these faculties in suspense before relinquishing to vulgar and deceitful sensuous pleasure. Even worse, due to a 'Degeneracy' of understanding, the Haymarket audience appears to be unable to realize that this is a politically dangerous pleasure presumably demoralizing the national character. Given the gravity of the situation, Bickerstaff reports that John Dennis naturally 'fell into Fits' after the performance, fearing 'Languages and Nations confus'd in the most incorrigible Manner'. Concluding his report from Will's coffeehouse, Bickerstaff laments having 'already inclin'd us to Thoughts of Peace' *Pyrrhus and Demetrius* could now 'infallibly dispirit us from carrying on the War' (*T* I, 39; 4).

The reciprocity between great art and the body politic could not be more affectedly stated than in Bickerstaff's report. While satirical in tone (especially targeting Dennis), it addresses a genuine concern with transculturation, which was frequently regarded as incompatible with an effective loyalty to political society. Instead of tying the political *whole* together, the performance of *Pyrrhus and Demetrius* sows moral dissension.

From the stance of early-eighteenth-century moralists, the principle of great art was its moral commitment, which contained a nationalistic or cultured ethos. Along with Virgil, Homer naturally shared a determination to write, according

to Addison, poetry 'founded upon some important Precept of Morality, adapted to the Constitution of the Country in which the poet writes' (*S* I, 299; 70). This was a hub for British moralists: to bring out a needed fit between artistic, moral, and patriotic ambitions. One of the great achievements of Homer and Virgil was, according to Addison, precisely that they 'celebrate Persons and Actions which do Honour to their Country' (*S* I, 300; 70). And naturally one of the profound mimetic drives of Milton – the poet that Addison claimed outdid both Homer and Virgil – was to reinforce the connection between his British ethico-poetic vocation and the greatest tradition of ancient poetry. As Milton stated himself in one of his antiprelatical tracts, *The Reason of Church Government* (1642), when giving a set of reasons for writing poetry in his native language and not in Latin:

> For which cause, and not only for that I knew it would be hard to arrive at the second rank among the Latines, I apply'd my self to that resolution which [Ludovico] *Ariosto* follow'd against the perswasions of [Pietro] *Bembo*, to fix all the industry and art I could unite to the adorning of my native tongue; not to make verbal curiosities the end, that were a toylsom vanity, but to be an interpreter & relater of the best and sagest things among mine own Citizens throughout this Iland in the mother dialect. That what the greatest and choycest wits of *Athens*, *Rome*, or modern *Italy*, and those Hebrews of old did for their country, I in my proportion with this over and above of being a Christian, might doe for mine.[1]

Homer, Virgil, and Milton all shared a moral commitment to unite a divided political realm into a *whole*. Such a commitment, accompanied by other qualities, made them paradigmatic poets and classical antiquity a natural origin of British poetry. Addison saw present political circumstances as an occasion for British artists to finally realize their true potential, even if he remained unsure about their capacity to seize this historic moment. Art sometimes had too important a moral value to be admitted to slip out of the hands of the artists, and Addison advised philosophers and artists to consider the significance of art. For instance, in an attack on the British stage Addison states the following on 1 August 1712:

[1] John Milton, *Complete Prose Works of John Milton*, vol. 1: 1624–1642 (New Haven, CT: Yale University Press, 1953), 810–12. For Milton's observations on poetry, see esp. the opening (811–23) to Book 2. Ralph A. Haug notes in the 'Preface' (736–44) that Milton's 'preface to Book II ... is perhaps the most quoted passage in the prose because in it he announces himself as a serious national poet, mentions the types of poetry he will write, and lays down at least the outlines of a poetic creed' (741). One of the principles registered by Milton was, as Haug observes, precisely that '[p]oetry must be in the language of the poet's country if it is to be truly national' (743).

Were our *English* Stage but half so virtuous as that of the *Greeks* or *Romans*, we should quickly see the Influence of it in the Behaviour of all the Politer Part of Mankind. It would not be fashionable to ridicule Religion, or its Professors; the Man of Pleasure would not be the compleat Gentleman; Vanity would be out of Countenance, and every Quality which is Ornamental to Human Nature, wou'd meet with that Esteem which is due to it.² (*S* IV, 66; 446)

An element of drawing on the natural connection between Britain and a glorious ancient past consisted in the belief that the very consequences of art occasionally could transcend time and space, and provided that the '*English* Stage were under the same Regulations the *Athenian* was formerly, it would have the same Effect that had, in recommending the Religion, the Government, and Publick Worship of its Country' (*S* IV, 66; 446).

Nowhere is the gravity of the intermediate instrumental value of art as clearly stated as in Addison's writings on Italian opera. While a play containing songs had sporadically been given the name 'opera' during the second half of the seventeenth century, the advent of the Italian form denoted a new step in the British history of music performance.³ This was taxing since it brought the nature of a national musico-dramatic idiom and its expected value to the fore, a matter gaining further momentum because of the immense popularity of Italian opera in London. The Italian opera immediately became, as Thomas McGeary argues, 'an active historical-social agent, with supposed effects on listeners, their moral character, and the temporal fate of Britain'.⁴ Such an agent carried the notorious traits of the overseas *Other*, which allowed, in the words of McGeary, 'critics to construct binaries that had the effect of articulating the valorized features of British political, social, and cultural identity'.⁵ If a successful individual and national identity was supposed to fall back on a particular kind of affective response, it was an unending challenge to deal with the constant appearance of

² For similar thoughts, see Berkeley, *An Essay towards Preventing the Ruin of Great Britain*, 67–85.
³ See Henrik Knif, *Gentlemen and Spectators: Studies in Journals, Opera and the Social Scene in Late Stuart London* (Helsinki: Finnish Historical Society, 1995), 40–3. For early illustrative examples of English semi-opera, see William Davenant, *The Siege of Rhodes* (London, 1656). On the front piece Davenant defines *The Siege of Rhodes* as a 'Story sung in *Recitative* Music', and claims this to be 'unpractis'd here [in England]' (A4). See also Ellen T. Harris, *Henry Purcell's Dido and Aeneas* (Oxford: Clarendon Press, 1987), 6. Harris characterizes *Dido and Aeneas* as Purcell's 'only opportunity to compose a work in which the music carried the entire drama. It is Purcell's only opera in the modern sense of the term'. For a comprehensive study of Italian opera in Britain during the first half of the eighteenth century, see Thomas McGeary, *The Politics of Opera in Handel's Britain* (Cambridge: Cambridge University Press, 2013).
⁴ Thomas McGeary, 'Opera and British Nationalism, 1700–1711', *Revue LISA/LISA e-journal* 4, no. 2 (2006), 6.
⁵ Ibid.

nonconforming affections. Italian opera was an artistic form that tried out new ways for affective responses on foreign soil (in the words of Nicholas Till, with a 'prevailing English attitude of curmudgeonly roast-beef-and-ale xenophobia', such responses were essentially *foreign affections*).[6] Italian opera was destined to stir up a politically motivated critic like Addison.

Addison's concern for mere operatic sensuousness or irrational representations is present at an early stage of his writing. In a letter to the dramatist William Congreve, written during the Grand Tour, from Paris, in August 1699, Addison claims to long for Congreve's company 'at ye Opera where [he] would have seen paint enough on ye actors Faces to have Dawbed a whole street of sign-posts'.[7] Gestures, facial expressions, and costumes are all too extravagant, précised by Addison in the negative remark that 'Every man that comes upon the Stage is a Beau'.[8] It is simply as 'ridiculous to criticise an opera as a puppet-show', and if Congreve believes that Addison is exaggerating, he states that he 'cd send [Congreve] a Long Catalogue of the like Indecencys'.[9] The letter to Congreve is reused in a *Spectator* essay published on 3 April 1711, and although Addison's tone is less unforgiving this time, the cultural differences that radically separate a vulgar experience of a Frenchman, from an experience of a native British gentleman, remain very hard to reconcile:[10]

> I remember the last Opera I saw in that merry Nation [France], was the Rape of *Proserpine*, where *Pluto*, to make the more tempting Figure, puts himself in a *French* Equipage, and brings *Ascalaphus* along with him as his *Valet de Chambre*. This is what we [in Britain] call Folly and Impertinence; but what the *French* look upon as Gay and Polite. (*S* I, 123; 29)

The Italian seventeenth-century composer and naturalized French Jean-Baptiste Lully is commended by Addison for recognizing that '*French* Musick [was] extreamly defective, and very often barbarous', but also for that he did not 'pretend to extirpate the *French* Musick, and plant the *Italian* in its stead' (*S* I,

[6] Nicholas Till, '"An Exotic and Irrational Entertainment": Opera and Our Others; Opera as Other', in *The Cambridge Companion to Opera Studies*, ed. Nicholas Till (Cambridge: Cambridge University Press, 2012), 298.
[7] Addison, *The Letters of Joseph Addison*, no. 4, 4.
[8] Ibid. Addison writes, for instance, that 'Alpheus [In Greek mythology, Alpheus was a river and a river-god, in love with the nymph Arethusa. See Ovid, *Metamorphoses*, vol. 1, 2.250; and 5.576 and 5.599] throws aside his Sedge and makes Love in a Fair periwig and a plume of Feathers but with such a horrid voice that one woud think the murmurs of a Country-Brook much better music'.
[9] Ibid.
[10] See *S* I, 119–23 (esp. 122–3); 29. Addison is slightly less confrontational here. He acknowledges that '*French* Musick is now perfect in its kind', which simply means that he thinks that the music better corresponds to the national mental disposition by, for instance, being 'properly adapted to their [i.e. French people's] Pronunciation and Accent' (122).

122; 29). Lully composed *Proserpine* (the famous *tragédie lyrique* referred to by Addison in the quotation above) by delicately bringing separate elements from the Italian musico-dramatic idiom into contact with the historically inferior French tradition, thus allowing the 'whole Opera [to] wonderfully favour... the Genius of such a gay airy People' (*S* I, 122; 29).[11] Thus, the chorus of Lully's production granted, for instance, the 'Parterre frequent Opportunities of joining in Consort with the Stage', which naturally befitted the unsophisticated aesthetic inclinations of the French audience.

One might assume that Addison's forthright attitude to continental opera when performed on British soil collides with Shaftesbury's careful efforts to anchor aesthetic matters to the classical period. But in the case of French and Italian opera, there is a certain agreement, at least about a general context for immoral art, false taste, and the fate of political society.

Shaftesbury's friend, the French Huguenot Pierre Coste, had sent Shaftesbury a copy of Abbé François Raguenet's pamphlet *Parallèle des Italiens et des François, en ce qui regarde la musique et les opéra*, which stimulated Shaftesbury to write a rare note on opera in a letter to Coste in the winter of 1709.[12] Apart from comparing Italian and French opera (much to the disadvantage of the latter), Shaftesbury extends, as McGeary argues, the 'discussion into the political realm by examining the effects of operatic spectacle on liberty and freedom'.[13] Shaftesbury dismisses the 'Mock-Chorus's of the French' as a 'gross sort of Musick fit only for the *Parterre*' that merely produces 'Psalm-Musick of a confus'd Multitude'.[14] But the central points of the letter revolve around neither French opera nor Raguenet's pamphlet. Instead, Shaftesbury focuses on the complex interaction between ancient tragedy ('true Opera') and political liberty. An unfortunate insistence on deceptive sensuousness is, according to Shaftesbury, obstructing a well-balanced correlation between a successful work of art and freedom. Turning to, and quoting from, Horace's *Epistle to Augustus* (*migravit ab aure voluptas | omnis ad incertos oculos et gaudia vana*),[15] he argues

[11] See Bond (footnote 1), *S* I, 122; 29. On Lully's position in late-seventeenth-century French culture, and on his role as the founder and director of Académie Royale de Musique, see e.g. John S. Powell, *Music and Theatre in France 1600–1680* (Oxford: Oxford University Press, 2000), e.g. 45–69; Peter Bennett and Georgia Cowart, 'Music under Louis XIII and XIV, 1610–1715', in *The Cambridge Companion to French Music*, ed. Simon Trezise (Cambridge: Cambridge University Press, 2015).

[12] For further comments on Shaftesbury's rare remark on opera, see Maria Semi, *Music as a Science of Mankind in Eighteenth-Century Britain*, trans. Timothy Keates (Farnham: Ashgate, 2012), 44–6.

[13] Thomas McGeary, 'Shaftesbury on Opera, Spectacle and Liberty', *Music & Letters* 74, no. 4 (1993), 530.

[14] TNA, PRO 30/24/22/7, fol. 499ʳ. For further comments on Shaftesbury's letter to Coste, see McGeary, 'Shaftesbury on Opera, Spectacle and Liberty'.

[15] Horace, *Epistles*, 2.1.187–8.

that while Roman poets naturally preferred tragedy – which wisely comforted free citizens by showing the miseries of political power – they nevertheless yielded to the temptations of plain sensuousness. The listening *ear* (principal to the rational experience of tragedy) was, according to Shaftesbury, replaced with extreme and transient pleasures of the *eye*.[16] As McGeary stresses, while tragedy was, to Shaftesbury, the 'expression of the natural interests of a free people, as well as a means of reassuring and encouraging their freedom', an opera 'corrupted by spectacle might harm a nation politically'.[17] Thus, Shaftesbury ends up faulting Raguenet for not spotting the motives for Italian recitative to nurture simplicity, a simplicity that could abet the restoration of ancient tragedy (in fact, Shaftesbury argues that Italian recitative is 'not reduc'd enough to its true antient simplicity'),[18] and thus implicitly suggests an expansion of political liberty.

We should note here that Shaftesbury (as well as Addison) is apprehensive about a specific kind of aesthetic seeing, not vision altogether. Along the lines of Plato's *Timaeus*, sight is, for Shaftesbury, intended for recognizing divine reason and implementing the knowledge of it in life.[19] Thus, proper seeing is, first and foremost, a natural act of the '*inward* EYE' (*Moralists* 344 [415]). What he suggests by drawing attention to the transformation from a rational *ear* to the ephemeral pleasures of the *eye* is not really diverging from the ocularcentrism that generally has distinguished Western culture.[20] Rather, what he wishes to stress is that natural aesthetic perception is a well-informed and rational kind of seeing, a seeing generated by knowledge, as opposed to a vision caused by mere ignorance.

Addison shares Shaftesbury's general belief in the intimacy between artistic expressions and the destiny of political society, as well as his distrust of mere aesthetic sensuousness. But he targets a general absence of simplicity in precisely Italian opera, before he relates his criticism to a set of racial-ethnic arguments on cultural differences. The problem so passionately addressed by Addison occurs primarily when the rational ways to reconcile cultural differences appear to be exhausted, but one nevertheless continues to force the aesthetic transculturation. This is, from Addison's perspective, precisely what is at stake when philosophers, artists, and audiences pursue the integration of Italian opera in British Protestant

[16] TNA, PRO 30/24/22/7, fol. 499ᵛ.
[17] McGeary, 'Shaftesbury on Opera, Spectacle and Liberty', 533.
[18] TNA, PRO 30/24/22/7, fol. 500ᵛ.
[19] See Plato, *Timaeus*, in *Timaeus, Critias, Cleitophon, Menexenus, Epistles*, vol. 9, trans. R. G. Bury, Loeb Classical Library 234 (Cambridge, MA: Harvard University Press, 1929), 47B.
[20] About ocularcentrism, see e.g. Martin Jay, *Downcast Eyes: The Denigration of Vision in Twentieth-Century French Thought* (Berkeley: University of California Press, 1994), esp. ch. 1.

culture. Commonsensical qualities are lacking, the only function of the mise-en-scène 'is to gratify the Senses, and keep up an indolent Attention in the Audience', and consequently the opera clashes with the 'Common Sense' of the rational spectator, who opposes anything 'Childish and Absurd' (S I, 22–3; 5). It is crucial to eschew the false combination of 'Shadows and Realities' in the 'same Piece', and 'Representations of Nature' must, according to Addison, 'be filled with Resemblances, and not with the Things themselves' (S I, 23; 5). The problem here concerns the 'joining together [of] Inconsistencies' (the collision of 'partly Real and partly Imaginary' elements), but in his typical manner Addison relates this to a racial-ethnic clash.

After his Italian visit in 1710, Handel became Kapellmeister to the elector of Hanover. The impresario and versifier Aaron Hill, manager of the Haymarket Theatre, arranged the English version of *Rinaldo* (1711), which was then put into Italian verse by the Italian librettist Giacomo Rossi. Given this cross-cultural quality of Handel's Haymarket triumph, Addison commented that *Rinaldo* contained two incompatible ethnic dispositions, 'contrived by two Poets of different Nations' (S I, 25; 5). The different poetic temperaments appeared in the scenes 'raised by two Magicians of different Sexes': when the libretto specified that Armida (the *Amazonian Enchantress*) ought to be sung by an Italian soprano 'versed in the Black Art', and that *Mago Christiano*, a role sung by an Italian alto castrato, should 'deal with the Devil' (even though he was a 'good Christian'), Addison was unaffected precisely because of these incompatibilities (S I, 25; 5). Similar to Dennis, Addison is troubled by the kind of taste to which audiences 'conform [them]selves' (S I, 26; 5). Italian poets – 'Modern *Italians*' – are in this case inferior to the sought classical standard: they 'express themselves in such a florid form of Words, and such tedious Circumlocutions, as are used by none but Pedants in our own Country'.[21] The difference between Italian and British poets was certainly not a 'difference of Genius', because Addison did not think that modern Italian poets shared any similarities with classical 'old *Italians*' like Cicero and Virgil (S I, 26; 5). Dennis had complained that while 'modern *Italians* have the very same Sun and Soil which the antient *Romans* had ... their Manners [are] directly opposite; their Men are neither Vertuous, nor Wise, nor Valiant'.[22] To Dennis it was 'impossible to give any reasons of so great a Difference between

[21] It is symptomatic that Addison refers to Purcell when accentuating differences between British music and Italian opera. Purcell was often referred to in patriotic terms. See William Weber, *The Rise of Musical Classics in Eighteenth-Century England: A Study in Canon, Ritual, and Ideology* (Oxford: Clarendon Press, 1992), 93–102.

[22] Dennis, *An Essay on the Opera's after the Italian Manner*, 384.

antient *Romans*, and the modern *Italians*, but only Luxury; and the reigning Luxury of modern *Italy*, is that soft and effeminate Musick which abounds in the *Italian Opera*'.[23] Addison pursues a very similar idea when he stresses that it is the English poets who write in line with Cicero and Virgil, and thus 'resemble those Authors much more than the Modern *Italians* pretend to do' (S I, 26; 5).

Strange as it may seem, however, Addison's criticism of Italian opera cannot be written off as a simple attack on its aesthetic value per se, as much as it is a melodramatic fear that this value dissolves when art is repositioned in new historical and political contexts. In *A Discourse on Ancient and Modern Learning* (*posth.* 1739), he manages to bring out a clarifying perspective on how historical and national contexts at times alter, or even impede, aesthetic experiences. While a modern reader has access to 'essential standing Beauties' external to a specific ancient context, there are also 'secret Intimations' of the past that remain inaccessible.[24] Hence there is, to Addison, a melancholic pleasure (a 'Pleasure we have lost') inherent in every experience of a historical work of art:[25] a value only accessible to those 'within the Verge of the Poem', that is constantly slipping away from those within a different historical context.[26]

> Their [the ancients] being conversant with the Place, where the Poem was transacted, gave 'em a greater Relish than we can have at present of several Parts of it; as it affected their Imaginations more strongly, and diffus'd through the whole Narration a greater Air of Truth.[27]

Such an 'Air of Truth' is furthermore relying on the poet's ability to relate the theme of the poem to a specific national context, where the 'whole Poem comes more home' and moves us more emotionally than if the 'Scene [had] lain in another Country, and a Foreigner [had] been the Subject of it'.[28] This pattern of thought is relevant to all arts: 'We find, ev'n in Music, that different Nations have different Tastes of it', because of, for instance, climatological premises influencing sense perception, or, more importantly, the fact that we are, according to Addison, inflicted with a 'national Prejudice' which simply 'makes every thing appear odd to us that is new and uncommon'.[29] Hence, while we might gain access to a timeless quality of art ('essential standing Beauties'), temporal ones often

[23] Ibid. See also Berkeley, *An Essay towards Preventing the Ruin of Great Britain*, esp. 77.
[24] Addison, *A Discourse on Ancient and Modern Learning* (London, 1739), 2, 7.
[25] Ibid., 6.
[26] Ibid., 13.
[27] Ibid., 14.
[28] Ibid., 16.
[29] Ibid., 20.

remain inaccessible, and preconceptions occasionally inhibit the experience of foreign art altogether. Addison is thus in *A Discourse on Ancient and Modern Learning* surprisingly sensitive to the problem of culturally biased customs, when he concludes that 'we find by certain Experience, that what is tuneful in one Country, is harsh and ungrateful in another'.[30]

The wish to strike a balance between provinciality (by pursuing cultural difference) and transcultural mechanisms (by pursuing historical continuum) is a delicate task. If, as Addison claims at one point, 'no *Englishman* reads *Homer*, or *Virgil*, with such an inward Triumph of Thought, and such a Passion of Glory, as those who saw in them the Exploits of their own Country-men or Ancestors', one might indeed doubt if there is any continuity at all between post-revolutionary Britain and classical culture.[31] The solution is, as we will see, to strike a happy medium by detecting a new connection to the past as well as to the foreign.

Addison genuinely admired the first Italian opera star on the London stage and the singer of the role of Rinaldo, the Neapolitan contralto Nicolini,[32] specifically since he gave dignity to, and thus managed to transform, the 'forced Thoughts, cold Conceits, and unnatural Expressions of an *Italian* Opera' (*S* I, 59; 13). If only 'our [British] Tragœdians would copy after this great Master in Action', laments Addison. Unfortunately, Nicolini – 'the greatest Performer in Dramatick Musick that is now living, or that perhaps ever appeared upon a Stage' (*S* III, 513; 405) – was merely given the task to entertain a mainly ignorant audience with a 'wretched Taste' (*S* I, 59; 13). His skill was of a different kind, namely to attune his native features by harmonizing them with a new national culture which involved, or so Addison argues, stronger bonds to the classical age. The moderns and the modern age are not always met with delight by Addison. Even though we may perhaps exceed the 'First Ages of the World' in 'all the trivial Arts', 'we fall short at present of the Ancients in Poetry, Painting, Oratory, History, Architecture, and all the noble Arts and Sciences which depend more upon Genius than Experience' (*S* II, 467; 249). One occasionally 'meet[s] with more Raillery among the Moderns, but more Good Sense among the Ancients'

[30] Ibid. See also *S* II, 340; 215: 'It is therefore an unspeakable Blessing to be born in those Parts of the World where Wisdom and Knowledge flourish; though it must be confest, there are, even in these Parts, several poor uninstructed Persons, who are but little above the Inhabitants of those Nations of which I have been here speaking; as those who have had the Advantages of a more liberal Education rise above one another, by several different degrees of Perfection.'
[31] Ibid., 17.
[32] *S* III, 513–14; 405. On the celebrity of Nicolini, see Joseph R. Roach, 'Cavaliere Nicolini: London's First Opera Star', *Educational Theatre Journal* 28, no. 2 (1976).

(*S* II, 467; 249). However, British art, in general, is about to enter a new modern phase, which promises a fresh and strong connection between Britain and classical antiquity. Thus, a national opera may come to serve its true ethico-political end. Addison acknowledges that religious music mends the mind, and 'fills it with great Conceptions' and 'strengthens Devotion', while opera is more straightforwardly intended to reinforce human nature (*S* III, 516; 405). However, technical as well as cultural difficulties of translation hinder Italian opera from working successfully on the London stage. The desire to 'make the Numbers of the *English* Verse answer to those of the *Italian*', and accordingly preserve the original music, prompted the native poets to invent novel words, which obscured the true meaning of the verse (*S* I, 79; 18). Furthermore, when 'Sense was rightly translated, the necessary Transposition of Words which were drawn out of the Phrase of one Tongue into that of another, made the Musick appear very absurd in one Tongue that was very natural in the other' (*S* I, 80; 18). To achieve a proper musico-dramatic idiom (the matching of music and words) appeared almost impossible.

Moreover, Italian actors sang their parts in Italian, and since they often got the roles of heroes and kings, while native English actors sang the roles of slaves in English, the stage performances were politically partial according to Addison. This had great consequences for the assessment of opera, and because the ignorant British spectators only understood half of the scenario, they started to 'ease themselves intirely of the Fatigue of Thinking' (*S* I, 81; 18).[33] Italian opera, performed under these circumstances, was a 'monstrous Practice' (*S* I, 81; 18).

In his classic study of Addison's literary criticism, Lee Andrew Elioseff seeks to play down the nationalistic and moral features of Addison's opera criticism by accentuating that he is in principal indifferent to the 'immediate threat of Italian opera to the English church and state'.[34] But the dynamic condition of national art and politics that preoccupies Addison's writings suggests otherwise. To be exposed to the 'monstrous Practice' is clearly to have an inadequate aesthetic experience, which furthermore threatens the private virtues of the British people. Italian artists may perhaps have a 'Genius for Musick above the *English*',

[33] See also Semi, *Music as a Science of Mankind in Eighteenth-Century Britain*, 46–54. Semi draws attention to the fact that Addison levels his critique against three problematic aspects in performances of Italian opera: (1) texts poorly translated into English; (2) texts sung in the performer's mother tongue, 'with a jumble of Italian and English in one and the same performance'; (3) texts sung entirely in Italian and, as a result, English audiences failing to comprehend the plot.

[34] Lee Andrew Elioseff, *The Cultural Milieu of Addison's Literary Criticism* (Austin: University of Texas Press, 1963), 207. Elioseff also argues that while Dennis was 'explicitly moral and patriotic' when addressing Italian opera, Addison was 'only implicitly so' (204).

but the '*English* have a Genius for other Performances of a much higher Nature, and capable of giving the Mind a much nobler Entertainment' (*S* I, 81; 18). To permit this music to 'take the entire Possession of our Ears' would prevent us from 'hearing Sense', and 'it would exclude Arts that have a much greater Tendency to the Refinement of humane Nature' (*S* I, 81–2; 18). Accordingly, Addison identifies himself with Plato in the *Republic* when the latter expels such harmful art 'out of his Commonwealth' (*S* I, 82; 18).[35]

Thus, the status of works of art alters due to cultural and historical expectations. The current state of national music needs, to Addison, commonsensical consideration instead of immediate sensuousness (coincidentally this is precisely the timeless, transcultural quality that, according to Shaftesbury, unites modern opera and ancient tragedy), because the national taste is still in its initial stages: 'At present, our Notions of Musick are so very uncertain, that we do not know what it is we like; only, in general, we are transported with any thing that is not *English*' (*S* I, 82; 18). As Lydia Goehr remarks, '[w]hat Addison feared most about Italian opera sung in Italian was the sort of "foreignness" that would encourage an English liking for an art that purportedly offered no educational value.'[36] A dynamic and moral political *whole* bears a resemblance to a musical arrangement: each country has a distinctive tone and conveys passions by different sounds. Consequently, Addison identifies problems with recitative in opera: 'To go to the Bottom of this Matter, I must observe, that the Tone, or (as the *French* call it) the Accent of every Nation in their ordinary Speech is altogether different from that of every other People' (*S* I, 120; 29). As Maria Semi highlights, Addison even categorizes the moral agent himself as a musical instrument, and a 'concert of the instruments becomes a way of conceiving society and describing its fundamental virtues.'[37] Consequently, it is urgent that a 'man of taste must learn to listen to himself and others.'[38] Music is, according to Addison, of a 'Relative Nature' (*S* I, 122; 29). Artists must observe such relativity to accomplish the proper moral value of art: 'A Composer should

[35] See Plato, *Republic*, vol. 1, trans. Chris Emlyn-Jones and William Preddy, Loeb Classical Library 237 (Cambridge, MA: Harvard University Press, 2013), 3.398C–399E; for Plato's ambivalent view of poetry, see esp. vol. 2, Loeb Classical Library 276, 10.605B–607B. For comments, see *Plato on Poetry*, ed. Penelope Murray (Cambridge: Cambridge University Press, 1996).

[36] Lydia Goehr, 'The Concept of Opera', in *The Oxford Handbook of Opera*, ed. Helen M. Greenwald (Oxford: Oxford University Press, 2014), 107.

[37] Semi, *Music as a Science of Mankind in Eighteenth-Century Britain*, 30. See also *T* II, 358–62; 153. Here, Addison's concluding remarks are informative: 'I must entreat my Reader to make a narrow Search into his Life and Conversation, and upon his leaving any Company, to examine himself seriously, whether he has behaved himself in it like a Drum or a Trumpet, a Violin or a Bass-Viol; and accordingly endeavour to mend his Musick for the future' (362).

[38] Ibid., 30–1.

fit his Musick to the Genius of the People, and consider that the Delicacy of Hearing, and Taste of Harmony, has been formed upon those Sounds which every Country abounds with' (*S* I, 122; 29). Music, together with architecture, painting, poetry, and oratory, should 'deduce their Laws and Rules from the general Sense and Taste of Mankind, and not from the Principles of those Arts themselves; or in other Words, the Taste is not to conform to the Art, but the Art to the Taste' (*S* I, 123; 29). Art must simply adapt to (British) taste, and not the other way around.[39] This did not, however, imply that art was incapable of fostering moral development, or was prevented from cultivating the agent into a morally accomplished subject. As we have seen throughout Part One, art was certainly not unsupplied with self-determination and creative inventiveness. What Addison suggested was rather that art needed to be treated with a specific sensitivity *precisely* because it had the critical responsibility to provide moral instructions and breed political stability.

[39] See ibid., 49. As Semi observes, '[i]n Addison's view, art must not be a law unto itself and, above all, must never lose sight of the common man. Music is not a matter for the sophisticated ear alone; anyone capable of comfortably distinguishing the pleasantness of its sounds must be enabled to appreciate it.'

Part Two

Moved by affections: Shaftesbury on beauty and society

The European Enlightenment contains an informative account of how a shared interest and mutual acquaintance one time brought Addison and Shaftesbury together. In one of his many letters to the Secretary to the Lord Justices of Ireland, Joshua Dawson, dated 7 November 1709, St James's Place, Addison pens that he 'herewith transmitt to you the Certificates of Monsieur Desmaiseaux whose petition you have now under Reference'.[1] Addison, who was at the time Chief Secretary to the Earl of Wharton (Lord Lieutenant of Ireland), wrote to Dawson since Addison was a friend of the French Huguenot Pierre Des Maizeaux and was trying to secure a pension to Des Maizeaux from the Irish Establishment.[2] Des Maizeaux's family history was a common one among French Huguenots in the late seventeenth century.[3] Due to the revocation by Louis XIV of the Edict of Nantes in 1685 (the Edict from 1598 had originally granted French Protestants some freedom of consciousness), Des Maizeaux, whose father was a Protestant minister, fled France at the age of twelve together with his family to Avenches in the Canton of Vaud in Switzerland, never to return again. While commencing his education in Avenches, Des Maizeaux soon transferred to the Lyceum of Berne (1690–5), and then completed his ecclesiastical studies successfully

[1] Addison, *The Letters of Joseph Addison*, no. 228, 191.
[2] It was either Addison or Charles Spencer, the third Earl of Sunderland (1674–1722) – who would later on appoint Addison as Secretary of State – who secured a pension for Des Maizeaux in 1710. See Joseph Almagor, *Pierre Des Maizeaux (1673–1745), Journalist and English Correspondent for Franco-Dutch Periodicals, 1700–1720* (Amsterdam: Holland University Press, 1989), 4.
[3] On the role of Des Maizeaux in the European republic of letters, see e.g. Almagor, *Pierre Des Maizeaux*; Anne Goldgar, *Impolite Learning: Conduct and Community in the Republic of Letters, 1680–1750* (New Haven, CT: Yale University Press, 1995), esp. 131–54; J. H. Broome, *An Agent in Anglo-French Relationships: Pierre des Maizeaux, 1673–1745* (PhD diss., University of London, 1949), esp. 17–54.

at the Academy of Geneva (1695–9). After his education, he travelled to the Netherlands in April 1699, where the high testimonials of his studies caught the attention of yet another refugee philosopher in the Huguenot diaspora, Pierre Bayle, who was, at the time of the Edict of Nantes, already a recognized citizen of the scholarly community in Rotterdam. In late-seventeenth-century Europe, Rotterdam was not only a safe haven for French Huguenots in exile, but a cosmopolitan assembly point for the European republic of letters in general. In the centre of the intellectual life of the city stood the household of one of Bayle's close friends, the English Quaker Benjamin Furly, who had offered Locke political protection during his Dutch exile (1683–9), between 1687 and 1689, and who was a close friend of Shaftesbury. Via the house of Furly, Des Maizeaux, who appears to have possessed a remarkable talent for making acquaintances with the main European men of letters, was introduced to the scholarly community and, most importantly, to Bayle. Bayle, for his part, introduced Des Maizeaux to Shaftesbury, who was a regular guest at Furly's household, and after Des Maizeaux's move to London at the end of June or the beginning of July in 1699, the latter began to figure as intermediary between Bayle and Shaftesbury, and eventually came under the patronage and protection of the Earl.[4] The intellectual circle of contacts of the European republic of letters relied on an efficient logistic system of letters of recommendation, favours, and favours in return. Cheered on by Shaftesbury, Des Maizeaux soon initiated a French translation of the *Inquiry*.[5] Shaftesbury in his turn was obliging to make Des Maizeaux known to Addison sometime in 1705, and for Des Maizeaux the 'friendship of Addison was another step in the right direction, leading him into the heart of literary London as not even the patronage of Shaftesbury could have done'.[6]

Thus, by the time Addison wrote his letter to Dawson, Des Maizeaux had appealed to the goodwill of both him and Shaftesbury (who, on his part, appealed

[4] See Shaftesbury's letter to Des Maizeaux, 5 August 1701. When excusing himself for not writing to Bayle, Shaftesbury mentions that he has an 'additionall obligation to him [Bayle] by the acquaintance he has given me of one so deserving as your Self [Des Maizeaux]: wch is a favour I shall allways own to him' (BL, Add. MS 4288, fol. 99r). The historical accounts diverge regarding when a closer acquaintance between Des Maizeaux and Shaftesbury evolved, see e.g. Broome, *An Agent in Anglo-French Relationships*, esp. 17–54. Broome claims that Des Maizeaux did not 'enter into his association with the author of the Characteristicks for nearly two years after coming to England' (17). Recent scholarship often holds that Shaftesbury brought Des Maizeaux with him to England, see e.g. Rivers, *Reason, Grace, and Sentiment*, 97.

[5] While Des Maizeaux was translating the *Inquiry* into French, he remained for a long time unaware of the work's authorship. The translation by Des Maizeaux was never completed. For the translation, see *Des Maizeaux' French Translation of Parts of An Inquiry Concerning Virtue* (13–39).

[6] Broome, *An Agent in Anglo-French Relationships*, 65.

to Lord Halifax) on several occasions, in an attempt to secure a more regular public employment, and, by the help of Addison, a future pension.[7] Periodically, both Addison and Shaftesbury ended up supplying Des Maizeaux's wants. While I must leave to others to reflect on the imperative bearing of Des Maizeaux in the British and continental Enlightenment (Des Maizeaux became a Fellow to the Royal Society in 1720, and major European philosophers like Leibniz, Voltaire, Newton, and Hume all had frequent contact with Des Maizeaux),[8] it is interesting to note how Addison's and Shaftesbury's Whig political (and possibly self-regarding) conceptions of Europe briefly were brought together in the fate of a French refugee. Because, even though Addison and Shaftesbury shared a view of the *worldliness* of philosophy and art, their means to give topical interest to such a view often remained widely divergent.[9] All these differences, as well as, indeed, some general similarities, will become manifest here in Part Two.

While a tenacious self-reflection holds the centre stage for both Addison's and Shaftesbury's moral conceptions of the experience of nature and art, they end up accentuating different properties of such reflections. As we have seen, Addison holds a straightforward attitude to the ethico-political relevance of aesthetic experience, by anchoring it to matters concerning the realist politics of the nation. For Shaftesbury, the moral axis of taste is much more deeply rooted in what he terms natural affections.[10] I begin Part Two by exploring just how such natural affections are expected to unite the agent with the greater good of society (Chapter 2.1). Shaftesbury's notion of natural affections is the point

[7] See Shaftesbury's letter to the first Earl of Halifax, 16 December 1708 (TNA, PRO 30/24/22/4, fol. 327ʳ): "'Tis three or four years since I promis'd the Bearer (Monsʳ Desmazeaux; a French Protestant) to introduce him to your Lord[shi]ᵖ. Being a Man of Letters, his greatest hope was from your Favour: & knowing the Honour and Esteem I have for your Lordᵖ, he persuades himself that a Character from me may do him Service." See also Broome, *An Agent in Anglo-French Relationships*, 71–75.

[8] Almagor, *Pierre Des Maizeaux*, 7.

[9] On the worldliness of philosophy, see Klein, 'Introduction', in Shaftesbury, *Characteristics of Men, Manners, Opinions, Times*, esp. viii–x; and Klein, 'Making Philosophy Worldly in the London Periodical about 1700'. See also Grean, *Shaftesbury's Philosophy of Religion and Ethics*, 13: 'It was Shaftesbury's conviction that philosophy must make its effects felt in the world, and that it must serve the practicing statesman and artists, and in the broadest sense, the practicing citizen. Thus, he did not direct his work primarily to other philosophers or scholars, but to the broadest circle of cultivated readers.'

[10] See also Collis, 'Shaftesbury and Literary Criticism: Philosophers and Critics in Early Eighteenth-Century England', esp. 303–7. When addressing advice to authors of fiction, Collis highlights Shaftesbury's and Addison's different conceptions of the word *natural*. While Shaftesbury recognized (in a Ciceronian manner) that 'natural truths were universal and eternal truths', Addison (pursuing Locke's denial of innate, common concepts, κοιναὶ ἔννοιαι [see Locke, *An Essay*, 1.2, §1, 48]) concluded that 'moral ideas were the artificial creations of the mind' (304). Thus, Addison associated, according to Collis, the word *natural* with the mind's power to artistically combine images in unexpected ways, rather than, as Shaftesbury thought, 'to learn and express the natural truths described by Cicero' (304–5).

of departure for the conclusions he ultimately draws about the value of taste. However, it is not Shaftesbury's usage of the notion of taste per se, but one of its distinctive features, namely disinterestedness, that belongs to the most frequently analysed concepts in modern aesthetics. Shaftesbury defends, as we will see, a disinterested attitude (a true piety) to God, where it is the motives of our actions that settle our moral status (Chapter 2.2). Whether one decides to pursue the religious aspects of Shaftesbury's perception of disinterestedness, and his liberal theology, or opts for a de-theologizing of disinterestedness is crucial for how one eventually recognizes his position in the history of aesthetics in general, and in the history of the development of aesthetic autonomy in particular. While I will provide an account that accentuates the notion of aesthetic disinterestedness as necessarily integral to human morality and the experience of God, I will also look closer at a particularly influential interpretation made by Jerome Stolnitz that points out the secular features and thus does not do justice to Shaftesbury's perception of a virtuous agent's natural engagement in the harmony of God's nature (Chapter 2.3). Stolnitz separates a disinterested (aesthetic) perception of aesthetic objects and, what Shaftesbury refers to as, the 'Interest of that Universal ONE' (*Moralists* 274 [364]). But, as we will see, this is a modern separation of the classical triad of truth, goodness, and beauty that Shaftesbury hardly would have accepted. The so-called aesthetic object is for Shaftesbury animated with the divine presence and rational beauty of God, and as such it is always administrating the moral agent, not the other way around. Here in Part Two, I will also explore the relationship between Shaftesbury's perception of nature and the aesthetic experience of art (Chapter 2.4). The constant flux of the world is, according to Shaftesbury, a *Chorus* that should be accepted. Instead of turning one's attention to the realities of the political world, as Addison often does, one should aspire to reform one's affections and realize the natural disposition to experience beauty into a natural taste, in order to appreciate, and engage in, the rational whole. A very similar approach must, from Shaftesbury's perspective, also be pursued when experiencing art. Finally, I will (Chapter 2.5) examine how taste, via natural affections, ultimately remains interwoven not only with society overall but with a kind of beneficial societal environment that Shaftesbury believed was approaching in Britain after the events in 1688–9.

2.1

Natural affections

Both in the opening of *Soliloquy* and in Book II of the *Inquiry*, Shaftesbury prepares the way for a new science, a new 'Art of *Surgery*' (*Soliloquy* 44 [157]). The systematic focus of this science is not primarily the material world, but, as he stresses in the *Inquiry*, the 'inward Anatomy' of the mind (*Inquiry* 152 [83]). The '*Solutio Continui*' familiar to real surgery ought to be applied, he suggests, by 'Surgeons of another sort' (*Inquiry* 152 [84]); a sort that might reflect on the 'Parts and Proportions of *the Mind*' and thus reach a more profound knowledge of our affections (*Inquiry* 152 [83]). Ultimately, what he hopes to draw attention to by this new anatomy is the fact that (morally) wrong actions that violate our affections have more severe consequences for our well-being (and thus affect our social interactions) than we generally tend to imagine.

Shaftesbury then goes on to group three types of affections: (1) natural affections which lead to the good of the public, (2) self-affections which lead to the good of the private, and (3) unnatural affections which support neither public nor private good and are fundamentally vicious (*Inquiry* 156 [86/7]). Shaftesbury's main concern is to bring out an expedient balance between natural affections and self-affections. He finds the idea that 'Interest of *the private Nature* is directly opposite to that of *the common one*' to be an 'extraordinary Hypothesis' (*Inquiry* 148 [80]). Instead he argues for a '*right* BALLANCE *within*', between natural affections and self-affections (*Inquiry* 170 [95]), and he concerns himself greatly with the ways private self-affections are ultimately assimilated into natural affections, since to have the latter balanced and fixed '*towards the Good of the Publick, is to have the chief Means and Power of Self-Enjoyment*' (*Inquiry* 174 [98]).[1] Thus, there is a significant difference between the unpredictable sensuous pleasures of the body (such as sex and drinking) and reliable pleasures of the mind. The presence of the pleasures of the mind

[1] See also the remark about 'Instinct as that which [leads man] to the good of Society or his Fellows' from the letter to Stanhope, 7 November 1709 (TNA, PRO 30/24/22/7, fol. 490ᵛ).

determines the presence of bodily pleasures: while someone who rates certain actions or conduct highly might endure extreme bodily pain, the experience of 'outward Enjoyment', that appeals to the senses, terminates the moment the body suffers 'any *internal Ail* or *Disorder*' (*Inquiry* 184 [100]). Sensuous pleasures of the body are simply not a reliable source of enduring happiness.[2] Instead, real happiness ultimately relies on those solid mental pleasures which are 'either actually *the very natural Affections themselves in their immediate Operation*: Or they wholly in a manner *proceed from them*, and are no other than *their Effects*' (*Inquiry* 186 [101]).[3]

Here in the *Inquiry*, the reader also learns about the difference between being good and being virtuous. While goodness is, according to Shaftesbury, within reach for every sensible creature, virtue is a quality that distinguishes humans (or in any case ought to do so). As noted earlier, Shaftesbury and Addison are both apprehensive about uninformed aesthetic sensuousness. A rational kind of seeing must be caused by knowledge to be natural, and in order to be virtuous we must turn away from mere sensuousness and prove our ability to evaluate our natural affections.[4] A certain reflective affective awareness ('*Reflex Affection*') of the motives of ourselves and others, and the objects presenting themselves to us, is thus expected, which renders it difficult to merely allow the 'outward Beings which offer themselves to the Sense [to become] the Objects of the Affection' (*Inquiry* 66 [28]). Ideally, we are instead, with the help of reason, 'forc'd to receive Reflections back into [the] Mind of what passes in it-self, and in the Affections, or Will; in short, of whatsoever relates to [our] Character, Conduct, or Behaviour towards [our] Fellow-Creatures, and Society' (*Inquiry* 210 [118]). The human mind possesses, for Shaftesbury, a complex rational capacity to turn affections into '*Reflex Affection*[s]' (*Inquiry* 66 [28]). This ability to, so to speak, *feel* the

[2] See also Whichcote (*Select Sermons* e.g. 293–9, on the effects of religion): '[O]ur Care must be, that we be not only *Bodily-wise*. BODY indeed is a *heavy Weight*: But, let us bear up, as well as we can, against it.' While God united body and soul, it was, stresses Whichcote, 'always intended that *the governing Part* should be THE MIND. And, a Man, by *Wisdom*, and *Vertue*, may overcome *Bodily-Temper*, and *Inclination*' (297).

[3] See also Leibniz's comments on *Characteristicks* (here on the *Inquiry*) (TNA, PRO 30/24/26/8, fol. 50ᵛ): 'En effet nos Affections naturelles sont nôtre contentement; et plus on est dans le naturel, plus on est porté à trouver son Plaisir dans le bien d'autrui, ce qui est le fondement de la Bienveillance universelle, de la Charité, et de la Justice.'

[4] See Michael B. Gill on Shaftesburian virtue in 'Love of Humanity in Shaftesbury's *Moralists*', *British Journal for the History of Philosophy* 24, no. 6 (2016), 1119: 'A spider or a tiger that is affectively constituted to behave in ways that best promote spiders or tigers in general will be good even though it lacks the reflective capacity for the idea of its species to figure in its motivational aetiology. But the moral goal to which humans beings should aspire ... does require an awareness of the good of the human species.'

feelings is crucial in Shaftesbury's scheme; it is a reflective ability that constitutes a moral sense that naturally contributes to the good of the whole.[5]

Thus, self-reflective affections enable, as Dario Perinetti stresses, a proper 'affective endorsement of what is right or good and affective rejection of what is wrong or "ill" '.[6] And a similar kind of reflective disposition should be exercised to avoid being submissive recipients of sudden, undesirable, sensual pleasures. Such pleasure is, as Shaftesbury writes in an undated and untitled prayer, 'but a Scabb, a Sore, the Irritation of Proud Flesh, the Appeasing of an Itch, and the Asswaging of a Necessitouse & Pressing WANT wch gives itt being' (*Prayer* 540). Thus, the study of the inward anatomy of the mind teaches us that while brutes rely merely on sense, the '*Beauty* and *Good* [that man] enjoys, is in a nobler way, and by the help of what is noblest, his MIND and REASON' (*Moralists* 358 [425]). One proof of human dignity thus ultimately consists in what kind of objects we find pleasure in. As Theocles underlines in *The Moralists*, just as a '*riotous* MIND, captive to *Sense*, can never enter in competition, or contend for Beauty with the *virtuous* MIND of Reason's Culture', the '*Objects* which allure the former' cannot 'compare with those which attract and charm the latter' (*Moralists* 360 [425]).

While we naturally rely on sense organs to experience beauty and virtue, as well as, for instance, a piece of decoration, there is nevertheless a difference in how we must apply the organs. Thus, while supervising the Italian painter Paolo de Matteis, whom Shaftesbury commissioned to paint the different versions of *The Judgment of Hercules*,[7] he concludes in his treatise *A Notion of the Historical Draught or Tablature of the Judgment of Hercules* that

> whilst we look on *Painting* with the same Eye, as we view commonly the rich Stuffs, and colour'd Silks worn by our Ladys, and admir'd in Dress, Equipage, or

[5] For an account of the propagandistic Whig foundation of Shaftesbury's concept of moral sense, see Patrick Müller, 'Hobbes, Locke and the Consequences: Shaftesbury's Moral Sense and Political Agitation in Early Eighteenth-Century England', *Journal for Eighteenth-Century Studies* 37, no. 3 (2014). Müller's relevant point is that Shaftesbury's concept of moral sense was the 'supporting interface' in his theory about human agency, and as such '[his] theory [was] fit to support a stable, enlightened parliamentary monarchy based on altruistic values', and accordingly constituted the 'antithesis to the morose church politics of anti-social, atheistic Tory High Church men who, according, at least, to the earl's picture of them, were the stooges of the Catholic Pretender' (317).

[6] Dario Perinetti, 'The Nature of Virtue', in *The Oxford Handbook of British Philosophy in the Eighteenth Century*, ed. James A. Harris (Oxford: Oxford University Press, 2013), 342. See also Colin Heydt, *Moral Philosophy in Eighteenth-Century Britain: God, Self, and Other* (Cambridge: Cambridge University Press, 2018), 50.

[7] Prodicus's (*fl.* fifth century BC) story about the choice of Hercules (Heracles) is retold in Xenophon's *Memorabilia*, 2.1.21. De Matteis made several paintings of Hercules' choice, which formed the basis of the ideas put forward by Shaftesbury in *A Notion of the Historical Draught or Tablature of the Judgment of Hercules* (originally published in French in 1712). For a discussion, see Sheila O'Connell, 'Lord Shaftesbury in Naples: 1711–1713', *The Walpole Society* 54 (1988).

Furniture, we must of necessity be effeminate in our Taste, and utterly set wrong as to all Judgment and Knowledge in the Kind. (*Notion* 136 [390])

Thus, not only are we mirroring ourselves, our moral identities, and taste in the objects, the objects are also mirroring themselves in us. And to have a taste that is at the mercy of whatever strikes our senses, rather than being administered by what 'consequentially and by Reflection pleases the Mind, and satisfyes the Thought and Reason', is simply to yield to a questionable and deficient kind of pleasure (*Notion* 136 [390]).[8]

The opposite to 'Men of narrow or *partial* Affection' is thus a balanced and rational integrity of mind, which is naturally extolled in society and by its members (*Inquiry* 202 [113]). To develop such an integrity (or what Shaftesbury refers to as 'INTIRE AFFECTION') is furthermore '*to live according to Nature, and the Dictates and Rules of supreme Wisdom*', and he highlights that this is 'Morality, Justice, Piety, and natural Religion' (*Inquiry* 202 [114]).

The qualities of virtue and natural affections imbue Shaftesbury's great corpus of writings, and to gain a clear image of the arguments we must be prepared to explore his ideas by carefully laying them out in a philosophical mosaic. Famously opposing Hobbes's psychological egoism, as well as the Calvinist tenet about total depravity (where sin becomes unavoidable),[9] Shaftesbury introduced the moral bearings of natural affections already in his short preface to the *Select Sermons* (1698) of the Cambridge Platonist Benjamin Whichcote. Here, Shaftesbury accused Hobbes for having created an '*Unprosperous Alliance, and Building a Political Christianity*' (*Select Sermons* 50). By this unification Hobbes contributed neither to politics nor to religion, but rather did a '*very ill Service in the Moral World*' (*Select Sermons* 50). The alleged mistake of Hobbes derives from the fact that Shaftesbury, by referring to Whichcote's sermons, sought to outline a moral attitude that did not revolve around a specified Christian principle, as much as around a Christianity originating in a universal disposition for morality. Thus Whichcote – '*our excellent Divine, and truly Christian Philosopher*' – was commended by Shaftesbury especially because of his '*Defence of* Natural Goodness' (*Select Sermons* 58). A successful critique of

[8] See also Shaftesbury's letter to Ainsworth (28 January 1708/9). Here, Shaftesbury advises Ainsworth not to follow his instant sensuous desires because 'if thou fixest thy Eye on that wch most strikes & pleasest Thee at ye first sight, thou wilt most certainly never come to have a good Eye at all'. Shaftesbury 'cr[ies] out', to Ainsworth, 'against *Pleasure*' and 'to beware of those Paths wch lead to a wrong Knowledge a wrong Judgment of what is supreamly Beautifull & Good' (*Ainsworth Correspondence* 383/385).

[9] See Michael B. Gill, *The British Moralists on Human Nature and the Birth of Secular Ethics* (Cambridge: Cambridge University Press, 2006), 87–8.

Hobbes's formation of political Christianity could therefore only be of '*Service to Religion*' by focusing on a '*Correction of his Moral Principles*' (*Select Sermons* 50). Writing about Hobbes's impact on ethics and the comprehension of society, Shaftesbury remarked the following:

> *This is* He *who reckoning up the Passions, or Affections, by which Men are held together in Society, live in Peace, or have any Correspondence one with another, forgot to mention Kindness, Friendship, Sociableness, Love of Company and Converse, Natural Affection, or any thing of this kind; I say* Forgot, *because I can scarcely think so ill of any Man, as that he has not by experience found any of these Affections in himself, and consequently, that he believes none of them to be in others*. (*Select Sermons* 50)

Hobbes had thus erroneously traded vital social affections for '*only one Master-Passion, Fear, which has, in effect devour'd all the rest*' (*Select Sermons* 50). As a result, the human mind and the natural system of affections were unjustly believed to be in turmoil. Just how important the reality of natural affections is, to Shaftesbury, for confronting any view of human nature as self-centred is illustrated, however, not only in regular attacks on Hobbes, but also in the critique of his former supervisor Locke.

In a letter to Ainsworth, dated 3 June 1709, written five years after Locke's death, Hobbes, in fact, gets off lightly compared to Shaftesbury's uncompromising criticism of the principles of Locke's perception of human nature.[10] Shaftesbury's basic critique of Locke or the '*Lockist*' philosophers stems from the fact that 'Twas Mr Lock yt struck at all Fundamentals, threw all *Order* & *Vertue* out of ye World, & made ye Very Ideas of these (wch are ye same as those of *God*) *unnatural* & without foundation in our Minds' (*Ainsworth Correspondence* 403). Locke appears to have misunderstood, or so Shaftesbury somewhat unfairly suggests,[11] the very foundation of the question about innateness.[12] 'The question is not about the *Time* the Ideas enterd' but, according to Shaftesbury,

[10] Shaftesbury stresses (*Ainsworth Correspondence* 403) that 'Mr Lock as much as I honour him on account of other Writings (vizt on Government, Policy, Trade, Coin, Education, Toleration &c:) and as well as I knew him & can answer for his Sincerity as a most zealouse Christian & Beleiver; did however go in ye self same Track & is followd by ye Tindals [Matthew Tindal, 1657-1733] & all ye other ingeniouse free Authors of our Time. Twas Mr Lock yt struck ye home Blow (for Mr Hobbs's Character, & base slavish Principles in Government took off ye poyson of his Philosophy)'. Implicit criticism of Locke can be spotted earlier on in Shaftesbury's writings. About this, see John A. Dussinger, '"The Lovely System of Lord Shaftesbury": An Answer to Locke in the Aftermath of 1688?', *Journal of the History of Ideas* 42, no. 1 (1981).

[11] In his letter Shaftesbury's account of Locke's principles is indeed slightly unfair. See Voitle, *The Third Earl of Shaftesbury 1671-1713*, esp. 121.

[12] For Locke's view of innateness, see Locke, *An Essay*, 1.2, 48–65. For further discussion see esp. Carey, 'Locke, Shaftesbury, and Innateness', 13–45; *Locke, Shaftesbury, and Hutcheson*, 98–149.

'whether the Constitution of Man be such, that being adult, & grown up, at such or such a time, sooner or later, (no matter when) the Idea & Sence of *Order Administration & a God* will not infallibly, inevitably, necessarily spring up in him' (*Ainsworth Correspondence* 403/405). In Shaftesbury's reading of 'y^e credulouse M^r Lock' (*Ainsworth Correspondence* 405), it is thus the fact that the prospect of providential nature, and thus morality and ultimately society itself, is dangerously conditioned on the imponderabilia of human experience that causes the greatest distress. Given such a condition, it follows, from Shaftesbury's anti-voluntaristic point of view, that '*Virtue*, according to M^r Lock, has no other Measure Law or Rule, than *Fashion & Custome*' and 'Morality Justice Equity, depend only on *Law* and *Will*. and God indeed is a perfect *free Agent* in his Sense; that is, *free to any thing* however ill' (*Ainsworth Correspondence* 405).¹³ Of course, putting the Lockean principles in this way makes them completely incompatible with the reality of natural human affections and Theocles' Stoic dictum that 'NOTHING surely is more strongly imprinted on our Minds, or more closely interwoven with our Souls, than the Idea or Sense of *Order* and *Proportion*' (*Moralists* 164 [284]).¹⁴ Thus, the rejection of innate ideas is clashing with a feature that is sometimes referred to as *cosmic Toryism* (distinguished by the view that the world all together is good; that evil or ill is just apparent; and a satisfaction with the status quo as being what God proposed), by implying that there 'could be no natural understanding of the order and administration of the universe', and, as one commentator observes, 'no natural affection, no moral sense: in a word, all would be anarchy'.¹⁵

In this context, Shaftesbury readily drew attention to the fact that Locke had injudiciously addressed the question of cultural diversity in order to bear out the absence of innate moral principles.¹⁶ Locke and his 'Indian Barbarean Storys

[13] Shaftesbury's general argument here is directed against Locke's division of laws (divine law, civil law, and law of opinion or reputation). See Locke, *An Essay*, 2.28, esp. §7–10, 352–4. Klein observes, in *Shaftesbury and the Culture of Politeness*, that Locke brought forth '[m]oral prescriptions' as the 'commands of God, enforced by divine sanctions', and that Shaftesbury 'took exception to this anti-naturalism' (66).

[14] For the Stoic influence on Shaftesbury's perception of innateness, see Carey, 'Locke, Shaftesbury, and Innateness', esp. 21–7; *Locke, Shaftesbury, and Hutcheson*, esp. 110–16.

[15] Barry McCoun Burrows, *Shaftesbury and Cosmic Toryism: An Alternative World View* (PhD diss., University of Oklahoma, 1973), 186. The characterization of cosmic Toryism is from ibid., 48. For further discussion on cosmic Toryism, see Basil Willey, *The Eighteenth Century Background: Studies on the Idea of Nature in the Thought of the Period* (London: Chatto & Windus, 1950), esp. 43–56.

[16] See Locke, *An Essay*, 1.3, e.g. §9–10, 70–2. After retelling stories from, among others, Garcilaso de la Vega (1539–1616) about Peruvian cannibalism, and Jean de Léry (1536–1613) about the absence of a name for God in Tupinamba culture in Brazil, Locke remarks the following: 'Where then are those innate Principles, of Justice, Piety, Gratitude, Equity, Chastity? Or, where is that universal Consent, that assures us there are such inbred Rules?' (§9, 72). In the next paragraph (§10, 72) Locke concludes that '[h]e that will carefully peruse the History of Mankind, and look abroad into the several Tribes of Men, and with indifference survey their Actions, will be able to satisfy himself, That

of Wild Nations' (*Ainsworth Correspondence* 405) and their great variety of (im)moral beliefs did, from Shaftesbury's perspective, not refute innate principles, nor did these stories demonstrate moral degeneracy. Instead, Locke's argument about cultural diversity reflected on Locke himself for being credulous enough to believe all the incredible savage stories that 'Travellers, learnd Authors! and great Philosophers! & men of truth! have inform'd him', while he ought, in fact, to have questioned the 'Veracity or Judgment of ye Relater, who cannot be supposd to know sufficiently the Misterys & Secrets of those Barbarians whose Language they but imperfectly know' (*Ainsworth Correspondence* 405). Shaftesbury pursued a very similar censure in *Soliloquy*, of how contemporary moral philosophy uncritically made improper use of travel writing, however this time his criticism contained no explicit reference to his former tutor:

> I can produce many anathematiz'd Authors, who if they want a true *Israelitish* Faith, can make amends by a *Chinese* or *Indian* one. If they are short in *Syria*, or the *Palestine*; they have their full measure in *America*, or *Japan*. Historys of *Incas* or *Iroquois*, written by Fryars and Missionarys, Pirates and Renegades, Sea-Captains and trusty Travellers, pass for authentick Records, and are *canonical*, with the *Virtuoso's* of this sort. Tho *Christian* Miracles may not so well satisfy 'em; they dwell with the highest Contentment on the Prodigys of *Moorish* and *Pagan* Countrys. They have far more Pleasure in hearing the monstrous Accounts of monstrous Men, and Manners; than the politest and best Narrations of the Affairs, the Governments, and Lives of the wisest and most polish'd People. (*Soliloquy* 276/278 [345])

Shaftesbury did not then object to the proficient and knowledgeable accounts of foreign cultures as such. What he found so objectionable was the speculative stories that ultimately might become the vulgar pretext for 'very poor Philosophy' (*Ainsworth Correspondence* 407). The outcome of '*Facts* unably related' was, from Shaftesbury's Aristotelian perspective, not necessarily closer to truth than a 'judiciously compos'd' lie (*Soliloquy* 278 [346]).[17] The unsettling problem was

there is scarce that Principle of Morality to be named, or *Rule* of *Vertue* to be thought on (those only excepted, that are absolutely necessary to hold Society together, which commonly too are neglected betwixt distinct Societies) which is not, somewhere or other, *slighted* and condemned by the general Fashion of *whole Societies* of Men, governed by practical Opinions, and Rules of living quite opposite to others'.

[17] See the apparatus criticus to *Soliloquy* (*Printed Notes* 68 [346]): 'The greatest of Criticks [Aristotle] says of the greatest Poet [Homer], when he extols him the highest, "That above all others he understood *how* TO LYE"'. See also Aristotle, *Poetics*, in *The Complete Works of Aristotle*, The Revised Oxford Translation, vol. 2, ed. Jonathan Barnes (Princeton, NJ: Princeton University Press, 1984), 1460a19–20. Characteristically, Shaftesbury also stresses, in the apparatus criticus to *Miscellaneous Reflections* (*Printed Notes* 230 [260]), that Homer's 'LYES, according to that Master's [Aristotle's] Opinion, and the Judgment of many of the gravest and most venerable Writers, were, in themselves, the justest *Moral Truths*, and exhibitive of the best Doctrine and Instruction in Life and Manners'.

instead that these travel writings were an immoral halfway house between truth and lies, and 'to amuse our-selves with such Authors as neither know how *to lye*, nor *tell Truth*, discovers a TASTE, which methinks one shou'd not be apt to envy' (*Soliloquy* 278 [346]). The crux of the matter here was of course that philosophers (like Locke), who naively relied on the anthropological travel accounts in order to refute the innateness of moral principles by exposing a lack of common consent, exercised faulty judgements.[18] And given that "Tis the same *Taste* which makes us prefer a *Turkish* History to a *Grecian*, or a *Roman*; an ARIOSTO to a VIRGIL; and a Romance, or Novel, to an *Iliad*' (*Soliloquy* 278 [346]), the poor judgements of moral philosophy were needless to say a fast track to a paucity of taste in aesthetic matters.

It is sometimes suggested that Shaftesbury creates a straw man argument by his reference to Locke in the letter to Ainsworth.[19] Still, while the 'accuracy' of his 'accusations' against Locke 'can be debated', the 'strength of Shaftesbury's reaction indicates', as Carey stresses, 'the urgency and challenge of defining a philosophy of human nature in opposition to Locke'.[20] Shaftesbury's worries were real enough: the view of the natural human disposition for affections and morality (and thus for beauty) could be severely dented if 'neither *Right* or *Wrong*, *Virtue* or *Vice* are any thing, in themselves; nor … any trace or Idea of em *naturally imprinted* on human Minds' (*Ainsworth Correspondence* 405).

While Locke gets his share of criticism for assuming a human nature without moral consistency, it is Hobbes, however, who is the most frequent target of Shaftesbury's censures. If Addison's writings come across as an innocent antiphony between pragmatic aims and the spirit of the age, Shaftesbury's description of man's natural affections, society, and private and public good forms a glaring contrast to Hobbes's gloomy account of nature.[21] For Shaftesbury, nature interweaves human beings. As individuals we must acknowledge that we

[18] See Carey, 'Locke, Shaftesbury, and Innateness', 15; *Locke, Shaftesbury, and Hutcheson*, 39. Carey comments that one of the primary ways to prove that the claims about innateness ('literal or dispositional') were mistaken was to demand a confirmation of common consent (regarded by Locke as a necessary but not sufficient condition): 'Accordingly, Locke set about showing the lack of agreement over allegedly innate principles, beginning with speculative maxims before proceeding to moral tenets. Locke asserted that children, idiots, illiterates, savages – all those closest to nature and therefore to the source of fountain innateness – did not indicate their consent.'

[19] The assumption seems reasonable. See also e.g. Voitle, *The Third Earl of Shaftesbury 1671–1713*, 121; Klein, *Shaftesbury and the Culture of Politeness*, 65.

[20] Carey, *Locke, Shaftesbury, and Hutcheson*, 98. See also Tim Stuart-Buttle, 'Shaftesbury Reconsidered: Stoic Ethics and the Unreasonableness of Christianity', *Locke Studies* 15 (2015).

[21] As Müller observes in 'Hobbes, Locke and the Consequences: Shaftesbury's Moral Sense and Political Agitation in Early Eighteenth-Century England', 323: The inherent relativism in Hobbes's state of nature was, from Shaftesbury's Whig perspective, the 'death of any free and liberal civil society'.

are part of a larger whole, namely a beautiful and rational nature. Given that society remains naturally integrated in such a nature, any interest of individual bodies remains part of the interest of a cohesive societal body. An illustration of this natural relation is given in the apparatus criticus to *The Moralists* (see *Printed Notes* 294/296 [285]). While the Stoic philosopher Seneca does not entirely win Shaftesbury's favour (see e.g. *Miscellaneous* 46 [24]), his epistles come in handy here, due to their claim that we are all part of one great body (*membra sumus corporis magni*).[22] The forthright rhetoric of Addison, in relation to the unproductive 'dead Limbs' in the making of a political body (see Part One, Chapter 1.2), is of course alien to the point Shaftesbury wants to make by referring to Seneca. Individual natural affections inevitably address the beautiful and rational universal nature, and a correspondingly natural society and organic community are upheld by a shared intuitive collaboration (*Societas nostra lapidum fornicationi simillima est, quae casura, nisi in vicem obstarent, hoc ipso sustinetur*).[23] I shall return to Shaftesbury's idea about the *naturalness* of society throughout Part Two. For now, let us establish Shaftesbury's strong principles about it. Here, in a letter to General James Stanhope on 7 November 1709, he states,[24]

> And this for certain is most true, that if Man be not by Nature Sociable, he is the foolishest Creature on Earth to make Society or the Publick the least Part of his real Care or Concern. But if when he trys to shake off this Principle, he has either no Success, or makes things worse with him than before, 'tis a Shrew'd Presumption of what he is *born to*.[25]

In a glaring contrast, Hobbes's disapproval of Aristotle's political naturalism (where man is a political creature) leads him onwards to the claim that political societies cannot arise from the 'mutuall good will men had towards each other, but in the mutuall fear'.[26] As such, Hobbes's claim is also the target of a witty

[22] Seneca, *Epistles*, vol. 3, trans. Richard M. Gummere, Loeb Classical Library 77 (Cambridge, MA: Harvard University Press, 1925), 95.52.
[23] Ibid., 95.53.
[24] For a similar line of thought, see *Sensus Communis* (76/78 [109/110/111]). See also Whichcote (*Select Sermons* 157, 265). Whichcote stresses that there is a 'secret *Sympathy* in Human Nature, with Vertue and Honesty; with Fairness and good Behaviour; which gives a Man an Interest even in bad Men'. Furthermore, one should 'detest and reject that Doctrine which saith, that God made Man *in a State of War*'. Whichcote's positive outlook on human nature was a source of inspiration for Shaftesbury's critique of Hobbes's anthropology. Whichcote claimed that '*Man* is a sociable Creature' that 'delights in Company and Converse' (*Select Sermons* 265).
[25] TNA, PRO 30/24/22/7, fol. 490ᵛ. The letter to Stanhope also contains a noteworthy sentence of respect for Hobbes's philosophy: 'Tom Hobbs whom I must confess a Genius, and even an Original among these latter Leaders in Philosophy'.
[26] Thomas Hobbes, *De Cive: The English Version*, ed. Howard Warrender, The Clarendon Edition of the Philosophical Works of Thomas Hobbes (Oxford: Oxford University Press, 1983), 44.

critique by Shaftesbury in *The Moralists*. In the dialogue, Plautus's dictum *homo homini lupus* (man is a wolf to man), referred to by Hobbes in the Epistle Dedicatory of *De Cive* (1642) to describe the mayhem of nature,[27] is cleverly ridiculed by Theocles. If one proceeds, like the 'Transformers of Human Nature', and addresses this 'imaginary *State of Nature*' by reference to 'monstrous Visages of *Dragons, Leviathans*, and I know not what devouring Creatures' (*Moralists* 210/212 [319]), one must, Theocles declares, understand the absurd purport of the classic dictum. To disparage the state of nature by referring to wolves as violent and callous animals is plainly absurd. From observations of rational nature, one must, argues Theocles, rather conclude that '*Wolves* are *to Wolves* very kind and loving Creatures' (*Moralists* 212 [320]). Wolves are social, generous, and naturally affectionate to one another. Indeed, it would, argues Theocles, be more correct to claim that '*Man is naturally to Man, as a Wolf is to a tamer Creature*'. However, such a dictum is just as ridiculously nonsensical. By claiming that man is to man in a similar way as a wolf is to, for instance, a sheep, is merely to state something trivial, namely that there exists '*different* Species or Characters of Men'. For Theocles, the 'ill-natur'd Proposition' ultimately thus 'comes to nothing' (*Moralists* 212 [320]).

[27] Ibid., 24: '*Man to Man is a kind of God; and that Man to Man is an arrant Wolfe*: The first is true, if we compare Citizens amongst themselves; and the second, if we compare Cities.' The proverb is taken from Plautus's play *Asinaria*, see *Amphitryon, The Comedy of Asses, The Pot of Gold, The Two Bacchises, The Captives*, trans. Wolfgang de Melo, Loeb Classical Library 60 (Cambridge, MA: Harvard University Press, 2011), 495: 'Lupus est homo homini, non homo, quom qualis sit non nouit' (Man is a wolf and not a man towards a man when he doesn't know what he's like).

2.2

Self-knowledge and disinterestedness

Apart from the significance of natural affections and the concept of *moral sense* in philosophy, it is Shaftesbury's use of the concept of disinterestedness that has rendered most attention in aesthetics. The current diachronic narrative of aesthetic theory owes its debts to the revisionism of Jerome Stolnitz where he claims that Shaftesbury provides us with a particular modern mode of aesthetic perception (*aesthetic disinterestedness*).[1] In order to gain a complete understanding of Shaftesbury's notion of disinterestedness, and some of the main problems accompanying Stolnitz's highly influential reading of especially *The Moralists*, it is important for us to carry on focusing on the *Inquiry* (at least initially), as well as on natural affections, the conception of a virtuous self, and religion.

In book I of the *Inquiry*, Shaftesbury recapitulates his common holistic theme of the organic relation between the private system and the universal system. For instance, the fragile bodily structure and the rash behaviour of a fly 'fits and determines him as much *a Prey*, as the rough Make, Watchfulness and Cunning of the former [the spider], fits him for Capture, and the ensnaring part' (*Inquiry* 50 [18]). The 'Web and Wing are suted to each other' (*Inquiry* 50 [19]). But flies are also essential for other animals. Species remain related and subservient to other species. Following in the footsteps of the Roman emperor Marcus Aurelius' *Meditations*, private small-scale systems are, for Shaftesbury, incessantly linked together in the beautiful shape of larger systems, which are

[1] On intended revisionism, see Jerome Stolnitz, 'A Third Note on Eighteenth-Century "Disinterestedness"', *Journal of Aesthetics and Art Criticism* 22, no. 1 (1963), 69. Miles Rind, 'The Concept of Disinterestedness in Eighteenth-Century British Aesthetics', *Journal of the History of Philosophy* 40, no. 1 (2002), 68, makes a correct observation of the impact of Stolnitz: 'Today, the theory of the aesthetic attitude has little role in philosophy other than as a dummy set up in aesthetics courses to be knocked down by the onslaughts of George Dickie. Yet Stolnitz's account of the origins of the central concept of that theory, the concept of disinterested perception, retains an influence that the theory itself has long lost. Philosophers and others writing about eighteenth-century aesthetic thought continue to attribute such a concept to Shaftesbury and his successors, and continue to cite Stolnitz's essay as authority for such an attribution.'

then linked to even greater systems:[2] there is an '*Animal-Order* or *Oeconomy*, according to which the Animal Affairs are regulated and dispos'd', and such an oeconomy can be perceived 'in *one System* of a Globe or Earth', which is a system that furthermore has a 'real Dependence on something still beyond', for instance other planets, which implies that the system is then 'in reality but a PART of some other System' (*Inquiry* 50 [19]).

This organic chain of being naturally has consequences for Shaftesbury's theodicy. There are no separate systems present: the whole of God's cosmos is coherent and designed in a purposeful way.[3] To be entirely *ill* is related to the universal system: the ill contributes to the good of the universal system (contributions that also involve destructions and corruptions of other systems) and proves that the 'Ill of that private System [is] no real Ill in it-self' (*Inquiry* 52 [20]).[4] The interesting guiding principle for Shaftesbury at this point concerns the motives for doing good or ill. As we briefly touched upon in the case of a reflective affective awareness, motives are of great importance to Shaftesbury. It is the agent's motives, rather than the results, that determine his moral status. As Shaftesbury's biographer Robert Voitle observes, while 'any act which is beneficial to others or to the whole is *good*', the agent performing the act 'is not virtuous unless he acts upon the proper motive, love of the whole or of others, which is virtue itself'.[5] In the end, it is the impending intention that defines us as moral human beings and no one is, according to Shaftesbury, good if 'he abstains from executing his ill purpose, thro a fear of some impending Punishment, or thro the allurement of some expected Pleasure or Advantage' (*Inquiry* 52 [21].

The motive to act in a specific way is, furthermore, grounded in passions or affections. The agent can, according to Shaftesbury, only be 'suppos'd *Good*, when the Good or Ill of the System to which he has relation, is the immediate Object of some Passion or Affection moving him' (*Inquiry* 54 [21]). Thus, instead

[2] See Marcus Aurelius, *Meditations*, in *Marcus Aurelius*, trans. C. R. Haines, Loeb Classical Library 58 (Cambridge, MA: Harvard University Press, 1916), e.g. 7.9.
[3] See also e.g. Shaftesbury's letter to Locke (29 September 1694): 'If there bee any one yt knows not, or beleives not yt all things in ye Univers are done for ye best, & ever will goe on so, because conducted by ye same Good Cause ... Such a one is indeed wanting of knowledg' (*Correspondence* 202).
[4] For contributions containing destructions and corruptions, see *Inquiry* (52 [20]): '[A]s when one Creature lives by the Destruction of another; one thing is generated from the Corruption of another; or one planetary System or *Vortex* may swallow up another.' About Shaftesbury's theodicy, see Patrick Müller, '"Dwell with Honesty & Beauty & Order": The Paradox of Theodicy in Shaftesbury's Thought', *Aufklärung: Interdisziplinäres Jahrbuch zur Erforschung des 18. Jahrhunderts und seiner Wirkungsgeschichte* 22 (2010).
[5] Voitle, *The Third Earl of Shaftesbury 1671–1713*, 130. See also Gill, *The British Moralists on Human Nature and the Birth of Secular Ethics*, 90. As Gill observes, one of the key points made throughout the *Inquiry* is that a 'person who does good from selfish motives is morally equivalent to a person who does ill from selfish motives'.

of referring to our *motives* towards the good, Shaftesbury now begins to speak, in the *Inquiry*, about our *affections* towards the good. If the agent's affections towards self-good is, on the one hand, expedient for a private interest and, on the other hand, incompatible with a public good, it is a 'vicious Affection' (*Inquiry* 56 [22]). Clearly, that something might generate goodness by mere chance is secondary to Shaftesbury. Instead, it is the 'immediate Affection, *directly*, and not *accidentally*, to Good, and against Ill' (*Inquiry* 60 [25]) that determines moral status. When refraining from vicious selfishness and when 'all the Affections and Passions are suted to the public Good, or Good of the Species ... then is the *natural Temper* intirely good' (*Inquiry* 64 [26/27]).

While an immoderate affection is harmful to sociability and thus is a vicious affection, a moderate affection displays no such disadvantage. Shaftesbury certainly does not oppose care for a private good that serves a public good. Indeed, the 'Affection towards Self-Good, may be a good Affection, or an ill one' (*Inquiry* 58 [24]); which one it turns out to be is simply determined by whether or not we manage to maintain and coordinate a sense of balance of the affections.[6] Hence, ferocious selfishness – the vicious affective imbalance of a 'more than ordinary Self-Concernment, or Regard to private Good', which is naturally conflicting with the 'Interest of the Species or Publick' – is not equal to a care for a private good (*Inquiry* 56 [23]). The complex terminology, and the imprecise use of it, might cause a confusion of ideas, especially when Shaftesbury applies the notions of *selfishness* and *self-interest*. While selfishness consisting of an excessive preoccupation with one's own desires, to the extent that it destabilizes the balance of the affections and the agent's relation to the interest of the public, is negative, it is not necessarily wrong to be befittingly selfish or self-interested. Shaftesbury clarifies his view of subtle differences between the terms in *Sensus Communis*. Against the belief that '*Interest governs the World*', he argues that '*Passion, Humour, Caprice, Zeal, Faction*, and a thousand other Springs, which are counter to *Self-Interest*, have as considerable a part in the Movements of this Machine' (*Sensus Communis* 84 [115]). It appears then as if self-interest simply is utterly undesirable. But what Shaftesbury argues against is, more precisely, a reduction of natural human affections to 'that one Principle and Foundation of a cool and deliberate *Selfishneß*' (*Sensus Communis* 86 [116]). The diminution of a vital sentimental ability into an intentionally callous and self-absorbed interest is precisely the kind of Hobbesian psychological egoism that Shaftesbury throughout his writings

[6] See also *Inquiry* (148 [81]): 'That to be well affected towards the *Publick Interest* and *one's own*, is not only consistent, but inseparable.'

wants to avoid. Expecting nature to abet man, man becomes affronted by having to assist nature himself, and thus he feels 'forc'd' from what he believes is his *'true Interest'* (*Sensus Communis* 86 [117]). In order to protect this false and unnatural interest, 'narrow-minded Philosophers' (*Sensus Communis* 86 [117]) have, according to Shaftesbury, time and again endeavoured to overcome and master nature.[7] The result of such attempts is the renunciation of a natural public interest (families, friends, fellow citizens, laws, etc.). Modern philosophers persist in this attempted dominion, but with the use of a more extreme language 'They wou'd so explain all the social Passions, and natural Affections, as to denominate 'em *of the selfish kind*' (*Sensus Communis* 88 [118]). These modern philosophers are thus engaged in a nonsensical play with words, where it is popular to claim that you can 'act as disinterestedly or generously as you please, *Self* still is at the bottom, and nothing else' (*Sensus Communis* 90 [120]). Anticipating Hume's mid-eighteenth-century critique of the 'selfish hypothesis', where disinterestedness simply is reducible to self-interest, Shaftesbury observes that the imprudence of modern philosophers suggests a subjugation of natural affections and public interests, since it also turns 'every Passion towards *private* Advantage' and a 'narrow *Self-End*' (*Sensus Communis* 90 [120]).[8] To lose interaction with our natural affections is, to Shaftesbury, ultimately as detrimental as losing the intellectual capacities of memory and understanding.[9]

The most challenging standpoint on the selfish hypothesis in the early eighteenth century was taken by the Anglo-Dutch satirist Bernard Mandeville in his attack on Shaftesbury's view of natural affections. We should pause a moment to reflect on Mandeville's arguments in order to clarify Shaftesbury's unswerving conviction on the matter. Mandeville's arguments are traceable back

[7] For a comment on Shaftesbury's use of the notions *self-interest*, *selfishness*, and *public interest*, see Stanley Grean, 'Self-Interest and Public Interest in Shaftesbury's Philosophy', *Journal of the History of Philosophy* 2, no. 1 (1964), 38: 'In his writings Shaftesbury carried on a continual campaign against the type of reductionism which seeks to explain all human behaviour by "that one principle and foundation of a cool and deliberate selfishness." Thus, he attacks Epicurus and Lucretius among the ancients, and Hobbes, Lord Rochester, and La Rochefoucauld among the moderns.'
[8] David Hume, *An Enquiry Concerning the Principles of Morals*, ed. Tom L. Beauchamp (Oxford: Oxford University Press, 1998), 92: 'There is another principle ... which has been much insisted on by philosophers, and has been the foundation of many a system; that, whatever affection one may feel, or imagine he feels for others, no passion is, or can be disinterested; that the most generous friendship, however sincere, is a modification of self-love; and that, even unknown to ourselves, we seek only our own gratification, while we appear the most deeply engaged in schemes for the liberty and happiness of mankind.' For an account of the British debate on self-interest and disinterestedness, see Christian Maurer, 'Self-Interest and Sociability', in *The Oxford Handbook of British Philosophy in the Eighteenth Century*, ed. James A. Harris (Oxford: Oxford University Press, 2013).
[9] *Sensus Communis* (92 [121]): 'A Man is by nothing so much *himself*, as by his *Temper*, and the *Character of his Passions and Affections*. If he loses what is manly and worthy in these, he is as much lost to himself as when he loses his Memory and Understanding.'

to his verse pamphlet *The Grumbling Hive: Or, Knaves Turn'd Honest*, published anonymously in 1705 and reappearing in his *succès de scandale*, *The Fable of the Bees: Or, Private Vices, Publick Benefits* in 1714.[10] The pamphlet tells the story of a happy community of bees that makes a fatal decision to substitute vices for virtues, and by so doing also ends up replacing its thriving luxury with a deteriorating society. The moral of the fable turns Shaftesbury's idea of natural affections and virtues upside down: it is not, Mandeville suggests, the natural virtues of the bees but their selfish vices that relate them to a prosperous beehive (or, in a non-metaphorical sense that relate man to his nation and society). Given that the economy of society depends on vice since it stimulates spending, to lose vice is, for Mandeville, to lose the primary driving capacity of a wealthy and productive society:

> *So Vice is beneficial found,*
> *When it's by Justice lopt and bound;*
> *Nay, where the People would be great,*
> *As necessary to the State,*
> *As Hunger is to make 'em eat.*[11]

In the edition of *The Fable of the Bees* published in 1723 (the poem reached its final form in the sixth edition published in 1729), Mandeville included an essay entitled *A Search into the Nature of Society*, where he explicitly attacks '[t]his Noble Writer (for it is the Lord *Shaftesbury* I mean in his Characteristicks)', claiming that 'two Systems cannot be more opposite than his Lordship's and mine'.[12] Where Shaftesbury sees natural affections and a harmonious world, Mandeville sees hypocrisy, and where Shaftesbury builds his thinking on a firm trust that individual contributions to the good of the whole confirm that any

[10] For an exegesis of Mandeville's laborious work with *The Fable of the Bees* and the controversial impact of the poem, see F. B. Kaye's commentary and introduction to Bernard Mandeville, *The Fable of the Bees: Or, Private Vices, Publick Benefits*, vol. 1, ed. F. B. Kaye (Oxford: Clarendon Press, 1924), xxxiii–cxlvi. The scandalous success of Mandeville's *Fable of the Bees* occurred after 1723. The *Fable* was only reprinted twice in 1714, and published in an enlarged edition in 1723, before the attention and the criticisms received an impetus. It was republished in 1724, 1725, 1728, 1729, and 1732, and famously attacked by Dennis, Berkeley, Francis Hutcheson, et al. On Mandeville's controversial authorship, see M. M. Goldsmith, *Private Vices, Public Benefits: Bernard Mandeville's Social and Political Thought* (Cambridge: Cambridge University Press, 1985), esp. 120–59.
[11] Ibid., 37.
[12] Ibid., 323–4. Mandeville opens his essay by targeting Shaftesbury's conception of morality: 'THE Generality of Moralists and Philosophers have hitherto agreed that there could be no Virtue without Self-denial; but a late Author [i.e. Shaftesbury], who is now much read by Men of Sense, is of a contrary Opinion, and imagines that Men without any Trouble or Violence upon themselves may be naturally Virtuous. He seems to require and expect Goodness in his Species, as we do a sweet Taste in Grapes and China Oranges, of which, if any of them are sour, we boldly pronounce that they are not come to that Perfection their Nature is capable of' (323).

ill of a small-scale private system is not a real ill in itself, Mandeville claims to refute him by relying on the empirical proofs of 'daily Experience'.[13] Mandeville commences his arguments on hypocrisy in a noteworthy paragraph on the status of paintings, where he coalesces the experience and value of paintings with some foresighted remarks about the logic of art markets. Mandeville draws attention to the fact that the importance of a painting is permanently filtered via market values regulated by the forces of supply and demand. Our appreciation of a painting relies on (1) who the artist is, (2) the age in which the painting is made, (3) the scarcity of the artist's works, and (4) the personal qualities of the owner of the painting and the length of ownership.[14] Along with his remarks on the logic of the art world, Mandeville adds a comment about the 'Imperfection in the chief of our Senses [i.e. seeing]', where he suggests that it is not the natural flawlessness of sight that allows man to experience art, but his perceptual shortcomings.[15] The imitation of nature relies, according to Mandeville, on a 'happy Deceit', where the perspective of space and distance of the work of art (the case in point is painting) appeals to an acquired knowledge of the perceiver.[16] While cultured knowledge of perspectives permits us to have aesthetic experiences, natural perception rather prevents us from experiencing art properly. The 'Inventions of Drawings and Painting' rely, argues Mandeville, on this unnatural perspective.[17]

Accentuating works of art as inventions, and bluntly stressing them as commodities, is very much in line with Mandeville's general wish to punctuate Shaftesbury's positive conviction of the *pulchrum et honestum* of art and natural affections towards society and other human beings. The status of art is from Mandeville's perspective not determined by a tenacious conviction of a natural moral experience of art as such. Rather, our aesthetic experience is infiltrated by various commercial and cultural values. Of course, this means that there can be no such thing as a natural taste, or even a natural disposition to taste. What might look like a natural receptivity to harmonious works of art is in fact only a passing whim governed by remote and external conditions: '[O]ur Liking or Disliking of things chiefly depends on Mode and Custom, and the Precept and

[13] Ibid., 324. Shaftesbury's 'Notions' are, according to Mandeville, 'generous and refined: They are a high Compliment to Human-kind, and capable by the help of a little Enthusiasm of Inspiring us with the most Noble Sentiments concerning the Dignity of our exalted Nature: What Pity it is that they are not true.'
[14] Ibid., 326.
[15] Ibid., 327.
[16] Ibid.
[17] Ibid.

Example of our Betters and such whom one way or other we think to be Superior to us.'[18]

Mandeville then goes on to make similar assumptions about morals. While the practice of polygamy is permitted among Muslims, it is, Mandeville stresses, regarded as morally wrong among Christians, and while some cultures allow incestuous relationships between siblings, other cultures find incest morally repugnant.[19] In all these cases, however, the conflicting parties will mistakenly claim that their 'Antipathy proceeds from Nature'.[20] This leads Mandeville to conclude that the 'hunting after this *Pulchrum* & *Honestum* is not much better than a Wild-Goose-Chace that is but little to be depended upon'.[21] The natural constancy and harmony that permeate Shaftesbury's understanding of virtue and affections are to Mandeville merely a self-deceptive chimaera. Given that the 'Force of Custom warps Nature, and at the same time imitates her in such a manner, that it is often difficult to know which of the two we are influenced by', the act of identifying and classifying a conduct as being in accordance with nature becomes highly problematic.[22] To claim that man can be virtuous without being in a state of self-denial is to make oneself guilty of opening the gateway to hypocrisy, which is precisely what Mandeville accuses Shaftesbury of. The pages of *A Search into the Nature of Society* are bursting with exasperation over the existential detachment that Mandeville believes Shaftesbury exploits:

> That boasted middle way, and the calm Virtues recommended in the Characteristicks, are good for nothing but to breed Drones, and might qualify a Man for the stupid Enjoyments of a Monastick Life, or at best a Country Justice of Peace, but they would never fit him for Labour and Assiduity, or stir him up to great Achievements and perilous Undertakings.[23]

The bonds that unite fellow citizens are, from Mandeville's perspective, certainly not irrelevant, but they cannot be defined by reference to natural affections for other human beings and society itself. Man will indeed seek company if the company is of the *right* kind. But if the satisfaction is superior when in solitude, he will naturally prefer isolation to company. Thus, while there are social companies that are rightly desirable, they remain, according to Mandeville, merely means to strengthen self-interest.[24] Shaftesbury's belief in the reality of

[18] Ibid., 330.
[19] Ibid.
[20] Ibid., 331.
[21] Ibid.
[22] Ibid., 330.
[23] Ibid., 333.
[24] Ibid., 343.

natural affections is, or so Mandeville suggests, merely deceptive: it gives a highly idealized description of human nature and thus teaches us to overlook that the real source of our actions is vice, and that the deep-rooted structure of society itself is calculated selfishness.[25] Just like he intends to lay bare the unpredictable forces of taste and the unnatural and acquired experience of art, Mandeville wishes to unmask the sociable nature of man and his natural affections for society as a trumped-up story, invented to suppress our egoistic motives.

If he were alive to defend himself, Shaftesbury would naturally have found Mandeville's reduction of the natural affections of the self into psychological egoism highly disturbing. According to Shaftesbury, a natural self-interest is ideally a private good that is expected to incorporate a balance between self-affections and natural affections, excluding the vicious unnatural affections. Such a private good is simply part of the natural public good. While a moderate self-interest undoubtedly remains incompatible with a mercenary and calculated selfishness, it is at the same time allied with a genuine care for life itself. During his second retreat to Rotterdam, Shaftesbury notes the following, with reference to one of the Delphic maxims inscribed on the temple of Apollo at Delphi and to Epictetus:

> ΓΝΩΘΙ ΣΕΑΥΤΟΝ [know yourself]. Know but this SELF only & what SELF is indeed: and then fear not being too selfish: fear not to say ἐμοὶ παρ' ἐμὲ φίλτερος οὐδείς [no one is dearer to me than myself] and τοῦτο πατήρ, καὶ ἀδελφός, καὶ συγγενὴς καὶ πατρὶς καὶ θεός [this (i.e. the self's own interest) is its father and brother and kinsmen and country and God] (*Askêmata* 228).[26]

To pursue a rational self-interest is, in fact, the most natural undertaking we can do, and it obliterates the aberrant selfishness that arises from the failure to distinguish the natural source of the self. Alluding to the Cimmerians in the opening of the eleventh book of Homer's *Odyssey* whose foggy land the sun never visits, Shaftesbury makes the following note:[27]

[25] Ibid., 369. The concluding remark in *A Search into the Nature of Society* is revealing: 'After this I flatter my self to have demonstrated that, neither the Friendly Qualities and kind Affections that are natural to Man, nor the real Virtues he is capable of acquiring by Reason and Self-Denial, are the Foundation of Society; but that what we call Evil in this World, Moral as well as Natural, is the grand Principle that makes us sociable Creatures, the solid Basis, the Life and Support of all Trades and Employments without Exception: That there we must look for the true Origin of all Arts and Sciences, and that the Moment Evil ceases, the Society must be spoiled, if not totally dissolved.'

[26] Shaftesbury cites Epictetus, *Discourses*, 3.4.10 and 2.22.16 (*Nota bene*, the Loeb edition has συγγενεῖς, not συγγενὴς).

[27] Homer, *Odyssey*, vol. 1, trans. A. T. Murray, Loeb Classical Library 104 (Cambridge, MA: Harvard University Press, 1919), 11.13–19.

O, Cymmerian Darkness! fatal overcoming Blindness! Epidemical Contagion! universal & incurable! not to be sensible in this Cheif Part of Sense: not to see this clear apparent first fundamental Truth. not to see that Thing wch sees wch judges wch pronounces, and wch only *is*! for where cou'd any Selfishness remain, where any ill Interest Disorder Murmur Complaint or Quarrel either with Earth or Heaven, were this but seen, and nothing else were seen for SELF but what were truly so? (*Askêmata* 228)

There is then a difference between a rational self-interest or moderate selfishness and a corrupt selfishness. When a care for the self is pursued, it is, Shaftesbury stresses in *Sensus Communis*, the 'height of Wisdom, no doubt, to be rightly *selfish*' (*Sensus Communis* 92 [121]). The word *rightly* indicates that the concern for a private good consists of a proper balance between self-affections and natural affections. The argument put forward in *Sensus Communis* might appear confusing, but what Shaftesbury attempts to say is that a mercenary and callous selfishness is incompatible with natural affections and human feelings of sociability, and thus always a negative, but "Tis as these Feelings and Affections are intrinsically valuable and worthy, that *Self-Interest* is to be rated and esteem'd' (*Sensus Communis* 92 [121]). To be moderately selfish and naturally self-interested is valuable because it implicates a natural care for one's own moral, religious, and societal existence. As we observed earlier, private systems and universal systems are organically related. The proper care for the self is necessary, not only for the agent himself, but eventually for the public good and society. A thriving society not only revolves around external social relations, but is naturally established by, and related to, that 'Economy or Commonwealth within' the agent (*Askêmata* 191). There is, for Shaftesbury, ultimately no proper conflict of interests between a natural self-interest and natural affections. Throughout his writings Shaftesbury moves, just like Addison, quickly between a micro-perspective of the moral self to a macro-perspective of an intersubjective cognition fundamental to polite society. When posing the question of which values the proper care for one's own self holds in relation to others, Shaftesbury writes the following, in the entry entitled 'Self', during his first retreat to Rotterdam:

O, Folly! as if it were not apparent that if thou but continuest thus, & art able to persevere, thy Example alone (when thou least regard'st it) will be of more service than all yt thou canst do whilst thou retain'st thy Selfishness, thy Meanness & Subjection, wch thou canst no otherwise shake off but by this course. (*Askêmata* 190)

Self-interest and natural affections are furthermore closely related to Shaftesbury's view of proper knowledge of self, a relation that he analyses most thoroughly when addressing the 'Art of *Surgery*' in *Soliloquy*: '[T]he Study of *Human Affection* cannot fail of leading me towards the Knowledg of *Human Nature*, and of MYSELF' (*Soliloquy* 218 [297]). While he ridicules Descartes's Cogito argument – '"*What is, is.*" Miraculously argu'd! "If *I am*; *I am*"' (*Miscellaneous* 232 [193]) – the Earl stresses that we must endeavour to become 'comprehensible to our-selves' (*Soliloquy* 202 [283]).[28] Although he is a severe critic of any systematized approach to philosophical problems, Shaftesbury actually comes close to suggesting a specific inward method (or what he refers to as 'Science' or '*Surgery*') for achieving such knowledge: that of soliloquy, the '*self-discoursing Practice*' (*Soliloquy* 54 [164]). This mental operation holds the promise of inner emancipation, since 'a MIND, by knowing *it-self*, and its own proper Powers and Virtues, becomes *free*, and independent' (*Miscellaneous* 246 [204]). The Delphic maxim that Shaftesbury referred to in *Askêmata* is a source for his further contemporary speculations on soliloquy. Self-acknowledgement evolves from a moment of internal discourse. Similar to the Ancients, the agent needs to ensure, or so Shaftesbury argues, a belief in the method of soliloquy as such, by trusting that to 'RECOGNIZE YOUR-SELF' is also to '*Divide your-self*, or *Be* TWO' (*Soliloquy* 62 [170]). Thus, unity and harmony of the self, which are cornerstones for the experience of cosmological beauty and rationality, ultimately emerge, argues Shaftesbury, from an internal split. The agent needs to have access to a productive discourse with himself, and he creates this access by organizing an internal mental channel of communication.

Given that the exercise of soliloquy is essentially facultative, the practice of self-discourse is also egalitarian. However, it is important to keep in mind that when Shaftesbury claims that he seeks to 'correct *Manners* and regulate *Lives*' (*Miscellaneous* 224 [187]), he refers to a gentlemanly readership.[29] Although our natural disposition is an innate human impulse, a cultivated and decorous taste itself is certainly not congenital. While the 'predisposition toward it is connate, taste itself can', as Voitle observes, 'only be attained by contact with the

[28] See Descartes, *Meditations on First Philosophy*, in *The Philosophical Writings of Descartes*, vol. 2, trans. John Cottingham, Robert Stoothoff, and Dugald Murdoch (Cambridge: Cambridge University Press, 1984), 17 (see also *Les Méditations métaphysiques*, in *Oeuvres de Descartes*, vol. 9, ed. Charles Adam and Paul Tannery (Paris: Léopold Cerf, Imprimeur-Éditeur, 1904), 2.19); *Discourse on the Method*, in *The Philosophical Writings of Descartes*, vol. 1, 127 (see also *Discours de la méthode*, in *Oeuvres de Descartes*, vol. 6, 4.33); *Principles of Philosophy*, in *The Philosophical Writings of Descartes*, vol. 1, 195 (see also *Les Principes de la philosophie*, in *Oeuvres de Descartes*, vol. 9, 1, §7, 27).

[29] For Shaftesbury's (male) audience see Rivers, *Reason, Grace, and Sentiment*, 104–7.

world outside'.[30] Needless to say, such a contact brought empirical reality to the fore. British eighteenth-century society was after all not distinguished by equal opportunities. Thus, while Shaftesbury ascribes a critical significance to the possession of a sophisticated taste, we should keep in mind that given the great claims he attributes to the man of taste and his learning, he had to remain in doubt of the possibility of any widespread realization of the natural disposition.[31] To take advantage of our natural impulse to cultivate certain concepts requires a great private effort and, bearing in mind the social and gender disparity of the paternalistic society that Shaftesbury himself accepted, such an endeavour remained on the whole an unrealistic fantasy outside a gentlemanly readership. While, as we will see, this does not restrain Shaftesbury from believing that post-revolutionary British society is on the verge of a substantial (yet numerally limited) progress of taste, such a development must, then, by presupposing a combination of socio-economic hierarchies and rigorous classical learning, be relevant for some, while remaining irrelevant for many. The possession of taste is an exclusive privilege and involves, as Barbara Schmidt-Haberkamp observes, overcoming demanding challenges: '[T]he individual must learn to develop his inclinations against the persistent resistance of such seductive powers as habit and fashion'.[32] The privileged, yet challenging, task of soliloquy is ultimately to help us gain necessary knowledge of the self: 'Knowledge commences according to Shaftesbury with self-knowledge, which at the same time constitutes the only reliable knowledge'.[33] It is by '*Self-Study* and *inward Converse*' that authors are

[30] Voitle, *The Third Earl of Shaftesbury 1671–1713*, 340.
[31] Ibid., 112. Voitle's observation concerns Shaftesbury's dealings with religion and virtue in a paternalistic society, but is equally applicable to the realization of the natural disposition to taste: 'For his [Shaftesbury's] servants, for his farmers, for the great mass of mankind there is no hope except by earnest and continued attention to the moral dictates of religion from the earliest age. Even if these people escape from superstition born of ignorance, Shaftesbury admits that the fruits of self-interest – greed, laziness, and dishonesty – are likely to dominate. The paternalism of the system of which he is a part, and his own hopes, may encourage him to give them a second or a third chance, but often, he knows, they will fail anyway. Even among the better favored who have special opportunities or education to help them to turn out right, there is always the danger of backsliding.'
[32] My trans. of Barbara Schmidt-Haberkamp, *Die Kunst der Kritik: zum Zusammenhang von Ethik und Ästhetik bei Shaftesbury* (Munich: Wilhelm Fink, 2000), 39: 'das Individuum lernen muß, seine Neigungen gegen den beständigen Widerstand solcher verführerischen Kräfte wie Gewohnheit und Mode zu entwickeln.' See also *Soliloquy* (272 [339]): 'I LIKE! I fancy! I admire. How? By accident: or *as I please*? No. But I *learn* to fancy, to admire, *to please*, as the Subjects themselves are deserving, and can bear me out. Otherwise, I like at this hour, but dislike the next. I shall be weary of my Pursuit, and, upon Experience, find little *Pleasure* in the main, if my Choice and Judgment in it be from no other Rule than that single one, *because I please*.'
[33] My trans. of Schmidt-Haberkamp, *Die Kunst der Kritik*, 15: 'Erkenntnis beginnt bei Shaftesbury mit Selbsterkenntnis, die zugleich das einzig zuverlässige Wissen darstellt.'

'settl[ing] Matters, in the first place, with *themselves*', which then allows them to 'command their *Audience*, and establish a *good Taste*' (*Soliloquy* 192/194 [277]).

There are no short cuts to genuine self-knowledge and balanced affections, and taste cannot be taught by disclosing a set of facts about art. The didactic process that Shaftesbury has in mind has nothing to do with well-educated mentors teaching ignorant citizens how to gain good taste. Giving advice is a delicate matter. Often it is, argues Shaftesbury, entangled in a narcissistic moment where we rather 'shew our own Wisdom, at another's expence' (*Soliloquy* 40 [154]). Power and self-absorption must be kept out of the process. Instead, we must trust that there is a 'certain Knack or *Legerdemain* in Argument, by which we may safely proceed to the dangerous part of *advising*' (*Soliloquy* 42 [155]). While philosophy, to Shaftesbury, is the *Vitae Dux, Virtutis Indagatrix*,[34] this legerdemain does not consist of a basic set of aesthetic values. University learning and what Shaftesbury, in a letter to Ainsworth, refers to as 'ye narrow Principles & contageouse Manners of those corrupted Places' (*Ainsworth Correspondence* 353) are not the instruments to complete either morals or taste.[35]

The didactic process and the benefits of self-knowledge revolve around a relatedness to others and society at large. Shaftesbury constantly repositions his arguments on the self and self-knowledge in different contexts and relations, moving, as in the *Askêmata* notebooks, between a singular mind that 'acts upon a Body; and not on a Body only but on ye Senses of a Body', and the world, which is also a body, consisting of the 'Bodyes in this Body [the world]' (*Askêmata* 234). The individual body is united with the general body and the general mind. The sense of belonging that is integral to a 'particular Mind' over 'particular Body

[34] See Cicero, *Tusculan Disputations*, 5.2.5: 'O philosophy, thou guide of life, o thou explorer of virtue and expeller of vice!' In *Askêmata*, Shaftesbury styles philosophy 'the Studdy of Happiness' (284, 285), a definition that he later uses in *The Moralists* (378 [438]).

[35] Shaftesbury voices great objections to such scholarly knowledge. See *Sensus Communis* (38 [76]) and *Soliloquy* (266 [333/334]): 'I AM persuaded that to be a *Virtuoso* (so far as befits a Gentleman) is a higher step towards the becoming a Man of Virtue and good Sense, than the being what in this Age we call *a Scholar*. For even rude Nature it-self, in its primitive Simplicity, is a better Guide to Judgment, than improv'd Sophistry, and pedantick Learning. The *Faciunt, nae, intellegendo, ut nihil intellegant* [cf. Terence, *The Woman of Andros*, ed. and trans. John Barsby, Loeb Classical Library 22 (Cambridge, MA: Harvard University Press, 2001), 17], will ever be apply'd by Men of Discernment and free Thought to such Logick, such Principles, such Forms and Rudiments of Knowledg, as are establish'd in certain Schools of Literature and Science.' See also *Printed Notes* (58 [333, 334]) and Shaftesbury's letter to Ainsworth in February 1706/1707 (*Ainsworth Correspondence* 347). Here, in his first letter to Ainsworth, Shaftesbury cautions him about the learnings gained from university: '[T]ho' there be no part of Learning more advantageouse even towards Divinity than Logicks Metaphisicks & wt we call University Learning; yet Nothing proves more dangerous to Young Minds un-forewarn'd, or what is worse, prepossessd with the Excellence of such Learning, as if all Wisdome lay in the Solution of those Riddles of ye School-men ... If your Circumstances or Condition will suffer you to enter into ye World by a University, well is it for you that you have prevented such Prepossession.'

Senses' stems from the fact that the purpose of the agent is controlled by the 'General Mind'. If we perceive cosmos along these lines, we should, Shaftesbury notes, also be able to take great comfort in the assurance that we serve a greater mind and that 'With ye Univers, I know, all is, and will be well. and with My Self the same; whilst I think as I do at present of that Univers, know ye Order, & serve ye ORDERER' (*Askêmata* 234). Although it remains difficult enough, if our motives are rational, and thus natural, there should be no ambiguity about the result. It is, Shaftesbury argues, simply natural to comply with rational motives, because such motives are in harmony with providential nature designed by the Deity. The plea from Shaftesbury is that we should take comfort in this principle, and endeavour to act accordingly. The individual agent is perpetually ensured in a relatedness to the cosmological totality, and the natural affections lead the self into society and friendship. The workings of the particularized self remain the natural origin and critical constitutive part of a purposeful polite society. The practice of soliloquy can aid in the rediscovery of a particularized self that is likely to become disoriented throughout existence. In his notes in *Askêmata* Shaftesbury encapsulates his distress for such disorientations – stating 'how rediculouse is it to loose the way that lyes before one, & ever & anon, as if in a strang world, to ask *where am I?*' – before suggesting how to evade them by a persistent self-reflection, where the act of dividing oneself into two persons is equivalent to be(coming) 'ONE':

> recollect thy Self wholly within thy Self. be ONE intire & self same Man: and wander not abroad, so as to loose sight of *the End*; but keep that constantly in view both in ye least concerns, & in the greatest; in Divertions, in seriouse affaires; in Company, & alone; in ye Day time & at night. Let neither Ceremony, nor Entertainment in Discours, nor Pleasantry, nor Mirth amongst Friends, nor any thing of this kind, be the occasion of quitting that remembrance ... this is certain, that if thou forget'st *thy Self*; thou wilt forget thy Duty; and instead of acting for Vertue, act for something else very different; as following thy own Passion & irrationall Bent. (*Askêmata* 186/7)

Given what we have recognized thus far about the self and balanced affections, we can now return to book I of the *Inquiry*, where Shaftesbury, in an attempt to connect his examination of virtue with a discussion of the Deity, introduces three general threats to our natural affections towards the objects of right and wrong: (1) that which removes such a natural sense, (2) that which produces a mistaken sense of it, and (3) that which 'causes the right Sense to be oppos'd by *contrary* Affections' (*Inquiry* 86 [40]). Given that our sense of right and wrong

is a 'first Principle in our Constitution and Make' (*Inquiry* 92 [44]), a complete obliteration of this sense is not possible lest it is somewhat replaced by a second nature. Naturally, Shaftesbury finds such replacement unthinkable.[36] The second threat proceeds from powers (such as education and custom) working intensely against nature. Atheism can erode the agent's moral sense, although it does not necessarily cause misconceptions of actions that ought in fact to be valued. Given that the absence of belief in God makes atheism unable to reinforce morals by finding 'neither *Goodness* nor *Beauty* in the WHOLE it-self' (*Inquiry* 130 [70]), it is undoubtedly connected with a major impediment. It appears plainly improbable that one would 'respect any particular subordinate Beauty of *a Part*', when 'THE WHOLE it-self is thought to want Perfection' (*Inquiry* 130 [70]). However, while the problem with atheism is a natural failure to benefit from the experience of God, a truly corrupted religion, on the other hand, can critically distort our relation to God. In a provocative manner, Shaftesbury appears to argue that the outcomes of religion and extolling God are not necessarily positive, and he was indeed accused by British opponents throughout the eighteenth century for being an anti-Christian philosopher.[37] If there is a religion that instructs its devotees to worship a fraudulent and intolerant God who encourages treachery, this, in the words of Shaftesbury, 'must of necessity raise even an Approbation and Respect towards the Vices of this kind, and breed a sutable Disposition, a capricious, partial, revengeful, and deceitful Temper' (*Inquiry* 98 [48]). However, the worship of such a Deity remains highly abstract. If the agent follows a Deity that has eliminated all properties of love and heartiness, merely out of fear, and against his own perfect nature performs actions he genuinely detests, his sense of right and wrong is, to some extent, still functional. A more reasonable comprehension of the Deity is, for Shaftesbury, of course one that appeals to our natural affections. The affections, and the motives of a public good, protect the agent from being mistaken in his moral actions: 'And having once the Good of our Species or Publick in view, as our End or Aim, 'tis in a manner impossible we shou'd be misguided by any means to a wrong Apprehension or Sense of Right and Wrong' (*Inquiry* 102 [51]).

When dealing with the third threat, Shaftesbury develops ideas about rewards and punishments, and he significantly clarifies his view of disinterestedness. The

[36] See e.g. *Askêmata*, 88.
[37] See Isabel Rivers, 'Shaftesburian Enthusiasm and the Evangelical Revival', in *Revival and Religion since 1700: Essays for John Walsh*, ed. Jane Garnett and Colin Matthew (London: Hambledon Press, 1993). In this excellent chapter, Rivers discusses some of the eighteenth-century attacks on Shaftesbury for being an offensive anti-Christian writer.

'*perfect Theism*' advocated by Shaftesbury is a 'Presence' that superintends every human affection by being 'conscious of all that is felt or acted in the Universe' (*Inquiry* 112 [57]). Just as a too strong selfishness is relative to vanishing sociability, the 'over-sollicitous regard to private Good' is relative to a 'diminution of Piety' (*Inquiry* 114 [58/59]). What is desired then is a disinterested love of goodness and God:

> For whilst *God* is belov'd only as the Cause of private Good, he is no otherwise belov'd than as any other Instrument or Means of Pleasure by any vicious Creature. Now the more there is of this violent Affection towards *private Good*, the less room is there for the other sort towards *Goodness it-self*, or any good and deserving Object, worthy of Love and Admiration for its own sake; such as GOD is universally acknowledg'd, or at least by the generality of civiliz'd or refin'd Worshippers. (*Inquiry* 114 [59])

Rather than reducing goodness itself by an ever-increasing unbalanced private good and fierce affections, Shaftesbury comes to advocate a disinterested attitude to God, where we 'love GOD *for his own sake*', and places such an attitude on a level with '*true Piety*' (*Inquiry* 114 [58]). Theocles encapsulates, in a characteristic fashion, Shaftesbury's fears of making, in a Lockean manner, advantages in the afterlife the cornerstone of morality, when he argues that 'by making Rewards and Punishments the principal Motives to Duty, the Christian Religion in particular is overthrown, and its greatest Principle, that of *Love*, rejected and expos'd' (*Moralists* 156 [279]).[38] Shaftesbury's emphasis on the problems attached to the Christian doctrine of rewards and punishments is a connecting thought that runs through the corpus of his writings. Already in the preface to *Select Sermons* he is pinpointing the absurdity that Christians confessing themselves to a '*Religion where* Love *is chiefly enjoyn'd*', should '*degrade the Principle of Good-nature, and refer all to Reward; which being made the only Motive in Mens Actions, must exclude all worthy and generous Disposition, all that Love, Charity, and Affection, which the Scripture enjoyns*' (*Select Sermons* 54). In *Sensus Communis*, after remarking on the paradox

[38] Here Shaftesbury thus offers a counterargument against Locke's view in *An Essay*, 2.21, §70, 281: 'The Rewards and Punishments of another Life, which the Almighty has established, as the Enforcements of his Law, are of weight enough to determine the Choice, against whatever Pleasure or Pain this Life can shew, when the eternal State is considered but in its bare possibility, which no Body can make any doubt of. He that will allow exquisite and endless Happiness to be but the possible consequence of a good Life here, and the contrary state the possible Reward of a bad one, must own himself to judge very much amiss, if he does no conclude, That a vertuous Life, with the certain expectation of everlasting Bliss, which may come, is to be preferred to a vicious one, with the fear of that dreadful state of Misery, which 'tis very possible may overtake the guilty; or at best the terrible uncertain hope of Annihilation.'

progressed by 'cool Philosophy' – ancient Epicureanism (Epicurus and Lucretius) and its novantique approaches (Hobbes)[39] – that if mercenary egoism was truly governing all affections and actions it would merely be absurd to enlighten an unsuspicious public about it, Shaftesbury goes on to elaborate his view on the doctrine of rewards and punishments further by claiming that if 'Virtue be not really estimable in it-self' he 'can see nothing estimable in following it for the sake of *a Bargain*' (*Sensus Communis* 66 [97/98]). With the doctrine of rewards and punishments, it is as if the entire focus of Shaftesbury's moral thinking runs the risk of disintegration. What is in fact left of disinterestedness if the motive of such a desirable attitude is external to the natural emotional impulses of the agent and beyond present life? Disturbed by the fact that motives and actions might become depleted of their proper values, and providential nature itself challenged, Shaftesbury remarks, dejected, that 'If the Love of doing Good, be not, of it-self, a *good* and *right* Inclination; I know not how there can possibly be such a thing as *Goodness* or *Virtue*' (*Sensus Communis* 66 [98]).

Shaftesbury illustrates his point about disinterestedness most lucidly in a letter addressed to an unknown friend, on 2 December 1704. When Locke was dying he sent his close friend Anthony Collins a letter where he made his farewell.[40] Shaftesbury included a piece of the letter in his own. Part of the Earl's motives for referring to Locke's farewell to Collins was clearly to deride Locke for his self-important vanity as a philosopher.[41] Shaftesbury's comments do not really render justice to the design of the letter: while Locke was concerned with providing a final instruction to Collins and the other Trustees about the legacy to Francis Cudworth Masham – in his will Locke left a considerable legacy to Francis, whom he had tutored[42] – Shaftesbury quoted only from the last part

[39] An observation made by Klein in Shaftesbury, *Characteristics of Men, Manners, Opinions, Times*, 43 (footnote Q). Stuart-Buttle finds it more accurate to say that Shaftesbury regarded 'Hobbes's philosophy as a grievously perverted form of true Epicureanism' (see 'Shaftesbury Reconsidered', 171, footnote 25). On the term 'novantique', see e.g. Sarah Hutton, *British Philosophy in the Seventeenth Century* (Oxford: Oxford University Press, 2015), 18–20.

[40] See 'Locke to Anthony Collins, Oates, 23 August, 1704', in *John Locke: Selected Correspondence*, ed. Mark Goldie (Oxford: Oxford University Press, 2002), 334–5.

[41] See TNA, PRO 30/24/47/25, fol. 1ʳ: 'The Piece of a Letter you sent me [i.e. Locke's letter to Collins] savours of the good Christian. It puts me in Mind of One of those dying Speeches which come out under the Title of a Christian warning piece. I should never have guessed it to have been of a dying Philosopher[.] *Consciousness* indeed is a high Term, but those who can be conscious of doing no good but what they are frighted or bribed into, can make but a sorry *account* of it, as I imagine.' See also Voitle, *The Third Earl of Shaftesbury 1671–1713*, 229. Voitle comments that, while Shaftesbury avoided explicitly attacking Locke during the latter's lifetime, 'he had no such compunctions about assailing him privately' after Locke's death. See also Rivers, *Reason, Grace, and Sentiment*, 89.

[42] Francis Cudworth Masham was the son of Locke's close friend, the English philosopher Lady Damaris Masham, née Cudworth (1659–1708). Locke lived in the Masham estate at Oates in the County of Essex from 1691 to his death.

of the letter, where Locke was selfishly concerned with his own posthumous reputation, in order to put his former tutor in a somewhat unfavourable light.[43] Against this backdrop, Shaftesbury had the opportunity to bring the notion of disinterestedness to the fore. The lasting bond of the friendship and love described by Shaftesbury is formed by the 'consciousness of doing good for *Goods sake* without any farther regard, nothing being truely pleasing or Satisfactory, but what is thus Acted disinterestedly, generously and freely.'[44] The only preparation that can be made with the aim of becoming virtuous is, as it seems, to pursue the love of God (and virtue) disinterestedly. On the closing lines of the letter, Shaftesbury accordingly exclaims: 'Thank Heaven I can do good and find Heaven in it.'[45] This disinterested position comes with the relief of having removed further worries about being moral or not. If disinterestedness itself is not the right moral way to love and serve God – 'if this Disposition fits me not for Heaven' – then Shaftesbury himself 'desire[s] never to be fitted for it, nor come into the place.'[46]

The reason why some virtues occasionally remain unnoticed is also proportionate to the presence of the disinterested attitude. The strength of Christianity is within this context that there are not merely moral duties, but 'Virtues purely voluntary' (*Sensus Communis* 66 [99]). A Christian patriot or friend might, according to Shaftesbury, exercise his *voluntary* virtues, and thus remain unworried about what is 'still behind the Curtain, and happily conceal'd from us' (*Sensus Communis* 68 [100]). In the apparatus criticus to *Sensus Communis*, Shaftesbury stresses that there is a difference between the benevolence that Christians are *obliged* to show towards other Christians, and the '*peculiar Relation* which is form'd by a Consent and Harmony of Minds', which is generally referred to as friendship (*Printed Notes* 268 [98]).[47] History

[43] Locke's concern in the letter (see 'Locke to Anthony Collins, Oates, 23 August, 1704', in *John Locke: Selected Correspondence*, 334) is primarily to secure that 'when the Legacy, which I [Locke] have given you Trustees for the use of him [Francis Cudworth Masham] and his mother [Damaris], comes to be put into your hands, whether you take it in money or any other securities, a morgage which I have of Sir Francis in the name of my Cosin King and Mr Churchill should be no part of it'.
[44] TNA, PRO 30/24/47/25, fol. 1ʳ.
[45] Ibid, fol. 2ʳ.
[46] Ibid. 'I ask no reward from Heaven for that which is Reward it self. Let my being be continued or discontinued, as in the main is best: The Author of it best knows, and I trust Him with it. To me 'tis indifferent, and always shall be so. I have never yet served God or Man, but as I loved and liked, having been true to my own and Family Motto, which is, — Love Serve —.'
[47] Shaftesbury clarifies the difference in the following passage (see *Printed Notes* 268 [98]): 'By *Private Friendship* no fair Reader can here suppose is meant *that common Benevolence* and *Charity* which every Christian is oblig'd to shew towards all Men, and in particular towards his Fellow-Christians, his Neighbour, Brother, and Kindred, of whatever degree; but *that peculiar Relation* which is form'd by a Consent and Harmony of Minds, by mutual Esteem, and reciprocal Tenderness and Affection; and which we emphatically call *a* FRIENDSHIP.'

provides us, according to Shaftesbury, with numerous examples of such admirable friendships, as, for instance, the bond between Socrates and his companion Antisthenes, between Plato and his philosophical disciple Dion, or the homosexual relationship between Pylades and his cousin Orestes, the son of Agamemnon.[48] However, the most memorable and ideal of all friendships occurs, according to Shaftesbury, in the Jewish dispensation. With reference to the Old Testament's two books of Samuel, Shaftesbury recognizes that the first king of Israel, Saul, held, despite his shortcomings, the love of a true patriot, and the friendship between his son, Jonathan, and the second king of Israel, David, demonstrates the 'noble View of a disinterested Friendship' (*Sensus Communis* 68 [101]). The disinterested virtues revealed in the love between Jonathan and David (see 1 Sam. 18.1-4) could, as Shaftesbury stresses, 'not claim a future Recompence under a Religion which taught no future State, nor exhibited any Rewards or Punishments, besides such as were Temporal, and had respect to the written Law' (*Sensus Communis* 68 [101]). This naturally had, or so Shaftesbury suggests, some generally beneficial outcomes. The Jews – elsewhere rudely condemned by Shaftesbury as a 'very cloudy People' (*A Letter Concerning Enthusiasm* 342 [29])[49] – reached access to virtue via the exercise of voluntary decisions, rather than via some directive, and since 'No Premium or Penalty [was] being inforc'd in these Cases, the disinterested Part subsisted' (*Sensus Communis* 68 [101]).

We should, however, pause here to elucidate that the disinterested attitude to God is not always completely disengaged from questions of rewards and punishments. Hopes of rewards and fears of punishments might still have a strictly utilitarian value by, as we observed earlier, creating an emotional equilibrium where a moral quality overcomes an immoral quality, and in this way they constitute a means of egress for corrupted souls. For instance, if someone despises lenity and admires revenge, one could, or so Shaftesbury suggests, alter

[48] On the friendship between Socrates and Antisthenes, see Diogenes Laertius, *Lives of Eminent Philosophers*, vol. 2, 6.2; on the friendship between Plato and Dion, see Plato, *Epistles*, in *Timaeus, Critias, Cleitophon, Menexenus, Epistles*, vol. 9, trans. R. G. Bury, Loeb Classical Library 234 (Cambridge, MA: Harvard University Press, 1929), e.g. 7.327A–330B; on the relationship between Pylades and Orestes, see Lucian, *Affairs of the Heart*, in Lucian, vol. 8, trans. M. D. Macleod, Loeb Classical Library 432 (Cambridge, MA: Harvard University Press, 1967), 47.

[49] See *A Letter Concerning Enthusiasm* (342 [29]): 'Religion [among the Jews] was look'd upon with a sullen Eye; and Hanging was the only Remedy they cou'd prescribe for any thing that look'd like setting up a new Revelation. The sovereign Argument was, *Crucify, Crucify*. But with all their Malice and Inveteracy to our Saviour, and his Apostles after him, had they but taken the Fancy to act such Puppet-Shews in his Contempt, as at this hour the Papists are acting in his Honour; I am apt to think they might possibly have done our Religion more Harm, than by all their other ways of Severity.' See also *Miscellaneous Reflections* (146 [116]).

such affections by maintaining that '*Lenity* is, by its Rewards, made the cause of a greater Self-Good and Enjoyment than what is found in Revenge', so that 'Affection of *Lenity* and *Mildness* may come to be industriously nourish'd, and the contrary Passion depress'd' (*Inquiry* 120 [62/63]). Thus, the affections initially rejected might ultimately be 'valu'd *for their own sakes*' (*Inquiry* 120 [63]). As long as rewards and punishments are justly distributed, they are, according to Shaftesbury, of benefit to society and liberal education since they might eventually yield an employment of virtue devoid of precisely any concern about rewards or punishments. The desirable motive is the disinterested attitude where we truly love virtue '*for its own sake*' (*Inquiry* 124 [66]). Once again, the motives we have for our actions determine our moral status. If someone who claims to love life and hate virtue is persuaded, by means of rewards or punishments, to 'practise Virtue, and even *endeavour* to be truly virtuous, by a Love of what he practises', this attempt cannot 'be esteem'd *a Virtue*' (*Inquiry* 124 [66]). As long as the agent's intentions are somewhat motivated by a desire for rewards or fear of punishments, he impedes his natural affections, and he remains unable to be virtuous. However, 'as soon as he is come to have any Affection towards what is morally good, and can like or affect such Good *for its own sake*, as good and amiable *in it-self*, then is he in some degree good and virtuous, and not till then' (*Inquiry* 124 [66]).

Divine forgiveness, heaven, hell, and rewards and retributions in the afterlife are, as we can see, persistently pushed into the background by a personal union between the agent's affections and God as an omnipresent witness. In the closing of book I of the *Inquiry*, Shaftesbury remarks on the relation between virtue and piety that the '*first* being not compleat but in the *latter*', and that the 'Perfection and Height of VIRTUE must be owing to *the Belief of a* GOD' (*Inquiry* 142 [76]). However, given Shaftesbury's anti-voluntarism, the relation between morality and the belief in God does not appear as straightforward for him as we have seen that it was for Addison. Indeed, it seems as if the Earl's liberal theology allows for several ways to reach virtue. As we have observed, even an atheist is sometimes able to act virtuously, even though the absence of piety makes atheism utterly undesirable and a virtuous behaviour very difficult to achieve. Provocatively enough, atheism appears almost as a zero point in the *Inquiry*: the point on a scale from which both positive (perfect theism) and negative (polytheism and daemonism) can be measured.[50] Also, given that one of the primary objectives

[50] Shaftesbury differentiates between four attitudes towards religion: (1) perfect theism, (2) perfect atheism, (3) polytheism, and (4) daemonism. While a perfect theist believes that 'every thing is govern'd, order'd, or regulated *for the best*, by a designing Principle, or Mind, necessarily good and

of the *Inquiry* is, as we have seen, to determine what virtue is '*in it-self*' (*Inquiry* 84 [39]), it becomes critical for us to address to what extent Shaftesbury in fact advocates modern secularism.[51] Indeed, I take the fact that the conception of God and morality remains integral to taste and a disinterested perception to be a determining factor for understanding Shaftesbury's historical position in aesthetics.[52] In order to bring out the relevance of this perspective, we must now revisit Stolnitz's continuously important diachronic account of disinterested aesthetic perception. As we observed in the introduction, aesthetics has slowly begun to move away from extreme versions where Shaftesbury introduces a modern disinterested aesthetic attitude detached from questions about religion, politics, and morals. However, 'despite the objections to Stolnitz, the interpretation which considers Shaftesbury as a pre-Kantian or pre-romantic still prevails' (which suggests that we are not, after all, paying sufficient attention to the temporality of Shaftesbury's notion of taste).[53] Thus, while aesthetics sporadically has diagnosed some of the problems inbuilt in Stolnitz's account of modern aesthetic disinterestedness, its loyalty to, and trust in, the traditional diachronic narrative nevertheless impedes it from dealing thoroughly with the temporal relevance of Shaftesbury's philosophy.[54]

permanent', the perfect atheist claims that there is neither such a 'designing Principle or Mind, nor any Cause, Measure, or Rule of Things, but *Chance*'. The polytheist claims that there are several designing principles or minds, and the daemonist (someone who is superstitious) holds that the designing mind or minds are 'not absolutely and necessarily good, nor confin'd to what is best, but capable of acting according to mere Will or Fancy' (*Inquiry* 36 [11]).

[51] The overall aim of the *Inquiry* is to analyse 'What *Honesty* or VIRTUE is, consider'd by it-self; and in what manner it is influenc'd by Religion: How far *Religion* necessarily implies *Virtue*; and whether it be a true Saying, *That it is impossible for an Atheist to be Virtuous, or share any real degree of Honesty, or MERIT*' (*Inquiry* 30 [7]).

[52] Müller makes a similar claim with reference to Shaftesbury's notion of moral sense. See Müller, 'Hobbes, Locke and the Consequences: Shaftesbury's Moral Sense and Political Agitation in Early Eighteenth-Century England', 322.

[53] Jorge V. Arregui and Pablo Arnau, 'Shaftesbury: Father or Critic of Modern Aesthetics?', *British Journal of Aesthetics* 34, no. 4 (1994), 351.

[54] For further discussion, see introduction. Stolnitz's account of Shaftesbury is still central to contemporary readings of the rise of aesthetics, see e.g. Carlson, *Nature and Landscape*, 2–3.

2.3

A disinterested (aesthetic) perception

A reappearing theme in the exegesis of Shaftesbury's moral ideas, and of his impact on the German *Bildung* tradition in the eighteenth century, deals with whether he was a *traditionalist* or an advocate of the *modern*.[1] Stolnitz's account in aesthetics is no exception to the rule. Unsurprisingly, Stolnitz claims that Shaftesbury's intermediary position is marked by a tension between *traditional* (pre-eighteenth-century) aesthetic instrumentalism and *modern* aesthetic autonomy. While the latter implicates the evaluation of the intrinsic value of a work of art, and a disregard for it as a primary source of knowledge and morals, Stolnitz wishes to remind the reader that in 'traditional thought, moral edification, "truth", or the dignity of the "real life" model "imitated" in the work, legislate for the value of the art-object'.[2] A modern aesthetic autonomy opposing the traditional instrumental value of art is the critical result of the emergence of the notion of disinterestedness, and it is Shaftesbury, or so Stolnitz suggests, who initiates this idea 'which, more than any other, marks off *modern* from *traditional* aesthetics'.[3] Accordingly, we might expect Stolnitz to confidently claim Shaftesbury as a paradigmatic philosopher of modern aesthetic autonomy. But initially he does not. In fact, Stolnitz appears to associate the Earl with aesthetic instrumentalism when claiming that he 'employs moral and cognitive criteria of evaluation which were later repudiated in the name of his own concept [i.e. disinterestedness]'.[4] This is indeed a surprising claim. How can someone so intensely traditional be the ancestor of modern aesthetic autonomy and creator of this 'new centre of gravity in aesthetic theory'?[5] While Stolnitz's

[1] See Gill, *The British Moralists on Human Nature and the Birth of Secular Ethics*, 85. With reference to the eighteenth-century tradition of *Bildung*, Rebekka Horlacher identifies a similar position; see *Bildungstheorie vor der Bildungstheorie: Die Shaftesbury-Rezeption in Deutschland und der Schweiz im 18. Jahrhundert* (Würzburg: Königshausen & Neumann, 2004), 9.
[2] Stolnitz, 'On the Significance of Lord Shaftesbury in Modern Aesthetic Theory', 99.
[3] Ibid., 98. My italics.
[4] Ibid., 100.
[5] Ibid., 111.

diachronic account fails, as we will see, to reflect on several critical elements regarding the division between recipient subject and perceived object, we should recognize that the descriptive part of his analysis to some extent clarifies the general modern value of the notion of aesthetic disinterestedness. Stolnitz vacillates between openly converting Shaftesbury into a *modern* philosopher of art and doubting his own methodology.[6] Unfortunately, such reservations are immediately overshadowed by the belief that 'Shaftesbury conceives of God and His handiwork, Nature, on the model of the aesthetic'.[7]

Although the attributes of this model remain undefined, we can follow Stolnitz's argument up to the point where it turns out to be unconvincing. Stolnitz wishes to differentiate between the *axiological* sense and the *conative* sense of the term 'interest'. In the latter sense, interest refers to a 'desire for what one takes to be good', while the axiological sense of the term implies that 'interest either of an individual or of society is its "true" and lasting good'.[8] The difference between the axiological sense and the conative sense refers to a difference in agency and activity. In the conative sense, to *take an interest in* viewing a beautiful landscape involves an agent, and the activity of becoming interested in a beautiful landscape. But in the axiological sense, interest only implies a set of circumstances or state of affairs. Following Stolnitz, the difference between the two senses of interest is distinct in a sentence such as the following: 'It is in his own interest (axiological) to do *x*, but he has no interest (conative) in doing *x*.'[9] The axiological sense of interest excludes desire and choice, and according to Stolnitz, Shaftesbury uses interest in the conative sense where it refers to 'actions or agents which are selfish'.[10] A contrast to such a selfish (interested) action is the action performed out of love and friendship. Although Shaftesbury does not apply the term 'disinterest' here to capture this action of benevolence, such a connotation presents itself immediately.[11] However, it would, according to Stolnitz, be a mistake to identify disinterest with benevolent actions seeking social well-being. A more reasonable association (with relevance for aesthetics) is to state *non-selfish* actions, rather than *unselfish/altruistic* actions, as the opposite of selfish actions. This is, according to Stolnitz, closer to the sense implied

[6] Ibid., 107: '[T]he question might be raised whether we are justified in taking Shaftesbury's account of the proper approach to God to be an instance of aesthetic experience.'
[7] Ibid.
[8] Ibid., 105.
[9] Ibid.
[10] Ibid., 106.
[11] Ibid. Stolnitz accurately remarks that actions of love and friendship are not referred to as disinterested actions by Shaftesbury, but that it 'would [nevertheless] follow ... that the term applies to acts of benevolence'.

by Shaftesbury, where the non-selfish action means that it is impersonal and impartial. This is, Stolnitz suggests, the meaning implied by Shaftesbury when he refers to a disinterested love of God in Christianity. This disinterested love thus suggests no benevolence but merely, in the words of Stolnitz, the circumstance that when 'one loves God disinterestedly, one loves God simply for His own sake, because of the "excellence of the object"'.[12] Given what we have observed about the necessity of natural social affections, one might indeed ask if the fact that Shaftesbury does not explicitly associate disinterestedness with benevolence at this particular point in *Characteristicks* gives Stolnitz a mandate to rule out such a correlation altogether, or if Stolnitz in fact implies that Shaftesbury on the whole thought that God could be loved without a benevolent eighteenth-century agent pursuing social well-being. But more interestingly, Stolnitz's remarks about the disinterested love of God and the excellence of the object marks a crucial point in his attempt to make the historical notion of disinterestedness relevant within a modern aesthetic discourse. After his remark, Stolnitz immediately concludes that this 'passage brings us close to the aesthetically relevant meaning of "disinterestedness"', because '[p]erception cannot be disinterested unless the spectator forsakes all self-concern and therefore trains attention upon the object for its own sake'.[13]

There is an elusive slide in Stolnitz's reading that comes into view when he begins to define this particular mode of modern attention of the virtuous agent as a modality of perception *tout court*, and concludes that '[g]iven the etymology of the word "aesthetic", it is, for the first time, appropriate to speak of "aesthetic disinterestedness"'.[14] Anticipating the criticism, he hurries to remark that stating the argument as if the Earl 'arrived at the concept by working backward from ethics' might indeed be 'misleading'.[15] But since the 'whole impulse and bent of Shaftesbury's thought, from the very beginning, was toward the aesthetic', Stolnitz nevertheless finds it appropriate to insist on extricating aesthetic perception (*aesthetic disinterestedness*) of 'aesthetic objects' from a disinterested perception naturally engaged in God's nature and ready to confirm a perfect theism.[16] Clearly, this extrication is highly problematic. Over the years, philosophers and historians have struggled to counterbalance Stolnitz's diachronic account of aesthetic theory, where the wish to anchor modern aesthetic autonomy in

[12] Ibid., 107.
[13] Ibid.
[14] Stolnitz, 'On the Origins of "Aesthetic Disinterestedness"', 133.
[15] Ibid.
[16] Ibid.

history is made at the expense of exegetical accuracy. Scholars have proceeded by stressing Shaftesbury's anti-mechanistic approach,[17] the omitted metaphysical overtones of the notion of disinterestedness,[18] Shaftesbury's empiricism,[19] disinterestedness as a category that positions aesthetic contemplation in the moral objectives of the arising British middling orders,[20] or, most recently, by recognizing that Shaftesbury's philosophy is indeed a source of modern aesthetic theory but that there simply is not a 'specifically aesthetic mode of perception, a specifically aesthetic mode of attention, or a specifically aesthetic mode of anything else', in his philosophy.[21] It is of course easy to criticize diachronic accounts for being too simplistic and exegetically selective. It is to some extent the nature of diachronic accounts to abridge complex historical processes. However, Stolnitz's account is, I believe, problematic not primarily by being diachronic, selective, and intentionally revisionist. In fact, most of Stolnitz's critics, during the past decades, concur with his overall proposition that early-eighteenth-century British philosophy and criticism shaped the emergence of modern aesthetic theory to a larger extent than previously has been acknowledged. What makes his account problematic is rather that the proposed version of aesthetic disinterestedness appears historically incongruous. How can a Shaftesburian disinterested perception be independent of the '*Sovereign* MIND' (*Moralists* 248 [346]) that is itself the initial agent and cause of all perceptions and affections in the universe? Given that our minds are attributable to a rational 'Presence', and, as Theocles argues, the 'peculiar Dignity of [our] Nature is to know and contemplate Thee' (*Moralists* 248 [346]), Stolnitz's account seems essentially implausible. To support his argument, Stolnitz turns to a paradigmatic passage on disinterestedness from *The Moralists* where Theocles speaks to Philocles – the sceptic narrator whom Theocles brings around so that he can recognize the beauty of the world – about directing his contemplation of beauty to the proper objects:

> Imagine then, good PHILOCLES, if being taken with the Beauty of the Ocean which you see yonder at a distance, it shou'd come into your head, to seek how to command it; and like some mighty Admiral, ride Master of the Sea; wou'd not the Fancy be a little absurd?

[17] Arregui and Arnau, 'Shaftesbury: Father or Critic of Modern Aesthetics?'
[18] David A. White, 'The Metaphysics of Disinterestedness: Shaftesbury and Kant', *Journal of Aesthetics and Art Criticism* 32, no. 2 (1973).
[19] Dabney Townsend, 'Shaftesbury's Aesthetic Theory', *Journal of Aesthetics and Art Criticism* 41, no. 2 (1982).
[20] Mortensen, *Art in the Social Order*, 119–37.
[21] Rind, 'The Concept of Disinterestedness in Eighteenth-Century British Aesthetics', 69.

Absurd enough, in conscience. The next thing I shou'd do, 'tis likely, upon this Frenzy, wou'd be to hire some Bark, and go in Nuptial Ceremony, VENETIAN-like, to wed the *Gulf,* which I might call perhaps as properly *my own.*

LET who will call it theirs, reply'd THEOCLES, you will own *the Enjoyment* of this kind to be very different from that which shou'd naturally follow from the Contemplation of the Ocean's *Beauty.* The Bridegroom-*Doge,* who in his stately *Bucentaur* floats on the Bosom of his THETIS, has less *Possession* than the poor *Shepherd,* who from a hanging Rock, or Point of some high Promontory, stretch'd at his ease, forgets his feeding Flocks, while he admires *her Beauty.* — But to come nearer home, and make the Question still more familiar. Suppose (my PHILOCLES!) that, viewing such a Tract of Country, as this delicious *Vale* we see beneath us, you shou'd for *the Enjoyment* of the Prospect, require the *Property* or *Possession* of the Land?

THE *Covetous* Fancy, reply'd I, wou'd be as absurd altogether, as that other *Ambitious* one. (*Moralists* 320 [396/397])

Here, Theocles suggests to Philocles that there is a psychological abyss between experiencing beauty and the task of the Doge of Venice, who on Ascension Day leads a procession of boats (Bucentaur denotes the name of the state galley of the Doge) into the Adriatic, where he casts a consecrated ring into the sea to renew the nuptial union between Venice and the sea. One can, as it seems, either command the sea and possess the land, or one can, like the shepherd and Philocles, simply enjoy the beauty of nature's scenery itself. Clearly, the shepherd and Philocles do not share the objectives of the preoccupied Doge responsible for this Venetian state ceremony, but does this, as Stolnitz claims, imply that their (aesthetic) perception 'no longer run[s] together with moral and religious virtue', that 'disinterestedness leaves behind its origins in the Hobbes controversy', and that Shaftesbury now is completely unconcerned with 'moral character', and instead addresses a 'familiar kind of aesthetic object, viz., scenes in nature'?[22] While Stolnitz believes that indifference for utility and possession is 'only an inference from a specification of the broader proposition that the aesthetic spectator does not relate the object to any purpose that outrun the act of perception itself', he fails to recall that the Deity is eternally immanent in the so-called aesthetic object.[23] Stolnitz's attempt to draw on Shaftesbury in order to

[22] Stolnitz, 'On the Origins of "Aesthetic Disinterestedness"', 134.
[23] Ibid. For a comment, see Rind, 'The Concept of Disinterestedness in Eighteenth-Century British Aesthetics', 73: '[T]here is no evidence that Shaftesbury subscribes to this "broader proposition." When Shaftesbury speaks of disinterest, he means the disregard of private advantage, not the disregard of non-perceptual purposes.'

give the impression that, as Miles Rind observes, 'aesthetic disinterestedness is a mode of attention and concern in which the perceiver's interest is in perception alone and terminates upon the object', is misleading.[24] One takes the risk of diminishing Shaftesbury's arguments if one accepts Stolnitz's reading of the passage and concludes that the shepherd and Philocles merely apply their sense perception to an external aesthetic object, while they are in fact revealing a true self-interest, which is naturally consistent with a public and societal interest, and accordingly expose their commendable virtue and genuine piety by naturally involving themselves in the divine presence.[25] Their motives are neither hope for rewards nor fear of punishments, and accordingly they are pursuing the absolute, '*Supreme* and *Sovereign* BEAUTY' (*Moralists* 176 [294]). In short, they lay bare the true disinterested attitude towards God's beautiful nature. While the Doge performs a specific task, the shepherd and Philocles pay, as it seems, no attention to any task whatsoever. Beauty is the *summum bonum* and as such it is irresistible and naturally insists on the shepherd's undivided affectionate participation, which, tellingly enough, makes him neglect his flock of sheep. Hence, the shepherd is obviously disinterested in the sense that he naturally and intuitively gives priority to the uncompromising beauty of the ocean rather than to the task of herding. But even if the perceptible task is erased from his mind, there is one task that permanently claims his absolute and natural engagement and without which no beauty at all can be experienced: the '*Supreme Mind or* DEITY' in nature (*Moralists* 150 [274]). The only way for the shepherd to approach this beautiful nature is by being disinterested. The attitude of the shepherd is not indicative of an indifference to moral and religious consequences. One could get the impression that the shepherd acts disinterestedly because he is arguably unable to explain why the beauty of God's providence itself exerts such a pull on him. How can he indeed act with a specific interest, when he is obviously unknowing of his actions? But such a perspective omits the fact that the shepherd is a specifically virtuous agent – other kinds of agents are ruled out in this case – and by being so he is naturally engaged in the rational harmony of God's nature. After all, the kind of experience displayed in the case of the shepherd is only accessible for a 'fair and just Contemplator' (*Moralists* 168 [288]). The shepherd is spontaneously experiencing the realized disinterested

[24] Rind, 'The Concept of Disinterestedness in Eighteenth-Century British Aesthetics', 70.
[25] See also *A Letter Concerning Enthusiasm* (358 [41/2]). Here, Shaftesbury stresses self-knowledge as a prerequisite for honouring the Deity: 'For 'tis hard to imagine, what Honour can arise to *the* DEITY from the Praises of Creatures, who are unable to discern what is *Praise-worthy* or *Excellent* in their own Kind.'

impulse in his involvement with nature, since his affections are balanced and serene.[26] As Patrick Müller comments when analysing Shaftesbury's notion of moral sense, a 'competent grasp of the harmony within the divinely ordained cosmos ... is necessary in order to form complex moral and aesthetic value judgements'.[27] And just like a realized moral sense (relying on a true self-knowledge and engagement in nature) is 'at once the product and the means of acquiring true knowledge of the world and, as a result, *Gotteserkenntnis*', so is the shepherd's aesthetic experience of beauty naturally absorbed in God's infinite presence.[28]

Stolnitz appears to think that the annulment of the marriage between, on the one hand, the disinterested perception of the 'scenes in nature' and, on the other, the 'Interest of that Universal ONE' (*Moralists* 274 [364]) is a happy divorce. From such a secular separation, Stolnitz brings out the undisputable axiom of not only British Enlightenment theories of taste (or aesthetic theories) but modernity and modernism itself. Once we have accepted that an aesthetic object can be any object defined as one of disinterested perception, there is simply no need to limit ourselves to classical objects of beauty.[29] The ontological devaluation of beauty is, as the established aesthetic narrative goes, proportionate to an arising evaluation of the sublime and the multifarious aesthetic objects of modernism. In an incisive wording, it is as if Stolnitz believes that at the end of the line of Shaftesbury's eighteenth-century notion of disinterestedness and the serene beauty of a rural landscape stands a Duchampian bottle rack or a snow shovel. But to allow Shaftesbury's idea of disinterestedness to signify the definite source of such a narrative is problematic for several reasons. Shaftesbury would have found the modern separation of a disinterested perception of aesthetic objects and the 'Interest of that Universal ONE' downright impossible. To speak with J. M. Bernstein, beauty is not yet a 'silent beast'.[30] Although the shepherd and Philocles are contemplating beauty, they are not accurately

[26] See also Whichcote (*Select Sermons* 113): 'no Man hath internal Peace, that is either neglective of his Duty to God; or that is unrighteous.'

[27] Müller, 'Hobbes, Locke and the Consequences: Shaftesbury's Moral Sense and Political Agitation in Early Eighteenth-Century England', 322.

[28] Ibid.

[29] Stolnitz, 'On the Significance of Lord Shaftesbury in Modern Aesthetic Theory', 99.

[30] J. M. Bernstein, *The Fate of Art: Aesthetic Alienation from Kant to Derrida and Adorno* (Cambridge: Polity, 1992), 3: 'What can we make of a domain in which questions of truth, goodness, efficacy, even pleasure (since our interest in art is "disinterested") are eliminated at the outset? What sort of beast might beauty be if in considering it we are not considering how the world is (truth), how we do or should comport ourselves in the world (morality), or what might be useful or pleasurable to us? A silent beast, then, given voice only through the gestures of approximation and analogy to what it is not.'

contributing to the 'dissolution of the metaphysical totalities of the pre-modern age'.[31] The classical triad of truth, goodness, and beauty is still unscathed.[32] In the words of Shaftesbury himself (echoing Socrates and Diotima): 'Will it no be found in this respect, above all, That what is BEAUTIFUL is *Harmonious* and *Proportionable*: What is Harmonious and Proportionable, is TRUE; and what is at once both *Beautiful* and *True*, is, of consequence, *Agreeable* and GOOD?' (*Miscellaneous* 222/224 [182/183]).[33] If anything, the disinterested attitude demonstrated by the shepherd and Philocles aims to reinforce and corroborate the natural union between aesthetic experience, morality, and God.

While the reliance on the traditional connection of truth, goodness, and beauty might be disturbing for Stolnitz, it allowed Shaftesbury's ethico-theological union to fall on fertile ground in the eighteenth century, particularly in German-speaking Europe where Shaftesbury's ideas played a critical role in the *Bildung* tradition.[34] Johann Joachim Spalding, a theological neologist who brought the Earl's writings before a German public, is representative of the affirmative mid-eighteenth-century reception.[35] In his *Lebensbeschreibung*, Spalding writes that reading Shaftesbury (one of the first books Spalding read in English was by Shaftesbury), and learning about the basic principles of moral feeling (*moralischen Gefühl*) and disinterested virtue (*uneigennützen*

[31] Ibid., 6.
[32] See also Mortensen, *Art in the Social Order*, 114–15. Mortensen makes a somewhat similar point, though within the context of separating the 'desire for possessions and property', and the enjoyment of something simply for its beauty: 'It is my contention that Shaftesbury, rather than separating the contemplation of beauty from the sphere of morality, wants to place it solidly within the realm of an acceptable morality. He wants to assert that there is a moral way of admiring things, a way which is not to be identified with luxury, covetousness, avarice, ostentation, and similar – to Shaftesbury and most of his contemporaries – immoral qualities.'
[33] See Plato, *Symposium*, in *Lysis, Symposium, Gorgias*, trans. W. R. M. Lamb, Loeb Classical Library 166 (Cambridge, MA: Harvard University Press, 1925), 210A–212B. See also Xenophon, *Memorabilia*, 3.8.
[34] Via the many German mid-eighteenth-century translations of his work, Shaftesbury became the originator of the concept of *innere Bildung*. See Rebekka Horlacher, 'Bildung – A Construction of a History of Philosophy of Education', *Studies in Philosophy and Education* 23, no. 5–6 (2004), 409. Shaftesbury's concept of 'inward form' was, in Johann Joachim Spalding's translation of *The Moralists*, published in 1745 and, in a translation by Friedrich Christoph Oetinger (1702–1782), translated into *innere Bildung*, and 'formation of a genteel character' and 'good breeding' was translated into *Bildung* and *Selbstbildung*. See Susan L. Cocalis, 'The Transformation of *Bildung* from an Image to an Ideal', *Monatshefte* 70, no. 4 (1978), 401; Franz Rauhut, 'Die Herkunft der Worte und Begriffe "Kultur", "Civilisation" und "Bildung" '; in *Beiträge zur Geschichte des Bildungsbegriffs*, ed. Wolfgang Klafki (Weinheim: Beltz, 1965), 19; Ilse Schaarschmidt, 'Der Bedeutungswandel der Begriffe "Bildung" und "bilden" in der Literaturepoche von Gottsched bis Herder', in ibid., 50; Horlacher, *Bildungstheorie vor der Bildungstheorie*, 21; Mark-Georg Dehrmann, *Das 'Orakel der Deisten': Shaftesbury und die deutsche Aufklärung* (Göttingen: Wallstein, 2008).
[35] Horlacher, *Bildungstheorie vor der Bildungstheorie*, 64: 'Die Neologen kritisieren das traditionelle theologische Denken der aristotelischen Metaphysik, da dieses zu theoretisch und ohne Bezug auf die Lebenswirklichkeit sei. Ziel der Neologen ist nicht eine theoretische, weltabgewandte Theologie, sondern eine gelebte Religion.'

Tugend), moved his soul intensely.³⁶ And Spalding's *Betrachtung über die Bestimmung des Menschen* (1748) – one of the most widely reprinted and read works in eighteenth-century Germany – is deeply imbued with Shaftesbury's soliloquized vision of a natural religion and a genuine selflessness consistent with the rational beauty of the world.³⁷ The evolving self-knowledge of the ideal narrator, throughout *Die Bestimmung des Menschen*, moves in a representative manner from investigation (*Untersuchung*) to conviction (*Ueberzeugung*),³⁸ where the narrator is an ideal human being when he pursues the collective benefit (*gemeinschaftlichen Nutzens*) as an end in itself (*Endzweck*).³⁹ The recognition of the collective benefit is, for Spalding, coherent with the greater autonomous source of every being (*selbständige Quelle alles Wesens*).⁴⁰ While mercenary selfishness clearly is something negative, the disinterested motives serve a theistic purpose by acknowledging 'a force [*Kraft*] that causes the whole thing; an understanding [*Verstand*] that thinks for the whole thing; a spirit [*Geist*] that, through its incomprehensible emanations, gives all things existence [*Daseyn*], duration, powers, usability [*Nutzbarkeit*], and beauty; through which I also am what I am'.⁴¹ The narrator is simply happy to gently lose himself in – and to confess that he is a natural part of – a general beauty (*allgemeinen Schönheit*) that is incorruptible.⁴² The legacy of Shaftesbury in the German *Bildung* tradition is firmly anchored in this vision of a moral knowledge that is able to challenge hypocritical religious gestures, and that can, through its genuine mindset, remove unbecoming mercenary selfishness and self-righteous actions, and engage disinterestedly with a religious pattern in God's rational beauty. It is only natural for someone like Spalding to rely on Shaftesbury's coalescence of disinterestedness and the triad of truth, goodness,

[36] Johann Joachim Spalding, *Lebensbeschreibung*, in *Kleinere Schriften 2: Briefe an Gleim, Lebensbeschreibung*, ed. Albrecht Beutel and Tobias Jersak, in *Kritische Ausgabe: Schriften*, vol. 6 (Tübingen: Mohr Siebeck, 2002), 124.

[37] *Die Bestimmung des Menschen* was a standard work in the German Enlightenment after mid-century. The book was translated into French and Latin. As Ernest Boyer, Jr, stresses in 'Schleiermacher, Shaftesbury, and the German Enlightenment', *The Harvard Theological Review* 96, no. 2 (2003), 194, the 'piece is Shaftesburian through and through, an extended meditation on the English thinker's main themes'.

[38] Spalding, *Die Bestimmung des Menschen*, in *Kritische Ausgabe: Schriften*, vol. 1, ed. Albrecht Beutel, Daniela Kirschkowski and Dennis Prause (Tübingen: Mohr Siebeck, 2006), 113. References are to the edition from 1794.

[39] Ibid., 87.

[40] Ibid., 221.

[41] Ibid., 141: 'eine Kraft, die das Ganze bewirkt; ein Verstand, der für das Ganze denkt; ein Geist, der durch seine unbegreiflichen Ausflüsse allen Dingen Daseyn, Dauer, Kräfte, Nutzbarkeit und Schönheit mittheilet; durch welchen auch ich bin, was ich bin.'

[42] Ibid., 129.

and beauty, in an accompanied text to his translation of the *Inquiry*, entitled *Schreiben des Uebersetzers* (1747):

> Accordingly the soul does not yet have any taste, no internal pleasure of the good, of order, or of justice [*Gerechtigkeit*], if it merely carries out good, orderly, and lawful actions because it expects a private advantage [*Privatvortheils*], or if it by a fear of a severe guard, and thus by means of slavery and coercion, holds back its erroneous inclination [*Neigung*] so that it does not result in any action.[43]

While the classical tripartite of principles remained central throughout the eighteenth century, and for the impending German Romantic movement's perception of nature, Stolnitz wishes to extricate an aesthetic disinterestedness of aesthetic objects from such a triad.[44] By doing so, he plays the dangerous game of reducing Shaftesbury's notion of plastic nature. Needless to say, the shepherd and Philocles have to view the ocean and the vale in order to experience them. But it would be a mistake to claim that Shaftesbury's primary focus is limited to the utilization of ordinary sense perception in order to straightforwardly attend to an external aesthetic object. It is misrepresentative of the Earl's notion of nature to claim that it is an external object present to bestow aesthetic experiences. Shaftesbury does not at all envision nature as a pressured provider of such experiences. Rather, the burden of being a provider is on the moral agent, whose primary task is to bear out God's infinite presence in nature as a testimony of the universal mind.

Characteristically, when delivering one of his enthusiastic speeches to nature, Theocles not only stresses the '*Sovereign* MIND' as the source of subjective rationality, but also comments on his own moral responsibility to 'tread the Labyrinth of wide Nature' in order to 'trace thee in thy Works' (*Moralists* 248 [346]). In his prayer, Shaftesbury voices a similar 'religious attitude' when defining the natural intention of rational human beings as a desire to 'Obey Thee, & to Seek thy End & Purpose in my Nature & Life: this alone, being *the End*, and, when attain'd, *the Good*' (*Prayer* 535).[45] Here we should hasten to

[43] Spalding, 'Schreiben des Uebersetzers an Herrn ---', in *Kleinere Schriften 1*, ed. Olga Söntgerath, in *Kritische Ausgabe: Schriften*, vol. 6 (Tübingen: Mohr Siebeck, 2006), 182: 'Die Seele hat damit noch keinen Geschmack, kein innerliches Wohlgefallen an der Güte, an der Ordnung, an der Gerechtigkeit, wenn sie bloß aus Erwartung eines Privatvortheils gute, ordentliche und gesetzmäßige Handlungen vollbringet, oder aus Scheu für einem strengen Aufseher, folglich aus Sklaverey und Zwang ihre unrichtige Neigung zurück hält, daß sie in keine Thaten ausbricht.'

[44] Boyer, Jr, even argues that '[t]here is, in fact, a direct and unmistakable line from Shaftesbury to Romanticism as a whole, one that runs straight through eighteenth-century German thought' (see Boyer, Jr, 'Schleiermacher, Shaftesbury, and the German Enlightenment', 182–3).

[45] On Shaftesbury's 'religious attitude' and similarities between this prayer and *The Moralists*, see F. H. Heinemann, 'The Philosopher of Enthusiasm: With Material Hitherto Unpublished', *Revue Internationale de Philosophie* 6, no. 21 (1952), esp. 315–16.

recall that being a tracer with this particular end is a natural step for a virtuous agent: he has to make every effort to realize his natural disposition into a proper taste, but granted that he does so, he will ultimately reach the desirable point where he cannot opt between experiencing and *not* experiencing the beauty of nature. In a sense, the shepherd and Philocles are fortunate victims of their own human impulse to form a conception of virtue and taste. Rather than being deliberate viewers of an external object, they are being naturally perceptive to the sovereignty of the beauty of God's creation as well as attentive to their realized innate disposition. They do not merely apply sense perception to an external aesthetic object; they are, due to their virtuousness, *committed* to their mind's perfect internal sensation. Shaftesbury writes about the immediacy of such internal sensation (*Moralists* 164 [285]) in a similar way when he deals with the notion of moral sense and what he calls the '*inward* EYE'.[46] But he does not treat the idea of internal sensation at the sacrifice of external perception. What he implies is rather that perceiving God's nature is an insightful and empathic act that must be in conjunction with the natural '*Order* and *Proportion*' that is 'strongly imprinted on our Minds' (*Moralists* 164 [284]).

A further clue to Shaftesbury's understanding of internal sensation is presented in *Sensus Communis*. Here, the Latin notion itself, *sensus communis*, is not smoothly rendered into common sense. Referring to a '*Greek* Derivation, to signify *Sense* of *Publick Weal*, and of the *Common Interest*' (*Sensus Communis* 70 [104]), Shaftesbury elaborates on the notion in his apparatus criticus (see *Printed Notes* 272 [103]). From Marcus Aurelius' *Meditations*, he picks up the notion *koinonoēmosynē* (κοινονοημοσύνη),[47] from *koinos* (κοινός, common) and *nous* (νοῦς, mind or intellect). Here, the stress is on the internal insight and self-reflection of the mind (as one scholar puts it, '*sensus communis* is a natural affection that has become self-conscious').[48] Thus, just like the process of the '*inward* EYE', a care for the common (*sensus communis*) entails an internal, empathic, and rational comprehension about a shared and beautiful nature.

Tellingly enough, on the closing pages of *The Moralists*, Philocles asks Theocles to demonstrate that beauty is not really an external object of sense at all. The discussion that follows works primarily as a rhetorical hyperbole to

[46] See *The Moralists* (344 [414/415]): 'No sooner are ACTIONS view'd, no sooner the *human Affections* and *Passions* discern'd (and they are most of 'em as soon discern'd as felt) than straight *an inward* EYE distinguishes, and sees *the Fair* and *Shapely*, *the Amiable* and *Admirable*, apart from *the Deform'd, the Foul, the Odious*, or *the Despicable*'.

[47] Marcus Aurelius, *Meditations*, 1.16.

[48] John D. Schaeffer, *Sensus Communis: Vico, Rhetoric, and the Limits of Relativism* (Durham, NC: Duke University Press, 1990), 42.

ensure that the reader has not missed Shaftesbury's point about the balanced affections of the mind, and the ethico-theological and societal ramifications of beauty. If the agent only needed to *see* objects to comprehend beauty, this would ultimately endanger the hierarchy of the Great Chain of Being. Given that brutes only exercise sense and remain detached from the '*virtuous* MIND of Reason's Culture', a priority of sense over mind would place man on an equal footing with brutes (*Moralists* 360 [425]). That thought is agonizing for both Theocles and Philocles. Man is certainly not an irrational creature, and Theocles' conclusion, which is approved by Philocles, is that there can be 'nothing so divine as BEAUTY' (*Moralists* 360 [426]), which must belong to mind and reason, 'For whate'er is void of Mind, is *Void* and *Darkneß* to the *Mind's* EYE' (*Moralists* 362 [426]). A pleasure 'captive to *Sense*' and unrelated to the human mind must lack relevance and be incapable of causing an experience of beauty. But to enjoy friendship, '*Honour, Gratitude, Candour, Benignity*, and all internal Beauty', as well as 'all the *social* Pleasures, [and] *Society* it-self', is to experience the mind's 'own Advancement and Growth in Beauty' (*Moralists* 360 [425/426]).

As we have observed, taste is not congenital but requires the agent to firmly exert himself.[49] Here, the immediacy of internal sensation follows a similar pattern: in order to be properly natural and immediate, it must be a realized disposition. The commitment to this internal capacity and the mind's 'Growth in Beauty' is necessary for recognizing the value of God's nature. With reference to the second-century writer Maximus of Tyre, Theocles captures the essence of a somewhat intransigent quality of Shaftesbury's argument, where such a commitment is seen as leading to further happiness, and where being excluded from this ability merely leads one astray: '*The River's Beauty, the Sea's, the Heaven's, and Heavenly Constellation's, all flow from hence as from a Source Eternal and Incorruptible. As Beings partake of this, they are fair, and flourishing, and happy: As they are lost to this, they are deform'd, perish'd, and lost*' (*Moralists* 178 [295]).[50] In relation to the so-called aesthetic object, the shepherd and Philocles are, then, in a very technical sense, less the free agents than they might initially appear to be. Rather than making a premeditated decision to apply ordinary sense perception to the '*Sovereign* MIND', which would render the beauty of nature morally and socially charged, the shepherd and Philocles are, due to their

[49] See e.g. *Soliloquy* (266–76 [336–344]).
[50] See also Maximus of Tyre, *The Philosophical Orations*, trans. M. B. Trapp (Oxford: Clarendon Press, 1997), 11.11.

virtuousness, ultimately destined to be immersed in the beauty of such mind, and accordingly they are also experiencing the ultimate self-sufficiency as free agents.

An overall feature of Shaftesbury's metaphysics that needs to be recalled here is that there is, in the midst of his optimistic leaning towards a kind of Pelagianism, also an unavoidable element of determinism in the experience of the universal whole.[51] The participation or non-participation of the shepherd and Philocles cannot regulate the structure of the whole. A failure to engage in the beauty of God's nature is simply a personal failure of the agent, not a failure of providential nature. The inability to perceive God's nature disinterestedly or resolutely trust the good of the whole cannot change the perception and rationality of the whole. The great *interest* of the whole always outweighs any individual attempts to undermine it. As Shaftesbury writes in the *Askêmata* notebooks, 'what a Shame to wish against *the Whole* & agt that general Good & universal highest greatest noblest Interest! And wt Folly too! Since this Interest must & will prevail, whether thou art willing or not willing, pleasd or not pleasd' (*Askêmata* 176).

By focusing further on Shaftesbury's notion of plastic nature, we are getting near to the challenging crux of Stolnitz's influential reading. Is it in fact at all right to equate Shaftesbury's notion of providential nature with an aesthetic object? Grean mentions that '[t]hrough the experience of beauty man transcends the separation of subject and objects, and is at last at one with Nature and with Nature's God'.[52] There is a truth in Grean's very brief remark. Clearly nature is not an aesthetic object in the technical sense that it claims an active disinterested perception to exist. Such a belief would be absurd to Shaftesbury, since he really defends a moral and aesthetic realism. Regardless of whether the agent exercises a disinterested perception or not, God's nature, as well as accomplished works of art, will, as the Earl highlights on the closing pages of *Soliloquy*, always remain beautiful and rational:

[51] See Grean, *Shaftesbury's Philosophy of Religion and Ethics*, 90. Grean stresses that Shaftesbury, in his critique of especially the Calvinistic doctrine of predestination, comes close to defending a form of the fifth-century Christian heresy referred to as Pelagianism (lectured by the British Christian moralist Pelagius [c.354–c.418] and his Roman followers). One of the key moral features of Pelagianism was the insistence of Man's free will to choose between *good* (and thus follow God's law) and *evil*. Grean remarks the following: 'He [Shaftesbury] argues that providence has granted us the power to know and obtain what is good, and to know and avoid what is evil. It is up to us to make use of these powers, to be *men* in the true sense – autonomous agents of Deity itself.' See also Burrows, *Shaftesbury and Cosmic Toryism*, 67–68.

[52] Ibid., 257. Unfortunately, Grean does not develop his thought on the complex separation between *subject* and *object*.

> For HARMONY is Harmony *by Nature*, let Men judg ever so ridiculously of Musick. So is *Symmetry* and *Proportion* founded still *in Nature*, let Mens Fancy prove ever so barbarous, or (their Fashions ever so) *Gothick*, in their Architecture, Sculpture, or whatever other designing Art. (*Soliloquy* 286 [353])[53]

The inherent rationality and immanent divine presence articulated in and by nature calls for cautiousness whenever we expect to define and evaluate sovereign experiences of distinct and autonomous objects. Rather than being *an* object (or consisting of several objects), nature is physis (φύσις), which means that it is an 'impower'd *Creatreß*' (*Moralists* 246 [345]) that operates as a rational principle, inherent and pronounced in every organism (and cosmos as such).[54] More than anything, the act of detaching one organism from another with a purpose of objectifying it is reminiscent of lamentable patterns of praxis, considered in *Soliloquy*, where 'Searchers of *Modes* and *Substances*' that are 'inrich'd with Science' merely produce 'pretended Knowledg of the Machine of *this World*' and 'introduce Impertinence and Conceit with the best Countenance of Authority' (*Soliloquy* 210/212 [291]). Similar to aesthetic experiences, the praxes of science (natural philosophy) are of little value, unless they do justice to the multilayered and beautiful coalescence of organisms by recognizing '*All in One*' (*Moralists* 168 [287]). Shaftesbury's strong reservations about the alleged progress of modern science (or natural philosophy) is present early on in his writings. We are, as Shaftesbury notes in a letter to Locke in September 1694, not in the least abetted by 'new Discoverys' and detailed knowledge (here, Shaftesbury is openly targeting Hobbes and Descartes, but indirectly also the addressee himself) unless we 'know our selves' and how to remain, on a large scale, natural 'Friends wth Providence' (*Correspondence* 201 and 204). Tellingly enough, Philocles' 'Insight into the nature of *Simples*' (*Moralists* 160 [282]) agitates Theocles to such an extent that he deems Philocles a very poor '*Naturalist*' (*Moralists* 162 [283]). The reason is simply that while Philocles voices his expertise knowledge about '*the Particulars*', he nevertheless appears to 'understand so little the Anatomy of *the World* and *Nature*, as not to discern the same Relation of Parts, the same Consistency and Uniformity in *the Universe*' (*Moralists* 162 [283]).

So, it would clearly be a mistake to identify God's intelligent and beautiful nature as an aesthetic object that is a reactive entity responsive to a disinterested

[53] Shaftesbury remarks (*Soliloquy* 284/286 [353]) that 'SHOU'D a Writer upon *Musick*, addressing himself to the Students and Lovers of the Art, declare to 'em, "That the Measure or Rule of HARMONY was *Caprice* or *Will*, *Humour* or *Fashion*," 'tis not very likely he shou'd be heard with great Attention, or treated with real Gravity'.
[54] See also Voitle, *The Third Earl of Shaftesbury 1671–1713*, 141.

attitude of the agent. Guyer rightly remarks that while we love beauty and virtue because of their order and proportion, it is actually 'not so much the manifestation of order and proportion in the object in which they are manifested' that we admire.[55] Instead, what we admire here is the 'divine intelligence which is behind all order and proportion' – an intelligence that is the very source also of our own human disposition to experience beauty.[56]

The division between, on the one hand, an active agent and, on the other, a reactive object relying on the disinterested perception of the agent needs to be clarified to make sense. Fortunately, Shaftesbury sheds further lights on the problem in *The Moralists*. Here Philocles is bid to criticize Theocles, and remarks that Theocles is reflecting neither on the self-created being (*first cause*) nor on 'How clear the *Idea* was of an *Immaterial Substance*; And how plainly it appear'd, that at some time or other *Matter must have been created*' (*Moralists* 178 [296]). Rather, Theocles argues that ''tis not about what was *First*, or *Foremost*; but what is *Instant*, and *Now* in being' (*Moralists* 180 [297]). If 'DEITY [is] *now* really extant', we can, according to Theocles, simply conclude that there '*ever* was one'. From Philocles' point of view this gives the impression that Theocles 'go[es] (if I may say so) upon *Fact*, and wou'd prove that things *actually are* in such a state and condition, which if they really *were*, there wou'd indeed be no dispute left' (*Moralists* 180/182 [297]). Theocles simply submits insufficient proofs of the universal rational system, according to Philocles. What Theocles has provided is a system where God's great creation is embraced to such an extent that there is apparently no responsibility left for nature itself. It is almost as if the universal system is hermetically sealed. While traditional theology, according to Philocles, allows nature to make mistakes, Theocles does not, or so Philocles argues, appear to admit that nature might fail since a perfect Deity assumes responsibility for all of nature. Theocles has thus simply 'defend[ed] her [nature's] Honour so highly, that I [Philocles] know not whether it may be safe for me to question her' (*Moralists* 184 [299]). Following the conventions of the Socratic method, Theocles naturally pleads Philocles to continue and be 'free to censure *Nature*', and Philocles decides to pursue a remark alluding to a theme in the flexible Promethean myth (a myth I will return to in Chapter 2.4).

A vital topic in the Promethean myth concerns Epimetheus's task of assigning abilities to mortal (θνητά) creatures.[57] In Plato's *Protagoras*, the cosmogony

[55] Guyer, *Values of Beauty*, 10.
[56] Ibid.
[57] Plato, *Protagoras*, in *Laches, Protagoras, Meno, Euthydemus*, trans. W. R. M. Lamb, Loeb Classical Library 165 (Cambridge, MA: Harvard University Press, 1924), 320D.

involves the fable of how the injudicious and myopic Epimetheus forgets to furnish man, while squandering everything on the irrational (τὰ ἄλογα) brutes.[58] When reviewing Epimetheus's distribution, Prometheus notices, much to his dismay, that man is naked and exposed.[59] Alluding to this part of the Promethean myth, Philocles, now playing the part of *Advocatus Diaboli*, states, 'How comes it, I intreat you, that in this noblest of Creatures [i.e. man], and worthiest her Care, she shou'd appear so very weak and impotent; whilst in mere *Brutes*, and the irrational Species, she acts with so much Strength, and exerts such hardy Vigour?' (*Moralists* 184 [300]). But when Theocles urges Philocles to not only consider some advantages of the brutes but rather 'stand for *All*', and ask why not man should 'take possession of *each* Element, and reign in *All*', Philocles immediately modifies his critique and concludes that to treat man as 'if he were, by Nature, LORD *of All*' would indeed be absurd (*Moralists* 186 [301]). To this Theocles adds that 'if *Nature* her-self be not for MAN, but *Man* for NATURE; then must *Man*, by his good leave, submit to *the Elements of* NATURE, and not *the Elements* to him' (*Moralists* 186 [302]). Theocles' crucial point here is not to make nature impossible to address in its singular elements (nature's aesthetic objects, as Stolnitz calls them), but that man has not been given the moral right to administer nature in order to remove natural differences between species. Man must at all times remain sensitive to the moral constitution and rational intelligence of nature.

At this point, Philocles' 'Adversary', the 'old Gentleman', briefly enters the dialogue and by sheer ignorance brings home Shaftesbury's point (*Moralists* 198 [310]). Due to the fact that Philocles, at the request of Theocles, 'censure[d] Nature' for neglecting the 'noblest of Creatures' while, in an Epimethean manner, providing for the '*wild Creatures*' to live 'discharg'd of Labour, and freed from the cumbersom Baggage of a necessitous human Life' (*Moralists* 186 [300/301]), the antagonist thinks that Philocles has revealed himself as a defender of '*the State of Nature*' as '*a State of War*' (*Moralists* 198 [310]). Thus, Philocles appears to have exposed himself as an anti-Christian champion of a callous Hobbesian anthropology. However, Philocles immediately spots the weakness in the gentleman's argument. He replies that the gentleman himself has acknowledged

[58] Ibid., 321C. The context in *Protagoras* is a discussion about the nature of civic virtue. On the history of the Promethean myth, see Carol Dougherty, *Prometheus* (London: Routledge, 2006), esp. 78–84 (about Prometheus in *Protagoras*).

[59] Ibid. See also *Aesop's Fables*, trans. Laura Gibbs, Oxford World's Classics (Oxford: Oxford University Press, 2002), 514. In Aesop's fable, Zeus intentionally grants animals great abilities (wings, speed, etc.), while he leaves man naked and envious. Man becomes content, however, when learning about his ability to speak and to reason.

that such a state of nature was not a '*State of Government*, or *publick Rule*'. And if the state of nature was not a '*State of Fellowship*, or *Society*', what was it then? Unsuspectingly, treading in the footsteps of Hobbes and Locke and the idea of society as an artificial (re)creation by a liberal social contract, the gentleman answers that 'when Men enter'd first into Society, they pass'd from *the State of Nature* into that new one which is founded upon *Compact*'.[60] Here, a rarely studied 'political message' is brought out by the naive gentleman: does not the vision of a strategic and artificial '*Compact*', able to grant a strong moral principle for eighteenth-century society, suggest that human beings lack natural social affections and that God's nature is imperfect and not beautiful at all?[61] At this point, Philocles remarks that the 'old Gentleman seem'd a little disturb'd at my Question', but the gentleman pulls himself together for a final reply and proposes that 'MAN indeed, from his own *natural Inclination*, might not have been mov'd to associate; but rather from some particular *Circumstances*' (*Moralists* 200 [311]). Given that man is, in the gentleman's account, 'forc'd into a social State, *against his Will*', Philocles is now able to deliver his inspired *coup de grâce* by concluding that '*Nature* then ... was not so very good'. Having turned the tables, the gentleman's account now looks like a truncated Hobbesian version of nasty nature. A godless state of nature where man 'wou'd fight *for Interest*' must, in the words of Philocles, by all means be 'little different from *a State of* WAR' (*Moralists* 200 [312]).

Every species has, as we have observed, a natural way of existing and operating, and exercises its own natural affections and passions within an organic system. The discussion about nature and the allusion in *The Moralists* to the Promethean myth and Epimetheus's undertaking are also visible in Shaftesbury's reference to Epictetus under the heading 'Nature' in *Askêmata*. Main parts from this section were in fact revised and included in *The Moralists*, but the section opens with a reference that works more like a summary elucidating Shaftesbury's general point. Here, Epictetus wishes to end any wondering of why other animals have, by

[60] See Locke, *Two Treatises of Government*, §96, 331.
[61] Michael Billig, *The Hidden Roots of Critical Psychology: Understanding the Impact of Locke, Shaftesbury and Reid* (London: Sage, 2008), 105. Billig comments briefly that Shaftesbury challenges the contractual idea that political society grants a moral order to fight selfishness (Hobbes) and protect 'individual interests' (Locke). The fascinating role performed by the antagonistic 'old Gentleman' (*Moralists* 198 [310]), with reference to seventeenth- and eighteenth-century contractualism, is rarely studied and commented. Müller ('Hobbes, Locke and the Consequences: Shaftesbury's Moral Sense and Political Agitation in Early Eighteenth-Century England', 323) notes that the section, beginning with the old gentleman's comment, is the 'longest of the addenda to the *editio princeps* of *The Moralists*' and as such it is a 'lengthy refutation of social contract theories'. See also Burrows, *Shaftesbury and Cosmic Toryism*, esp. 129–33.

nature, capacities prepared for their bodies (*Μὴ θαυμάζετ᾽ εἰ τοῖς μὲν ἄλλοις ζῴοις τὰ πρὸς τὸ σῶμα ἕτοιμα γέγονεν* ...); a marvelling speculation that Shaftesbury is just as eager to get rid of,[62] because human beings are not rational and social by mere coincidence. Rather, it is the absence of certain qualities attributed to other species that ultimately defines the rational and social character of human beings. While newborns of other species are, according to Theocles, 'instantly helpful to themselves', the '*human Infant* is of all the most helpless' (*Moralists* 196 [308]). But does not, asks Theocles, 'this *Defect* engage' man 'the more strongly to Society'? A society where '*social* Intercourse and Community' is a '*Natural State*'. Thus, to be reliant on others is not a disadvantage, since it is the deficiency that immediately 'force[s] him to own that he is purposely, and not by Accident, made rational and *sociable*' (*Moralists* 196 [309]). The outcome of the deficiency is then important and good. The agent is essentially rational and, by his natural affections, gregarious and part of society. He is not capable of disciplining and, in an act of anthropocentrism, overseeing the intelligence of nature, because that would incorrectly imply that he presides over the providential mind itself.[63]

We can now see more clearly the problems attached to a traditional understanding of the paradigmatic passage from *The Moralists*, where Theocles talks to Philocles about the contemplation of beauty: to imply that the shepherd and Philocles address nature as an aesthetic object by a disinterested aesthetic perception gives the impression that they are self-determining, and that they disclose some kind of ascendancy over the particular aesthetic object. Nothing could be further from the truth. The shepherd and Philocles are not able to administrate the so-called aesthetic objects; the intelligence and superiority of nature is explained by the fact that God, who is immanent in nature, administrates them. Characteristically, when Shaftesbury's persona in *Miscellaneous Reflections* goes over the main points from the *Inquiry* and *The Moralists*, he concludes that a natural quality of man consists in precisely granting the '*Supreme* CAUSE' (*Miscellaneous* 270 [224]) and its creation a self-explanatory and legitimate

[62] *Askêmata*, 335. See also Epictetus, *Discourses*, 1.16.1. For further discussion on Epictetus' accounts on the relation between humans and animals, see William O. Stephens, 'Epictetus on Beastly Vices and Animal Virtues', in *Epictetus: His Continuing Influence and Contemporary Relevance*, ed. Dane R. Gordon and David B. Suits (Rochester: RIT Press, 2014).

[63] See also Grean, *Shaftesbury's Philosophy of Religion and Ethics*, 50. Grean stresses that Shaftesbury carried on a Platonic tradition (rather than a Baconian empiricist tradition) when he addressed nature in a non-dominating way: 'Our ultimate aim [according to Shaftesbury] must not be power over Nature, but communion *with* Nature – a communion which makes it possible for the power of Nature to work in and through us. The inner reality of Nature will not be disclosed by mechanistic analysis, but only by aesthetic intuition. Love not only provides the dynamic means by which we grasp this truth, it is also the innermost bond of Nature itself.'

control. In order to attain aesthetic experience, the agent must simply submit his mind to the superior Mind and nature, and acknowledge that they administrate his rational and societal existence: 'He is not only *born to* VIRTUE, *Friendship, Honesty* and *Faith,* but to RELIGION, *Piety, Adoration,* and a *generous Surrender* of his Mind to whatever happens from that *Supreme* CAUSE, or ORDER of Things, which he firmly thinks to be absolutely *just,* and *perfect*' (*Miscellaneous* 270 [224]).

Hence, one ought to face great challenges when attempting to define what Stolnitz refers to as the aesthetic object. While the 'modern term "aesthetic disinterestedness" stresses', as John Andrew Bernstein remarks, the 'element of spectatorial detachment as the prerequisite for pure contemplative experience',[64] Shaftesbury does not at all appear to regard aesthetic objects as reactive entities responsive to a disinterested attitude of the agent. Rather, Shaftesbury believes that there is 'Intelligence in Things, or in the Nature of Things & as eternally belonging to them' (*Askêmata* 88). Providential nature is animate and wise, which makes it difficult to consider aesthetic objects as simply reactive entities organized to supply aesthetic experiences to the determination of an active disinterested perception. As stated earlier, the virtuous agent is, in a technical sense, a less free subject than Stolnitz implies. The fact that the agent is *virtuous* determines his involvement in, and awareness of, divine nature and beauty. Although Stolnitz's account in part offers an accurate description of Shaftesbury's notion of disinterestedness, the substructure containing the modern notion of the aesthetic object remains, as we can see, problematic. To recognize that Shaftesbury acknowledges a disinterested aesthetic attitude that later on becomes an accepted modern attitude towards art does not of course imply that the objects of such an attitude were similar. When Stolnitz equates natural scenery with aesthetic objects, he unfortunately deprives Shaftesbury's notion of nature of its fundamental derivation, namely that 'mighty *Nature*' is, as Theocles claims, the 'Wise Substitute of *Providence*' (*Moralists* 246 [345]). While various aesthetic objects can be profane, rational nature is, for Shaftesbury, not

[64] John Andrew Bernstein, 'Shaftesbury's Identification of the Good with the Beautiful', *Eighteenth-Century Studies* 10, no. 3 (1977), 308. Bernstein's point is that the modern notion of aesthetic disinterestedness 'does not stress the specifically moral advantages, the conquest of personal passion, allegedly involved in such detachment'. Indeed, one can fault Shaftesbury 'for not perceiving the element of amoral indifference which is often inherent in "aesthetic disinterestedness"'; however, it is, as Bernstein agues, 'precisely because of this failure' that one must 'place "disinterestedness" within a wider context'. See also Bernstein, *Shaftesbury, Rousseau, and Kant: An Introduction to the Conflict between Aesthetic and Moral Values in Modern Thought* (Rutherford, NJ: Fairleigh Dickinson University Press, 1980), 25.

only externally formed by God, but indeed animated with his divine presence and beauty.

Thus, to avoid any aesthetic reductionism, the so-called aesthetic object needs to be historically and culturally explained. Shaftesbury's understanding of natural scenery has nothing in common with a mainstream view of a twentieth-century artwork. But by suggesting that both sources of the aesthetic experience are aesthetic objects targeted by a disinterested sense-perception, Stolnitz risks carting off the most essential quality of nature for Shaftesbury. It should be recognized that Stolnitz, to some extent, appears to be aware of the problem with attributing a modern conception of aesthetic objects to Shaftesbury. As he stresses himself, Shaftesbury 'impose[s] a limitation upon disinterestedness *ab extra*, on behalf of the sort of beauty which he esteems most highly'.[65] In other words, Stolnitz appears at one point to acknowledge that Shaftesbury's ethico-theological claim about the aesthetic experience does not encompass all objects ad infinitum. As we have observed, Shaftesbury distinguishes between sensuous pleasures of the body and pleasures of the mind, the latter being superior to the former. Shaftesbury's reasons for making this distinction is determined by his understanding of the realized natural disposition: only certain eighteenth-century men have the accurate cognitive capacity to experience God's rational nature. Hence, an aesthetic object cannot be any kind of object but has to be a special kind of object – an object that furthermore requires a disinterested engagement in order to be experienced. Still, this is not what Stolnitz is saying. Given that he claims that the modern 'concept of "disinterestedness" has no built-in limitations upon the nature of the objects that can be admired by "mere view"', Shaftesbury's belief that the 'object enters awareness through the sense-organ, but its beauty is only discerned subsequent to physical sensation' by internal sensation, and that harmony is an 'inner coherence which is never disclosed merely on the surface of things', causes Stolnitz a great deal of distress.[66] Ultimately, Shaftesbury's historical metaphysics is simply an obstruction – 'metaphysics is the villain of the piece' since it 'invokes the presence of the invisible kingdoms which lie behind things merely seen and it is a plea against preoccupations with the shadows' – to modern claims about the agent's concern for a disinterested perception that simply terminates upon aesthetic objects in general.[67]

[65] Stolnitz, 'On the Significance of Lord Shaftesbury in Modern Aesthetic Theory', 111.
[66] Ibid., 110–11.
[67] Ibid., 111–12. Stolnitz remarks that the 'bias of the metaphysic blunts Shaftesbury's insight into the nature of aesthetic perception and distorts his account of it'.

Stolnitz needs a more 'empirically faithful account of disinterested perception' to prove his point about the Earl's immediate relevance for modern aesthetic theory.[68] But even if it would suit a current purpose to detect a strong claim for mere sensuous beauty in Shaftesbury's writings, it cannot be accomplished without severely compromising the Earl's intentions and the early-eighteenth-century British context. Shaftesbury was, as David A. White accurately observes, 'working within a conceptual framework which outlined a complex organic theory of beauty', and 'it was not to his purpose to develop and emphasize as a self-sufficient aspect of that theory the mode *in which* we perceive aesthetically to the exclusion of *what* it is we perceive in this manner'.[69]

Shaftesbury himself offers no ambiguity whatsoever about God's active and rational presence in nature. In the *Inquiry*, Shaftesbury straightforwardly defines God as 'WHATSOEVER is superiour in any degree over the World, or rules in Nature with Discernment and a Mind' (*Inquiry* 36 [10]). Hence, the 'perfect THEIST' believes in God as a 'designing Principle, or Mind' that regulates nature (*Inquiry* 36 [11]). Shaftesbury doubts the rituals of established religion, while he accepts *natural religion* as true. Instead of relying on the Scriptures, the Sacrifice of Jesus Christ, and Revelations, we should, according to Shaftesbury, take comfort in the fact that the attributes of God are present and revealed in the divinity of rational nature itself.[70] The presence of God is thus immanent and dynamic in the beauty of nature, rather than, as a too narrowly deistic perspective would have argued, transcendent.[71] We could try to define what Stolnitz implies when he refers to aesthetic objects (e.g. scenes in nature) as things or objects disinterestedly perceived, by distinguishing between *phenomenal objectivity* and *phenomenal subjectivity*. One might characterize the contrast between the two forms as a traditional difference of the location of *where* something is thought to

[68] Ibid., 111.
[69] White, 'The Metaphysics of Disinterestedness: Shaftesbury and Kant', 240.
[70] See also Whichcote (*Select Sermons* 120): 'God is every-where, in every thing. So we cannot miss of him. For *the Heavens declare the Glory of God* [see Ps. 19. 1], and every Grass in the Field declares God.' As Willey states in *The Eighteenth Century Background*, 65, 'in Shaftesbury's view "true religion" should be based on "Nature" rather than on Revelation.'
[71] Shaftesbury can accurately be described as a 'Deist with a difference' (Grean, *Shaftesbury's Philosophy of Religion and Ethics*, 59). Occasionally, he is unwilling to exploit the term deism and unsympathetic to how the term appears in the works of the British deists. See e.g. *Askêmata*, 86–125 (122): 'Who are these *Deists*? how assume this Name? by wt Title or Pretence? ... The World, the World? say what? how? A *modifyed Lump? Matter, Motion?* ... what is all this? *Substance* what? Who knows? why these Evasions? Subterfuges of Words?' The question is, for Shaftesbury, rather '*Mind?* or not *Mind*? If Mind; a Providence: the Idea perfect: A GOD. If not Mind; what in ye place? For what ever it be, it cannot without absurdity be call'd *God* or *Deity*; nor ye Opinion without absurdity be call'd *Deisme*.'

exist.⁷² While an affection for God is experienced *in* the agent, the source of such an affection is experienced as *outside* the agent. But this does not make much sense in the case of the passage from *The Moralists*. The distinction between the source of the aesthetic experience and the shepherd and Philocles is not definite. Neither Philocles nor the shepherd, nor anyone else, can address nature and art perceptually in a way that resembles the attention of the modern viewer. In fact, it is not so much the detached perception as such that is essential to the aesthetic experience, but the emotional devotion and participation. Characteristically, Theocles is introduced by Philocles to his friend Palemon, in the beginning of *The Moralists*, as someone who is genuinely in love with nature (*Moralists* 72 [219]), followed by a discussion that serves to underpin Shaftesbury's general suspicion of one-dimensional pleasures deriving from sensation. It is not by a detached perception that such a love is properly displayed but rather by a tender moral engagement in God's rational creation. Hence it is by their natural engagement in and devotion to the cosmological whole that Philocles and the shepherd can begin to experience beauty and maintain their immersion in society. To experience nature and art is, for Shaftesbury, ultimately to be completely absorbed in the very source of the experience, that is, God.⁷³

No prophet (or man of letters) is accepted in his own country: while German-speaking Europe endorsed Shaftesbury's ideas, he remained, if we are to believe Stolnitz, largely neglected in Britain.⁷⁴ In his last paper on the topic of disinterestedness, Stolnitz refers to his own aim to challenge the established paradigm where it is argued that modern aesthetics originates in the German tradition, and instead claim the notion of aesthetic disinterestedness, understood as a specific mode of perception first advanced by Shaftesbury, as the original source. Thus, Stolnitz wishes to replace a (at the time) prevailing diachronic account of Enlightenment aesthetic theory with a new diachronic account. Ironically, in order to do so he let pass the same cause that produced the first lacuna: the Earl's original metaphysical vision of a telic cosmos, where the notion of disinterestedness is inseparable from the classical triad of truth,

[72] See Dorothy Walsh, 'Aesthetic Objects and Works of Art', *Journal of Aesthetics and Art Criticism* 33, no. 1 (1974), 9. *Nota bene*, Walsh's point is that whereas this distinction might be expedient to keep in mind whenever addressing aesthetic objects such as natural scenery, it is generally acknowledged that the appreciation of an object as *aesthetic* 'involves the recognition of an objectivity that transcends the mere phenomenal objectivity that characterizes the aesthetic object of immediate apprehension' (11).

[73] See also Guyer, *Values of Beauty*, 10.

[74] That Shaftesbury was 'largely ignored' in 'his own age' (Stolnitz, 'On the Significance of Lord Shaftesbury in Modern Aesthetic Theory', 97) is an exaggeration. *Characteristicks* was, next to Locke's *Second Treatise*, the most reprinted book written in English during the eighteenth century.

goodness, and beauty. It is as if Stolnitz believes that Shaftesbury's thinking has to be adjusted to the modern properties of aesthetic autonomy and liberated from the fetters of a more traditional perception of nature and art, in order to catch the eye of contemporary aesthetics. But as Skinner appositely observes about the *mythology of doctrine* (for further discussion, see introduction), there is always an inevitable risk in recognizing an ideal type of a doctrine. Although Shaftesbury indeed referred to disinterestedness, we must, as we move ahead, be cautious of grasping his notion as a proto-autonomist version of modern aesthetic disinterestedness. Instead, the triad of truth, goodness, and beauty, and the recognition that natural affections subsist at the heart of the experience of nature and art, open up singular aesthetic categories for questions of social well-being and political conditions of society.

2.4

The work of art as a *whole*

True to the Socratic movement of the dialogue, Theocles slowly but surely leads Philocles towards a new compassion for beauty, which, crucially, also involves the moment when Philocles learns about himself, namely that he has previously neglected '*Beauty it-self* (*Moralists* 328 [402]). In the light of Philocles' regrettable past, where he enjoyed 'Surface' and 'superficial Beautys', his final entrance to a new phase of taste becomes all the more distinct and rational.

Philocles is expected to reach this phase via insights about three hierarchically arranged degrees of beauty. The lowest degree in the hierarchy is '*the Dead Forms*', which are formed by nature or man but 'have no forming Power, no Action, or Intelligence' themselves (*Moralists* 334 [406]). Such dead forms always need art (which rely on mind) to be beautiful: '*the Art* is that which beautifies' and 'that which is beautify'd, is beautiful only by the accession of something beautifying' (*Moralists* 330 [404]). Thus, the second degree of beauty consists of human minds ('*the Forms which form*') which provide matter with a required harmony (*Moralists* 334 [406]). This degree includes 'both the Form (the *Effect* of Mind) and *Mind* it-self' (*Moralists* 334 [406]). Finally, 'whatever Beauty appears in our *second* Order of Forms, or whatever is deriv'd or produc'd from thence', must be 'eminently, principally, and originally in this *last* Order of *Supreme* and *Sovereign Beauty*' (*Moralists* 336 [408]). This third degree of beauty is that Absolute Beauty 'which forms not only such as we call mere Forms, but even *the Forms which form*' (*Moralists* 336 [408]).[1] That is to say, this 'Fountain of all Beauty' is the source of human minds and affections, and all the beauty that they create (*Moralists* 336 [408]). From this hierarchy of beauty, we should of course

[1] Absolute Beauty is here applied in a generic sense. See Robert W. Uphaus, 'Shaftesbury on Art: The Rhapsodic Aesthetic', *Journal of Aesthetics and Art Criticism* 27, no. 3 (1969), 344: 'In Platonic terms, which are immediately relevant to Shaftesbury's discussion, the third level is Absolute Beauty. At best, man (a mind) can create objects that are themselves the effect of mind, but he cannot himself fashion minds; and it is the virtue of fashioning minds that constitutes the third and final level of beauty.'

note an emphatic stress on the status of mind. Any transformation of dead forms into works of art relies on the creative and forming power of the human mind. Beauty is, as Mark-Georg Dehrmann stresses in this context, 'not a *material*, but rather a *mental* phenomenon'.[2] One cannot rely on sense perception. Instead, a proper '[a]ppreciation of beauty is a recognition, an *anámnesis* which prompts the spectator to discover the very nature of his own mind'.[3]

When we experience art, we are not further away from the rational perfection and beauty of nature as such, but since the artistic creation of art introduces elements depending on the realized disposition of the artist, rather than on the perfection of created nature, we are, as it seems, also unveiling a new and potentially disturbing factor. The '*Forms which form*' might indeed successfully relate to the Absolute Beauty and bring out the rational harmony of nature in the dead forms, but, then again, such artistic *Forms* might also fail to do so. A lack of experience of Absolute Beauty will inevitably result in a failed artistic representation. Given that, as Shaftesbury stresses in *Soliloquy*, the 'Schemes must be defective, and the Draughts confus'd, where *the Standard* is weakly establish'd, and *the Measure* out of use' (*Soliloquy* 268 [337]),[4] the artist needs to truly *know* the perfection of rational nature, and exercise his judgement and affections, to create a successful work of art. The risk is of course that artists will not create works which originate in the mind's proper experience of the rational beauty of nature, but rather from the absence of such an experience. Such artists would thus lack natural taste and consequently address the vulgar pleasures of a public sharing a similar lack. In a downward spiral, the artists and the public would thus join forces and affirm each other's low expectations of art.

For Shaftesbury, it is of course vital that 'ONE who aspires to the Character of a Man of Breeding and Politeness, is careful to form his Judgment of Arts and Sciences upon right Models of *Perfection*' (*Soliloquy* 270 [338]). A true virtuoso and gentleman must operate with great rationality and well-balanced judgement when he struggles to 'turn his *Eye* from every thing that is gaudy, luscious, and of *a false Taste*' and 'his *Ear* from every sort of Musick, besides that which is of

[2] Mark-Georg Dehrmann, 'Transition: "Pedagogy of the Eye" in Shaftesbury's *Second Characters*', in *New Ages, New Opinions: Shaftesbury in His World and Today*, ed. Patrick Müller (Frankfurt am Main: Peter Lang, 2014), 50.
[3] Ibid.
[4] Shaftesbury's point here (*Soliloquy* 268 [336/337]) is that when we experience works of art ('which are merely Imitations of that outward Grace and Beauty') we tend to pursue 'amidst the many false Manners and ill Stiles, the true and natural one, which represents the real *Beauty* and VENUS of the kind'. The artist needs to completely comprehend 'this VENUS, these GRACES' in order to make art. If the artist is not 'ever struck with the *Beauty*, the *Decorum* of this *inward* kind, he can neither paint advantageously after the Life, nor in a feign'd Subject, where he has full scope'.

the best Manner, and truest Harmony' (*Soliloquy* 270 [338]).[5] As we have already recognized, Shaftesbury's moral psychology is holistic. Characteristically, the comments in *Soliloquy* find a match in Shaftesbury's *Inquiry*, where the strength of natural affections and sociability involves a harmony of the complete '*inward Constitution*' (*Inquiry* 234 [134]).[6] Balanced natural affections ensure that our actions are in accordance with nature; to adhere to the natural affections is ultimately to obey the harmony and beauty of nature. As Shaftesbury records to himself in a note during his first retreat to Rotterdam in August 1698, '[t]o have Naturall Affection is *to affect according to Nature, or the Design & Will of Nature*. For without respect to a Design & Will of Nature, nothing can be said to affect naturally, or have Naturall Affection' (*Askêmata* 74). Failure to balance and perfect natural affections is destined to result in a lack of taste, and when this failure is made into a standard for artistic creation, as well as for the experience of art, it will only cause further vulgarity.[7] Clearly, this is of great concern for Shaftesbury and he states his point with much apprehension in *Soliloquy*:

> We care not how *Gothick* or *Barbarous* our Models are; what ill-design'd or monstrous Figures we view; or what false Proportions we trace, or see describ'd in History, Romance, or Fiction. And thus our *Eye* and *Ear* is lost. Our Relish or *Taste* must of necessity grow barbarous, whilst *Barbarian* Customs, *Savage* Manners, *Indian* Wars, and Wonders of the *Terra Incognita*, employ our leisure Hours, and are the chief Materials to furnish out a Library. (*Soliloquy* 276 [344])

In contrast to the degeneration of taste, described by Shaftesbury in *Soliloquy*, where the receptive sensuousness for art ultimately is eliminated, he also expands his vision of the ideal artist who manages to bring together diverse elements to create a *whole*. Thus, not only are we as agents holistically related to cosmos as a structured whole, but indeed also to the individual work of art as a whole.

[5] See also e.g. *The Moralists* (328 [403]), where Theocles urges Philocles to choose more carefully between '*Subjects*' and decide which of them he prefers, since whatever is the 'Worth of these Companions, such will your Worth be found'.

[6] See also *Inquiry* (236 [135]): 'WHOEVER is the least vers'd in this moral Kind of Architecture, will find the inward *Fabrick* so adjusted, and *the whole* so nicely built; that the barely extending of a single Passion a little too far, or the continuance of it too long, is able to bring irrecoverable Ruin and Misery.'

[7] Shaftesbury phrases a strong apprehension for the kind of downward moral spiral that follows from reading inferior literature (*Soliloquy* 274 [341/342/343]): 'Whatever Company we keep; or however polite and agreeable their Characters may be, with whom we converse, or correspond; if the *Authors* we read are of another kind, we shall find our Palat strangely turn'd their way. We are the unhappier in this respect, for being *Scholars*; if our Studys be ill chosen. Nor can I, for this reason, think it proper to call a Man *well-read* who reads *many* Authors: since he must of necessity have more ill Models, than good; and be more stuff'd with Bombast, ill Fancy, and wry Thought; than fill'd with solid Sense, and just Imagination.'

While cosmos is much like the body of a human being, where the complex coordination of interdependent parts amounts to the successful arrangement of the whole of the body, works of art function in a similar manner. Resonating with Aristotle's claim in the *Poetics* (echoing in its turn of a comment made by Socrates in *Phaedrus*) that a plausible plot in epic poetry must be assembled around an action that is a perfect whole (περὶ μίαν πρᾶξιν ὅλην) in itself (consisting of beginning, middle, and end) which then allows the poem, just like a whole living animal, to create its own appropriate pleasure (ὥσπερ ζῷον ἓν ὅλον ποιῇ τὴν οἰκείαν ἡδονήν),[8] Shaftesbury remarks in the opening of *A Notion of the Historical Draught or Tablature of the Judgment of Hercules*: "'tis then that in Painting we may give to any particular Work the name of *Tablature*, when the Work is in reality "*a single Piece*, comprehended in *one* View, and form'd according to *one single* Intelligence, Meaning, or Design; which constitutes a *Real* WHOLE, by a mutual and necessary Relation of its Parts, the same as of the Members in a natural Body"' (*Notion* 74 [348]). As we will see further ahead, the idea of the work structured as a whole implies certain moral responsibilities for the artist and the addressee.

It is fair to say that, from Shaftesbury's perspective, most past and present artists remain unsuccessful in the artistic process that ought to result in such works. But even when artists are successful and manage to create true works of art, there is of course a remaining risk that the natural taste of the artist that resulted in the work is encountered by a public with vulgar taste. While experiencing the providential whole is at the same time to recognize the 'Source Origine & Principle of Excellence & Beauty', the failure to do so arises from too strong a focus on the 'imperfect Fragments' structuring the work itself (*Askêmata* 139). Although the agent may not completely understand the whole – the whole of the rational cosmos and the whole of the work of art – he must nevertheless always strive to experience the whole, because that is how he commits himself morally to the Deity: there is a 'Supream Eternall Mind or Intelligent Principle belonging to this Whole; and this is DEITY' (*Askêmata* 90).

As we observed earlier, there is, for Shaftesbury, a fundamental organic relation between private systems and universal systems, which implies that separate parts are always related and intended as parts of a purposeful telos: '[T]here is a Concatenation & Connexion: all things are related to one another, depend on

[8] See Aristotle, *Poetics*, 1459ᵃ19–21. Malcolm Heath draws attention to the fact that Plato appears to have anticipated the Aristotelian account of the plot structure; see Malcolm Heath, *Ancient Philosophical Poetics* (Cambridge: Cambridge University Press, 2013), 84. See Plato, *Phaedrus*, 264C.

one another, and every thing is necessary to every thing' (*Askêmata* 112). Given that the 'Nature of the Whole' is 'more perfect than that of particulars contain'd in the Whole', it is simultaneously a 'Supream Nature', which should be perceived as 'perfectly Wise & Just' (*Askêmata* 90). As it turns out, the same rule must indeed apply to the aesthetic experience of art:

> See in Painting, See in Architecture, where it is yt Beauty lyes. is it in every single Stroak or Stone wch unitedly compose ye whole Design? is it in any seperate narrow Part, or in the WHOLE taken together? is it (suppose) in the foot-square of the Building, or in the Inch-square of the Painting? or is it not evident yt if the Eye were confin'd to this, the Cheif & Soverain Beauty would be lost, whatever slender Graces might appear in those imperfect Fragments? (*Askêmata* 139)

Thus, in his comprehension of art, as well as in his moral vision, Shaftesbury voices a similar appeal: the experience of the providential world, as well as the moral experience of art, must at all times be determined by the natural inclination to 'Go to ye FIRST OBJECT', that is to the 'Source Origine & Principle of Excellence & Beauty', because where there is 'perfect Beauty' there is also 'perfect Enjoyment' and the 'Highest GOOD' (*Askêmata* 139). As we will see, Shaftesbury perceives history to be in constant vicissitude, where periods of philistinism are replaced by opportunities for culture and taste (as in post-1688 British society) in an eternal circular movement, and where the moral agent must have confidence in the whole rather than attempt to understand the whole through its particularities. What the work of art, and the artistic process of combining different elements to create the work, thus sheds light upon is the general risk that when concentrating on particularities, one might fail to perceive the providential whole.

The flux of the world is captured by Shaftesbury in the poetic image of an ongoing '*Chorus*'.[9] To accept the fluctuations of this *Chorus* and to turn one's gaze to the self – 'reform thy Self, rather than the World' (*Askêmata* 157) – is simultaneously to experience a great beauty.[10] To strive against nature is, needless to say, to oppose the natural vicissitude of history.[11] The *Chorus* is, for Shaftesbury, a rhythmical pattern, and an acceptance of its irrefutable nature excludes narrow-minded 'reasonings about the Duration of things'

[9] See also Uehlein, *Kosmos und Subjektivität*, esp. 74–80.
[10] See *Askêmata* 146: 'is it not in these very Changes yt all those Beautyes consist wch are so admir'd in Nature & wch all but ye grosser sort of Mankind are so sensibly mov'd by?'
[11] See ibid., e.g. 145–7. Here, Shaftesbury sketches a picture of history where 'Nothing is new or strang' (146). Man is destined to exist within the oscillating immensity of history, where 'That that now is, after it has ceas'd, shall one time or other be again: and that that is not now, shall in time be as it was before' (146).

(*Askêmata* 157).¹² Instead, the acceptance of the *Chorus* revolves around a moral perceptiveness where the agent entrusts the absolute rationality of God's providence: 'if there must be Winter; if there must be Night; what is it to me, *when*, or *for how long*? & what should I do but committ this to Him, who has appointed the Seasons of the World, as is most conducing, & as was necessary for ye Safety, Happiness, & Prosperity of ye WHOLE?' (*Askêmata* 157). The aesthetic experience of nature and art emerges from their being structured in a similar manner as history itself, namely as a *Chorus*. It is, for Shaftesbury, through the disparities in the qualities organizing nature and art that harmony ultimately must arise. A work of art is constituted by different elements that hinge on one another in an organic relation. A work without an integral difference between the unique elements is simply incapable of producing the highest rational harmony. Just as the whole, from an imperfect and narrow perspective, might appear to be torn in different and disagreeing directions (in a circular movement from ages of barbarity and philistinism to ages of politeness and taste), but rational and harmonious from the perspective of a virtuous agent accepting the *Chorus*, the work of art, in order to be appropriately experienced, must be regarded as a whole, even though it is constituted by a concentration of dissimilar parts.

> What is Music? what is one Note prolongd? Nothing more dissonant & odiouse. but, seek the Changes & Vicessitudes, and those too the most odd & variouse ones; and here it is where Harmony arises. mix even a Dissonance after a certain manner; and the Musick is still more excellent: and in the management of these Dissonancyes is the Sublime of the Art. What is Dance but a like Succession of Motions diversifyed, of wch not one single one would continue gracefull, if view'd by itself, & out of this Chang; but wch taken as they are joynd together & depending on one another, form ye highest Grace imaginable. (*Askêmata* 163–4)

Works of art are certainly not insignificant. Indeed, they relate to the universal mind of Absolute Beauty. But what Shaftesbury wishes to accentuate is that one constantly must pursue the whole when experiencing works, as well as in life in general. The agent should seek to be 'deep in this Imagination & Feeling; so as to enter into what is done', in order to experience what is 'cheifly Beautifull Splendid & Great in things' (*Askêmata* 94). Rather than seeking a mere sensuous pleasure in transitory details, the agent must pursue the qualities that can secure the experience of the whole. As Shaftesbury notes, in Rotterdam in

¹² Ibid., e.g. 157. 'Wt is it to Thee, whether ye Antients be rememberd or not? whether their Manners & Government, whether Liberty, generouse Sentiments, or Philosophy be restord for a while, & flourish for one age or two, as then? is it to last for ever? must not other things prevail, & have their Cours? must not Superstition, Tyranny, Barbarity, Darkness & Night succeed again in their Turns?'

1698, 'my Good is elsewhere than in outward things' and 'by conceiving highly of the Deity, we despise outward things' and by doing so 'we become strong & firm in the opinion & conception of Deity' (*Askêmata* 99). To pursue the experience of the whole is ultimately the key to ensure the avoidance of moral corruption: '[R]emember THAT ONE, who is more than all: and contemplating Him; how is it possible thou shouldst either act or think any thing mean abject or servile?' (*Askêmata* 96).

It is evident from these remarks in *Askêmata* that, to understand Shaftesbury's approach to art, one cannot sidestep his metaphysical beliefs. Works of art are not isolated aesthetic objects of beauty arranged to provide aesthetic experiences detached from the truth of a rational providence and the morals of the agent. Whenever the Earl addresses the ontology of works of art or the status of the artist, he makes sure to anchor such matters in the relevance of the affections, the cognitive capacity of the mind, and the experience of the providential whole. Works of art are, in a sense, true works to the extent that they are successful in retaining a natural moral value throughout a complex creative process that begins in the artist's mind and affections and ends in the completion of the work. The fact that what is most predisposed to affect us is, as Shaftesbury observes in *Sensus Communis*, originating from the '*Beauty of Sentiments*' or the '*Proportions and Features of a human Mind*' (*Sensus Communis* 112 [135/136]) is a lesson ultimately taught by art to the same extent as by philosophy:

> This Lesson of Philosophy, even a Romance, a Poem, or a Play may teach us; whilst the fabulous Author leads us with such Pleasure thro the Labyrinth of the Affections, and interests us, whether we will or no, in the Passions of his Heroes and Heroines: [*qui pectus inaniter*] *Angit, Irritat, mulcet, falsis terroribus implet, Ut Magus* [Shaftesbury quotes from Horace, *Epistles*, 2.1.211–213: 'who with airy nothings wrings my heart, inflames, soothes, fills it with vain alarms like a magician'] (*Sensus Communis* 112 [136]).

The original source of a poem is, for Shaftesbury, a 'Force of *Nature*' or a '*moral Magick*' that can never be truly denied, and the 'Passion which inspires' the poet is properly self-interested since it addresses 'in a friendly social View; for the Pleasure and Good of others; even down to Posterity, and future Ages' (*Sensus Communis* 112 [136]). What ultimately completes the poem and transports the reader is the fact that the poet preserves the natural internal beauty of the soul in the rhythm and stanza of the poem:

> For this is the Effect, and this the Beauty of their Art; 'in vocal Measures of Syllables, and Sounds, to express the Harmony and Numbers of an inward kind;

and represent the Beautys of a human Soul, by proper Foils, and Contrarietys, which serve as Graces in this Limning, and render this Musick of the Passions more powerful and enchanting'. (*Sensus Communis* 112/114 [136/137])

Following Shaftesbury's argument in *Sensus Communis*, the poet administers the inward beauty and rational harmony in the creative process where the poem is shaped. If the poem is successful it will ultimately relate to truth in an analogous, albeit not identical, way as the agent himself relates to God's nature. Given that beauty refers to morality and truth ('all *Beauty is* TRUTH'), the '*True* Features make the Beauty of a Face; and true Proportions the Beauty of Architecture; as *true* Measures that of Harmony and Musick', and in poetry '*Truth* still is the Perfection' (*Sensus Communis* 120 [142]). Even so, there is of course, for Shaftesbury, a qualitative difference between the truth of the empirical world and the truth of art, and a difference between the truth of successful works of art and less successful ones.[13] The desirable attribute of an ideal painter is not his ability to imitate what is 'peculiar, or distinct' in nature (*Sensus Communis* 120 [143]). The painter's 'Art allows him not to bring *All* Nature into his Piece, but *a Part* only' (*Sensus Communis* 120 [142/143]). A good painter does not take an interest in duplicating nature. In his commentary on Matteis's painting *The Judgment of Hercules*, Shaftesbury characteristically observes that compared to an actor performing on a stage, a successful painter must attempt to 'come a little nearer (Nature,) to TRUTH, and take care that his Action be not *theatrical*' in order to produce originality (*Notion* 100 [368]). The closeness to nature allows for the painting to be 'drawn from NATURE her-self', rather than being a reproduction of nature (*Notion* 100 [368]).

Resonating yet again with Aristotle's *Poetics*, there is for Shaftesbury a critical difference between, on the one hand, 'Truth of *Fact*' or '*historical Truth*' and, on the other hand, 'Poëtical' truth (which is, for Shaftesbury, relevant for the arts in general) which is 'govern'd not so much by *Reality*, as by *Probability*, or *plausible Appearance*' (*Notion* 108 [372/373]).[14] Successful works of art are cohesive as objects, and successful artists are related as members of a genus, since they are interwoven in a dialectical relation not only with nature but with the historical

[13] Confidently, Shaftesbury comments (*Sensus Communis* 120 [142]) that 'whoever is Scholar enough to read the antient Philosopher, or his modern Copists, upon the nature of a Dramatick and Epick Poem, will easily understand this account of *Truth*'.

[14] Aristotle, *Poetics*, 1451ª36–1452ª10. See also Shaftesbury's comment (*Notion* 76 [349]) on '*History-Painting*' where the '*Unity of Design* must with more particular Exactness be preserv'd, according to the just Rules of poëtick Art; that in the Representation of any Event, or remarkable Fact, the *Probability* or *seeming Truth* (which is the *real Truth* of Art) may with the highest advantage be supported and advanc'd'.

truth and previous successful works and artists – a relation that must at all times remain artistically dynamic, and elude slavish representation, in order to result in true originality: 'The *good Painter* in this, as in all other occasions of like nature, must do as the *good Poet*; who, undertaking to treat some common and known Subject, refuses however to follow strictly, like a mere Copyist or Translator, any preceding Poet or Historian; but so orders it, that his Work in it-self becomes really new, and original' (*Notion* 112 [375/376]).[15]

The organic correlation between providential nature, the artistic process, and the work of art thus arises from the complete work, of the successful painter, constituting '*a Whole*, by it-self' (*Sensus Communis* 120 [143]), and the artist ought not to focus on the '*Minuteneß*' and '*Singularity*' of nature (*Sensus Communis* 122 [144]). The whole created by the artist in the shape of a work offers a fresh awareness of the rational unity, intelligence, and beauty of God's nature. Thus, a successful painting becomes a concentration 'from the *many* Objects of Nature, and not from *a particular one*' (*Sensus Communis* 122 [145]). The 'vicious Poets' or 'Composers of irregular and short-liv'd Works' are in a technical sense perfectionists, but they ultimately fail due to their obsession with imitating singularity, while the 'standing Pieces of good Artists' are always destined to arise 'under those natural Rules of Proportion, and *Truth*' (*Sensus Communis* 122 [145]). The good artist has experienced the rational whole of cosmos himself, and by creating a work as a whole, he grows to be godlike: his experience of the whole of cosmos is comparable to how God himself must experience the world. For the work of art to be successful, two kinds of concerns are crystallized, both revolving around Shaftesbury's unswerving confidence in the rational laws of nature. First, it is, of course, required of the artist to have experienced a rational and moral whole and to have exercised his natural affections to be able to create an accomplished work of art. However, having made such an experience, the artist is somewhat fated to succeed in his creation, while, as the Earl stresses in *Soliloquy*, an artist who tries 'to bring *Perfection* into his Work' but 'has not at least the *Idea of* PERFECTION to give him Aim'

[15] Here, Shaftesbury refers to Horace, *Ars poetica*, 131–5: *publica materies privati iuris erit, si | non circa vilem patulumque moraberis orbem, | nec verbo verbum curabis reddere fidus | interpres, nec desilies imitator in artum, | unde pedem proferre pudor vetet aut operis lex* (In ground open to all you will win private rights, if you do not linger along the easy and open pathway, if you do not seek to render word for word as a slavish translator, and if in your copying you do not leap into the narrow well, out of which either shame or the laws of your task will keep you from stirring a step). See also the apparatus criticus to *Miscellaneous Reflections* (*Printed Notes* 234 [262]). Here, Shaftesbury stresses that 'We see in outward Carriage and Behaviour, how ridiculous any one becomes who imitates another, be he ever so graceful. They are mean Spirits who love to copy *merely*'. For Shaftesbury, 'Nothing is agreeable or natural, but what is *original*'.

naturally 'will be found very defective and mean in his Performance' (*Soliloquy* 264 [332]):

> there can be no kind of Writing which relates to Men and Manners, where it is not necessary for the Author to understand *Poetical* and *Moral* TRUTH, *the Beauty* of Sentiments, *the Sublime* of Characters; and carry in his Eye the Model or Exemplar of that *natural Grace*, which gives to every Action its attractive Charm. If he has naturally no Eye, or Ear, for these *interiour Numbers*; 'tis not likely he shou'd be able to judg better of that *exteriour Proportion* and *Symmetry* of Composition, which constitutes *a legitimate Piece*. (*Soliloquy* 266/268 [336])

The second concern that is crystallized, from Shaftesbury's claims about works of art, refers to the laws of nature that direct the recipient of the work. If, as Shaftesbury claims, the 'Familiarity and Favour of the *moral* GRACES are essential to the Character of a deserving Artist, and just Favourite of the MUSES' (*Soliloquy* 270 [338]), there is a very similar kind of moral awareness that is commanded from the recipient. To experience the work, the agent must be morally and emotionally disposed, in Humean terms, 'to that which is required by the performance'.[16] By submitting himself to the work created by the good artist, the agent is bound to go through something very similar to what the artist experienced himself.

What appears to be important for Shaftesbury here is that the artist constantly allows the work to be disconnected from the singularity of individual natural objects, simultaneously as he preserves the truth of nature in the creation of a self-governing work of art. This is the kind of autonomy of works of art that Shaftesbury has in mind when he insists on the artistic need to create an original whole. The artist must, of course, at all times engage with providential nature in order to make a successful work. But the artist should also remain somewhat disengaged from nature. The creative quality of the artist consists in his ability to address this artistic (dis)engagement. In his remarks on the *Inquiry*, Klein mentions that Shaftesbury 'defined moral goodness, understood as a quality of agents, with respect both to its objects and to its origins'.[17] Morality is thus *autonomous* in the sense that agents are authorities of their own actions, concurrently as the importance of such actions consists in their *relatedness* to other agents, society, and the whole itself.[18] Although Klein is not referring to art

[16] Hume, 'Of the Standard of Taste', 239.
[17] Klein, *Shaftesbury and the Culture of Politeness*, 54.
[18] Ibid. 'According to the *Inquiry*, morality consisted in pursuing one's relatedness to others and the world, but it depended on one's capacity to act independently. The claims of both relatedness and autonomy were registered in the fact that Shaftesbury defined moral goodness by reference to both.'

here, but to Shaftesbury's overall objective in the *Inquiry*, his sharp observation elicits a vital feature of Shaftesbury's perception of art. For a work of art to be a whole, the artist has to secure a certain autonomy of the work in relation to the singularity of natural objects, but at the same time also pursue the relatedness to the truth of nature as a whole. The successful artist thus perfectly balances his creativity between autonomy and relatedness.

One of the informative images used by Shaftesbury to characterize the creative strength required from the ideal artist is when he, in *Soliloquy*, identifies the poet as a 'second *Maker*: a just PROMETHEUS, under JOVE' (*Soliloquy* 110 [207]). Although Shaftesbury provides a contrasting picture to the constructive creative power, by allowing the disillusioned Palemon, in the opening of *The Moralists*, to hold Prometheus, in a Hesiodian spirit, accountable for the misery of mankind, that passage is only expected to justify the abundance of counterevidence, and the optimistic image of human nature, advanced throughout the rest of the text.[19]

The first recognized account of Prometheus occurs in the Greek poet Hesiod's *Theogony* and *Works and Days* (*c*.700 BC). In Hesiod's cosmogony in the *Theogony*, we learn of Iapetus's son Prometheus, who, by his 'deceptive craft', challenges and tricks Zeus to agree to take fats and bones of a great ox, rather than meat, and who steals the 'far-seen gleam of tireless fire' from the Olympian gods and bestows it to earth and man.[20] Prometheus's creativity – deriding the gods, challenging the autocracy of Zeus, and giving power, in the shape of fire, to earth and man – is ultimately the cause of Zeus's great wrath. As punishment, Prometheus is tormented by a partial hepatectomy night after night, only to have his liver restored during the daytime.[21] As described by Hesiod in *Works and Days*, Zeus also commands misery upon mankind by instructing Hephaestus to create Pandora, who brings the jar of evils into the marriage of Prometheus's brother Epimetheus (Ἐπιμηθεύς, Afterthinker), who by taking the lid off the jar releases misery and disease upon humanity.[22] Prometheus's inventiveness

[19] 'O WRETCHED State of Mankind! Hapless Nature, thus to have err'd in thy chief Workmanship! Whence sprang this fatal Weakness? What Chance or Destiny shall we accuse? Or shall we mind the Poets, when they sing thy Tragedy (PROMETHEUS!) who with thy stoln Celestial Fire, mix'd with vile Clay, didst mock Heaven's Countenance, and in abusive Likeness of the Immortals mad'st the Compound MAN; that wretched Mortal, *ill* to himself, and Cause of *Ill* to all' (*Moralists* 34/36 [192/193]). See also Gill, *The British Moralists on Human Nature and the Birth of Secular Ethics*, 103. Gill recognizes that Palemon's pessimistic view of mankind is refuted in *The Moralists*.

[20] Hesiod, *Theogony, Works and Days, Testimonia*, trans. Glenn W. Most, Loeb Classical Library 57 (Cambridge, MA: Harvard University Press, 2006), 540–1 (about deceptive craft), and 566 (about tireless fire).

[21] Ibid., 520–6.

[22] Zeus's punishment for Prometheus's stealing of the fire is the creation of Pandora, who brings misery on mankind; see ibid., 42–104.

is thus punished, as is stated in Aeschylus' tragedy *Prometheus Bound*, for giving 'privileges to mortals' rather than benefitting the gods.[23] While Hesiod describes how Pandora is created out of clay, in order to punish the impiety of Prometheus, Aesop's fables, as well as Ovid, and the first-century handbook of Greek mythology entitled the *Library*, add further to the image of Prometheus as an inventive maker by claiming that Prometheus himself, in a creative act, made man out of clay.[24] In the opening of the *Metamorphoses*, Ovid argues that man was either created out of the Creator's own divine substance or by the son of Iapetus, who in his act of creation moulded man from the earth into the form of gods.[25]

Prometheus is a mythological image of a natural inventive and prophetic power, and Shaftesbury evokes the powerful image – of Aeschylus' creative and confident Prometheus ('Why should I be afraid, when death is not in my destiny?') rather than Hesiod's sly rascal – when he defines the features of an ideal poet, by relating it to the image of the poet as a second maker.[26] By doing so, he is, however, not only drawing on the mythologies of the classical Greek and Roman period but also on a national legacy relating the poet with *prophesizing* and *making*. In Sir Philip Sidney's Renaissance poetics, *A Defence of Poetry* (*c*.1579–84), the etymological origin of the English word 'maker' is assumed to be a synthesis of '$\pi o\iota\varepsilon\tilde{\iota}\nu$ [poiein] which is to make', and the Roman's word for poet (*vates*) which is 'as much as a diviner, foreseer, or prophet, as by his conjoined words *vaticinium* and *vaticinari* is manifest'.[27] Poetry, or 'speaking picture', is supra-rational for Sidney, and a mode of reflection that constitutes the origin of other sciences.[28] Historiographers and ancient Greek philosophers neither dared nor could, according to Sidney, elaborate their thinking without utterly relying

[23] Aeschylus, *Prometheus Bound*, vol. 1, trans. Alan H. Sommerstein, Loeb Classical Library 145 (Cambridge, MA: Harvard University Press, 2008), 108.

[24] Apollodorus, *Library*, vol. 1, trans. James George Frazer, Loeb Classical Library 121 (London: William Heinemann, 1921), 1.7.1: 'Prometheus moulded men out of water and earth and gave them also fire, which, unknown to Zeus, he had hidden in the stalk of fennel.' See also *Aesop's Fables*, 516.

[25] Ovid, *Metamorphoses*, vol. 1, 1.78–84.

[26] Aeschylus, *Prometheus Bound*, vol. 1, 933. In *The Byronic Hero: Types and Prototypes* (Minneapolis: University of Minnesota Press, 1962), 113, Peter L. Thorslev characterizes the Hesiodian Prometheus aptly as 'a scamp and a wily cheat'. See also Dougherty, *Prometheus*, 65: 'No longer a trickster figure, Aeschylus' Prometheus adopts the role of a rebel fighting for mankind against the tyranny of Zeus, and his story highlights progress rather than decline as the master narrative of the human condition.'

[27] Sir Philip Sidney, *A Defence of Poetry*, in *Miscellaneous Prose of Sir Philip Sidney*, ed. Katherine Duncan-Jones and Jan Van Dorsten (Oxford: Oxford University Press, 1973), 76–7. Sidney did not provide his discourse with a title. Dorsten recommends *A Defence of Poetry* to be used as the standard title.

[28] Ibid., 80.

on the authority of poetry.²⁹ While philosophers could observe and follow nature without a profound sense of interaction, the creative and prophesizing poet was, as long as he advanced in careful conjunction with nature, at liberty to enhance a second nature in his poetic representation of ideas by being 'lifted up with the vigour of his own invention'.³⁰ The poet was thus an autonomous and creative *maker*, participating in the divine (re)creation of nature, although his mimetic activity naturally remained determined by the 'heavenly Maker of that maker'.³¹

The images of Prometheus and the second maker allow Shaftesbury to guide the eighteenth-century reader's imagination to the artistic self-determination that has to be integrated in the artistic decorum and in the creation of works of art.³² Prometheus is, in Shaftesbury's account, a 'Moral Artist', which means that he is, at all times, able to distinguish the 'exact *Tones* and *Measures*' of the passions, and thereby capable of creating a convincing heterocosm (*Soliloquy* 110 [207]). To some extent, such a second maker is of course mimetically relying on the Maker – the 'Sovereign Artist' or the 'universal Plastick Nature' – but that is because he manages to make '*a Whole*, coherent and proportion'd in it-self', on the one hand, through being determined by the Deity immanent in nature and, on the other, through self-sufficiently re-creating nature in the form of a work that re-awakens our responsiveness to the Deity (*Soliloquy* 110 [207]).

As we have noted, the arguments put forward about the work of art are, especially in *Sensus Communis*, profoundly imbued with Aristotle's *Poetics*. In the apparatus criticus to *Sensus Communis* Shaftesbury quotes at length from chapter 7 of the *Poetics*,³³ where Aristotle, after concluding that tragedy is the

²⁹ See ibid., 75: 'This did so notably show itself, that the philosophers of Greece durst not a long time appear to the world but under the masks of poets. So Thales, Empedocles, and Parmenides sang their natural philosophy in verses; so did Pythagoras and Phocylides their moral counsels; so did Tyrtaeus in war matters, and Solon in matters of policy: or rather they, being poets, did exercise their delightful vein in those points of highest knowledge, which before them lay hid to the world.'
³⁰ Ibid., 78. Nature is, argues Sidney, the 'principle object' on which every astronomer, geometrician, and arithmetician depends. Accordingly, the 'natural philosopher thereon hath his name, and the moral philosopher standeth upon the natural virtues, vices, or passions of man'. The poet, on the other hand, 'disdain[s] to be tied to any such subjection'.
³¹ Ibid., 79.
³² For a comment on Shaftesbury and the Promethean myth, see e.g. Jean-Paul Larthomas, *De Shaftesbury à Kant* (Paris: Didier Erudition, 1985), esp. 252–6. Larthomas identifies the impact of Shaftesbury's reference to the poet as a second maker for German Romanticism. See also Oskar Walzel, *Das Prometheussymbol von Shaftesbury zu Goethe*, 2nd edn (Munich: Max Hueber, 1932).
³³ See also the apparatus criticus to *Miscellaneous Reflections* (see *Printed Notes* 228 [259]). Here Shaftesbury makes a similar reference to Aristotle's *Poetics* (1450ᵇ26–31) but also to Horace and his stress on the necessity that a poem is *simple* and *uniform* (see *Ars poetica*, 23). Shaftesbury makes the following approving comment: "Tis an infallible proof of the want of just *Integrity* in every Writing, from the *Epopee* or *Heroick* Poem, down to the familiar Epistle, or slightest Essay either in *Verse* or *Prose*, if every several Part or Portion fits not its proper place so exactly, that the least Transposition wou'd be impracticable. Whatever is *Episodick*, tho perhaps it be *a Whole*, and in it-self *intire*, yet

imitation of an action that is a *whole* (of some magnitude) in itself, and stating that a *whole* consists of a beginning, middle, and end, engages himself in the dimensions of objects of beauty.[34] Similar to the arrangement of a successful plot, a beautiful object must have its parts systematically arranged, and composed of proper magnitude. The sensuous experience of beauty requires a balanced magnitude of the object. While an experience of something very small leaves the perceiver unsatisfied – since whenever the perceiving moment is hardly noticeable, perception itself becomes indistinct – an experience of extremely large object is just as unsatisfactory – because we lose a sense of both unity and wholeness.[35] While we must seek a plot that can be remembered, we must also, according to Aristotle, as regards the objects of beauty, seek a size that can be seen at once.[36] The work of art offers the opportunity to sensuously engage with and experience beauty. Shaftesbury draws on Aristotle's arguments and adds that when works of ancient artists as well as modern artists[37] fail, it is often because they are 'running into the unsizable and gigantick' (*Printed Notes* 286 [143]). He recommends the reader to remember Pliny the Elder's *Natural History*, and especially his account of the ancient Greek painter Zeuxis. According to Pliny, Zeuxis led, on the one hand, 'forward the already not unadventurous paintbrush … to great glory'[38] and, on the other, he was 'criticized for making the heads and joints of his figures too large in proportion'.[39] Thus, although he was an ideal classical artist, Zeuxis occasionally failed when it came to the magnitude of the object and, following Shaftesbury's path of association, sometimes also remained unsuccessful in creating a proper whole. Shaftesbury also directs the reader to Pliny's account of the celebrated Greek sculptor and painter Euphranor. Whereas Euphranor is acknowledged for achieving proper proportions, he is criticized for sometimes being 'too slight in his structure of the whole body and too large in his heads and joints'.[40] Like Zeuxis, Euphranor is occasionally unsuccessful in constructing the proper magnitude and thus, or so we are led to believe by Shaftesbury, sometimes also unproductive in creating a successful artistic whole.

being inserted in a Work of ever so great a length, it must appear only in its *due place*. And that Place alone can be call'd its *due*-one, which alone befits it.'

[34] Aristotle, *Poetics*, 1450b24–26.
[35] Ibid., 1450b38–1451a1.
[36] Ibid., 1451a4–6.
[37] Shaftesbury exemplifies (see *Printed Notes* 286 [143]) by referring to 'MICH. ANGELO, the great Beginner and Founder among the Moderns, and ZEUXIS the same among the Antients'.
[38] Pliny, *Natural History*, vol. 9, trans. H. Rackham, Loeb Classical Library 394 (Cambridge, MA: Harvard University Press, 1952), 35.36.61.
[39] Ibid., 35.36.64.
[40] Ibid., 35.40.128.

What is Shaftesbury trying to say by leading the eighteenth-century reader to Pliny's first-century account of Greek and Roman sculpture and painting? The most obvious moral is that the creation of the whole – the artistic making of, what Shaftesbury refers to as, *poetical* truth in poetry and *graphical* or *plastic* truth in painting and sculpture – depends on a composition of the right proportions. The origins of the formation of such balanced proportions are, according to Shaftesbury, not located in the particularity of nature. In a similar vein as Zeuxis is said to have prepared his painting of Helen of Troy, for a temple at the city of Croton, by selecting five maidens with the 'purpose of reproducing in the picture the most admirable points in the form of each',[41] Shaftesbury suggests that the most successful artists bring together the various elements of the best works of art in order to create a new work, a new whole.

In the light of the famous myth retold by Pliny, of the artistic competition between Zeuxis and the Greek painter Parrhasius of Ephesus – where Zeuxis' painting of grapes, according to Pliny, was realistic enough to deceive birds that the grapes were physical, and Parrhasius's painting of a curtain was realistic enough to tempt Zeuxis himself to try to lift it, only to realize that the panel was in fact a painting of a curtain[42] – the complexity of Shaftesbury's argument becomes manifest. With all due deference to the remarkable *technē* proved by Zeuxis and Parrhasius, Shaftesbury recognizes that artistic quality also consists in providing further complexity to the experience of nature. While a meticulous imitation of nature suggests the kind of *trompe l'oeil* advanced by Zeuxis and Parrhasius, Shaftesbury reminds the reader that a copying of God's nature is both unachievable and undesirable: 'A PAINTER, if he have any Genius, understands the *Truth* and Unity of Design; and knows he is even then unnatural, when he follows Nature too close, and strictly copies *Life*' (*Sensus Communis* 120 [142]). A perfect work of art is thus an autonomous entity, at the same time as it is, of course, absolutely dependent on and engaged in God's rational nature. The truth of the work is not identical with providential nature's truth, but it is simultaneously completely analogous with nature's truth. Along the lines of Leon Battista Alberti, who relies heavily on Pliny's encyclopaedic work and recommends the painter to 'take all things from Nature herself' and thus assure that his 'hand [will be] exercised to such a point that whatever thing he will undertake, he will always imitate Nature', Shaftesbury visions rational

[41] Ibid., 35.36.64. See also Leon Battista Alberti, *On Painting*, ed. and trans. Rocco Sinisgalli (Cambridge: Cambridge University Press, 2011), 3.56.
[42] Ibid., 35.36.65–66.

nature to be instinctively present in the artistic selections behind the work.[43] Instead of duplicating nature, the good artist allows the echo of nature and truth to resonate in every quality of the work, and the whole to deepen the experience and knowledge of nature.

Shaftesbury's references to the 'Truth of Art' in *Soliloquy* (e.g. 178 [263]) contain a dedicated defence of the 'honest *Artizan*, who has no other *Philosophy*, than what *Nature* and his *Trade* have taught him' (*Soliloquy* 176 [262]). Such artists or '*Mechanicks*' might be lazy or self-indulgent, but they always 'abhor any Transgression *in their Art*, and wou'd chuse to lose Customers and starve, rather than by a base Compliance with *the WORLD*, to act contrary to what they call the *Justness* and *Truth of Work*' (*Soliloquy* 174/176 [261]).[44] Honest artists (especially the poets of classical Greece) are able to make original works that attract attention, rather than creating passing works that merely adapt themselves to contemporary consideration. While modern authors 'regulate themselves by the irregular Fancy of the World; and frankly own they are preposterous and absurd, in order to accommodate themselves to the Genius of the Age', the moral artist demonstrates his poised integrity by adhering to the artistic decorum, as well as to virtue and truth (*Soliloquy* 178/180 [264]). True artistic integrity is a rational self-interest, and as such it naturally overlaps with obedience to providential nature and care for virtue as such: 'Let Others go theirs: Thou thy own. Let others praise yᵉ Vertuouse, yᵗ can praise, & dispraise, so cheaply, & at their Ease. But for thy own part, be contented not to praise so much as Vertue it self: and Θαρρει' (*Askêmata* 360).[45]

The moral uprightness of the artist is, for Shaftesbury, a protector of truth in a world that generally fails to recognize the value of a work of art as a whole. There is no conflict of interest here between obeying nature and occasionally walking out of step with the general taste of the public. Although artists do not 'always [have] *the* WORLD on their side', they will, by 'conforming to Truth and Nature',

[43] Alberti, *On Painting*, 3.56: 'If, in fact, in a *historia* the figure of some known person appears, although some [figures] of great skill emerge, nevertheless, a known face attracts to itself the eyes of all observers. So much grace and strength inhabits in itself what has been take from Nature! Therefore, let us always take from Nature [objects] that we wish to paint and from them always let us select the most beautiful and deserving.'

[44] Shaftesbury illustrates his point about artistic/workmanship integrity by narrating a possible reply to a request for a work that defies the '*Truth of Work*' (*Soliloquy* 176 [261/262]): 'SIR, (says a poor Fellow of this kind, to his rich Customer) "You are mistaken in coming to me, for such a piece of Workmanship. Let who will make it for you, as you fancy; I know it to be *Wrong*. Whatever I have made hitherto, has been *true* Work. And neither for your sake or any body's else, shall I put my Hand to any other."'

[45] In this section of *Askêmata* (Πολιτικά, 357–64) Shaftesbury is addressing a self-worth that is accompanying philosophy. Θαρρει (Take courage!), now rendered Θάρρει.

eventually turn the 'Judgment on their side' (*Soliloquy* 178 [263]).[46] While the surrounding world might fail to acknowledge the consequences of this artistic integrity, the artists are, by working 'independent of *Opinion*, and above *the* WORLD', able to influence the taste of the present culture (*Soliloquy* 176 [262]).

The question that is relevant for Shaftesbury is not so much whether the truth of the whole shaped by the artist is inferior or not to the truth of created nature. Given that the success of the work of art does not hinge on the complete correspondence between the work and the particulars of nature, but on the correspondence of the work's truth to nature's truth, such questions are somewhat beside the point. Rather, the relevance of Shaftesbury's analysis of the three hierarchically organized degrees of beauty relates to a possible risk integral to the artistic process, where the artist occasionally might fail to create a whole that corresponds to the rationality and truth of providential nature. Indeed, successful works of art offer, as we can see, truth, but not by being indistinguishable from the particulars of nature itself. Rather, good works of art rely on the same metaphysical principles of harmony and rationality as nature, and thus proper works also succeed in reaching truth, although the materialization of truth naturally differs between, say, the epistle by Horace, 'the best Genius and most Gentleman-like of *Roman* Poets' (*Soliloquy* 260 [328]), where he 'praise[s] the lovely country's brooks, its grove and moss-grown rocks', and a physical moss-covered rock created by God.[47] Beauty appears in the poetic verse of Horace where the work is the harmonious reflection of Absolute Beauty, as well as in the physical rock, and as such they are true, although this truth is manifested in two different ways.

[46] See also Leibniz's comments on *Characteristicks* (here on *Soliloquy*) (TNA, PRO 30/24/26/8, fol. 34ᵛ): 'C'est un excellent avis qu'on donne aux Auteurs … de ne se pas regler uniquement sur les préjugez de leur Païs et de leur Siécle; et au lieu de flatter le Vulgaire, de travailler à le corriger.'

[47] Horace, *Epistles*, 1.10.6–7.

2.5

Taste for society

Although Shaftesbury, as we have seen throughout this book, firmly believes that it is '*We our-selves* that make our TASTE', and that if 'we resolve to have it *just*' it will also be in 'our power' (*Miscellaneous* 224 [186]), he never considers such personal responsibilities as straightforwardly private interests or isolated matters of aesthetic education. While the social dimension is, of course, inherent in natural affections, self-understanding (a true self-interest) is equally important for a thriving society. Shaftesbury's own manner of living serves as an excellent example of the truth that the human mind and affections need withdrawal from quotidian concerns to be able to interact with Absolute Beauty and society. As Theocles remarks in *The Moralists*, '[s]ociety it-self cannot be rightly enjoy'd without some Abstinence and separate Thought' (*Moralists* 80 [224]). Achieving true knowledge of the self and balanced natural affections is essential for individuals in order to act as natural members within polite society. Thus, 'the Sum of Philosophy is, To learn what is *just* in Society, and *beautiful* in Nature, and the Order of the World' (*Miscellaneous* 196 [161]). So, the kind of natural society that Shaftesbury alludes to relies on individual cognitive realizations – a process culminating in 'Affections *right* and *intire*' – but, as he stresses in the *Inquiry* when referring to virtue, 'not only in respect of one's self, but of Society and the Publick' (*Inquiry* 144 [77]). A proper self-interest, like personal happiness, good taste, or morality, will thus unavoidably overlap with the interest of society. After all, man's 'natural end is Society' and '*to operate as is by Nature appointed him towards the Good of such his* SOCIETY, *or* WHOLE, is in reality *to pursue his own natural and proper* GOOD' (*Miscellaneous* 268 [223]).

Thus, the epicentre of the moral agent's end, and the agent's good, is society itself. If one cannot conclude that pleasures like sexual intercourse, eating, or sleeping are means for accomplishing something else,[1] but in a hedonistic vein

[1] Shaftesbury remarks the following (*Askêmata* 126): 'What is it then that we can call the End? To Eat, Drink, Sleep, Copulate, and the Pleasures wch belong to either eating, drinking, sleeping, or copulating, are all of them but as Means & refer to something further.'

rather considers them as ends, then one also has, as Shaftesbury writes during his first retreat to Rotterdam, to endeavour to reach a 'certain sound & perfect State of *Body* only, & such as serves to generate other such Bodyes' (*Askêmata* 127). However, pleasures are, for Shaftesbury, means, not ends. The reality of natural human affections suggests that the end of the agent is very different from pursuing an ephemeral physical pleasure. Such a pleasure merely results in an existential unpredictability where the agent pursues an indeterminable cause for no purpose, since he cannot make out 'what he follows; since contrary things procure it; and what pleases at one time, displeases at another: neither are the things on wch It [i.e. pleasure] depends ever in his power' (*Askêmata* 128). The natural affections, on the other hand, lead the agent away from precisely the volatility of physical pleasures, towards the stability of society and virtue. To pursue a natural end is equal to following virtue, and since man's natural end is society, the forms of polite social interactions that are expected to structure natural society must also be the good of man:

> The End & Design of Nature in Man is Society. for, wherefore are the naturall Affections towards Children, Relations, Fellow-ship & Commerce but to that End? The Perfection of human nature is in that wch fitts and accommodates to Society. for He who wants those Naturall Affections wch tend thither, is imperfect & monstrouse. Now, if ye ultimate Design & End of Nature in the Constitution of Man be this; that he be fram'd & fitted for Society; And if it be the Perfection of Human Nature to be thus fitted; how should not this wch is the End & Perfection of human Nature, be also the Good of Man? (*Askêmata* 127)

Shaftesbury's notion of society appears to work almost as a regulative (though natural) idea. However, the settings in which our natural dispositions are realized are never evasively or abstractly described. Just as the failure to accomplish self-knowledge, and the disregard for natural affections (and taste), is interrelated with the threat of decaying social conditions, so natural society is, as we will see in this chapter, anchored in concrete and productive political conditions. Shaftesbury is not, as one might perhaps assume, speculative or nostalgic in his perception of natural society. As Basil Willey commented a long time ago, the '"natural" condition of a thing, and so of man, is' for Shaftesbury 'not its "original" state, but rather that state in which it realizes most fully its inner intention, or individuating principle'.[2] As we will see, his vision of natural

[2] Willey, *The Eighteenth Century Background*, 69.

society is progressive and politically specific, rather than sentimental and utopian.³

Just like Addison, Shaftesbury explores a moral void caused by the ongoing process of the displacement of political authority. As Brewer observes, '[n]o British monarch was ever to match Charles I either as a patron of the arts or as the fabricator of such an astonishingly rich and complex representation of royal power'.⁴ Even though Charles II and James II struggled 'to re-create the monarchy of old and even to emulate the lavish embodiment of royal authority epitomized by Louis XIV's Versailles', they essentially 'failed to represent [the court] as a seat of heroic power'.⁵ Taste and moral impact were destined to follow a similar pattern. Along with financial deficiencies cultural capital began to trickle out. As Jeremy Black observes, by 'European standards, the British monarchs were not great patrons, in part because of the limited nature of royal revenues and the dependence on parliamentary financial support'.⁶ Thus, as far as arts were concerned, early-eighteenth-century court culture was, as we observed in Part One (see Chapter 1.2), attenuated and doomed to gradually become 'only one of many sources of patronage'.⁷ In a related fashion, 'church culture fell foul of religion' and at the dawn of the century it was clear that the church 'lacked the institutional presence enjoyed by Catholicism through much of Europe'.⁸ At this point new actors were destined to appear on the stage. Shaftesbury's optimistic view of Britain and freedom after the Revolution turns precisely around this courtly and ecclesiastical vacuum, and he makes the most of it to accentuate his view of taste.

However, while the nation is self-assuredly believed to be on the verge of becoming 'the Head and Chief of the EUROPEAN *League*' (*Soliloquy* 130 [222]), everything in the garden is not yet lovely. Shaftesbury is certainly not content

³ Ibid. Willey also remarks that 'Shaftesbury is no "primitivist," no dreamer of dreams about ages of gold' and that his 'naturalism is on the whole of the progressivist' kind.
⁴ Brewer, *The Pleasures of the Imagination*, 6.
⁵ Brewer, '"The Most Polite Age and the Most Vicious": Attitudes towards Culture as a Commodity, 1660–1800', 342.
⁶ Jeremy Black, *A Subject for Taste: Culture in Eighteenth-Century England* (London: Hambledon and London, 2005), 25.
⁷ Brewer, '"The Most Polite Age and the Most Vicious": Attitudes towards Culture as a Commodity, 1660–1800', 342. Brewer accentuates that '[s]ubsequent monarchs [to the Restoration court of Charles II and James II] and their courts were less licentious but also less successful in becoming centers of cultural power. Neither the Whig supporters of the Hanoverian regime nor its Tory and Jacobite opponents wanted a cult of monarchy focused on the new dynasty and its court. Between the late seventeenth century and the accession of George III the court shriveled in size and shrank in stature.'
⁸ Ibid., 343: 'In short, in the early eighteenth century culture was without a clearly determined site. Or, to shift the metaphor, there was a cultural vacuum. Culture failed to thrive as an artifact of state power, court intrigue, or religious instruction and understanding.'

with British poetry and culture, and he appears ambivalent especially about British Renaissance and seventeenth-century poets. He blames John Fletcher, Ben Jonson, Shakespeare, and Milton for continuing to use a style which has the Muses speak in 'wretched Pun and Quibble', and even blames 'a latter Race' of poets for seeking a 'false *Sublime*, with crouded *Simile*, and *mix'd Metaphor*' and thus gratifying the 'unpractis'd Ear; which has not as yet had leisure to form it-self, and become truly *musical*' (*Soliloquy* 122/124 [217]). However, Shaftesbury is, as we have seen, confident about the future. Hence, he also claims that the aforementioned poets are part of a general social progress and advancement of taste, and that they have provided Britain with the 'richest Oar' (*Soliloquy* 124 [217]). Due to them, it is, in the end, less trying for forthcoming British poets to 'find out the true *Rhythmus*, and harmonious Numbers, which alone can satisfy a just Judgment, and *Muse-like* Apprehension' (*Soliloquy* 124 [218]). While his preference for the 'Days of ATTICK Elegance' (*Soliloquy* 144 [233]) certainly stands in contrast to this ambivalence, it is crucial to note that Shaftesbury recognizes that an instinctive disposition to taste is, via natural social affections, interwoven with the new domestic liberty evolving from a symmetry between civil liberty, court, and church.[9] Thus, while Shaftesbury certainly does not suggest that liberty and government straightforwardly beget taste, it is important to acknowledge that taste is, to him, not only reliant on a will to realize our natural disposition, but indeed interrelated with a successful set of political conditions in early-eighteenth-century Britain.[10]

While fleshing out his take on Aurelian *sensus communis* (and its affinity with natural affections), where a '*gross* sort of *Raillery*' is contested by liberty ('Freedom of Conversation') (*Sensus Communis* 20/22 [63]), Shaftesbury unsurprisingly also underlines that a 'PUBLICK Spirit can come only from a social Feeling or *Sense of Partnership* with Human Kind' (*Sensus Communis* 72 [106]). Perfectly balanced natural affections are a sort of admission ticket to an equivalent society that incorporates, for self-evident reasons, a thriving public domain. Consequently, the moral chasm is once again confirmed between natural society and political absolutism. Shaftesbury concludes – referring to absolute monarchs and by implication to the Stuart Pretender – that ethics always is at the heart of a proper government, and that 'There is no real Love

[9] In a letter (29 November 1706) to his friend Teresias, Shaftesbury takes pleasure in how 'we are happily contrould by the Nature of our mix'd Government' (TNA, PRO 30/24/22/4, fol. 358ʳ).

[10] See also Douglas J. Den Uyl, 'Shaftesbury and the Modern Problem of Virtue', *Social Philosophy and Policy* 15, no. 1 (1998), 310: 'It is important to understand that liberty does not bring us to virtue, because that is something only the individual can do for him- or herself. Liberty does, however, set in motion forces that shape conditions ideal for the *pursuit* of virtue.'

of Virtue, without the Knowledg of *Public Good*. And where Absolute Power is, there is no PUBLICK' (*Sensus Communis* 72 [106/107]). A community and a public integrated by a forced and unnatural power, argues Shaftesbury in the apparatus criticus to *Miscellaneous Reflections*, are 'not properly united: Nor does such a Body make *a People*' (*Printed Notes* 174 [143]). The only effect of 'Absolute Power' is that it 'annuls *the Publick*: And where there is no *Publick*, or *Constitution*, there is in reality no *Mother*-COUNTRY, or NATION' (*Printed Notes* 174 [143]).[11]

Thus, in a similar vein to Addison, Shaftesbury regards a natural British society to be relentlessly hampered by the danger of French universal monarchy (*Soliloquy* 122 [217]). But the threat is paralysing neither Addison nor Shaftesbury. The events of 1688–9, and the political removal of the threat of Catholicism represented by James II, are faced with extraordinary confidence. In *Sensus Communis* Shaftesbury voices this confidence when claiming that 'BRITONS' now have a 'Notion of A PUBLICK, and A CONSTITUTION; how *a Legislative*, and how *an Executive* is model'd' (*Sensus Communis* 74 [108]). Britain is, as he confidently observes in *Soliloquy*, a 'happy Nation' where real 'LIBERTY is once again in its Ascendant' (*Soliloquy* 130 [222]).[12]

The emergence of such a national liberty is intertwined with the fact that Shaftesbury believes that a proper self-reflecting praxis can be carried out at this historical moment with an entirely new intensity. As he observes in *A Letter Concerning Enthusiasm*, '[n]ever was there in our Nation a time known, when Folly and Extravagance of every kind were more sharply inspected, or more wittily ridicul'd' (*A Letter Concerning Enthusiasm* 316 [9]).[13] Notions of art, criticism, liberty, society, and taste are organically fused together. Just as *naturalness* prospers by a demanding process of sophistication, a 'legitimate and just TASTE can neither be begotten, made, conceiv'd or produc'd, without the antecedent *Labour* and *Pains* of CRITICISM' (*Miscellaneous* 202 [164]). Ultimately it is by rational criticism that our natural affections and dispositions can be completed.[14] As Karen Collis correctly notes, '[p]hilosophy was concerned

[11] In the apparatus criticus to *Miscellaneous Reflections* (see *Printed Notes* 174 [143]) Shaftesbury stresses that "'Tis the social Ligue, Confederacy, and mutual Consent, founded in some common Good or Interest, which joins the Members of a Community, and makes a People ONE'.
[12] In his private writings, where there was less need for a programmatic political agenda, Shaftesbury was more cautious; see e.g. his letter to Teresias, 29 November 1706 (TNA, PRO 30/24/22/4, fols 359ᵛ–358ᵛ [sic]).
[13] See also *Letter Concerning Design* (44 [398/399]).
[14] For the significance of the concept of criticism in Shaftesbury, see Schmidt-Haberkamp, *Die Kunst der Kritik*.

with the ethical life, and because criticism was foundational to philosophy, it contributed to the refinement of society and government.'[15]

The naturalness of trusting a regime or a political constitution assumes different shapes. Oppression of freedom, and the ideological blinders that follow in its footsteps, certainly exudes moral wickedness and impiety. As Shaftesbury argues in *Sensus Communis*, 'THEY who live under *a Tyranny*, and have learnt to admire its Power as Sacred and Divine' must have 'scarce a Notion of what is Good or Just, other than as mere *Will* and *Power* have determin'd' (*Sensus Communis* 72/74 [107]). Still, even at this point, the force of social affections remains obvious. We cling to moral and political powers for a spirit of community, and if there are only despotic social communities and authorities present, we nevertheless persist by a natural use of our imagination. Even in 'Eastern Countrys, and many barbarous Nations', the people's love for their prince reveals 'how natural an Affection there is towards Government and Order among Mankind' (*Sensus Communis* 74 [107/108]). Thus, if political regimes are depraved or if governance is lacking altogether, people will 'still *imagine* they have such a one; and, like new-born Creatures that have never seen their Dam, will fancy one for themselves' (*Sensus Communis* 74 [108]).

The fact that a '*publick Principle*' (*Sensus Communis* 74 [107]) may attract us emotionally to wrong kinds of political authorities is however not the key focus for Shaftesbury. It is the harmony of natural society and the potential of nature that he is concerned with. The aesthetic relevance of such a society appears in glaring light. Feelings of solidarity manifest themselves in a social harmony that reverberates with the beauty of the Deity. A society originating in such settings holds, according to Shaftesbury, a beauty, and allows an idea of beauty *as such* to present itself. As he remarks in the entry entitled 'Providence' in *Askêmata*,

> What is there in the World yt has more of Beauty, or yt gives ye Idea of the τὸ καλόν [beauty itself] more perfect & sensible, than ye View of an equal Commonwealth, or City, founded on good Laws? a well built Constitution, fenc'd agt exteriour & interiour Force. a Legislature & a Militia. a Senate propounding debateing councelling; a People resolving, electing; a Magistry executing & in rotation? (*Askêmata* 331)

[15] Karen Collis, '"The Advancement of all Antient and Polite Learning": Education and Criticism in *Characteristicks*', in *New Ages, New Opinions: Shaftesbury in His World and Today*, ed. Patrick Müller (Frankfurt am Main: Peter Lang, 2014), 225. Collis's main concern is a comparison between Shaftesbury's perception of learned culture and university education, and the ideas expressed by Meric Casaubon (1599–1671). However, in sketching out Shaftesbury's 'late humanist context' (238), Collis also provides a non-anachronistic account of Shaftesbury's wide-ranging understanding of the notion of criticism.

A striking indication that Shaftesbury believes that this kind of beauty is approaching appears in *Letter Concerning Design*. This letter was originally addressed to Lord Somers and planned as one part (in a collection of four treatises, containing, apart from *Letter Concerning Design*, *A Notion of the Historical Draught or Tablature of the Judgment of Hercules*, also *An Appendix Concerning the Emblem of Cebes*; and *Plasticks, or the Original, Progress, & Power of Designatory Art*) in the never-completed *Second Characters*. The writing in *Letter Concerning Design* is arguably one of Shaftesbury's most explicit attempts to show just how beauty and taste are intricately related to specific political conditions, and he 'focused', as Klein observes, 'on the new circumstances that would allow British genius to flower'.[16] The beauty of an auspicious civic concord and unity of a coordinated natural society is what Shaftesbury thinks can be advanced in post-revolutionary Britain, a society that is 'exert[ing] her-self so resolutely in behalf of the *common Cause*, and that of her own *Liberty*, and happy *Constitution*' (*Letter Concerning Design* 44 [398/399]). While natural affections, taste, and society are all part of nature, a removal of particularly disadvantageous political circumstances can emancipate our potential to reach perfection. Although political powers cannot eliminate natural human dispositions, they can, however, improve or worsen their prospects of completion. The conditions have, from Shaftesbury's perspective, not always been as favourable as they are this time. The Restoration period, 'The long Reign of Luxury and Pleasure under King CHARLES *the second*' (*Letter Concerning Design* 44 [399]), severely hampered the completion of the natural disposition into proper taste: it is simply 'not the Nature of a Court (such as Courts generally are) to improve, but rather corrupt *a Taste*' (*Letter Concerning Design* 50 [405]).[17] Taste forms an integral part of a larger political process, where different arts (here architecture, painting, and statuary) are 'in a manner link'd together', and the 'Taste of one Kind brings necessarily that of the Others along with it' (*Letter Concerning Design* 50 [404]). Thus, when the 'Spirit of the Nation was grown more *free*' in post-1688 Britain,

[16] Klein, *Shaftesbury and the Culture of Politeness*, 210.
[17] See also the apparatus criticus to *Soliloquy* (*Printed Notes* esp. 62/64 [341]). Here, Shaftesbury refers to Pliny's account of painting/painters in *Natural History* (vol. 9, 25.37–40): 'One of the mortal Symptoms by which PLINY pronounces the sure Death of this noble Art ... was what belong'd in common to all the other perishing Arts after the Fall of Liberty, I mean *the Luxury* of the ROMAN Court, and the Change of *Taste* and *Manners* naturally consequent to such a Change of Government and Dominion.' A connecting thought that runs through Shaftesbury's perception of the relation between sumptuous court cultures and vulgar taste is encapsulated here in his remarks about statues and architecture: 'Precious Rock, rich Metal, glittering Stones, and other luscious Ornaments, poisonous to Art, came every day more into request, and were impos'd on the best Masters. And in respect of these Court-Beautys and gaudy Appearances, good Drawing, just Design, and Truth of Work began to be despis'd.'

the public also 'rais'd [itself] an *Ear*, and *Judgment* not inferiour to the best now in the World' (*Letter Concerning Design* 44 [399]).[18] Here, then, it is the politically dynamic liaison between Britain's 'national Constitution, and legal Monarchy', its '*free* Spirit', and refined judgements that not only 'hold[s] together so mighty a People', but also ensures that 'a right Taste prevails' (*Letter Concerning Design* 50 [404]). In his letter to Lord Somers, Shaftesbury perceives in a 'kind of Spirit of Prophecy' the

> rising Genius of our Nation; That if we live to see a Peace any way answerable to that generous Spirit with which this Warr was begun, and carry'd on, for our *own* Liberty and that of EUROPE; the Figure which we are like to make abroad, and the Increase of Knowledge, Industry and Sense at home, will make *united* BRITAIN the principal Seat of Arts. (*Letter Concerning Design* 44 [398])

The balanced natural social affections and a realized innate disposition are evidently expected to coincide with the natural harmony of society: '[T]he Admiration and Love of Order, Harmony and Proportion, in whatever kind, is naturally improving to the Temper, advantageous to social Affection, and highly assistant to *Virtue*; which is it-self no other than the Love of Order and Beauty in Society' (*Inquiry* 140 [75]). Affections and social conditions are ultimately indissoluble. While certain corrupt political principles (typical of Toryism, High Church Anglicanism, or Bourbon power) sometimes catch the attention of our emotions, Shaftesbury is, as we have already observed, rarely troubled with exceptional cases, at least not acutely so. Indeed, in his letter to Lord Somers, Shaftesbury even stresses that there is a naturalness of 'national Taste' (*Letter Concerning Design* 46 [402]), which he then associates with social harmony (opposed to the disorder accompanying Gothicism).[19]

If self-knowledge and the purged self are indicative of perfectly balanced natural affections, the '*Corruption of* TASTE' (*Miscellaneous* 212 [172]) occurs precisely when individuals fail to recall their true self, 'chang[ing] their honest

[18] Here Shaftesbury specifically addresses music, but he carries on with similar claims about other art forms. See e.g. his remarks about painting (*Letter Concerning Design* 44/46 [399/400]), where he argues that 'Tho' we have as yet nothing of our own native Growth in this kind worthy being mentioned; yet since the Publick has of late begun to express a Relish for Engravings, Drawings, Coppyings, and for the original Paintings of the chief *Italian* Schools' Britain will soon 'make an equal progress in this other Science'. And when one has started to 'cultivate these designing Arts', Shaftesbury is convinced that 'our Genius ... will naturally carry Us over the slighter Amusements, and lead Us to that higher, more seriouse, and noble Part of *Imitation*, which relates to *History*, *Human Nature*, and *the chief Degree or Order of* BEAUTY'.
[19] Gothicism is an umbrella term which, in Shaftesbury, covers all sorts of evils such as social discord, Hobbes's perception of human nature, or the papacy. See e.g. *Sensus Communis* (54 [88/89]) and *Soliloquy* (128 [221/222]). See also Richard Woodfield, 'The Freedom of Shaftesbury's Classicism', *British Journal of Aesthetics* 15, no. 3 (1975).

Measures, and sacrific[ing] their *Cause* and *Friends* to an *imaginary private Interest*' (*Miscellaneous* 208 [169]). When Shaftesbury introduces 'a noted PATRIOT, and reputed *Pillar* of the religious Part of our Constitution' (that is, a Tory partisan), and a 'noted Friend to LIBERTY in *Church* and *State*' (that is, a Whig partisan), in this context, he certainly thinks that the former runs the greater risk of falling into this trap (though both of them run a risk of being corrupted by their lengthy public service).[20] Although Shaftesbury is, as we have observed, addressing a rather clearly defined readership of gentlemen, his political concerns are of course far-reaching. As the monarchy gradually began to lose privileges and status in the sequel to the events of 1688–9, political forces and various self-interests struggled to secure the settlement 'from the possibility of a more thorough-going revolution and from Jacobite attempts to restore the old Stuart order'.[21] The liberties that had recently been gained were still hanging by a thread.[22] Safeguarding against future political disorders and upholding the achieved Whig impact over culture at large were prioritized matters. While the '*natural* Affection of all Mankind towards moral Beauty and Perfection' always postulates that we 'have something estimable and worthy in respect of others of [our] Kind; and that [our] *genuine, true*, and *natural* SELF, is, as it ought to be, of real value in Society' (*Soliloquy* 198 [280]), this is precisely what the advocates of extreme self-interest neglect. They reveal a forgetfulness of nature. Instead of pursuing their true interests, they depend on precisely such ephemeral '*outward* Subjects' (*Miscellaneous* 240 [198]) that ought to be rejected. Echoing Theocles' discussion of pursuing real beauty, where the benefits of self-knowledge – 'To know *Ourselves*, and what *That* is' – are naturally the same as 'to advance our Worth, and real Self-Interest' (*Moralists* 362 [427]), such interest (which is compatible with the social nature of man) is now swapped for an excessive private interest. The '*interestedneß*' of self-affections is, if we apply Shaftesbury's line of reasoning from the *Inquiry* (see 242/244 [139/140]), too intense, while natural affections are reduced, and accordingly the champions of excessive self-interest fail to display natural taste.[23] The unbalanced, callous, and self-absorbed affections feed on the natural affections. In a downward spiral, the

[20] See *Miscellaneous Reflections* (208 [170]): "'TIS not in *one* Party alone that these *Purchases* and *Sales* of HONOUR are carry'd on."
[21] Ayres, *Classical Culture and the Idea of Rome in Eighteenth-Century England*, xiv.
[22] See e.g. *Soliloquy* (122 [216]). When addressing the events of 1688–9, Shaftesbury refers to 'our hitherto precarious Libertys'.
[23] Shaftesbury refers (*Inquiry* 242/244 [139/140]) to 'Home-Affections, which relate to the private Interest or separate Oeconomy of the Creature'. Such affections 'relate to the private System, and constitute whatever we call *Interestedneß* or *Self-Love*'.

true benevolent interest of the agent simply loses its natural focus on society and fellow citizens, and instead pursues a vulgar self-interest and further suspicions of others:

> A *separate End* and *Interest* must be every day more strongly form'd in us: *Generous Views* and *Motives* laid aside: And the more we are thus sensibly disjoin'd every day from Society and our Fellows; the worse Opinion we shall have of those uniting Passions which bind us in strict Alliance and Amity with others. (*Inquiry* 290/292 [162])

Now, if the harmony of our affections and the very realization of our disposition for natural taste are constantly claimed by Shaftesbury himself to disclose important social qualities, what is the real significance of these qualities for current aesthetics? As should be evident by now, common contemporary accounts, where Shaftesbury's *Characteristicks* and Addison's *Pleasures of the Imagination* are confidently fixed as the 'foundational texts of eighteenth-century aesthetics',[24] are greatly concerned with similarities and differences with subsequent perceptions of taste, rather than with sprawling time-bound properties. Historical temporality is a delicate subject for mainstream aesthetics principally because it calls for an academic culture and ideals of education that are not present anymore. Any kind of professionalization of knowledge demands a proper set of definitions of what kind of knowledge is being pursued, and what kind is not. The problem is that British eighteenth-century aesthetics might not be as *modern* as we want to think, and accordingly it might fit our contemporary definitions and expectations somewhat poorly.

While Raymond Laurence Brett argues, in his famous mid-twentieth-century study of Shaftesbury's aesthetics, that the Earl moves forward the idea of a 'special sense which can be identified with taste' (i.e., a faculty of aesthetic judgement),[25] Kivy has briefly challenged such a claim, pointing out that Shaftesbury 'nowhere refers to taste in art as a "sense" or "faculty"' and underlining that we are far afield from a 'full-fledged aesthetic faculty'.[26] I find these two contrasting views illustrative of how aesthetics sometimes goes astray in addressing a historically delicate matter such as eighteenth-century theories of taste (irrespective of the fact that Kivy is right in his remark). One significant reason for the disorientation is that Shaftesbury's position in the history of aesthetics primarily is taken to be relative to arguments about the putative autonomy of this faculty of aesthetic

[24] Gigante, *Taste: A Literary History*, 48–9.
[25] Brett, *The Third Earl of Shaftesbury*, 151.
[26] Kivy, *The Seventh Sense*, 20.

judgement. Examinations and discourses concerned with the idea that taste is an autonomous faculty of aesthetic judgement, which may or may not be consistent with subsequent notions, are naturally liable to dispense with specific temporal references of the concept itself. Typically, then, Kivy is somewhat quiet about what Shaftesbury, in fact, implied by his post-revolutionary idea of taste. If we are to follow the diachronic narrative provided by Kivy, Shaftesbury is a 'transitional figure in the history of aesthetics', on the one hand, observing the 'Enlightenment quest for a *subjective* critical standard' of taste and, on the other, submitting to the 'Renaissance tradition of objectivity and reason in art'.[27]

Reminiscent of the recent debate about the legacy of Kristeller's account, a concern for the origin of the diachronic narrative is naturally tangential to questions about the identity of modern aesthetics. But to enhance our knowledge of how Shaftesbury relates to the past as well as to the future, we need to begin to incorporate (to a greater degree than we previously have) the complex synchronic context which formed the basis for his notion of taste. An instinctive bias towards the beauty of nature and art may indeed be common to all human beings, but, as we have seen throughout this book, it does not produce a shared judgement because taste as such is not congenital. Shaftesbury unites the realization of our human disposition to certain emotions and self-knowledge, and consequently to a systematic refinement of the instinct. Now, although beauty is not depending on a set of political circumstances, or on the agent's actual taste, the refinement of the instinct is indeed subjected to the specific temporal political conditions of society itself.[28] Hence, we are left with a challenging question: which political conditions were ultimately regarded as prerequisite for instinctively appreciating beauty? To take such temporal historical conditions into account is challenging precisely because it invites us to expand the present identity of aesthetics.

It is natural for philosophers with a special interest in the eighteenth century to waver when approaching this question. A scholar like Kivy recognizes that taste must be produced, and that the question concerning which aesthetic standards should inform our judgements must lead to a predictable answer: 'reason is the judge, harmony the law.'[29] Yet, because the massive historical project that unfolds when natural human dispositions to experience beauty are related to the political contexts of early-eighteenth-century Britain, it turns out that such an

[27] Ibid.
[28] For a comment on Shaftesbury's realism, see Glauser, 'Aesthetic Experience in Shaftesbury', 28: 'Beauty is a real form of things in a quasi-Aristotelian sense of "form": it is a natural feature depending neither on social convention nor on individual taste.'
[29] Kivy, *The Seventh Sense*, 22.

explanation is really begging the question. Richard Glauser ends up in a similar impasse: he correctly maintains that 'it is wrong to claim, as is often done, that aesthetic experience is *always* an immediate response in Shaftesbury', arguing instead that 'the whole approach to beauty leans on the hopeful promise of important progress in scientific, psychological and moral knowledge'.[30] Indeed, as we have observed, the pressure on the agent to realize his natural disposition is extensive and arduous. But the list of personal responsibilities and wanted moral improvements must also be regarded within a comprehensive political progress, because that was precisely what Shaftesbury did. However, to complete that line of thought, to address such an assumed progress in detail, is challenging because it forces us to enter unfamiliar scholarly terrain, with provoking (sociological) questions about whether taste might be reduced to a human reflex determined by a set of social conditions. Any categorical answer to such a question is, of course, likely to misinterpret the notion of taste. Primarily concerned with *Second Characters*, Isabella Woldt captures the very essence of Shaftesbury's line of reasoning: 'The inclination to shape a civil government as a foundation for a free society is based on a natural feeling, and if a desire or feeling is natural, then a sense of community is too.'[31] Shaftesbury wishes to elucidate a complex cyclical course of civilization: both the realization of natural dispositions and the status of our emotions are relative to the harmony within polite society. While the political circumstances during the Restoration era were inconsistent with civil liberty, rational criticism, balanced affections, and ultimately taste itself, this begins to change, or so Shaftesbury thought, in post-revolutionary Britain. Here, Shaftesbury draws an analogy to Athenian society in which the enhancement of a polite taste was also a 'real Reform of *Taste* and *Humour* in the Commonwealth or Government it-self', going hand in hand with 'an Increase of *Liberty*' (*Soliloquy* 162 [250]). Shaftesbury thus claims that proper taste is inseparable from the harmonious order of polite societies. Natural affections can only flourish extensively under the propitious, liberal (Whig) social conditions outlined by Shaftesbury, and these are the proper circumstances that the natural disposition requires in order to be transformed into an enduring, decorous taste. At the same time, it is the natural affections themselves that shape these social

[30] Glauser, 'Aesthetic Experience in Shaftesbury', 45, 35.
[31] My translation of Isabella Woldt, *Architektonik der Formen in Shaftesburys 'Second Characters': Über soziale Neigung des Menschen, Kunstproduktion und Kunstwahrnehmung* (Munich: Deutscher Kunstverlag, 2004), 59: 'Die Neigung zur Gestaltung einer bürgerlichen Regierung als Basis einer freien Gesellschaft beruht auf einem natürlichen Empfinden, und wenn ein Verlangen oder Gefühl natürlich ist, so ist es ebenso ein Gemeinschaftsgefühl.'

conditions: taste is ultimately both a formative force of polite society, and a cause of the very same.

Throughout his writings, Shaftesbury remains attentive to the fact that we should allow our natural affections to rely on a relation to small communities and concrete conditions to make sense of our position within larger regional, national, or continental communities. In line with his cosmological perception of the organic relation between private micro-systems and universal macro-systems, he recognizes that a totality needs to be subdivided into smaller civil and political spheres in order to be comprehensible. The 'UNIVERSAL Good, or the Interest of *the World in general*' is 'a kind of remote Philosophical Object' (*Sensus Communis* 80 [111]). In fact, it is too remote an object to be embarked upon straight off, since a '*greater Community* falls not easily under the Eye. Nor is a National interest, or that of a whole People, or Body Politick, so readily apprehended' (*Sensus Communis* 80 [111]). It is then within the parameters of smaller communities (ultimately composed of the affections of the self) that we begin to recognize the true affective value of our own natural and political participation in society and history as a whole. As Shaftesbury notes to himself in *Askêmata*: '*How goes the World*? — No matter. but *how go I*? This is a Matter, & ye only matter. This is of Concern. This *Mine*, and at my perill — *How do I govern the World*? — No. But *how do I govern MY SELF*?' (*Askêmata* 360). Although it is natural and consistent for Shaftesbury to advance this line of thought, he remains sensitive to a holistic perception where the interdependence of small civil entities allows for the rational and beautiful whole to reveal itself. Here it is, as we have observed, vital to recognize that, for Shaftesbury, a post-revolutionary body politic offered a particularly fertile ground for the realized disposition for taste. Not because the events of 1688–9 simply transferred some of the political control from the executive to Parliament and consequently fulfilled a Whig wish,[32] but because Shaftesbury truly thought that he beheld the cyclical nature of time and history, where Britain was on the verge of sharing a real point of contact with the ancient era. I have no intention here to give my support to any outdated separation between classical cyclical conceptions of time and eschatological, linear ones. Nowadays, 'scholars have moved away from this simple typology,'[33] and I am confident that a systematic study of Shaftesbury's

[32] Julian Hoppit rightly highlights this in *A Land of Liberty? England 1689–1727* (Oxford: Oxford University Press, 2000), 23–7.
[33] Marc Brettler, 'Cyclical and Teleological Time in the Hebrew Bible', in *Time and Temporality in the Ancient World*, ed. Ralph M. Rosen (Philadelphia: University of Pennsylvania Museum of Archaeology and Anthropology, 2004), 111.

view of time and temporality would confirm that it is dialectically shaped by both a (classical) view, where a 'human social and political world were believed to recur in cycles', and Jewish and Christian ideas of a teleological history and a rectilinear vision of time.[34] But in order to conclude this book's particular focus on taste, we need to pay specific attention to Shaftesbury's view of cyclical time and history.

During his first retreat in Rotterdam, at the end of the seventeenth century, Shaftesbury deepens his thoughts about the circularity and vicissitudes of history and the risk of a subjective purposelessness emerging from witnessing a reiteration of a seemingly unpredictable past.[35] Superstition, conflicts, Goths, philistinism, and vulgar nations and societies are in time destined to be replaced by polite societies, distinguished by art, science, and taste – polite societies which are then replaced, in a perpetual vicissitude, by a new period of political disorder, darkness, and vulgarity. Shaftesbury's understanding of the circularity of history is, as Müller briefly notes, marked by the fact that 'after the War of the Spanish Succession, Britain would either overcome its Catholic and absolutist past once and for all or it would descend into darkness again'.[36] The flux of the world is, for Shaftesbury, an inescapable '*Chorus*' (*Askêmata* 157), and history consists of prosperous and perishing societies by turns: 'whenever it seems that great things are in hand; remember to call this to mind: that all is but of a Moment: all must again decline' (*Askêmata* 145).[37] History advances in an organic dialectic between progression and regression. Cultivated societies, successful works of art, and natural taste are, as he writes in his notebook in 1698, all destined to thrive and perish by turns:

> Consider the severall Ages of Mankind; the Revolutions of the World; the Rise, Declension, & Extinction of Nations, one after another; after what manner the Earth is peopled; sometimes in one part, & then in another: first, desert; then cultivated; & then desert again. from Woods, & Wilderness; to Cityes & Culture: and from Cityes, & Culture; again into Woods. one while Barbarouse;

[34] Gerald A. Press, *The Development of the Idea of History in Antiquity* (Montreal: McGill-Queen's University Press, 1982), 7. Press examines and criticizes generally accepted differences between Graeco-Roman conceptions of society and history as essentially circular, and Judaeo-Christian ideas about time and history as linear (see esp. 3–22).

[35] About Shaftesbury's cyclic theory of history, see also Voitle, *The Third Earl of Shaftesbury 1671–1713*, e.g. 143 and 334–5. Voitle's comments on this matter are very brief and general, and few other scholars have paid sufficient attention to Shaftesbury's perception of the circularity of history and the notion of *Chorus*.

[36] Müller, 'Hobbes, Locke and the Consequences: Shaftesbury's Moral Sense and Political Agitation in Early Eighteenth-Century England', 326.

[37] See *Askêmata*, 157.

then Civiliz'd; and then Barbarouse again. after Darkness, & Ignorance; Arts & Sciences: and then again Darkness & Ignorance as before. (*Askêmata* 145)

Human memory is, for Shaftesbury, too short to absorb all the lessons from ancient philosophical wisdom. Indeed, reading philosophy is to evoke the melancholic remembrance that 'All was Darkness but a while since. Now, there is a little Glimmering of Light. and whether this proceed or no; in a little while all will be again Dark' (*Askêmata* 152). On the subject level this implies that existential avarice, distressful and unrestful minds, will eventually be replaced by moral agents aiming towards the common good of society, conducing towards the whole, and recognizing the value of natural affections, sociability, and rationality. There will thus be openings in the *Chorus* for the natural disposition to be realized and taste to be accomplished. However, an obvious risk of acknowledging the infinite vicissitude of history is of course that it might be taken to justify the withdrawal of personal moral responsibility. As Shaftesbury himself asks in his notes, 'how, in the midst of all this, to preserve a Sound & Steady Mind, a Just & Right Affection; how to have a Uniform & suitable Will' (*Askêmata* 149). We should, as it seems, expect much of the self, while systematically rejecting and resisting any kind of existential naivety that threatens to arise from perceiving a world in endless flux. The vicissitude of the world does not deprive the agent of a moral responsibility. Just as a moderate selfishness and natural self-interest involve a care for the self that is valuable for general polite society, the responsibility of the self and its natural affections must always be directed towards the rational nature and the whole. It is the interest of the whole that governs the world, and Shaftesbury invites man to take great comfort in committing himself to the fact that the 'Mind & Reason of the Universe can act nothing against Itself' (*Askêmata* 154).[38] There is thus a great reassurance for those who accept the inaccessible principles that oversee the whole and for those who recognize that it is by care of the affections that the agent does justice to himself: 'See, therefore, that thy Affection be but right; and *all* is right' (*Askêmata* 165).

What is valuable for the whole is at all times what is valuable for the agent, because 'What I know & am assur'd of, is, that if it be best for the Whole, it is what should have been, & is perfect, just, good' (*Askêmata* 154). The fact that history

[38] See also *Askêmata*, e.g. 111: 'If there be an Order & Economy for the Good of ye Whole; then nothing can happen to me from that Economy, wch provided for me in particular the best yt was possible, & had respect to my Good. If I am convinc'd of this; I must naturally love w'ever happens to me from that Economy.'

is a flux does not challenge the natural constancy of the whole. Once again, it is by a careful self-examination and self-knowledge – 'see what thy part is: and remember the Præcept given' (*Askêmata* 155) – that we become convinced of the natural end and give 'applause to wt God has for the best decreed. for, to will agt that wch is best, and to will wt is impossible, what else were this but to be Wicked & Miserable' (*Askêmata* 156). To accept the flux of the world is, as Shaftesbury argues in *Soliloquy*, to allow for a natural constancy, since the failure to recognize the whole is destined to merely result in a culturally subjective and narrow-minded self-comprehension. The discerning acceptance of the wide-ranging and natural progress and regress of time and history is ultimately a true mark of a '*Naturalist* or *Humanist*, who knows the Creature MAN, and judges of his Growth and Improvement in Society', while the psychological block of the so called '*Criticks by Fashion*' entraps them in the momentary standards of the present age (*Soliloquy* 188 [272]):

> THEY who have no Help from Learning to observe the wider Periods or Revolutions of Human Kind, the Alterations which happen in Manners, and the Flux and Reflux of Politeness, Wit, and Art; are apt at every turn to make the present Age their Standard, and Imagine nothing barbarous or savage, but what is contrary to the Manners of their own Time. (*Soliloquy* 188 [271/272])

The acceptance of the flux and reflux of the world involves the recognition that taste itself is perpetual. Regardless of the fact that the prospects of realizing the natural disposition for taste might differ from individual to individual – in the *Inquiry*, Shaftesbury compares 'the more perfect with the imperfect Natures' (238 [136]) – our affections, as we have observed, undoubtedly presuppose a certain cognitive order.[39] It is, as Shaftesbury states, 'our own *Thought* that must restrain our Thinking' (*Miscellaneous* 350 [299]). For instance, the corollary of an unrestrained reign of fancy is, according to Shaftesbury, ultimately a dangerous relativism of taste. We are not expected to ascribe the pleasures of the mind to shifting and conceited external matters, but rather to keep such pleasures safely within the mind itself by referring to the absolute standard of morals as well as taste. As we have observed, virtue should be determined by what Shaftesbury refers to as 'real Satisfaction', and rather than depending on ephemeral and vulgar matters, such as wealth or fame, we should place worth 'where it is truest, in *the Affections* or *Sentiments*, in the *governing Part* and *inward Character*' and accordingly 'have then the full Enjoyment of it within our power' (*Miscellaneous*

[39] See Glauser, 'Aesthetic Experience in Shaftesbury', 37.

240 [198]). In conjunction with the moral realism which is most thoroughly advanced in *The Moralists*, this is how Shaftesbury evolves an aesthetic realism originating from the perceived fact that 'in the very nature of Things there must of necessity be the Foundation of a wrong and a right TASTE' (*Soliloquy* 268 [336]). Given the danger that 'if FANCY be left Judg of any thing, she must be Judg of all', Shaftesbury believes that 'some *Controuler* or *Manager*' (*Soliloquy* 252 [322]) is needed to allow access to this absolute standard of taste and thus to avoid relativism. The cognitive order of the mind requires that 'FANCY and I are not *all one*' and that it is the very 'Disagreement [that] makes me *my own*' (*Soliloquy* 256 [325]). Therefore, the general task of the 'known Province of Philosophy' (*Soliloquy* 202 [283]) is to evolve the prospect of a symmetry of the affections, and to allow reason and judgement to guide fancy.[40] When such symmetry is achieved, the agent will then naturally accept the flux of the world and turn his back on a narrow-minded understanding of history.

Thus, we should recognize the imperative role ascribed to philosophy for the agent's ultimate acceptance and appreciation of the natural constancy in the flux of the world. Since the critical objective of philosophy revolves around the agent's self-examination and the coordinated natural affections that allow him to interact naturally with society and fellow citizens, a crucial part of philosophy must also be able to address the fundamental matters that govern such a critical objective, rather than being caught up in detailed theoretical expert knowledge. In a malicious remark in *Soliloquy*, Shaftesbury questions the advantage of a Lockean philosophy that explains what ideas the agent can form about space, as well as the usefulness of the '*Atomist*, or *Epicurean*, pleading for a *Vacuum*', and the '*Plenitudinarian*' (i.e. Descartes), who 'brings his *Fluid* in play, and joins the Idea of *Body* and *Extension*' (*Soliloquy* 224 [301]). Such a notional philosophy is, for Shaftesbury, too closely connected with a failure to accept and appreciate the constancy of the flux of the world. Instead of addressing the appropriate practical objective – 'What Judgment am I to make of Mankind and human Affairs? What Sentiments am I to frame? What Opinions? What Maxims?' (*Soliloquy* 224 [301]) – the notional philosophy advanced by Epicureans, Locke, Descartes, and others appears to create precisely the lack of self-confidence that ultimately must end in a failure to recognize the wide-ranging historical perspective that allows the agent to appreciate the natural *Chorus* of the changing world:

[40] For the intellectual history of the term 'fancy' and its grounding in the thought of Epictetus, see Patrick Müller, 'Shaftesbury on the Psychoanalyst's Couch: A Historicist Perspective on Gender and (Homo)Sexuality in *Characteristicks* and the Earl's Private Writings', *Swift Studies* 25 (2010), 71–2, 75.

> TO *day* things have succeeded well with me; consequently my Ideas are rais'd: "'Tis a fine World! All is glorious! Every thing delightful and entertaining! Mankind, Conversation, Company, Society; What can be more desirable!' *To morrow* comes Disappointment, Crosses, Disgrace. And what follows? 'O miserable Mankind! Wretched State! Who wou'd live out of Solitude? Who Wou'd write or act for such a World?' Philosopher! where are thy *Ideas*? Where is *Truth, Certainty, Evidence*, so much talk'd of? 'Tis here surely they are to be maintain'd, if any where. (*Soliloquy* 222 [300])

While the *Chorus* of history repeats itself, Shaftesbury nevertheless finds, as we have seen, reason to be confident about his own age and his own country. Despite criticizing British art, Shaftesbury draws heavily on the idea that Britain in a circular movement relates to a glorious classical history and that the nation is on the verge of a new critical age after the Revolution, an age which due to a prospering liberty and national superiority might allow Britain to establish a paragon of ethics, arts, and taste. He associates future Britain with an original ancient Greek culture where '*Musick, Poetry*, and the rest came to receive some kind of shape, and be distinguish'd into their several Orders and Degrees' (*Miscellaneous* 168 [138]). One such point of departure is the claim in *Soliloquy*, that Britain is about to reap the harvest of a ferocious past in which national liberty was secured: 'we are still at this moment expending both our Blood and Treasure, to secure to our-selves this inestimable Purchase of our *Free Government* and *National Constitution*' (*Soliloquy* 122 [216]). Although the war enemy, Catholic France, threatened Europe, and the 'BRITISH MUSES, in this Dinn of Arms, may well lie abject and obscure; especially being as yet in their mere Infant-State' (*Soliloquy* 122 [216/217]), the prospect for British art remains optimistic. The 'natural Genius [of Britain] shines above that airy neighbouring Nation [France]', and the advantage stems, according to Shaftesbury, from the consequences which 'establish'd Liberty will produce in every thing that relates to *Art*; when *Peace* returns to us on these happy Conditions' (*Soliloquy* 124/126 [218/219]). Part of his readiness to identify the vicissitudes of history, where the echoes of classical antiquity reverberate in current British culture, is, just as we observed of Addison in Part One, structured by Shaftesbury's rhetorical isolation of a provincial distinctiveness in relation to Europe. In particular, the establishment of a provincial contrast to a set of unwanted properties abets the distinguishing of a contextual relation to a pivotal historical past. Accordingly, it comes as no surprise when Shaftesbury resorts to the device of associating the rivalry between Greek city states and the Persian Empire with the antagonism between a Protestant Britain and a Catholic France, and points out the exclusive

position of the former: like 'antient GREECE', Britain 'shou'd for succeeding Ages be contending with a foreign Power, and endeavouring to reduce the Exorbitancy of a *Grand Monarch*' (*Soliloquy* 130 [222/223]). From this, it then follows that 'those *Arts* have been deliver'd to us in such Perfection, by *Free Nations*; who from the Nature of their Government, as from a proper Soil, produc'd the generous Plants' (*Soliloquy* 152 [239]), ancient Greece being, of course, 'that sole polite, most civiliz'd, and learned of all Nations' (*Miscellaneous* 168 [138]). Roman civilization had 'scarce an intermediate Age, or single Period of Time, between the Rise of Arts and Fall of Liberty' (*Soliloquy* 126 [219]). Liberty and art are forever entwined and, according to Shaftesbury, 'No sooner had that Nation begun to lose the Roughness and Barbarity of their Manners, and learn of GREECE to form their *Heroes*, their *Orators* and *Poets* on a right Model, than by their unjust Attempt upon the Liberty of the World, they justly lost their own' (*Soliloquy* 126 [219]).

Greek classicism is the natural epitome of Shaftesbury's vision of polite society, and in order to identify the present and the future values of British society and arts, Shaftesbury falls back on the history of classical Greek art. Winckelmann's famous belief that proper taste had its origins under the Grecian sky[41] would have befitted Shaftesbury's conviction that ancient Greek culture was truly '*Original* in Art' and its poetry '*self-form'd*, wrought out of Nature, and drawn from the necessary Operation and Course of things, working, as it were, of their own accord, and proper inclination' (*Miscellaneous* 170 [139/140]). What emerged in ancient Greece was then a '*natural* Growth of Arts' (*Miscellaneous* 172 [140]). Strongly 'animated by that social, publick and *free* Spirit', the Greeks pursued an ideal language, which stimulated other arts (*Miscellaneous* 170 [138]). In an initial historical phase of language, the '*Lofty*, the *Sublime*, the *Astonishing* and *Amazing* wou'd be the most in fashion' (*Miscellaneous* 172 [140]). Even in the 'Commonwealth it-self, and in the Affairs of Government', the '*High-Poetick* and the *Figurative* Way began to prevail', according to Shaftesbury (*Miscellaneous* 172 [140]). But as the '*Taste* of GREECE was … polishing', a 'better Judgment was soon form'd', and 'in all the principal Works of *Ingenuity* and *Art*, SIMPLICITY and NATURE began chiefly to be sought', a taste was firmly established 'which lasted thro so many Ages, till the Ruin of all things, under a Universal Monarchy [i.e. the reign of Alexander III of Macedonia (356–323 BC)]' (*Miscellaneous* 172

[41] Winckelmann, *Gedanken über die Nachahmung der griechischen Werke in der Malerei und Bildhauerkunst*, 1: 'Der gute Geschmack, welcher sich mehr und mehr durch die Welt ausbreitet, hat sich angefangen zuerst unter dem griechischen Himmel zu bilden.'

[140/141]. A nexus between this ancient progress and the conditions in Britain is suggested by Shaftesbury himself: 'If the Reader shou'd peradventure be led by his Curiosity to seek some kind of Comparison between this antient *Growth* of TASTE, and that which we have experienc'd in modern days, and within our own Nation; he may look back to the *Speeches* of our Ancestors in Parliament' (*Miscellaneous* 172 [141]). As Klein points out, Shaftesbury was, on the one hand, 'arguing for British cultural superiority on the basis of British genius and British politics' and thought that the 'British had already begun to imitate ancient Hellenic experience'; on the other hand, he 'recognized the deficiencies of British culture'.[42] While Shaftesbury remains ambivalent over the current state of art and taste, he is clear about the chain of progress, in which Britain might, at this particular moment in time, realize its unique historical potential. Britain is enjoying a new sense of freedom and, given the new sense of self-determination, the nation is also able to set the standard for the European continent, and 'by our Greatness and Power give Life and Vigour to it abroad; and [be] the Head and Chief of the EUROPEAN *League*, founded on this *common Cause*' (*Soliloquy* 130 [222]).

[42] Klein, *Shaftesbury and the Culture of Politeness*, 208–9.

Coda: Reading Addison and Shaftesbury in the future

The modern conspectus of the humanities is not particularly well suited to the major question addressed by this book: should we read eighteenth-century thinkers as our contemporaries, that is, as contributing to contemporary philosophical problems in aesthetics, or, alternatively, should we simply read these thinkers and their texts in their own terms without regard to their fit within modern concerns? In this book I have given priority to a miscellany of seventeenth- and eighteenth-century British texts and let them define my investigation. An account drawing on such a historical method is destined to occasionally consider seemingly obsolete ethico-theological and political claims about nature and art, but to avoid such a method would be a mistake. Aesthetics and art benefit from being defined both historically and contemporaneously. It is precisely in the friction between these asymmetric ways of thinking about nature and art that we can carve out a balanced knowledge of the past. The aim of this book – the past, and the (ir)relevance of the past, is inevitably tackled from a particular standpoint, distinguished by some kind of *purpose* – has been to demonstrate that the current account of the origin of the diachronic narrative of aesthetic autonomy is, in brief, too simplistic and in some respects utterly inaccurate. What are, then, the implications of the conclusions drawn in this book? If Addison's and Shaftesbury's writings on taste are as deeply rooted in their temporal historical contexts as I have claimed, why bother about them anymore?

The ongoing process of the displacement of political authority, and the inclination to (re)define the nature and truth of political power, had great consequences for how Addison and Shaftesbury addressed taste and aesthetic experience. But while Addison in a Hobbesian vein replaces Aristotle's political

naturalism and trust in man as a natural political creature, with beliefs about political society as a man-made (re)creation, ultimately dependent on the instrumental moral value of aesthetic experience and taste, Shaftesbury pursues a somewhat different course. To him, society is not an artificial invention straightforwardly tied to just a set of political and realist principles of Enlightenment Britain (even if it is that too) but, first and foremost, a natural and intricate outcome of the moral agent's balanced affections and taste. Thus, Addison's and Shaftesbury's theories of taste demonstrate – in very different ways – some of the inherent complexities in the tense interrelation between aesthetic experience and ethico-political contexts. It is an interrelation that is normative and as such it is, as we have observed, never thoroughly challenged by the British men of letters of the early eighteenth century. An experience of nature or art for Addison necessitated a moral engagement in the powers of the Deity and in the beauty of providence. Addison offers no prospect for modern aesthetic disinterestedness. Neither is it accurate to characterize Shaftesbury as a devoted advocate of such disinterestedness. The aesthetic experience refers, from Shaftesbury's ethico-theological perspective, to a natural moral and emotional engagement in the *Whole* (as instantiated in natural society, nature, and works of art).

However, this does not imply that we should reject the fact that there indeed is a processual change – rather than a fragmentation or collapse – in the correlation between ideal aesthetic experience and morality throughout eighteenth-century Europe. But it is particularly problematic to rely on the writings of Addison and Shaftesbury as evidence for such processual change. Throughout the pages of this book I have, to a large extent, remained silent about Kantian and post-Kantian models of taste and aesthetic autonomy, and I do not intend to address them in this brief coda. Nevertheless, it is worth recalling that not even the anticipated climax of Addison's and Shaftesbury's theories of taste, and the very centre of modern aesthetic autonomy, namely Kant's Third Critique – the alleged 'unconscious goal' of eighteenth-century British theories[1] – staged a straightforward notion of pure aesthetic disinterestedness. In a 'strained footnote', Kant famously suggests that our interest in disinterestedness can only occur in a societal context: 'Only in society does it become **interesting** to have taste.'[2]

[1] This idea is fundamental in the classic study by Monk. See Monk, *The Sublime*, 6. As I hope my book has made evident, this idea lingers on in more recent studies.
[2] Kant, *Critique of the Power of Judgment*, 91 (*Kant's gesammelte Schriften/Akademie-Ausgabe* 5:205). Bold in original. Adorno refers to Kant's footnote as a 'strained footnote'. See Theodor W. Adorno, *Aesthetic Theory*, ed. Gretel Adorno and Rolf Tiedemann, trans. Robert Hullot-Kentor (London: Continuum, 2002), 96.

Hence, the conclusions drawn from the investigation made in this book call, if anything, for caution when addressing the assumed origins and progress of eighteenth-century aesthetics in the future. To what extent have we simplified an exceptionally complex moment in history to justify that we (too) quickly move into seemingly more urgent contemporary philosophical problems? A gnawing worry is, of course, that mainstream aesthetics will continue to overlook the relevant eighteenth-century ramifications of taste, pursued by men of letters, simply because they ask too much of us.

The miscellaneous aesthetic writings (scattered in essays, books, letters, and notebooks) that Addison and Shaftesbury left to posterity might look like a cry for the moon. The kind of sharp distinctions that characterize contemporary research in the humanities (where even interdisciplinary methods run the risk of becoming set in a fixed academic mould) were alien to Addison and Shaftesbury. Their un-disciplinarity makes them recalcitrant for any field of humanities, also for aesthetics. Thus, to read and make sense of Addison's and Shaftesbury's essays involves raising disturbing queries about our current practice in aesthetics, perhaps even about our own modern lack of precisely the kind of ideal *general* learning sought by these men of letters. By defying contemporary distinctions between literature, philosophy, religion, politics, and aesthetics, Addison's and Shaftesbury's polyhistoric attitudes to taste challenge the naturalized perspective of mainstream aesthetics. And if we fail to uncover the features of aesthetic autonomy where it is generally claimed to have been fashioned, we might ultimately also need to re-evaluate the *modern* nature of eighteenth-century aesthetics on the whole. As made evident from the recent debate on the protracted legacy of Kristeller's thesis outlined in the introduction of this book, this could indeed be a trying challenge for all involved.

British eighteenth-century criticism and philosophy are destined to remain significant for contemporary thinking, but arguably not in the technically prearranged manner that is too often the case. Addison and Shaftesbury are only reluctantly willing to help out with contemporary problem-solving proposed, to paraphrase Shaftesbury, by the '*Criticks by Fashion*' (*Soliloquy* 188 [272]). However, it is paradoxically by contradicting current expectations that Addison and Shaftesbury also might *raise* (and thus indirectly provide *answers* to) questions about the current strengths and shortcomings of aesthetics. Hence, prior to lending a hand, the corpus of their miscellaneous writings asks us to enter into the temporal moment of the sources we are about to survey, in order to reduce the risk of being a submissive prey of presentism (see *Soliloquy* 188 [271/272]). What we need to think more about in the future is the kind of

predetermined purpose that often governs surveys of British eighteenth-century theories of taste. Of course, the answers produced by historical analyses are destined to be determined by the kind of questions asked and, as Hannah Arendt reminds us, 'every selection of material in a sense interferes with history, and all criteria for selection put the historical course of events under certain man-made conditions'.[3] It is neither desired, nor possible, to edit out ourselves and our contemporary questions. But we ought to be aware of what a too narrowly and contemporarily defined and detailed purpose does to the historical material that we claim to survey. If we have genuine intentions to understand the nature of British early-eighteenth-century theories of taste, we need to let the purpose emerge from the material itself. Because early-eighteenth-century writings on taste are different from current aesthetic theories, they help us towards a more self-reflective mode in which we might begin to recognize that we are part of an essentially different way of historical thinking, and thus also begin to free ourselves from the pursuit of contemporary problem-solving and from any ideal purposelessness. Thus, by their differentness, Addison's and Shaftesbury's writings offer an opening to self-conscious reflections on the complexities integral to what we perfunctorily are doing when we claim to study, or even understand, the history of eighteenth-century aesthetics.

[3] Hannah Arendt, 'The Concept of History: Ancient and Modern', in *Between Past and Future: Six Exercises in Political Thought* (London: Faber and Faber, 1961), 49. Arendt's essay is referred to by Mark Donnelly and Claire Norton, *Doing History* (London: Routledge, 2011), 14: 'the kinds of answers that we find in any form of human enquiry are always dependent on the questions asked – and the questions that we ask are always *our* questions.'

Bibliography

Manuscript sources

British Library, London: BL, Add. MS 4288
The National Archives, London: TNA, PRO 30/24

Primary works

Joseph Addison

A Discourse on Ancient and Modern Learning (London, 1739).
Evidences of the Christian Religion (London, 1730).
The Freeholder, ed. James Leheny (Oxford: Oxford University Press, 1979).
A Letter from Italy, to the Right Honourable Charles, Lord Halifax (London, 1709).
The Letters of Joseph Addison, ed. Walter Graham (Oxford: Oxford University Press, 1941).
The Old Whig: On the State of the Peerage; with Remarks upon the Plebeian (London, 1719).
The Present State of the War, and the Necessity of an Augmentation Consider'd (London, 1708).
The Spectator, 5 vols, ed. Donald F. Bond (Oxford: Oxford University Press, 1965).
The Tatler, 3 vols, ed. Donald F. Bond (Oxford: Oxford University Press, 1987).

Shaftesbury

Askêmata; Prayer (Appendix V), in *Standard Edition: Complete Works, Correspondence and Posthumous Writings*, vol. II, 6, ed. Wolfram Benda, Christine Jackson-Holzberg, Patrick Müller, and Friedrich A. Uehlein (Stuttgart-Bad Cannstatt: frommann-holzboog, 2011).
Characteristics of Men, Manners, Opinions, Times, ed. Lawrence E. Klein (Cambridge: Cambridge University Press, 1999).
Chartae Socraticae: Design of a Socratick History, in *Standard Edition: Complete Works, Selected Letters and Posthumous Writings*, vol. II, 5, ed. Wolfram Benda,

Christine Jackson-Holzberg, Friedrich A. Uehlein, and Erwin Wolff (Stuttgart-Bad Cannstatt: frommann-holzboog, 2008).

Correspondence, in *Standard Edition: Complete Works, Correspondence and Posthumous Writings*, vol. III, 1, ed. Christine Jackson-Holzberg, Patrick Müller, and Friedrich A. Uehlein (Stuttgart-Bad Cannstatt: frommann-holzboog, 2018).

Des Maizeaux' French Translation of Parts of an Inquiry Concerning Virtue, in *Standard Edition: Complete Works, Selected Letters and Posthumous Writings*, vol. II, 3, ed. Wolfram Benda, Wolfgang Lottes, Friedrich A. Uehlein, and Erwin Wolff (Stuttgart-Bad Cannstatt: frommann-holzboog, 1998).

An Inquiry Concerning Virtue, or Merit; An Inquiry Concerning Virtue, in Two Discourses, in *Standard Edition: Complete Works, Selected Letters and Posthumous Writings*, vol. II, 2, ed. Gerd Hemmerich, Wolfram Benda, and Ulrich Schödlbauer (Stuttgart-Bad Cannstatt: frommann-holzboog, 1984).

A Letter Concerning the Art, or Science of Design; A Notion of the Historical Draught or Tablature of the Judgment of Hercules; Letters & Billets on Hercules; *Plasticks, or the Original, Progress, & Power of Designatory Art*, in *Standard Edition: Complete Works, Selected Letters and Posthumous Writings*, vol. I, 5, ed. Wolfram Benda, Wolfgang Lottes, Friedrich A. Uehlein, and Erwin Wolff (Stuttgart-Bad Cannstatt: frommann-holzboog, 2001).

Miscellaneous Reflections, in *Standard Edition: Complete Works, Selected Letters and Posthumous Writings*, vol. I, 2, ed. Wolfram Benda, Gerd Hemmerich, Wolfgang Lottes, and Erwin Wolff (Stuttgart-Bad Cannstatt: frommann-holzboog, 1989).

The Moralists, A Philosophical Rhapsody, in *Standard Edition: Complete Works, Selected Letters and Posthumous Writings*, vol. II, 1, ed. Wolfram Benda, Gerd Hemmerich, and Ulrich Schödlbauer (Stuttgart-Bad Cannstatt: frommann-holzboog, 1987).

Printed Notes to the Characteristicks, in *Standard Edition: Complete Works, Selected Letters and Posthumous Writings*, vol. I, 4, ed. Wolfram Benda, Wolfgang Lottes, Friedrich A. Uehlein, and Erwin Wolff (Stuttgart-Bad Cannstatt: frommann-holzboog, 1993).

Select Sermons of Dr Whichcot, with the Earl's Preface; The Ainsworth Correspondence, in *Standard Edition: Complete Works, Selected Letters and Posthumous Writings*, vol. II, 4, ed. Wolfram Benda, Christine Jackson-Holzberg, Friedrich A. Uehlein, and Erwin Wolff (Stuttgart-Bad Cannstatt: frommann-holzboog, 2006).

Sensus Communis: An Essay on the Freedom of Wit and Humour, in *Standard Edition: Complete Works, Selected Letters and Posthumous Writings*, vol. I, 3, ed. Wolfram Benda, Wolfgang Lottes, Friedrich A. Uehlein, and Erwin Wolff (Stuttgart-Bad Cannstatt: frommann-holzboog, 1992).

Soliloquy: Or, Advice to an Author; A Letter Concerning Enthusiasm, in *Standard Edition: Complete Works, Selected Letters and Posthumous Writings*, vol. I, 1, ed. Gerd Hemmerich and Wolfram Benda (Stuttgart-Bad Cannstatt: frommann-holzboog, 1981).

Standard Edition: Complete Works, Correspondence and Posthumous Writings, ed. Wolfram Benda, Gerd Hemmerich, Christine Jackson-Holzberg, Wolfgang Lottes, Patrick Müller, Ulrich Schödlbauer, Friedrich A. Uehlein, and Erwin Wolff (Stuttgart-Bad Cannstatt: frommann-holzboog, 1981–).

Secondary works

Abrams, M. H., 'Art-as-Such: The Sociology of Modern Aesthetics', in *Doing Things with Texts: Essays in Criticism and Critical Theory* (New York: W. W. Norton, 1989), 135–58.
Abrams, M. H., 'Kant and the Theology of Art', *Notre Dame English Journal* 13, no. 3 (1981), 75–106.
Adam, Robert, *Ruins of the Palace of the Emperor Diocletian at Spalatro in Dalmatia* (London, 1764).
Adorno, Theodor W., *Aesthetic Theory*, ed. Gretel Adorno and Rolf Tiedemann, trans. Robert Hullot-Kentor (London: Continuum, 2002).
Aeschylus, *Prometheus Bound*, vol. 1, trans. Alan H. Sommerstein, Loeb Classical Library 145 (Cambridge, MA: Harvard University Press, 2008).
Aesop's Fables, trans. Laura Gibbs, Oxford World's Classics (Oxford: Oxford University Press, 2002).
Akenside, Mark, *An Ode to the Right Honourable the Earl of Huntingdon* (London, 1748).
Alberti, Leon Battista, *On Painting*, ed. and trans. Rocco Sinisgalli (Cambridge: Cambridge University Press, 2011).
Aldridge, Alfred Owen, 'Shaftesbury and the Deist Manifesto', *Transactions of the American Philosophical Society* 41, no. 2 (1951), 297–382.
Almagor, Joseph, *Pierre Des Maizeaux (1673–1745), Journalist and English Correspondent for Franco-Dutch Periodicals, 1700–1720* (Amsterdam: Holland University Press, 1989).
Apollodorus, *Library*, vol. 1, trans. James George Frazer, Loeb Classical Library 121 (London: William Heinemann, 1921).
Arendt, Hannah, 'The Concept of History: Ancient and Modern', in *Between Past and Future: Six Exercises in Political Thought* (London: Faber and Faber, 1961), 41–90.
Ariosto, Ludovico, *Orlando Furioso*, trans. David R. Slavitt (Cambridge, MA: Harvard University Press, 2009).
Aristotle, *Poetics*, in *The Complete Works of Aristotle*, The Revised Oxford Translation, vol. 2, ed. Jonathan Barnes (Princeton, NJ: Princeton University Press, 1984).
Aristotle, *Politics*, in *The Complete Works of Aristotle*, The Revised Oxford Translation, vol. 2, ed. Jonathan Barnes (Princeton, NJ: Princeton University Press, 1984).

Armitage, David, 'John Locke, Carolina, and the *Two Treatises of Government*', *Political Theory* 32, no. 5 (2004), 602–27.
Arregui, Jorge V., and Arnau, Pablo, 'Shaftesbury: Father or Critic of Modern Aesthetics?', *British Journal of Aesthetics* 34, no. 4 (1994), 350–62.
Ashcraft, Richard, *Locke's Two Treatises of Government*, Routledge Library Editions: Political Science, vol. 17 (London: Routledge, 2010).
Ashfield, Andrew, and de Bolla, Peter, 'Introduction', in *The Sublime: A Reader in British Eighteenth-Century Aesthetic Theory*, ed. Andrew Ashfield and Peter de Bolla (Cambridge: Cambridge University Press, 1996), 1–16.
Axelsson, Karl, 'Joseph Addison and General Education: Moral Didactics in Early Eighteenth-Century Britain', *Estetika: The Central European Journal of Aesthetics* 46, no. 2 (2009), 144–66.
Axelsson, Karl, *The Sublime: Precursors and British Eighteenth-Century Conceptions* (Oxford: Peter Lang, 2007).
Ayres, Philip, *Classical Culture and the Idea of Rome in Eighteenth-Century England* (Cambridge: Cambridge University Press, 1997).
Bacon, Francis, *The Advancement of Learning*, in *The Works of Francis Bacon*, vol. 3, ed. James Spedding, Robert Leslie Ellis, and Douglas Denon Heath (London: Longman, 1870).
Baeumker, Clemens, 'Das pseudo-hermetische "Buch der vierundzwanzig Meister" (Liber XXIV philosophorum): Ein Beitrag zur Geschichte des Neupythagoreismus und Neuplatonismus im Mittetalter', in *Studien und Charakteristiken zur Geschichte der Philosophie insbesondere des Mittelalters: Gesammelte Vorträge und Aufsätze von Clemens Baeumker*, ed. Martin Grabmann (Münster: Aschendorff, 1927), 194–214.
Baumgarten, Alexander Gottlieb, *Ästhetik*, vol. 1, ed. and trans. Dagmar Mirbach (Hamburg: Felix Meiner Verlag, 2007).
Beardsley, Monroe C., *Aesthetics: Problems in the Philosophy of Criticism*, 2nd edn (Indianapolis, IN: Hackett, 1981).
Bennett, Peter, and Cowart, Georgia, 'Music under Louis XIII and XIV, 1610–1715', in *The Cambridge Companion to French Music*, ed. Simon Trezise (Cambridge: Cambridge University Press, 2015), 69–87.
Bennington, Geoffrey, 'Postal Politics and the Institution of the Nation', in *Nation and Narration*, ed. Homi K. Bhabha (London: Routledge, 1990), 121–37.
Berkeley, George, *Alciphron: Or the Minute Philosopher*, in *The Works of George Berkeley, Bishop of Cloyne*, vol. 3, ed. Arthur Aston Luce and Thomas Edmund Jessop (London: Thomas Nelson, 1950).
Berkeley, George, *An Essay towards Preventing the Ruin of Great Britain*, in *The Works of George Berkeley, Bishop of Cloyne*, vol. 6, ed. Arthur Aston Luce and Thomas Edmund Jessop (London: Thomas Nelson, 1953), 67–85.
Berkeley, George, *The Theory of Vision or Visual Language Shewing the Immediate Presence and Providence of a Deity Vindicated and Explained*, in *The Works of George*

Berkeley, Bishop of Cloyne, vol. 1, ed. Arthur Aston Luce and Thomas Edmund Jessop (London: Thomas Nelson, 1948), 251–76.

Bernstein, J. M., *The Fate of Art: Aesthetic Alienation from Kant to Derrida and Adorno* (Cambridge: Polity Press, 1992).

Bernstein, John Andrew, 'Shaftesbury's Identification of the Good with the Beautiful', *Eighteenth-Century Studies* 10, no. 3 (1977), 304–25.

Bernstein, John Andrew, *Shaftesbury, Rousseau, and Kant: An Introduction to the Conflict between Aesthetic and Moral Values in Modern Thought* (Rutherford, NJ: Fairleigh Dickinson University Press, 1980).

Bhabha, Homi K., 'Introduction: Narrating the Nation', in *Nation and Narration*, ed. Homi K. Bhabha (London: Routledge, 1990), 1–7.

Billig, Michael, *The Hidden Roots of Critical Psychology: Understanding the Impact of Locke, Shaftesbury and Reid* (London: Sage, 2008).

Black, Jeremy, 'The Middling Sort of People in the Eighteenth-Century English-Speaking World', *XVII–XVIII* 72 (2015). DOI: 10.4000/1718.286.

Black, Jeremy, *A Subject for Taste: Culture in Eighteenth-Century England* (London: Hambledon and London, 2005).

Blaicher, Günther, ' "The Improvement of the Mind": Auffassungen vom Lesen bei John Locke, Richard Steele und Joseph Addison', in *Lesen und Schreiben im 17. und 18. Jahrhundert: Studien zu ihrer Bewertung in Deutschland, England, Frankreich*, ed. Paul Goetsch (Tübingen: Gunter Narr, 1994), 91–107.

Bloom, Edward A., and Bloom, Lillian D., 'Addison on "Moral Habits of the Mind" ', *Journal of the History of Ideas* 21, no. 3 (1960) 409–27.

Bloom, Edward A., and Bloom, Lillian D., 'Joseph Addison and Eighteenth-Century "Liberalism" ', *Journal of the History of Ideas* 12, no. 4 (1951), 560–83.

Bloom, Edward A., and Bloom, Lillian D., *Joseph Addison's Sociable Animal: In the Market Place, on the Hustings, in the Pulpit* (Providence, RI: Brown University Press, 1971).

Boileau-Despréaux, Nicolas, 'Préface', *Traité du sublime ou du merveilleux dans le discours, traduit du grec de Longin*, in *Œuvres Complètes* (Paris: Gallimard, 1966), 333–40.

Boileau-Despréaux, Nicolas, 'Préface', in *Œuvres Complètes* (Paris: Gallimard, 1966), 1–5.

Bowers, Terence, 'Universalizing Sociability: *The Spectator*, Civic Enfranchisement, and the Rule(s) of the Public Sphere', in *The Spectator: Emerging Discourses*, ed. Donald J. Newman (Newark, NJ: University of Delaware Press, 2005), 150–74.

Boyer, Ernest, Jr, 'Schleiermacher, Shaftesbury, and the German Enlightenment', *The Harvard Theological Review* 96, no. 2 (2003), 181–204.

Brett, R. L., *The Third Earl of Shaftesbury: A Study in Eighteenth-Century Literary Theory* (New York: Hutchinson's University Library, 1951).

Brettler, Marc, 'Cyclical and Teleological Time in the Hebrew Bible', in *Time and Temporality in the Ancient World*, ed. Ralph M. Rosen (Philadelphia: University of Pennsylvania Museum of Archaeology and Anthropology, 2004), 111–28.

Brewer, John, 'Cultural Production, Consumption, and the Place of the Artist in Eighteenth-Century England', in *Towards a Modern Art World*, ed. Brian Allen (New Haven, CT: Yale University Press, 1995), 7–25.

Brewer, John, '"The Most Polite Age and the Most Vicious": Attitudes towards Culture as a Commodity, 1660–1800', in *The Consumption of Culture 1600–1800: Image, Object, Text*, ed. Ann Bermingham and John Brewer (London: Routledge, 1995), 341–61.

Brewer, John, *The Pleasures of the Imagination: English Culture in the Eighteenth Century* (London: HarperCollins, 1997).

Broome, J. H., *An Agent in Anglo-French Relationships: Pierre des Maizeaux, 1673–1745* (PhD diss., University of London, 1949).

Brown, Andrew, *The Character of the True Publick Spirit Especially with Relation to the Ill Condition of a Nation, Thro' the Prevalency of the Privat Spirit, Selfish and Sinister Designs* (Edinburgh, 1702).

Brown, Stuart, 'The Critical Reception of Malebranche, from His Own Time to the End of the Eighteenth Century', in *The Cambridge Companion to Malebranche*, ed. Steven Nadler (Cambridge: Cambridge University Press, 2000), 262–87.

Burnet, Thomas, *The Sacred Theory of the Earth: Containing an Account of the Original of the Earth, and of All the General Changes Which It Hath Already Undergone, or Is to Undergo, till the Consummation of All Things*, vol. 1, 4th edn (London, 1719).

Burrows, Barry McCoun, *Shaftesbury and Cosmic Toryism: An Alternative World View* (PhD diss., University of Oklahoma, 1973).

Butterfield, Herbert, *The Whig Interpretation of History* (London: G. Bell, 1931).

Cannan, Paul D., '*A Short View of Tragedy* and Rymer's Proposals for Regulating the English Stage', *The Review of English Studies* 52, no. 206 (2001), 207–26.

Carey, Daniel, *Locke, Shaftesbury, and Hutcheson: Contesting Diversity in the Enlightenment and Beyond* (Cambridge: Cambridge University Press, 2006).

Carey, Daniel, 'Locke, Shaftesbury, and Innateness', *Locke Studies* 4 (2004), 13–45.

Carlson, Allen, *Nature and Landscape: An Introduction to Environmental Aesthetics* (New York: Columbia University Press, 2009).

Carroll, Noel, 'Hume's Standard of Taste', *Journal of Aesthetics and Art Criticism* 43, no. 2 (1984), 181–94.

Cassirer, Ernst, *Die platonische Renaissance in England und die Schule von Cambridge* (Leipzig: B. G. Teubner, 1932).

Champion, Justin, *Republican Learning: John Toland and the Crisis of Christian Culture, 1696–1722* (Manchester: Manchester University Press, 2003).

Cheetham, Mark A., *Artwriting, Nation, and Cosmopolitanism in Britain: The 'Englishness' of English Art Theory since the Eighteenth Century* (Farnham: Ashgate, 2012).

Chisick, Harvey, 'David Hume and the Common People', in *The 'Science of Man' in the Scottish Enlightenment: Hume, Reid and Their Contemporaries*, ed. Peter Jones (Edinburgh: Edinburgh University Press, 1989), 5–32.

Cicero, *De Oratore*, vol. 2, trans. H. Rackham, Loeb Classical Library 349 (Cambridge, MA: Harvard University Press, 1942).
Cicero, *Tusculan Disputations*, trans. J. E. King, Loeb Classical Library 141 (Cambridge, MA: Harvard University Press, 1927).
Cocalis, Susan L., 'The Transformation of *Bildung* from an Image to an Ideal', *Monatshefte* 70, no. 4 (1978), 399–414.
Colley, Linda, *Acts of Union and Disunion: What Has Held the UK Together – and What Is Dividing It?* (London: Profile Books, 2014).
Colley, Linda, *Britons: Forging the Nation 1707–1837*, 2nd edn (New Haven, CT: Yale University Press, 2005).
Collis, Karen, '"The Advancement of All Antient and Polite Learning": Education and Criticism in *Characteristicks*', in *New Ages, New Opinions: Shaftesbury in His World and Today*, ed. Patrick Müller (Frankfurt am Main: Peter Lang, 2014), 223–38.
Collis, Karen, 'Shaftesbury and Literary Criticism: Philosophers and Critics in Early Eighteenth-Century England', *The Review of English Studies* 67, no. 279 (2016), 294–315.
Coppola, Al, 'Imagination and Pleasure in the Cosmography of Thomas Burnet's *Sacred Theory of the Earth*', in *World-Building and the Early Modern Imagination*, ed. Allison B. Kavey (Basingstoke: Palgrave Macmillan, 2010), 119–39.
Costelloe, Timothy M., *The British Aesthetic Tradition: From Shaftesbury to Wittgenstein* (Cambridge: Cambridge University Press, 2013).
Cowan, Brian, 'The Curious Mr Spectator: Virtuoso Culture and the Man of Taste in the Works of Addison and Steele', *Media History* 14, no. 3 (2008), 275–92.
Cowan, Brian, 'Mr. Spectator and the Coffeehouse Public Sphere', *Eighteenth-Century Studies* 37, no. 3 (2004), 345–66.
Cowan, Brian, 'What Was Masculine about the Public Sphere? Gender and the Coffeehouse Milieu in Post-Restoration England', *History Workshop Journal* 51 (2001), 127–57.
Coward, Barry, *The Stuart Age: England, 1603–1714*, 4th edn (London: Routledge, 2014).
Coxe, William, *Memoirs of the Life and Administration of Sir Robert Walpole, Earl of Orford*, vol. 1 (London, 1798).
Crowe, Michael J., *The Extraterrestrial Life Debate, 1750–1900: The Idea of a Plurality of Worlds from Kant to Lowell* (Cambridge: Cambridge University Press, 1986).
Davenant, William, *The Siege of Rhodes* (London, 1656).
de Bolla, Peter, *The Architecture of Concepts: The Historical Formation of Human Rights* (New York: Fordham University Press, 2013).
de Bolla, Peter, *The Education of the Eye: Painting, Landscape, and Architecture in Eighteenth-Century Britain* (Stanford, CA: Stanford University Press, 2003).
de Bolla, Peter, 'The Invention of Concepts: Sense as a Way of Knowing According to Francis Hutcheson', *Études Anglaises* 66, no. 2 (2013), 161–70.

Defoe, Daniel, *The Original Power of the Collective Body of the People of England, Examined and Asserted* (London, 1702).

Dehrmann, Mark-Georg, *Das 'Orakel der Deisten': Shaftesbury und die deutsche Aufklärung* (Göttingen: Wallstein, 2008).

Dehrmann, Mark-Georg, 'Transition: "Pedagogy of the Eye" in Shaftesbury's *Second Characters*', in *New Ages, New Opinions: Shaftesbury in His World and Today*, ed. Patrick Müller (Frankfurt am Main: Peter Lang, 2014), 45–60.

DeMaria, Jr, Robert, 'The Eighteenth-Century Periodical Essay', in *The Cambridge History of English Literature, 1660–1780*, ed. John Richetti (Cambridge: Cambridge University Press, 2005), 527–48.

Den Uyl, Douglas J., 'Shaftesbury and the Modern Problem of Virtue', *Social Philosophy and Policy* 15, no. 1 (1998), 275–316.

Dennis, John, *An Essay on the Opera's after the Italian Manner, Which Are about to Be Establish'd on the English Stage: With Some Reflections on the Damage Which They May Bring to the Publick*, in *The Critical Works of John Dennis*, vol. 1, ed. Edward Niles Hooker (Baltimore, MD: Johns Hopkins Press, 1939), 382–93.

Dennis, John, *The Impartial Critick: Or, Some Observations upon a Late Book, Entituled, a Short View of Tragedy, Written by Mr. Rymer*, in *The Critical Works of John Dennis*, vol. 1, ed. Edward Niles Hooker (Baltimore, MD: Johns Hopkins Press, 1939), 11–41.

Descartes, *Discours de la méthode*, in *Oeuvres de Descartes*, vol. 6, ed. Charles Adam and Paul Tannery (Paris: Léopold Cerf, Imprimeur-Éditeur, 1902), 1–78.

Descartes, *Discourse on the Method*, in *The Philosophical Writings of Descartes*, vol. 1, trans. John Cottingham, Robert Stoothoff, and Dugald Murdoch (Cambridge: Cambridge University Press, 1984), 109–51.

Descartes, *Les Méditations métaphysiques*, in *Oeuvres de Descartes*, vol. 9, ed. Charles Adam and Paul Tannery (Paris: Léopold Cerf, Imprimeur-Éditeur, 1904), 13–72.

Descartes, *Les Principes de la philosophie*, in *Oeuvres de Descartes*, vol. 9, ed. Charles Adam and Paul Tannery (Paris: Léopold Cerf, Imprimeur-Éditeur, 1904), 1–325.

Descartes, *Meditations on First Philosophy*, in *The Philosophical Writings of Descartes*, vol. 2, trans. John Cottingham, Robert Stoothoff, and Dugald Murdoch (Cambridge: Cambridge University Press, 1984), 1–62.

Descartes, *Principles of Philosophy*, in *The Philosophical Writings of Descartes*, vol. 1, trans. John Cottingham, Robert Stoothoff, and Dugald Murdoch (Cambridge: Cambridge University Press, 1984), 177–291.

Dickie, George, *The Century of Taste: The Philosophical Odyssey of Taste in the Eighteenth Century* (Oxford: Oxford University Press, 1996).

Diffey, T. J., 'Aesthetic Instrumentalism', *British Journal of Aesthetics* 22, no. 4 (1982), 337–349.

Diogenes Laertius, *Lives of Eminent Philosophers*, vol. 2, trans. R. D. Hicks, Loeb Classical Library 185 (Cambridge, MA: Harvard University Press, 1925).

Donnelly, Mark, and Norton, Claire, *Doing History* (London: Routledge, 2011).

Donnelly, Phillip J., 'Enthusiastic Poetry and Rationalized Christianity: The Poetic Theory of John Dennis', *Christianity and Literature* 54, no. 2 (2005), 235–64.
Dougherty, Carol, *Prometheus* (London: Routledge, 2006).
Dunn, John, *The Political Thought of John Locke: An Historical Account of the Argument of the 'Two Treatises of Government'* (Cambridge: Cambridge University Press, 1969).
Dussinger, John A., '"The Lovely System of Lord Shaftesbury": An Answer to Locke in the Aftermath of 1688?', *Journal of the History of Ideas* 42, no. 1 (1981), 151–8.
Egan, Jim, *Authorizing Experience: Refigurations of the Body Politic in Seventeenth-Century New England Writing* (Princeton, NJ: Princeton University Press, 1999).
Elioseff, Lee Andrew, *The Cultural Milieu of Addison's Literary Criticism* (Austin: University of Texas Press, 1963).
Ellis, Elisabeth, 'The Received Hobbes', in *Leviathan: Or the Matter, Forme, & Power of a Common-Wealth Ecclesiasticall and Civill*, ed. Ian Shapiro (New Haven, CT: Yale University Press, 2010), 481–518.
Ellis, Markman, 'Coffee-Women, "*The Spectator*" and the Public Sphere in the Early Eighteenth Century', in *Woman, Writing and the Public Sphere, 1700–1830*, ed. Elizabeth Eger, Charlotte Grant, Clíona Ó Gallchoir, and Penny Warburton (Cambridge: Cambridge University Press, 2001), 27–52.
Empedocles, *Die Fragmente der Vorsokratiker*, vol. 1, ed. Hermann Diels and Walther Kranz, 5th edn (Berlin: Wiedmann, 1934–7).
Engell, James, *The Creative Imagination: Enlightenment to Romanticism* (Cambridge, MA: Harvard University Press, 1981).
Engell, James, *Forming the Critical Mind: Dryden to Coleridge* (Cambridge, MA: Harvard University Press, 1989).
Epictetus, *Discourses*, trans. W. A. Oldfather, Loeb Classical Library 131 (Cambridge, MA: Harvard University Press, 1925).
Fenves, Peter, 'The Scale of Enthusiasm', in *Enthusiasm and Enlightenment in Europe, 1650–1850*, ed. Lawrence E. Klein and Anthony J. La Vopa (San Marina, CA: Huntington Library, 1998), 117–52.
Field, George, 'Aesthetics, or the Analogy of the Sensible Sciences', *Pamphleteer* 17, no. 23 (1820), 195–227.
Filmer, Robert, *Patriarcha*, in *Patriarcha and Other Writings*, Cambridge Texts in the History of Political Thought, ed. Johann P. Sommerville (Cambridge: Cambridge University Press, 1991).
Forster, Greg, *John Locke's Politics of Moral Consensus* (Cambridge: Cambridge University Press, 2005).
Fulton, Gordon D., '*Evidences of the Christian Religion*: Using Pascal to Revise Addison in Eighteenth-Century Scotland', *Lumen: Selected Proceedings from the Canadian Society for Eighteenth-Century Studies* 26 (2007), 227–41.
Garber, Daniel, 'What's Philosophical about the History of Philosophy?', in *Analytic Philosophy and the History of Philosophy*, ed. Tom Sorell and G. A. J. Rogers (Oxford: Oxford University Press, 2005), 129–46.

Gellius, *Attic Nights*, vol. 1, trans. John C. Rolfe, Loeb Classical Library 195 (Cambridge, MA: Harvard University Press, 1927).
Geuss, Raymond, *A World without Why* (Princeton, NJ: Princeton University Press, 2014).
Gibson-Wood, Carol, *Jonathan Richardson: Art Theorist of the English Enlightenment* (New Haven, CT: Yale University Press, 2000).
Gibson-Wood, Carol, 'Jonathan Richardson and the Rationalization of Connoisseurship', *Art History* 7, no. 1 (1984), 38–56.
Gibson-Wood, Carol, *Studies in the Theory of Connoisseurship from Vasari to Morelli* (New York: Garland, 1988).
Gigante, Denise, *Taste: A Literary History* (New Haven, CT: Yale University Press, 2005).
Gill, Michael B., *The British Moralists on Human Nature and the Birth of Secular Ethics* (Cambridge: Cambridge University Press, 2006).
Gill, Michael B., 'Love of Humanity in Shaftesbury's *Moralists*', *British Journal for the History of Philosophy* 24, no. 6 (2016), 1117–35.
Glauser, Richard, 'Aesthetic Experience in Shaftesbury', *Proceedings of the Aristotelian Society, Supplementary Volumes* 76, no. 1 (2002), 25–54.
Goehr, Lydia, 'The Concept of Opera', in *The Oxford Handbook of Opera*, ed. Helen M. Greenwald (Oxford: Oxford University Press, 2014), 92–133.
Goldgar, Anne, *Impolite Learning: Conduct and Community in the Republic of Letters, 1680-1750* (New Haven, CT: Yale University Press, 1995).
Goldie, Mark, 'The English System of Liberty', in *The Cambridge History of Eighteenth-Century Political Thought*, ed. Mark Goldie and Robert Wokler (Cambridge: Cambridge University Press, 2006), 40–78.
Goldsmith, M. M., *Private Vices, Public Benefits: Bernard Mandeville's Social and Political Thought* (Cambridge: Cambridge University Press, 1985).
Göricke, Walter, *Das Bildungsideal bei Addison und Steele* (Bonn: Peter Hanstein, 1921).
Gracián y Morales, Baltasar, *The Courtiers Manual Oracle, or, the Art of Prudence* (London, 1685).
Grean, Stanley, 'Self-Interest and Public Interest in Shaftesbury's Philosophy', *Journal of the History of Philosophy* 2, no. 1 (1964), 37–45.
Grean, Stanley, *Shaftesbury's Philosophy of Religion and Ethics: A Study in Enthusiasm* (New York: Ohio University Press, 1967).
Griffin, Dustin, 'Akenside's Political Muse', in *Mark Akenside: A Reassessment*, ed. Robin Dix (Cranbury, NJ: Associated University Presses, 2000), 19–50.
Grote, Simon, *The Emergence of Modern Aesthetic Theory: Religion and Morality in Enlightenment Germany and Scotland* (Cambridge: Cambridge University Press, 2017).
Guyer, Paul, *A History of Modern Aesthetics, Volume 1: The Eighteenth Century* (Cambridge: Cambridge University Press, 2014).
Guyer, Paul, *Values of Beauty: Historical Essays in Aesthetics* (Cambridge: Cambridge University Press, 2005).

Habermas, Jürgen, *The Structural Transformation of the Public Sphere: An Inquiry into a Category of Bourgeois Society*, trans. Thomas Burger with the assistance of Frederick Lawrence (Cambridge: Polity Press, 1992).

Haley, K. H. D., *The First Earl of Shaftesbury* (Oxford: Oxford University Press, 1968).

Halliwell, Stephen, *The Aesthetics of Mimesis: Ancient Texts and Modern Problems* (Princeton, NJ: Princeton University Press, 2002).

Halliwell, Stephen, *Between Ecstasy and Truth: Interpretations of Greek Poetics from Homer to Longinus* (Oxford: Oxford University Press, 2011).

Hanvelt, Marc, *The Politics of Eloquence: David Hume's Polite Rhetoric* (Toronto: University of Toronto Press, 2012).

Harloe, Katherine, *Winckelmann and the Invention of Antiquity: History and Aesthetics in the Age of Altertumswissenschaft* (Oxford: Oxford University Press, 2013).

Harries, Karsten, 'The Infinite Sphere: Comments on the History of a Metaphor', *Journal of the History of Philosophy* 13, no. 1 (1975), 5–15.

Harris, Ellen T., *Henry Purcell's Dido and Aeneas* (Oxford: Clarendon Press, 1987).

Harris, James A., *Hume: An Intellectual Biography* (Cambridge: Cambridge University Press, 2015).

Havelock, Eric A., *Preface to Plato* (Oxford: Blackwell, 1963).

Haynes, Clare, *Pictures and Popery: Art and Religion in England, 1660–1760* (Aldershot: Ashgate, 2006).

Heath, Malcolm, *Ancient Philosophical Poetics* (Cambridge: Cambridge University Press, 2013).

Heine, Heinrich, *Die romantische Schule*, in *Historisch-kritische Gesamtausgabe der Werke*, vol. 8.1, ed. Manfred Windfuhr (Hamburg: Hoffmann und Campe, 1979).

Heinemann, F. H., 'The Philosopher of Enthusiasm: With Material Hitherto Unpublished', *Revue Internationale de Philosophie* 6, no. 21 (1952), 294–322.

Hesiod, *Theogony, Works and Days, Testimonia*, trans. Glenn W. Most, Loeb Classical Library 57 (Cambridge, MA: Harvard University Press, 2006).

Hess, Jonathan M., *Reconstituting the Body Politic: Enlightenment, Public Culture and the Invention of Aesthetic Autonomy* (Detroit, MI: Wayne State University Press, 1999).

Heyd, Michael, *'Be Sober and Reasonable:' The Critique of Enthusiasm in the Seventeenth and Early Eighteenth Centuries* (Leiden: Brill, 1995).

Heydt, Colin, *Moral Philosophy in Eighteenth-Century Britain: God, Self, and Other* (Cambridge: Cambridge University Press, 2018).

The History of Parliament: The House of Commons 1715–1754, vol. 1, ed. Romney Sedgwick (London: HMSO, 1970).

'Hobbes, History, Politics, and Gender: A Conversation with Carole Pateman and Quentin Skinner', in *Feminist Interpretations of Thomas Hobbes*, ed. Nancy J. Hirschmann and Joanne H. Wright (Pennsylvania: Pennsylvania State University Press, 2012), 18–43.

Hobbes, Thomas, *The Answer of Mr. Hobbes to Sir William Davenant's Preface before Gondibert*, in *The Collected Works of Thomas Hobbes*, vol. 4, ed. William Molesworth (London: Routledge/Thoemmes, 1992), 441–58.

Hobbes, Thomas, *De Cive: The English Version*, ed. Howard Warrender, The Clarendon Edition of the Philosophical Works of Thomas Hobbes (Oxford: Oxford University Press, 1983).

Hobbes, Thomas, *The Iliads and Odysses of Homer. Translated Out of the Greek into English, by Thomas Hobbes of Malmesbury*, in *The Collected Works of Thomas Hobbes*, vol. 10, ed. William Molesworth (London: Routledge/Thoemmes, 1992).

Hobbes, Thomas, *Leviathan, or the Matter, Forme, & Power of a Common-Wealth Ecclesiasticall and Civill*, vol. 2, ed. Noel Malcolm, The Clarendon Edition of the Works of Thomas Hobbes (Oxford: Oxford University Press, 2012).

Home, Henry (Lord Kames), *Elements of Criticism*, vol. 1, 3rd edn (Edinburgh, 1765).

Homer, *Odyssey*, vol. 1, trans. A. T. Murray, Loeb Classical Library 104 (Cambridge, MA: Harvard University Press, 1919).

Hoppit, Julian, *A Land of Liberty? England 1689–1727* (Oxford: Oxford University Press, 2000).

Horace, *Ars Poetica*, in *Satires, Epistles and Ars Poetica*, trans. H. Rushton Fairclough, Loeb Classical Library 194 (Cambridge, MA: Harvard University Press, 1929).

Horace, *Epistles*, in *Satires, Epistles and Ars Poetica*, trans. H. Rushton Fairclough, Loeb Classical Library 194 (Cambridge, MA: Harvard University Press, 1929).

Horlacher, Rebekka, 'Bildung – A Construction of a History of Philosophy of Education', *Studies in Philosophy and Education* 23, nos 5–6 (2004), 409–26.

Horlacher, Rebekka, *Bildungstheorie vor der Bildungstheorie: Die Shaftesbury-Rezeption in Deutschland und der Schweiz im 18. Jahrhundert* (Würzburg: Königshausen & Neumann, 2004).

Howell, A. C., '*Res et Verba*: Words and Things', *ELH* 13, no. 2 (1946), 131–42.

Hulatt, Owen, 'Introduction', in *Aesthetic and Artistic Autonomy*, ed. Owen Hulatt (London: Bloomsbury, 2013), 1–11.

Hume, David, *An Enquiry Concerning the Principles of Morals*, ed. Tom L. Beauchamp (Oxford: Oxford University Press, 1998).

Hume, David, *The History of England: From the Invasion of Julius Caesar to the Revolution in 1688*, vol. 1 (Indianapolis, IN: Liberty Fund, 1983).

Hume, David, 'Of Essay-Writing', in *Essays Moral, Political, and Literary*, ed. Eugene F. Miller, rev. edn (Indianapolis, IN: Liberty Fund, 1987), 533–7.

Hume, David, 'Of the Middle Station of Life', in *Essays Moral, Political, and Literary*, ed. Eugene F. Miller, rev. edn (Indianapolis, IN: Liberty Fund, 1987), 545–51.

Hume, David, 'Of the Standard of Taste', in *Essays Moral, Political, and Literary*, ed. Eugene F. Miller, rev. edn (Indianapolis, IN: Liberty Fund, 1987), 226–49.

Hunt, Margaret R., *The Middling Sort: Commerce, Gender, and the Family in England, 1680–1780* (Berkeley: University of California Press, 1996).

Hutton, Sarah, *British Philosophy in the Seventeenth Century* (Oxford: Oxford University Press, 2015).
Hutton, Sarah, 'Intellectual History and the History of Philosophy', *History of European Ideas* 40, no. 7 (2014), 925–37.
Irlam, Shaun, *Elations: The Poetics of Enthusiasm in Eighteenth-Century Britain* (Stanford, CA: Stanford University Press, 1999).
Israel, Jonathan I., 'General Introduction', in *The Anglo-Dutch Moment: Essays on the Glorious Revolution and Its World Impact*, ed. Jonathan I. Israel (Cambridge: Cambridge University Press, 1991), 1–43.
Israel, Jonathan I., *Radical Enlightenment: Philosophy and the Making of Modernity 1650–1750* (Oxford: Oxford University Press, 2001).
Jaffro, Laurent, 'Les *Exercices* de Shaftesbury: un stoïcisme crépusculaire', in *Le stoïcisme au XVIe et au XVIIe siècle: Le retour des philosophies antiques à l'âge classique*, ed. Pierre-François Moreau (Paris: Albin Michel, 1999), 340–54.
Jaffro, Laurent, 'Shaftesbury on the "Natural Secretion" and Philosophical *Personae*', *Intellectual History Review* 18, no. 3 (2008), 349–59.
James I, *A Speech to the Lords and Commons of the Parliament at White-Hall* from 1610, in *Divine Right and Democracy: An Anthology of Political Writing in Stuart England*, ed. David Wootton (London: Penguin, 1986), 107–9.
Jay, Martin, *Downcast Eyes: The Denigration of Vision in Twentieth-Century French Thought* (Berkeley: University of California Press, 1994).
Johnson, Donald R., 'Addison in Italy', *Modern Language Studies* 6, no. 1 (1976), 32–6.
Johnson, James William, 'What *Was* Neo-Classicism', *Journal of British Studies* 9, no. 1 (1969), 49–70.
Johnson, Samuel, *The Lives of the Most Eminent English Poets; With Critical Observations on Their Works*, vol. 3, ed. Roger Lonsdale (Oxford: Oxford University Press, 2006).
Jones, Robert W., *Gender and the Formation of Taste in Eighteenth-Century Britain: The Analysis of Beauty* (Cambridge: Cambridge University Press, 1998).
Jupp, Peter, *The Governing of Britain, 1688–1848: The Executive, Parliament and the People* (London: Routledge, 2006).
Kahn, Victoria, *Wayward Contracts: The Crisis of Political Obligation in England, 1640–1674* (Princeton, NJ: Princeton University Press, 2004).
Kant, Immanuel, *Critique of the Power of Judgment*, Cambridge Edition of the Works of Immanuel Kant, ed. Paul Guyer, trans. Paul Guyer and Eric Matthews (Cambridge: Cambridge University Press, 2000).
Kelly, Paul, *Locke's 'Second Treatise of Government': A Reader's Guide* (London: Continuum, 2007).
Ketcham, Michael G., *Transparent Designs: Reading, Performance, and Form in the Spectator Papers* (Athens: University of Georgia Press, 1985).
Kidd, Colin, 'Protestantism, Constitutionalism and British Identity under the Later Stuarts', in *British Consciousness and Identity: The Making of Britain, 1533–1707*, ed.

Brendan Bradshaw and Peter Roberts (Cambridge: Cambridge University Press, 1998), 321–42.

Kishlansky, Mark, *A Monarchy Transformed: Britain 1603–1714* (London: Penguin, 1996).

Kivy, Peter, 'Hume's Standard of Taste: Breaking the Circle', *British Journal of Aesthetics* 7, no. 1 (1967), 57–66.

Kivy, Peter, 'Recent Scholarship and the British Tradition: A Logic of Taste – The First Fifty Years', in *Aesthetics: A Critical Anthology*, ed. George Dickie, Richard Sclafani, and Ronald Roblin, 2nd edn (New York: St Martin's Press, 1989), 254–68.

Kivy, Peter, *The Seventh Sense: Francis Hutcheson and Eighteenth-Century British Aesthetics*, 2nd rev. edn (Oxford: Clarendon, 2003).

Kivy, Peter, 'What *Really* Happened in the Eighteenth Century: The "Modern System" Re-examined (Again)', *British Journal of Aesthetics* 52, no. 1 (2012), 61–74.

Klein, Lawrence E., 'Addisonian Afterlives: Joseph Addison in Eighteenth-Century Culture', *Journal for Eighteenth-Century Studies* 35, no. 1 (2012), 101–18.

Klein, Lawrence E., 'Introduction', in Shaftesbury, *Characteristics of Men, Manners, Opinions, Times*, ed. Lawrence E. Klein (Cambridge: Cambridge University Press, 1999), vii–xxxi.

Klein, Lawrence E., 'Joseph Addison's Whiggism', in *'Cultures of Whiggism': New Essays on English Literature and Culture in the Long Eighteenth Century*, ed. David Womersley (Newark, NJ: University of Delaware Press, 2005), 108–26.

Klein, Lawrence E., 'Making Philosophy Worldly in the London Periodical about 1700', in *Perspectives on Early Modern and Modern Intellectual History: Essays in Honor of Nancy S. Struever*, ed. Joseph Marino and Melinda W. Schlitt (Rochester, NY: University of Rochester Press, 2001), 401–18.

Klein, Lawrence E., 'Politeness for Plebes: Consumption and Social Identity in Early Eighteenth-Century England', in *The Consumption of Culture 1600–1800: Image, Object, Text*, ed. Ann Bermingham and John Brewer (London: Routledge, 1995), 362–82.

Klein, Lawrence E., *Shaftesbury and the Culture of Politeness: Moral Discourse and Cultural Politics in Early Eighteenth-Century England* (Cambridge: Cambridge University Press, 1994).

Klein, Lawrence E., 'Sociability, Solitude, and Enthusiasm', in *Enthusiasm and Enlightenment in Europe, 1650–1850*, ed. Lawrence E. Klein and Anthony J. La Vopa (San Marino, CA: Huntington Library, 1998), 153–77.

Knif, Henrik, *Gentlemen and Spectators: Studies in Journals, Opera and the Social Scene in Late Stuart London* (Helsinki: Finnish Historical Society, 1995).

Kristeller, Paul Oskar, 'The Modern System of the Arts: A Study in the History of Aesthetics (I)', *Journal of the History of Ideas* 12, no. 4 (1951), 496–527.

Kristeller, Paul Oskar, 'The Modern System of the Arts: A Study in the History of Aesthetics (II)', *Journal of the History of Ideas* 13, no. 1 (1952), 17–46.

Kumar, Krishan, 'Greece and Rome in the British Empire: Contrasting Role Models', *Journal of British Studies* 51, no. 1 (2012), 76–101.

La Vopa, Anthony J., 'The Philosopher and the *Schwärmer*: On the Career of a German Epithet from Luther to Kant', *Huntington Library Quarterly* 60, nos 1/2 (1997), 85–115.

Larthomas, Jean-Paul, *De Shaftesbury à Kant* (Paris: Didier Erudition, 1985).

Laslett, Peter, 'Introduction', in John Locke, *Two Treatises of Government*, Cambridge Texts in the History of Political Thought, ed. Peter Laslett (Cambridge: Cambridge University Press, 1988), 3–122.

Levinson, Jerrold, 'Hume's Standard of Taste: The Real Problem', *Journal of Aesthetics and Art Criticism* 60, no. 3 (2002), 227–38.

Levinson, Jerrold, 'The Real Problem Sustained: Reply to Wieand', *Journal of Aesthetics and Art Criticism* 61, no. 4 (2003), 398–9.

Locke, John, 'The Character of Mr. Locke', in *The Works of John Locke*, vol. 9, 12th edn (London, 1824), 162–74.

Locke, John, *An Essay Concerning Human Understanding*, The Clarendon Edition of the Works of John Locke, ed. Peter H. Nidditch (Oxford: Oxford University Press, 1975).

Locke, John, 'Locke to Anthony Collins, Oates, 23 August, 1704', in *John Locke: Selected Correspondence*, ed. Mark Goldie (Oxford: Oxford University Press, 2002), 334–5.

Locke, John, *Two Treatises of Government*, Cambridge Texts in the History of Political Thought, ed. Peter Laslett (Cambridge: Cambridge University Press, 1988).

Longinus, *On the Sublime*, ed. and trans. W. Rhys Roberts (Cambridge: Cambridge University Press, 1907).

Lovejoy, Arthur O., *The Great Chain of Being: A Study of the History of an Idea* (Cambridge, MA: Harvard University Press, 1936).

Lowth, Robert, *Lectures on the Sacred Poetry of the Hebrews*, vol. 1, trans. G. Gregory (London, 1787).

Lucian, *Affairs of the Heart*, in *Lucian*, vol. 8, trans. M. D. Macleod, Loeb Classical Library 432 (Cambridge, MA: Harvard University Press, 1967).

Luther, Martin, 'Lectures on Genesis', in *Luther's Works*, vol. 2, ed. Jaroslav Pelikan (Saint Louis, MO: Concordia, 1960).

Luther, Martin, 'Lectures on Isaiah', in *Luther's Works*, vol. 16, ed. Jaroslav Pelikan (Saint Louis, MO: Concordia, 1969).

Luther, Martin, 'Lectures on Isaiah', in *Luther's Works*, vol. 17, ed. Hilton C. Oswald (Saint Louis, MO: Concordia, 1972).

Luther, Martin, 'Text der Genesisvorlesung', in *Martin Luthers Werke: Kritische Gesamtausgabe*, vol. 42 (Weimar: Hermann Böhlaus Nachfolger, 1911).

Luther, Martin, 'Vorlesung über Jesaja', in *Martin Luthers Werke: Kritische Gesamtausgabe*, vol. 31.2 (Weimar: Hermann Böhlaus Nachfolger, 1914).

MacDougall, Hugh A., *Racial Myth in English History: Trojans, Teutons, and Anglo-Saxons* (Montreal: Harvest House, 1982).

Mackenzie, George, *Parainesis Pacifica; or, a Perswasive to the Union of Britain* (Edinburgh, 1702).
Mackie, Erin, *Market à la Mode: Fashion, Commodity, and Gender in The Tatler and The Spectator* (Baltimore, MD: Johns Hopkins University Press, 1997).
Malcolm, Noel, 'Editorial Introduction', in Thomas Hobbes, *Leviathan*, vol. 1, ed. Noel Malcolm, The Clarendon Edition of the Works of Thomas Hobbes (Oxford: Oxford University Press, 2012).
Mandeville, Bernard, *The Fable of the Bees: Or, Private Vices, Publick Benefits*, vol. 1, ed. F. B. Kaye (Oxford: Clarendon Press, 1924).
Manuscripts of the Earl of Egmont: Diary of Viscount Percival, Afterwards First Earl of Egmont, vol. 1, 1730–1733 (London: HMSO, 1920).
Marchand, Suzanne L., *Down from Olympus: Archaeology and Philhellenism in Germany, 1750–1970* (Princeton, NJ: Princeton University Press, 1996).
Marcus Aurelius, *Meditations*, in *Marcus Aurelius*, trans. C. R. Haines, Loeb Classical Library 58 (Cambridge, MA: Harvard University Press, 1916).
Martinich, A. P., *Hobbes: A Biography* (Cambridge: Cambridge University Press, 1999).
Martinich, A. P., 'Thomas Hobbes in Stuart England', in *A Hobbes Dictionary* (Oxford: Blackwell, 1995), 1–18.
Mattick, Paul, *Art in Its Time: Theories and Practices of Modern Aesthetics* (London: Routledge, 2003).
Mattick, Paul, 'Introduction', in *Eighteenth-Century Aesthetics and the Reconstruction of Art*, ed. Paul Mattick, Jr (Cambridge: Cambridge University Press, 1993), 1–15.
Maurer, Christian, 'Self-Interest and Sociability', in *The Oxford Handbook of British Philosophy in the Eighteenth Century*, ed. James A. Harris (Oxford: Oxford University Press, 2013), 291–314.
Maximus of Tyre, *The Philosophical Orations*, trans. M. B. Trapp (Oxford: Clarendon Press, 1997).
McCrea, Brian, *Addison and Steele Are Dead: The English Department, Its Canon, and the Professionalization of Literary Criticism* (Newark, NJ: University of Delaware Press, 1990).
McGeary, Thomas, 'Opera and British Nationalism, 1700–1711', *Revue LISA/LISA e-Journal* 4, no. 2 (2006), 5–19.
McGeary, Thomas, *The Politics of Opera in Handel's Britain* (Cambridge: Cambridge University Press, 2013).
McGeary, Thomas, 'Shaftesbury on Opera, Spectacle and Liberty', *Music & Letters* 74, no. 4 (1993), 530–41.
McLeod, Ken, 'Ideology and Racial Myth in Purcell's *King Arthur* and Arne's *Alfred*', *Restoration: Studies in English Literary Culture, 1660–1700* 34, nos 1–2 (2010), 83–102.
Mee, Jon, *Romanticism, Enthusiasm, and Regulation: Poetics and the Policing of Culture in the Romantic Period* (Oxford: Oxford University Press, 2005).

Meyer, Horst, *Limae labor: Untersuchungen zur Textgenese und Druckgeschichte von Shaftesburys 'The Moralists'* (Frankfurt am Main: Peter Lang, 1978).

Milton, John, *Complete Prose Works of John Milton*, vol. 1: 1624–1642 (New Haven, CT: Yale University Press, 1953).

Milton, John, *Paradise Lost*, in *John Milton: Complete Poems and Major Prose*, ed. Merritt Y. Hughes (Indianapolis, IN: Hackett, 2003).

Monk, Samuel H., *The Sublime: A Study of Critical Theories in Eighteenth-Century England* (New York: Modern Language Association of America, 1935).

Montesquieu, *De L'Esprit des Lois*, in *Oeuvres complètes de Montesquieu*, vol. 3, ed. Catherine Volpilhac-Auger (Oxford: Voltaire Foundation, 2008).

More, Henry, *Enthusiasmus Triumphatus, or, a Discourse of the Nature, Causes, Kinds, and Cure, of Enthusiasme* (London, 1656).

Mortensen, Preben, *Art in the Social Order: The Making of the Modern Conception of Art* (Albany: State University of New York Press, 1997).

Mothersill, Mary, 'Hume and the Paradox of Taste', in *Aesthetics: A Critical Anthology*, ed. George Dickie, Richard Sclafani and Ronald Roblin, 2nd edn (New York: St Martin's Press, 1989), 269–86.

Mücke, Dorothea E. von, *The Practices of the Enlightenment: Aesthetics, Authorship, and the Public* (New York: Columbia University Press, 2015).

Müller, Patrick, '"Dwell with Honesty & Beauty & Order": The Paradox of Theodicy in Shaftesbury's Thought', *Aufklärung: Interdisziplinäres Jahrbuch zur Erforschung des 18. Jahrhunderts und seiner Wirkungsgeschichte* 22 (2010), 201–31.

Müller, Patrick, 'Hobbes, Locke and the Consequences: Shaftesbury's Moral Sense and Political Agitation in Early Eighteenth-Century England', *Journal for Eighteenth-Century Studies* 37, no. 3 (2014), 315–30.

Müller, Patrick, 'Introduction: Reading Shaftesbury in the Twenty-First Century', in *New Ages, New Opinions: Shaftesbury in His World and Today*, ed. Patrick Müller (Frankfurt am Main: Peter Lang, 2014), 17–23.

Müller, Patrick, 'Shaftesbury on the Psychoanalyst's Couch: A Historicist Perspective on Gender and (Homo)Sexuality in *Characteristicks* and the Earl's Private Writings', *Swift Studies* 25 (2010), 56–81.

Newman, Donald J., 'Introduction', in *The Spectator: Emerging Discourses*, ed. Donald J. Newman (Newark, NJ: University of Delaware Press, 2005), 11–38.

Newton, Isaac, *Optice: Sive De Reflexionibus, Refractionibus, Inflexionibus & Coloribus Lucis. Libri Tres* (London, 1706).

Newton, Isaac, *Opticks: Or, a Treatise of the Reflections, Refractions, Inflections and Colours of Light*, 2nd edn (London, 1718).

Nicolson, Marjorie Hope, *Mountain Gloom and Mountain Glory: The Development of the Aesthetics of the Infinite* (Seattle: University of Washington Press, 1997; orig. 1959).

Norton, Brian Michael, 'The Spectator, Aesthetic Experience and the Modern Idea of Happiness', *English Literature* 2, no. 1 (2015), 87–104.
Norton, Brian Michael, 'The Spectator and Everyday Aesthetics', *Lumen: Selected Proceedings from the Canadian Society for Eighteenth-Century Studies* 34 (2015), 123–36.
O'Connell, Sheila, 'Lord Shaftesbury in Naples: 1711–1713', *The Walpole Society* 54 (1988), 149–219.
O'Gorman, Frank, *The Long Eighteenth Century: British Political & Social History 1688–1832* (London: Hodder Arnold, 1997).
Ovid, *The Art of Love, and Other Poems*, trans. J. H. Mozley, Loeb Classical Library 232, 2nd edn (Cambridge, MA: Harvard University Press, 1979).
Ovid, *Metamorphoses*, vol. 1, trans. Frank Justus Miller, Loeb Classical Library 42, 2nd edn (Cambridge, MA: Harvard University Press, 1971).
Pascal, *Pensées*, in *Œuvres Complètes*, vol. 2 (Paris: Gallimard, 2000).
Patey, Douglas Lane, 'The Eighteenth Century Invents the Canon', *Modern Language Studies* 18, no. 1 (1988), 17–37.
Perinetti, Dario, 'The Nature of Virtue', in *The Oxford Handbook of British Philosophy in the Eighteenth Century*, ed. James A. Harris (Oxford: Oxford University Press, 2013), 333–68.
Pieper, Josef, *Begeisterung und Göttlicher Wahnsinn: Über den platonischen Dialog Phaidros* (Munich: Kösel-Verlag, 1962).
Pieper, Josef, *Enthusiasm and Divine Madness: On the Platonic Dialogue Phaedrus*, trans. Richard Winston and Clara Winston (South Bend, IN: St Augustine's Press, 2000).
Pincus, Steve, *1688: The First Modern Revolution* (New Haven, CT: Yale University Press, 2009).
Plato, *Epistles*, in *Timaeus, Critias, Cleitophon, Menexenus, Epistles*, vol. 9, trans. R. G. Bury, Loeb Classical Library 234 (Cambridge, MA: Harvard University Press, 1929).
Plato, *Ion*, in *The Statesman, Philebus, Ion*, trans. Harold N. Fowler and W. R. M. Lamb, Loeb Classical Library 164 (Cambridge, MA: Harvard University Press, 1925).
Plato, *Phaedo*, in *Euthyphro, Apology, Crito, Phaedo, Phaedrus*, trans. Harold North Fowler, Loeb Classical Library 36 (Cambridge, MA: Harvard University Press, 1960).
Plato, *Phaedrus*, in *Euthyphro, Apology, Crito, Phaedo, Phaedrus*, trans. Harold N. Fowler, Loeb Classical Library 36 (Cambridge, MA: Harvard University Press, 1914).
Plato, *Protagoras*, in *Laches, Protagoras, Meno, Euthydemus*, trans. W. R. M. Lamb, Loeb Classical Library 165 (Cambridge, MA: Harvard University Press, 1924).
Plato, *Republic*, vol. 1, trans. Chris Emlyn-Jones and William Preddy, Loeb Classical Library 237 (Cambridge, MA: Harvard University Press, 2013).
Plato, *Republic*, vol. 2, trans. Chris Emlyn-Jones and William Preddy, Loeb Classical Library 276 (Cambridge, MA: Harvard University Press, 2013).
Plato, *Symposium*, in *Lysis, Symposium, Gorgias*, trans. W. R. M. Lamb, Loeb Classical Library 166 (Cambridge, MA: Harvard University Press, 1925).

Plato, *Timaeus*, in *Timaeus, Critias, Cleitophon, Menexenus, Epistles*, vol. 9, trans. R. G. Bury, Loeb Classical Library 234 (Cambridge, MA: Harvard University Press, 1929).
Plato on Poetry, ed. Penelope Murray (Cambridge: Cambridge University Press, 1996).
Plautus, *Asinaria*, in *Amphitryon, The Comedy of Asses, The Pot of Gold, The Two Bacchises, The Captives*, trans. Wolfgang de Melo, Loeb Classical Library 60 (Cambridge, MA: Harvard University Press, 2011).
Pliny, *Natural History*, vol. 9, trans. H. Rackham, Loeb Classical Library 394 (Cambridge, MA: Harvard University Press, 1952).
Pocock, J. G. A., *The Ancient Constitution and the Feudal Law: A Study of English Historical Thought in the Seventeenth Century* (Cambridge: Cambridge University Press, 1987).
Pocock, J. G. A., *The Machiavellian Moment: Florentine Political Thought and the Atlantic Republican Tradition* (Princeton, NJ: Princeton University Press, 1975).
Pollock, Anthony, *Gender and the Fictions of the Public Sphere, 1690–1755* (New York: Routledge, 2007).
Porter, James I., 'Is Art Modern? Kristeller's "Modern System of the Arts" Reconsidered', *British Journal of Aesthetics* 49, no. 1 (2009), 1–24.
Porter, James I., *The Origins of Aesthetic Thought in Ancient Greece: Matter, Sensation, and Experience* (Cambridge: Cambridge University Press, 2010).
Porter, James I., 'Reply to Shiner', *British Journal of Aesthetics* 49, no. 2 (2009), 171–8.
Powell, John S., *Music and Theatre in France 1600–1680* (Oxford: Oxford University Press, 2000).
Press, Gerald A., *The Development of the Idea of History in Antiquity* (Montreal: McGill-Queen's University Press, 1982).
Prince, Michael, *Philosophical Dialogue in the British Enlightenment: Theology, Aesthetics, and the Novel* (Cambridge: Cambridge University Press, 1996).
Quintilian, *Institutio Oratoria*, vol. 3, trans. H. E. Butler, Loeb Classical Library 126 (Cambridge, MA: Harvard University Press, 1921).
Rauhut, Franz, 'Die Herkunft der Worte und Begriffe "Kultur", "Civilisation" und "Bildung"', in *Beiträge zur Geschichte des Bildungsbegriffs*, ed. Wolfgang Klafki (Weinheim: Beltz, 1965), 11–22.
Richardson, Jonathan, *A Discourse on the Dignity, Certainty, Pleasure and Advantage, of the Science of a Connoisseur* (London, 1719).
Richardson, Jonathan, *An Essay on the Theory of Painting*, 2nd edn (London, 1725).
Richetti, John, 'Introduction', in *The Cambridge History of English Literature, 1660–1780*, ed. John Richetti (Cambridge: Cambridge University Press, 2005), 1–9.
Rind, Miles, 'The Concept of Disinterestedness in Eighteenth-Century British Aesthetics', *Journal of the History of Philosophy* 40, no. 1 (2002), 67–87.
Rivers, Isabel, *Reason, Grace, and Sentiment: A Study of the Language of Religion and Ethics in England, 1660–1780. Volume II: Shaftesbury to Hume* (Cambridge: Cambridge University Press, 2000).

Rivers, Isabel, 'Shaftesburian Enthusiasm and the Evangelical Revival', in *Revival and Religion since 1700: Essays for John Walsh*, ed. Jane Garnett and Colin Matthew (London: Hambledon Press, 1993), 21–39.

Roach, Joseph R., 'Cavaliere Nicolini: London's First Opera Star', *Educational Theatre Journal* 28, no. 2 (1976), 189–205.

Roelofs, H. Mark, 'Democratic Dialectics', *The Review of Politics* 60, no. 1 (1998), 5–29.

Rosenberg, Jordana, *Critical Enthusiasm: Capital Accumulation and the Transformation of Religious Passion* (Oxford: Oxford University Press, 2011).

Ryan, Alan, 'Hobbes's Political Philosophy', in *The Cambridge Companion to Hobbes*, ed. Tom Sorell (Cambridge: Cambridge University Press, 1996), 208–45.

Rymer, Thomas, *A Short View of Tragedy; It's Original, Excellency, and Corruption, with Some Reflections on Shakespear, and Other Practitioners for the Stage* (London, 1693).

Schaarschmidt, Ilse, 'Der Bedeutungswandel der Begriffe "Bildung" und "bilden" in der Literaturepoche von Gottsched bis Herder', in *Beiträge zur Geschichte des Bildungsbegriffs*, ed. Wolfgang Klafki (Weinheim: Beltz, 1965), 25–87.

Schaeffer, John D., *Sensus Communis: Vico, Rhetoric, and the Limits of Relativism* (Durham, NC: Duke University Press, 1990).

Schmidt-Haberkamp, Barbara, *Die Kunst der Kritik: zum Zusammenhang von Ethik und Ästhetik bei Shaftesbury* (Munich: Wilhelm Fink, 2000).

Scholar, Richard, *The Je-Ne-Sais-Quoi in Early Modern Europe: Encounters with a Certain Something* (Oxford: Oxford University Press, 2005).

Semi, Maria, *Music as a Science of Mankind in Eighteenth-Century Britain*, trans. Timothy Keates (Farnham: Ashgate, 2012).

Seneca, *Epistles*, vol. 3, trans. Richard M. Gummere, Loeb Classical Library 77 (Cambridge, MA: Harvard University Press, 1925).

Shapiro, Marianne, *The Poetics of Ariosto* (Detroit, MI: Wayne State University Press, 1988).

Shelley, James, 'Empiricism: Hutcheson and Hume', in *The Routledge Companion to Aesthetics*, ed. Berys Gaut and Dominic McIver Lopes, 2nd edn (London: Routledge, 2005).

Shelley, James, 'Hume's Double Standard of Taste', *Journal of Aesthetics and Art Criticism* 52, no. 4 (1994), 437–45.

Shevelow, Kathryn, *Women and Print Culture: The Construction of Femininity in the Early Periodical* (London: Routledge, 1989).

Shiner, Larry, 'Continuity and Discontinuity in the Concept of Art', *British Journal of Aesthetics* 49, no. 2 (2009), 159–69.

Shiner, Larry, *The Invention of Art: A Cultural History* (Chicago, IL: University of Chicago Press, 2001).

Sidney, Philip, *A Defence of Poetry*, in *Miscellaneous Prose of Sir Philip Sidney*, ed. Katherine Duncan-Jones and Jan Van Dorsten (Oxford: Oxford University Press, 1973), 59–121.

Simmons, A. John, 'John Locke's *Two Treatises of Government*', in *The Oxford Handbook of British Philosophy in the Seventeenth Century*, ed. Peter R. Anstey (Oxford: Oxford University Press, 2013), 542–62.

Skinner, Quentin, 'Meaning and Understanding in the History of Ideas', in *Visions of Politics, Volume I: Regarding Method* (Cambridge: Cambridge University Press, 2002), 57–89.

Smith, Anthony D., *National Identity* (London: Penguin Books, 1991).

Smith, William, 'Some Account of the Life, Writings *and* Character of *Longinus*', in *Dionysius Longinus on the Sublime* (London, 1739).

Smithers, Peter, 'Introduction', in *The Spectator*, vol. 1, ed. Gregory Smith (London: Dent, 1967), viii–x.

Smithers, Peter, *The Life of Joseph Addison* (Oxford: Clarendon Press, 1954).

Sorell, Tom, 'Hobbes, Locke and the State of Nature', in *Studies on Locke: Sources, Contemporaries, and Legacy*, ed. Sarah Hutton and Paul Schuurman (Dordrecht: Springer, 2008), 27–43.

Spadafora, David, *The Idea of Progress in Eighteenth-Century Britain* (New Haven, CT: Yale University Press, 1990).

Spalding, Johann Joachim, 'Die Bestimmung des Menschen', ed. Albrecht Beutel, Daniela Kirschkowski and Dennis Prause, in *Kritische Ausgabe: Schriften*, vol. 1 (Tübingen: Mohr Siebeck, 2006).

Spalding, Johann Joachim, *Lebensbeschreibung*, in *Kleinere Schriften 2: Briefe an Gleim, Lebensbeschreibung*, ed. Albrecht Beutel and Tobias Jersak, in *Kritische Ausgabe: Schriften*, vol. 6 (Tübingen: Mohr Siebeck, 2002), 105–240.

Spalding, Johann Joachim, 'Schreiben des Uebersetzers an Herrn ---', in *Kleinere Schriften 1*, ed. Olga Söntgerath, in *Kritische Ausgabe: Schriften*, vol. 6 (Tübingen: Mohr Siebeck, 2006), 173–95.

Speight, Allen, 'Hegel on Art and Aesthetics', in *The Palgrave Handbook of German Idealism*, ed. Matthew C. Altman (Basingstoke: Palgrave Macmillan, 2014), 687–703.

Spencer, Terence, *Fair Greece, Sad Relic: Literary Philhellenism from Shakespeare to Byron* (London: Weidenfeld & Nicolson, 1954).

Sprat, Thomas, *The History of the Royal Society: For the Improving of Natural Knowledge* (London, 1667).

Sprat, Thomas, *Sermons Preached on Several Occasions* (London, 1710).

Stark, Ryan J., 'From Mysticism to Scepticism: Stylistic Reform in Seventeenth-Century British Philosophy and Rhetoric', *Philosophy and Rhetoric* 34, no. 4 (2001), 322–34.

Stark, Ryan J., *Rhetoric, Science, and Magic in Seventeenth-Century England* (Baltimore, MD: Catholic University of America Press, 2011).

Stecker, Robert, 'Aesthetic Instrumentalism and Aesthetic Autonomy', *British Journal of Aesthetics* 24, no. 2 (1984), 160–5.

Stephens, William O., 'Epictetus on Beastly Vices and Animal Virtues', in *Epictetus: His Continuing Influence and Contemporary Relevance*, ed. Dane R. Gordon and David B. Suits (Rochester: RIT Press, 2014), 205–38.

Stollberg-Rilinger, Barbara, *Der Staat als Maschine: Zur politischen Metaphorik des absoluten Fürstenstaats* (Berlin: Duncker & Humblot, 1986).

Stolnitz, Jerome, 'On the Origins of "Aesthetic Disinterestedness"', *Journal of Aesthetics and Art Criticism* 20, no. 2 (1961), 131–43.

Stolnitz, Jerome, 'On the Significance of Lord Shaftesbury in Modern Aesthetic Theory', *Philosophical Quarterly* 11, no. 43 (1961), 97–113.

Stolnitz, Jerome, 'A Third Note on Eighteenth-Century "Disinterestedness"', *Journal of Aesthetics and Art Criticism* 22, no. 1 (1963), 69–70.

Stuart-Buttle, Tim, 'Shaftesbury Reconsidered: Stoic Ethics and the Unreasonableness of Christianity', *Locke Studies* 15 (2015), 163–213.

Taraborrelli, Angela, 'The Cosmopolitanism of Lord Shaftesbury', in *New Ages, New Opinions: Shaftesbury in His World and Today*, ed. Patrick Müller (Frankfurt am Main: Peter Lang, 2014), 185–200.

Terence, *The Woman of Andros*, ed. and trans. John Barsby, Loeb Classical Library 22 (Cambridge, MA: Harvard University Press, 2001).

Thorslev, Peter L., *The Byronic Hero: Types and Prototypes* (Minneapolis: University of Minnesota Press, 1962).

Till, Nicholas, '"An Exotic and Irrational Entertainment": Opera and Our Others; Opera as Other', in *The Cambridge Companion to Opera Studies*, ed. Nicholas Till (Cambridge: Cambridge University Press, 2012), 298–324.

Tillotson, John, *The Works of the Most Reverend Dr. John Tillotson, Late Lord Archbishop of Canterbury*, vol. 2, 5th edn (London, 1735).

Toland, John, *Anglia Libera: Or the Limitation and Succession of the Crown of England Explain'd and Asserted; as Grounded on His Majesty's Speech; The Proceedings in Parlament; The Desires of the People, The Safety of Our Religion; The Nature of Our Constitution; The Balance of Europe; And The Rights of All Mankind* (London, 1701).

Townsend, Dabney, 'Introduction: Aesthetics in the Eighteenth Century', in *Eighteenth-Century British Aesthetics*, ed. Dabney Townsend (Amityville, NY: Baywood, 1999), 1–31.

Townsend, Dabney, 'Shaftesbury's Aesthetic Theory', *Journal of Aesthetics and Art Criticism* 41, no. 2 (1982), 205–13.

Uehlein, Friedrich A., 'Anthony Ashley Cooper, Third Earl of Shaftesbury: Bibliographie der Schriften – Doxographie – Wirkung', in *Grundriß der Geschichte der Philosophie: die Philosophie des 18. Jahrhunderts*, vol. 1, ed. Helmut Holzhey and Vilem Mudroch (Basel: Schwabe, 2004).

Uehlein, Friedrich A., *Kosmos und Subjektivität: Lord Shaftesburys Philosophical Regimen* (Freiburg: Karl Alber, 1976).

Uehlein, Friedrich A., 'Whichcote, Shaftesbury and Locke: Shaftesbury's Critique of Locke's Epistemology and Moral Philosophy', *British Journal for the History of Philosophy* 25, no. 5 (2017), 1031–48.

Uphaus, Robert W., 'Shaftesbury on Art: The Rhapsodic Aesthetic', *Journal of Aesthetics and Art Criticism* 27, no. 3 (1969), 341–8.

Vickers, Brian, 'The Royal Society and English Prose Style: A Reassessment', in Brian Vickers and Nancy S. Struever, *Rhetoric and the Pursuit of Truth: Language Change in the Seventeenth and Eighteenth Centuries* (Los Angeles: William Andrews Clark Memorial Library, University of California, 1985), 3–76.

Voitle, Robert, *The Third Earl of Shaftesbury 1671–1713* (Baton Rouge: Louisiana State University Press, 1984).

Walsh, Dorothy, 'Aesthetic Objects and Works of Art', *Journal of Aesthetics and Art Criticism* 33, no. 1 (1974), 7–12.

Walzel, Oskar, *Das Prometheussymbol von Shaftesbury zu Goethe*, 2nd edn (Munich: Max Hueber, 1932).

Weber, William, *The Rise of Musical Classics in Eighteenth-Century England: A Study in Canon, Ritual, and Ideology* (Oxford: Clarendon Press, 1992).

White, David A., 'The Metaphysics of Disinterestedness: Shaftesbury and Kant', *Journal of Aesthetics and Art Criticism* 32, no. 2 (1973), 239–48.

Wieand, Jeffrey, 'Hume's Real Problem', *Journal of Aesthetics and Art Criticism* 61, no. 4 (2003), 395–8.

Wieand, Jeffrey, 'Hume's Two Standards of Taste', *Philosophical Quarterly* 34, no. 135 (1984), 129–42.

Willey, Basil, *The Eighteenth Century Background: Studies on the Idea of Nature in the Thought of the Period* (London: Chatto & Windus, 1950).

Winckelmann, Johann Joachim, '*Gedanken über die Nachahmung der griechischen Werke in der Malerei und Bildhauerkunst*', in *Kunsttheoretische Schriften* 1, Studien zur deutschen Kunstgeschichte, vol. 330 (Baden-Baden: Heitz, 1962).

Windelband, Wilhelm, *Geschichte und Naturwissenschaft* (Strasbourg: Heitz, 1904).

Woldt, Isabella, *Architektonik der Formen in Shaftesburys 'Second Characters': Über soziale Neigung des Menschen, Kunstproduktion und Kunstwahrnehmung* (Munich and Berlin: Deutscher Kunstverlag, 2004).

Wolin, Sheldon S., *Politics and Vision: Continuity and Innovation in Western Political Thought*, expanded edn (Princeton, NJ: Princeton University Press, 2004).

Wolterstorff, Nicholas, *Art Rethought: The Social Practices of Art* (Oxford: Oxford University Press, 2015).

Woodfield, Richard, 'The Freedom of Shaftesbury's Classicism', *British Journal of Aesthetics* 15, no. 3 (1975), 254–66.

Woodmansee, Martha, *The Author, Art, and the Market: Rereading the History of Aesthetics* (New York: Columbia University Press, 1994).

Xenophon, *Memorabilia*, in *Memorabilia, Oeconomicus, Symposium, Apology*, trans. E. C. Marchant and O. J. Todd, Loeb Classical Library 168 (Cambridge, MA: Harvard University Press, 2013).

Yadav, Alok, *Before the Empire of English: Literature, Provinciality, and Nationalism in Eighteenth-Century Britain* (New York: Palgrave MacMillan, 2004).

Young, James O., 'The Ancient and Modern System of the Arts', *British Journal of Aesthetics* 55, no. 1 (2015), 1–17.

Youngren, William H., 'Addison and the Birth of Eighteenth-Century Aesthetics', *Modern Philology* 79, no. 3 (1982), 267–83.

Åhlberg, Lars-Olof, 'The Invention of Modern Aesthetics: From Leibniz to Kant', in *Notions of the Aesthetic and of Aesthetics: Essays on Art, Aesthetics, and Culture* (Frankfurt am Main: Peter Lang, 2014), 31–53.

Index

Abrams, M. H. 3–4
Adam, Robert 129–30
Addison
 Aurelia and Fulvia 35, 71–8, 82, 86, 96
 Catholicism 45–6, 48, 94, 127
 civil war 56–8
 enthusiasm 102–3, 113–18
 Final Cause 89, 91–2
 France 46–8, 68–9, 127–8
 French opera 134–5
 great, uncommon, beautiful 89–91
 Italian opera 133–42
 nature and art (interplay) 100–1
 Nicolini 131, 139
 Pleasures of the Imagination 24, 35, 85–94
 taste 4–7, 14, 18, 63
 gustatory/aesthetic 77
 moral bodies of 60–1 *see also* Addison (Aurelia and Fulvia)
 national 137–42
 normativity of 23, 25, 55, 58, 62, 65, 67, 115
Aeschylus 122–3, 125, 212
aesthetic autonomy 1–3
 definitional autonomy/absolute autonomy 6 *see also* Shaftesbury (aesthetic disinterestedness)
aesthetic instrumentalism 1–2, 5, 7–8, 177
Aristotle
 Politics 19, 43
 Poetics 153, 204, 208, 213–14

Batteux, Charles 11
Berkeley, George 32, 75
Bernstein, J. M. 183
Bhabha, Homi K. 126
Boileau-Despréaux, Nicolas 47, 77, 77 n.12
Brewer, John 64, 66, 72, 221
Brown, Andrew 39

Carey, Daniel 8, 154
Charles II 26, 44–5, 50, 110, 221
Collis, Karen 223–4

de Bolla, Peter 15, 18, 67 n.27
Defoe, Daniel 40
Dennis, John 111, 124, 131, 137
Descartes, René 166, 190, 235
Des Maizeaux, Pierre 143–5

enthusiasm 102–18
Epictetus 8, 164, 193–4

Filmer, Robert 52–3

Gill, Michael B. 148 n.4, 158 n.5, 211 n.19
Goehr, Lydia 141
Gracián, Baltasar 61
Grote, Simon 4
Geuss, Raymond 81
Guyer, Paul 91, 191

Habermas, Jürgen 23
Halliwell, Stephen 12–13
Heine, Heinrich 13
Hesiod 211–12
Hobbes, Thomas 19–20, 54, 67, 150–1, 154–6, 172, 181, 190, 193
 Leviathan 40–4, 50–2
Home, Henry (Lord Kames) 125–6
Horace
 utile dulci 20, 120
 epistles 135, 207, 217
Hume, David 10, 20, 62, 160
 'Of the Standard of Taste' 78–81

Irlam, Shaun 77–8

Jaffro, Laurent 8 n.28, 28 n.107
James II 23, 44–5, 48–9, 128, 221, 223

Kant, Immanuel 2 n.5, 3, 240
Kivy, Peter 79–81, 228–9
Klein, Lawrence E. 15, 25–7, 73, 114–15, 210–11, 225
Kristeller, Paul Oskar 10–14

Leibniz, Gottfried Wilhelm 33 n.119, 145, 148 n.3, 217 n.46
Locke, John 25, 26, 27, 49–56, 59 144, 172–3 *see also* Shaftesbury (on Locke and innateness)
 on enthusiasm 106–8
Longinus 77, 89, 112–13
Luther (on enthusiasm) 104–5

Mandeville, Bernard 160–4
Marcus Aurelius 157, 187
men of letters (characterization of) 9–10
middling orders 20–2, 28, 54, 58, 64, 68, 71, 180
Milton, John 93, 98, 132, 222
More, Henry (on enthusiasm) 105–6, 111
Müller, Patrick 149 n.5, 154 n.21, 158 n.4, 176 n.52, 183, 193 n.61, 232

Ovid 71, 89, 212

Perrault, Charles 13
Plato
 Phaedo 21
 Ion 103
 Phaedrus 103–4, 204
 Timaeus 136
 Protagoras 191–2
Pliny the Elder 214–15
Porter, James I. 6, 11–12

Richardson, Jonathan, the Elder 120–3, 126
Rymer, Thomas 87–8, 124–5

Schmidt-Haberkamp, Barbara 167
Semi Maria 135 n.12, 140 n.33, 141, 142 n.39
Seneca, Lucius Annaeus 155
Shaftesbury
 anti-scholasticism 62
 Catholicism 45–6, 223
 Chorus 146, 205–6, 232–3, 235–6
 disinterestedness 170–5

aesthetic disinterestedness (Stolnitz) 177–84, 186, 189, 195–9
innateness 8–9
 on Locke and innateness 151–4
The Moralists 29–30, 33–4, 62
 contemplation of nature 180–3
 Epimetheus 192, 193
 enthusiasm 112
 hierarchy of beauty 201–2
 the old gentleman 192–3
 Philocles' critique of Theocles 191–2
 promethean myth 191–2
natural affections 30, 147–8, 150–1,
 critique of Hobbes 154–6
natural philosophy 190
opera 135–6
Prometheus 211–13
reflex affection 148–9
selfishness and self-interest 159–60, 164–5
sensus communis (Greek derivation of) 187
taste 4–6, 8, 14, 30–1, 154, 166–8, 187, 202–4, 221–2, 225–6, 228–30, 232–8
Shiner, Larry 2, 13–14
Sidney, Philip 212
Skinner, Quentin 16–18
Spalding, Johann Joachim 184–6
Sprat, Thomas 108–11
Stolnitz, Jerome *see* Shaftesbury (aesthetic disinterestedness)

Taraborrelli, Angela 28 n.106
taste *see also* Addison (taste) and Shaftesbury (taste)
 and aesthetic experience 4–6, 37
 and interest 2
 self-creative and self-legislative 77–8, 81
 temporality of 15, 65, 176

Uehlein, Friedrich A. 8 n. 28, 8 n.29, 31 n.112, 205 n.9

William III 48–9, 124
Winckelmann, Johann Joachim 126
Woldt, Isabella 230
Wolin, Sheldon S. 18–19
Wolterstorff, Nicholas 2
Woodmansee, Martha 11

www.ingramcontent.com/pod-product-compliance
Lightning Source LLC
Chambersburg PA
CBHW070023010526
44117CB00011B/1683